VIRGINIA BEACH

THROUGH THE 20TH CENTURY

AMY WATERS YARSINSKE

AMERICA
THROUGH TIME®
ADDING COLOR TO AMERICAN HISTORY

America Through Time is an imprint of Fonthill Media LLC
www.through-time.com
office@through-time.com

Published by Arcadia Publishing by arrangement with Fonthill Media LLC
For all general information, please contact Arcadia Publishing:
Telephone: 843-853-2070
Fax: 843-853-0044
E-mail: sales@arcadiapublishing.com
For customer service and orders:
Toll-Free 1-888-313-2665
Visit us on the internet at www.arcadiapublishing.com

First published 2017

Copyright © Amy Waters Yarsinske 2017

ISBN 978-1-63500-051-1

Typeset in Rotis Serif Std
Printed and bound by CPI Group (UK) Ltd, Croydon, CR0 4YY

CONTENTS

INTRODUCTION

T hough largely suburban in character, today's Virginia Beach is the most populous in Virginia and ranked forty-first most populous municipality in the United States at this writing. Located in Hampton Roads, an area known as "America's First Region," and situated on the Atlantic Ocean at the mouth of the Chesapeake Bay, Virginia Beach is a resort city with miles of beaches and a vibrant Oceanfront strip, several state parks, Naval Air Station Oceana-Dam Neck Annex, Joint Expeditionary Base Little Creek-Fort Story and Camp Pendleton State Military Reservation, a number of large corporations, two universities, and many historic sites. Near the point where the ocean and bay meet, Cape Henry was the site of the first landing of the English colonists, who eventually settled at Jamestown, on April 26, 1607. Virginia Beach is also located at the southern end of the Chesapeake Bay Bridge-Tunnel, the longest bridge-tunnel complex in the world. The story of today's Virginia Beach was written in the twentieth century, when a town and a county came together, taking the name of the better known and richly historic Oceanfront resort.

Going back in time, to the beginning of the twentieth century, we learn of a different Virginia Beach. Famed Antarctic explorer and *National Geographic* editor John Oliver La Gorce called what he observed of the ebb and flow of the ocean and land "a war of eternity." He was correct. Observant of remarkable geologic change to the coastline of the United States from the Virginia Capes to the Rio Grande in the fall of 1915, he opined that there was perpetual warfare between the land and sea, with the wind as a shifting ally. "Here the land is taking the offensive," he wrote, "driving the sea back foot by foot, always with the aid of the wind; there the sea assumes the offensive and eats its way landward slowly and laboriously, but none the less successfully." La Gorce called Cape Henry's smiling sands one of the most interesting points along the south Atlantic coast, a place to study "the battle royal" between the sea, the wind and the sand. Cape Henry had it all, he observed, "the weird beauty of its storm-buffeted beach, extending in broken masses of sand as far as the eye can reach," picked out here and there along the land edge by gnarled and stunted trees, beach grasses and hardy shrubs, all of which put up what he called a brave fight against the rhythm of the sea and sand.

The coastline from Virginia Beach to Cape Henry is geographically a continuation of the barrier reef that forms the coast of the Carolinas. Spanish explorers mapped Cape Henry's coastline in the sixteenth century, and it was these ill-fated travelers who left so many shipwrecks along the Virginia Beach coast. Cape Henry was the first land sighted by explorers arriving from the south and was thus the first strand approached by ships entering the "great shellfish bay" because of its proximity to the entrance of a navigable channel to the

cape. This bay, of course, would later be named Chesapeake Bay, and the best descriptions of it from Virginia Beach to Cape Henry are gleaned from early explorers and settlers, men whose observations of the land and navigable waters later played an important part in La Gorce's early twentieth-century study of the same.

As late as the turn of the twentieth century, Virginia Beach's shoreline was largely unblemished, most especially the Cape Henry Desert. Behind the first lighthouse ordered built by the fledgling United States government in 1791 was a more pretentious structure, the 1881 Cape Henry lighthouse. But the star attraction was neither. The original lighthouse was dwarfed by a great dune, a mountain of sand that eclipsed anything manmade. La Gorce called it the "savings bank of the winds for untold centuries." The dune stood more than one hundred feet high in long sections, and the great plateau on its crest stretched back into the country for several miles. He observed that this great mass of sand had slowly crept toward the interior, pushed back inch by inch by the restless wind and engulfing a great pine forest and filling up the Lynnhaven River, a tidal estuary that now flows into the Chesapeake Bay west of Cape Henry at Lynnhaven Inlet, beyond which is Lynnhaven Roads.

La Gorce called the Lynnhaven River "a small freshwater stream famous for its splendid oysters." Now more than a century later, the legendary Lynnhaven, its delectable oysters on the comeback, includes its eastern and western branches—Long Creek, Broad Bay, Crystal Lake and Linkhorn Bay—and all of the tributaries. The river's watershed is sixty-four square miles. Back in La Gorce's day, the advance of a giant sand dune on the Lynnhaven was the greatest threat to the river. To him it looked like a glacier, except, he opined, that the sand engulfed its prey without a sound, without a groan from the victim or the conqueror. Buffeted far offshore by many sandbars and reefs, the great dune had no enemies just then, hardly touched by wave action and seemingly immune to the ravages of high wind. La Gorce observed, in fact, that a good quarter mile of beach had been added to the Cape Henry shore since the old light was built.

Certainly, in the decades following the first English settlement at Jamestown, many of the early settlers to the Lynnhaven River reaches had outgrown the imprint of Captain John Smith and many of his contemporary explorers as they founded new homesteads and sought new opportunities. An evolved group of Englishmen, those whose footprint in some form still remains in the homes, historical record and descendants they left behind, represented a new generation of power brokers. Some of the names are familiar, to include Captain Adam Thoroughgood, Colonels Francis Mason and Anthony Lawson, Lieutenant William Willoughby, Henry Seawell, George Yardley, Daniel Gookin, and George Ludlow. These men and many more forged a society around Lynnhaven Bay in a parish that was modeled on the one they had left behind in England. Class distinction mattered. In the centuries to follow, most keenly at the start of the twentieth century, the impact of that influence was remarkably still being felt, carried forward generationally by equally powerful and influential families who bore their legacy and wealth. "It is easy enough," wrote Kathleen Eveleth Bruce on April 14, 1924, "to anglicize a country, if one [the Englishmen] first exterminates all the original inhabitants, and this he proceeded to do, filling plantation after plantation with his descendants and spreading his moral standards, intent upon establishing another England in this new land far away." And thus, it started. They built homes here and laid the foundation of the county's agrarian-driven economy that would prevail for centuries.

The earliest arrivals to what became Princess Anne County under the Dividing Act of 1691 set the stage, built homes—many of which are found herein—on exceptionally fertile farmland, all of it traveling on ridges, with creeks and swamps in-between. These ridges run

north to south, the best known of these being Pungo Ridge, which starts at the northernmost part of the county at the mouth of the Lynnhaven River and runs high and wide and fertile the length of the old county in the Pungo section. Though Pungo Ridge is the most readily recognizable, there are other ridges that played an important role in the early county history and most certainly into the twentieth century, including Poplar, Black Walnut, Chincapin, Brushby, Bullock's, Eastern, Cow Quarter, Porter's and Rattlesnake. All were excellent for farming. The clay subsoil was suitable for brickmaking, and nearby forests were full of trees good for lumber, both of which made these areas ideal for building homes and other buildings on their land. Tobacco was the primary crop but before the American Civil War the crop selection had been diversified to include hay—of which the county was once the number one producer in the commonwealth—and wheat and oats, among other particularly lucrative cash crops. Work performed on all plantations and farms in the county through the end of the Civil War was done by slaves, who at one point made up at least forty percent of the population. But not all of the county's families farmed. Some fished and crabbed while others, especially those living farther south, produced pitch, tar and turpentine for the Norfolk and Portsmouth shipyard industry that lined both sides of the Elizabeth River and even some of the river's smaller tributaries. The most unique enterprise by far was started by the Richard Murray family in the Indian River section [in what is today Virginia Beach] and juxtaposed on what was historically King's or Murray's Creek, a winding sliver of the eastern branch of the Elizabeth River; they were flax growers. In addition to the main house, Murray built a roothouse, smokehouse, the quarter kitchen and a large flax drying house constructed of brick. A cove of the creek came up behind the quarter kitchen, and it was there that the Murrays soaked their flax to separate the fiber from it. Other members of the Murray family resided across the creek and also south of the manor house. This family also serves as a good example of generational residence in the county. Lineal descendants of Richard Murray lived on the property eight years into the twentieth century.

Swamps and creeks separated fertile ridges. But a complex system of tidal rivers and tributaries, many of them flowing into small bays and inlets, folded into more creeks and marshes that made many areas impassable until much later—largely in the twentieth century—when bridges, hard surface roads and a rail network brought permanent changes to the landscape. The county's primordial natural waterways often cut so deeply into the land that the only way to move early settlers and their crops was by skiff or shallop and nearly every landowner from the extraordinarily wealthy plantation owners to the smallest farm operation had one in those salad days of Princess Anne County. We can credit the Lynnhaven Parish's Captain Adam Thoroughgood with the operation of the first ferry, which he initiated in 1636 at the convergence of the eastern and southern branches of the Elizabeth River between Norfolk and Portsmouth in what was still Lower Norfolk County. The ferry was nothing fancy, just a skiff handled by Thoroughgood's slaves. But the service quickly became so popular that the county took over his blossoming enterprise and continued to grow it well beyond Thoroughgood's expectations and lifetime. Rowboats were added. This ferry service advanced through the centuries and remained in constant operation until 1952, when the automobile made it an outdated mode of transportation not only between the two cities but also to points elsewhere in the region and up and down the East Coast. The birth of the interstate and bridge-tunnel systems put the last nail in the coffin of regional ferry service. The mid-twentieth century construction of the downtown and midtown tunnels between Norfolk and Portsmouth, the Hampton Roads Bridge-Tunnel between the southside and Peninsula, and the twenty-three-mile Chesapeake Bay Bridge-Tunnel linking southeastern

Virginia [at Virginia Beach] to the Delmarva Peninsula [Delaware plus the eastern shore counties in Maryland and Virginia] remain pointed examples of bridge-tunnel innovation eclipsing ferry service.

As the sun rose on the twentieth century, Virginia Beach was quickly becoming the premier summer retreat on the East Coast. From the first decade of the century through the end of World War II, the sleepy town of Virginia Beach held on, even when the lean times of the Great Depression tamped down the number of visitors to the Oceanfront. How quickly circumstances change. Fed by transportation improvements, the increased military presence and the post-World War II construction boom never before seen in the resort town, the public face of Virginia Beach was rapidly changing. One observer noted wryly that when you were headed to the beach, you did not have to say which beach. Virginia Beach was always "The Beach" in the mind's eye of locals and tourists. But today it has increasing competition from beach resorts up and down the East Coast. The Virginia Beach of yesteryear is all but gone; the fabric of old Princess Anne County's crazy quilt has been torn up by continued uncontrolled growth and encroachment of the transition zone and Green Line intended to preserve what remained of the agrarian and open space southern reaches of the city. Virginia Beach is still changing, plagued with the problems and politics to match a burgeoning population, many of whom were drawn to the city's reputation as "Virginia's front porch."

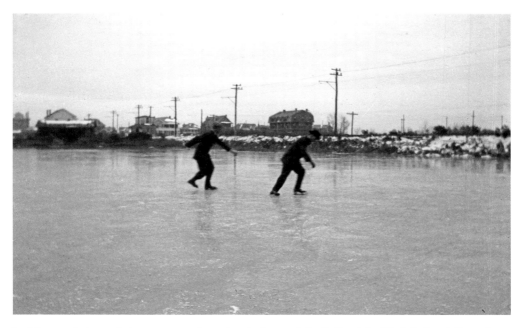

In this rare photograph, two men are shown ice skating on Lake Holly at the Virginia Beach Oceanfront, in the early 1900s and highly likely in 1918, the second major freeze recorded there up to that time. The first had been in 1857, the third was later, in 1936. All were the result of extended periods of deep freeze, making the water frozen enough to support the weight of two men skating on the lake. *Sargeant Memorial Collection, Norfolk Public Library*

I

New Century,
New Opportunities

For a very long time, there was no Virginia Beach and no seaside resort on the Atlantic Ocean below Cape Henry. No one ever went there. Virginia's golden shore was a beautiful blank canvas, a resort in waiting with no name. The August 14, 1881 *Norfolk Virginian* called it the "watering place that is to be." Still, it had no name. But the report went on to inform readers that Norfolk entrepreneur and civil engineer Colonel Marshall Parks' development company was moving forward to make it "the most attractive resort along the Atlantic coast." The *Norfolk Virginian*'s reporter crafted a beautifully written, if inaccurate, description of the beach. This as yet unnamed beach would not have been "entirely free of debris, sea grass, shells and pebbles." Debris, sea grass, shells and pebbles were strewn all over the beach, and in 1890 the resort's first streets were paved with seashells. "When we drove down the beach," continued the writer, "the wheels of the carriage hardly made an impression." Despite the article's utopian spin, we do learn that two and a half miles away the Lynnhaven River had already become famous for "the very best of oysters."

The story was written to capture the public's imagination; it mentions other place names that ring more familiar—Fort Monroe and Hampton Roads—as well as "the beautiful maritime scenery" for which the region was already known. But still no mention of "Virginia Beach." No one had given it a name, the reporter wrote. "As yet no name [has been] given to the place. The company is anxious to have a name that will be fully distinctive, and offer a prize for a name. The party who suggested a name and is accepted by the company will get the prize. This offer includes the ladies." There is no record of the contest nor any of the names that might have been suggested.

The first recorded use of the name "Virginia Beach" did not occur until the following year, on January 14, 1882, when the Virginia General Assembly approved the reorganization of Parks' Norfolk and Sewell's Point Railroad to the Norfolk and Virginia Beach Railroad and Improvement Company. The company's charter would be voided if it failed to complete a rail line to Virginia Beach in five years. Parks had his railroad in toperation the next year.

Marshall Ott Parks Jr. was born November 8, 1820, at Old Point Comfort, where his father, Marshall Ott Parks, managed the Hygiea Hotel. His mother was Norfolk-born Martha Sweeney Frances Sayer Boush. Parks' rise in the world of business was meteoric between 1850 and 1860, when he ascended from Hygiea Hotel clerk to president of the Albemarle and Chesapeake Canal, a prominent Norfolk city council and Virginia General Assembly member. He was still head of the canal company in 1870, but in the years to come (and up to the time of his death on June 10, 1900, at the home of his son-in-law and daughter Dr. George H. and Jane Weston Parks Rose at the age of eighty) Parks shifted his efforts largely to developing Virginia Beach into a resort destination like no other. Even after his company foreclosed, he continued to be one of its biggest boosters. Before he established the Norfolk

and Virginia Beach Railroad and Improvement Company, Parks stood up the Seaside Hotel and Land Company in 1880. Between 1880 and 1882, his land company negotiated the purchase of eleven farms from Princess Anne County landowners that totaled 1,350 acres that ran like a ribbon five miles parallel to the Atlantic Ocean. In 1882, the Norfolk and Virginia Beach Railroad and Improvement Company took control of Parks' hotel and land company and all of its holdings.

Parks' vision for the ribbony strip of beach began to take shape more quickly after he broke ground at Broad Creek in January 1883 for his railroad's eighteen-mile track to the beach. The first trip by rail to the Oceanfront was made on July 16, 1883, when Parks, company officers and invited guests made the winding trip through rural Princess Anne County to their final destination, a gracious pavilion being erected at the end of the line, presumably the Virginia Beach Club House at the end of Seventeenth Street adjacent to the rail stop. Lumber used to build everything from the pavilion to picnic tables came from nearby stands of pine. The Norfolk and Virginia Beach Railroad delivered 6,565 people to the beach between July 28 and September 30, 1883. Parks' patrons were happy enough, satisfied with opportunities to dance, picnic and play in the surf. But Parks wanted to offer the same seaside amenities that were already becoming wildly popular at the New Jersey shore, most of them associated with improved health and recreation.

The following year, in 1884, the Seaside Hotel and Land Company completed and opened the Virginia Beach Hotel at Fourteenth Street and Atlantic Avenue. This first beach hotel had sweeping views of the ocean from generously appointed verandas. But three years after it opened, the hotel and railroad were sold in foreclosure, only to be reformed under a plan devised by Pennsylvania corporate lawyer Charles William Mackey, who came to the Virginia shore with a reputation as "a positive genius for organization." Virginia Beach needed everything he had to offer. In whole or in part during the course of Mackey's career, he organized a hundred or more corporations with aggregate capital of nearly $150 million, including more than twenty railroad companies, six gas companies, sixty-seven manufacturing companies, eight to ten banks, three companies for the reduction of ores and several coal mining and quarrying companies. One of those railroads was Parks' Norfolk and Virginia Beach Railroad, which under Mackey's management established at Virginia Beach "a beautiful summer and winter resort."

The man credited with getting the Virginia Beach resort back on track has received little recognition for his hard work. Mackey was born on November 19, 1842, in Pennsylvania's Allegheny Valley. At the early age of eighteen, he started his law studies. When the Civil War broke out, he was commissioned a first lieutenant in the Tenth Pennsylvania Reserve Volunteers. While his service has been described in official records as "conspicuously useful and meritorious," the backstory of his Civil War experience proved the true measure of his character; it is not a story readily found in Mackey's biographies. The Tenth Pennsylvania Reserve Volunteers, also known as the Thirty-Ninth Infantry Regiment Pennsylvania, fought at nearly all major battles in Virginia and Maryland, including the Battle of Fredericksburg, Virginia, after which he was court-martialed and convicted of violation of the Fifty-Second Article of War, accused of abandoning his company and regiment while they were preparing to move to the front to engage the enemy on or about December 13, 1862. He pleaded "not guilty."

What happened at Fredericksburg was later determined to be beyond Charles Mackey's control. His division, led by Major General George Gordon Meade, became detached from the Union main force and was unsupported when it moved forward down the Richmond road. Overwhelmed, Meade's men broke and fled in disorder, leaving a large number of dead and

wounded on the field and several hundred prisoners in the hands of advancing Confederate forces. Mackey was, indeed, not guilty, and his record quickly expunged of the court-martial. He was promoted to captain and continued to serve through Gettysburg in June 1863.

After Mackey was discharged from the army on June 27, 1863, he accepted the appointment of special agent of the treasury from Secretary of the Treasury Salmon Portland Chase and was assigned to the Eastern District of Maryland, Virginia and North Carolina. He served in this role until August 1, 1865, when he tendered his resignation and returned to practicing law and fixing broken companies.

Under Mackey's direction, the Virginia Beach Hotel was expanded by the railroad from fifty to one hundred and thirty-nine rooms and took up two blocks from Fourteenth to Sixteenth Streets, with a railroad stop at its front door. The hotel's guest list was a who's who of politicians, captains of industry and American inventors: Presidents of the United States Benjamin Harrison and Grover Cleveland, William Jennings Bryan, Robert Green Ingersoll, Samuel Gompers, Cornelius Vanderbilt, Cyrus West Field and Alexander Graham Bell among others.

Four years after it was opened, the hotel's name was changed to the Princess Anne, and it was put under the management of New York hotelier Simeon E. Crittenden[1] (1834–1893). Soon after Crittenden took over, the Princess Anne became one of the premier vacation destinations on the East Coast, the star attraction of newly minted Virginia Beach. North and south of the Princess Anne beach property, owners built impressive seaside cottages with wide porches and big windows to take advantage of the ocean air. Back in those days, swimming was done in the early morning and late afternoon to avoid sunburn. Young ladies, most of them from out of town, made the train trip to Norfolk dressed in their finest batiste and lace, or sometimes organdie, as well as wide-brimmed hats and parasols. They were the cream of society, from Richmond, Lynchburg and Staunton, Virginia, to Washington, D.C., Boston and New York.

Virginia Beach's future first mayor, Bernard Peabody Holland, was barely eighteen when he came to the Virginia shore in 1885. Land was selling for twenty-five cents per acre, and opportunity was everywhere. He rented bicycles to the Princess Anne's guests. When interviewed by Kay Doughtie Sewell in March 1956, the eighty-nine-year-old Osceola, Fluvanna County, Virginia native recalled fondly that the Barrymore children—Ethel, John and Lionel—used to love to ride the bicycles around and around the pavilion. They were the attractive, lively children of actors Maurice and Georgiana Drew Barrymore, who came to the Virginia Beach shore on holiday. Not everyone saw them as so "attractive" just then. "Children are so hard to manage these days. It gives me great concern looking after these three,"[2] said Georgia Eva Cayvan (1857–1906), first in the great lineage of America's stage actresses, charged with the difficult duty of overseeing the activities of the Barrymore children.

Another visitor who stuck in Bernard Holland's mind was not nearly as attractive. He had "a big, fat face, a big nose, and side whiskers. He used to spend a lot of time on the beach in front of the hotel, with his pant legs rolled up, flying kites. He was always experimenting," Holland remembered, "always preoccupied." The man was Alexander Graham Bell. Bell and his family were regular visitors to the Princess Anne, but sometimes he came alone. During a solo visit in December 1901, he scouted a location for his tetrahedral kite research but found the area from Virginia Beach to Cape Henry unsuitable because of the telegraph wires and tall pines that might interfere with landing the kite.

Holland had been living and working at Virginia Beach for ten years when he took a wife and built her a house on a strip of land that ran from the shore to Lake Holly at Twelfth

Street. Upstairs, on the third floor, he installed a wireless telegraph station. From his telegraph room, Holland sent and received all of the news of happenings from the shore. He eventually served two noncontiguous terms as the town's mayor, the first after the resort was incorporated in March 1906 and which lasted for two years, and the second from 1913 to 1916. Fifty years later, he could still tell detailed stories of people he had met and the events that had unfolded.

"All the best people in Virginia used to come to the Beach," he told Sewell, "and the finest families in Norfolk." Then there were all these notables." Back then, famous faces were the rule, not the exception. As she spoke to Holland, Sewell looked over his shoulder, admiring the weathered but noble carved lion's head; it came from the wreckage of the fated Norwegian barque *Dictator* that ran aground off the hotel on March 27, 1881. Holland's own experience with the shipwreck had a happier ending. He had been ill for several days in his room on the hotel's third floor. One night, he got up about nine o'clock, and as he passed in front of the window, he looked out toward the beach. There, backlit by a bright moon, he thought he saw the majestic figure of a woman looking out to sea. What he saw, instead, was the figurehead of the *Dictator*, which had been first spotted by Emily Weld Randall Gregory (1873–1949), a visitor from Cooperstown, New York. She notified Simeon E. Crittenden and with the help of several strong men, the figurehead was pulled to shore and stood up in the sand. Four years later, the young woman who found it became Holland's wife.

Emily Gregory came from a wealthy family. Granddaughter Ann Francis Holland called her grandparents "the odd couple." Her grandmother, she wrote later, hated her life in Cooperstown, except for the opera, which she loved; the Gregorys had box seats at New York's old Metropolitan Opera. "She particularly loved Wagner." Her grandmother otherwise found her life there "boring and superficial. She used to say of it: 'We sat and sat and sat, and then we sat some more. The only work these ladies ever did,' she opined, 'was needlework, which as you know, came in handy later on and a bit of baking of special cakes and pies.' She was also very well read, an intellectual and a gifted musician; [she] played the piano, violin, viola and sang."

During one of the winter trips of Emily's parents, David Henderson and Emily Weld Randall Gregory, to Saint Augustine, Florida, they stopped at the Princess Anne Hotel, and there she met and fell in love with Bernard Holland; he fell immediately in love with her as well. Some called it love at first sight. "She was rich, intellectual and fat," recalled Ann Holland. "He was slim, dapper and unintellectual, though far from unintelligent. Her parents persuaded them to wait a couple of years." They were married on September 11, 1895, at Cooperstown, where her parents had a summer home they called Sunnyside.

Renting bicycles and being mayor were not the bookends of Holland's career. He was superintendent of the Norfolk, Virginia Beach and Southern Railroad and also an officer of the Princess Anne Hotel, where he lived until he built the first of two cottages for Emily, the second also located on Twelfth Street but one block inland from the first and built in 1904; Holland called the residence Ozone. "Mother was scared to death of fish," recalled the couple's only daughter Cornelia Randall Holland (1898–1988) decades later. "She went out in the boat [in Lake Holly] and the fish jumped on her." Cornelia was referring to the mullet fish in the saltwater lake behind the house. Back then, the Virginia Beach community called these fish "jumping mullets" because they would jump in the boat and bite. "Lot of people like mullets to eat," she said. "They were kind of nutty but a lot of people like them. There used to be a lot of them in the lake."[3]

Holland was also a shrewd real estate developer and well connected. In addition to the land on which he built his first cottage in 1895, he also bought property at Birdneck Point

and Back Bay. His connections with the hotel's distinguished roster of guests afforded friendship and business opportunities. Among the captains of industry and American politics he knew well were farm equipment manufacturer and Rockbridge County, Virginia native Cyrus Hall McCormick (1809–1884) and Maine United States senator James Gillespie Blaine, whose oldest son, William Emmons Blaine (1857–1892), eventually married Anita Eugenie McCormick, Cyrus and Nancy Maria Fowler McCormick's oldest daughter.

In the middle of his second term as mayor, Bernard Holland became extremely ill, and in 1916 he resigned from the railroad. In the years to come, he almost died several times. No one knew what caused his sickness until Emily took him back to New York, where her family owned a hospital room. There, according to Ann Holland, he was diagnosed with an inoperable inflammation of the secum, the flap that allows food into the stomach. From Ann Holland, we know that Bernard and Emily came back to Virginia Beach, where she took over support of the family. "[She] took in boarders," she wrote, "and rented out the house. She sent the children to Sunnyside and lived in the attic while summer renters lived downstairs. She opened The Variety Shop which had a lending library, yard goods [and other notions]. She did knitting and sewing for people. She sold a valuable piece of jewelry and probably some other things." This is how she managed to send the couple's three oldest boys to the University of Virginia. Their only daughter, Cornelia Holland, was given teaching lessons at the shore. She never got a formal education. But after five years passed, Emily cured her husband with a change of diet.

All that Emily Holland did to take care of her family, opined granddaughter Ann, came at a high price, and Cornelia paid for it. She was no more than a child when her mother put her in charge of younger brother David Gregory Holland (1901–1960) and all of the household chores. "Grandma always regretted sacrificing Nini [Cornelia's family nickname]. It was one of the last things she said before she died." Despite the trials of her early life, Cornelia would become as beloved to the Virginia Beach community as her mother and father had been during their lifetimes. But Emily never really got over what she did to her only daughter. "[Though] it was not unusual in those days for the eldest or only daughter to take over the mother role, Grandma realized that it was a tragedy. We all know that Nini was very much in love with a young man and [had been] forbidden to marry him. They bought her off with a trip to Europe and the promise of the property." Even after her husband recovered, Emily kept her store. Bernard Holland was never again as successful as he had been before his illness. He bought a general store, and they lived out their lives at Ozone. She died on December 8, 1949, and he died on January 4, 1960, at the age of ninety-two.

Bernard Holland filled in the blanks of early Virginia Beach history before his death. How else would we know today how Back Bay came into its own or what was going on down at the Cape Henry weather station or what the first town council was like? We would know little of it had it not been for his sharp memory and quick wit. Holland was an avid duck hunter. He told Kay Sewell that Marshall Parks spent his last years trying to get the federal government to construct a canal from the Lynnhaven River to Back Bay to create an inland waterway system. Currituck Inlet already drew enough saltwater into Currituck Sound and Back Bay to raise the salinity of the bay. "There were plenty of oysters in there [the bay] at the time; the shells are still there to show for it," he observed. "But after the inlet was closed, the waters in Back Bay became fresh, and soon there was a tremendous crop of luscious duck grasses. Wildfowl came down in hordes. For over one hundred years Back Bay has been one of the most used duck hunting grounds in the country."

Norfolk market gunners hunted the thousands of canvasbacks and redheads that flew into Back Bay and shipped their kill to buyers in the North. "The hunters," Holland recalled

in some detail, "used very large guns. Some of the birds were shot from swivels on boats. Some of the market gunners lived on little houseboats built low, on logs, and anchored out in the bay near [large concentrations of the duck]." Even President Harrison liked to hunt on Back Bay. No one knew quite how much until the consummate Republican got an invitation to hunt duck he couldn't refuse: "I remember when Judge [William Nathaniel] Portlock and several local politicians came and invited Harrison to go ducking with them. [This] meant driving a big old wagon, bigger than a buckboard, over twenty miles of the roughest Princess Anne [County] roads—just to go ducking with Democrats. I tell you, it would take Back Bay to make a Republican ignore politics and go off hunting with his opponents."

As a telegraph operator,[4] Holland supported the weather station at Cape Henry, which covered a wide swath of the coast from Virginia Beach to Cape Hatteras. After a big storm, weather station personnel would have to leave the bureau building, repair poles and restring the wire. "I'd help out," said Holland. "I'd take the messages and send them on to the weather bureau in Norfolk, and they'd send them on to Washington. Those signals had precedence over everything; when they came in, everything else had to stop." But one day, he got an urgent telegram from the Norfolk Western Union office. The hotel manager wanted to know if he knew the *Norfolk Virginian* owner and managing editor Michael Glennan (1843–1899) and, if so, where he had gone. Holland ran out the door and down to the beach, sure that he had last seen him down there with his son, Edward Keville Glennan (1880–1956). The Glennans were out on the sand. "I was running. What do you think was the news I had to bring? That the *Norfolk Virginian* newspaper building was burning down. Hadn't been built very long either. I remember it well. It was on Commerce Street."

Holland's leadership of the first Virginia Beach Town Council was one of the most important contributions that he would make to the budding resort. He was ably assisted by a handpicked group of men, all of them vested in some way in the community: Irish-born capitalist Daniel Stormont; Cape Henry Casino [also called O'Keefe's Casino] owner William John O'Keefe; James Sundy Groves, owner and president of the Virginia Beach Land Development Company; truck farmer William Joseph Wright, who became town mayor from September 6, 1910, to January 21, 1913, and headed the first commission to select the route of the new Norfolk-Virginia Beach highway; Amos Johnston Ackiss, an attorney; and painting contractor John P. Jones. The first meeting of the council occurred at the Princess Anne Hotel on March 15, 1906. There, the members accepted the town charter, posted a notice to recruit a town sergeant, named a committee to establish rules of order and dissolved the incorporation committee that had secured the charter. The town council continued to hold its meetings at the hotel, which had also been sold that year to Groves' development company, quartered in offices off the hotel lobby. But Groves' ownership of the grand dame of the shore was short-lived.

On the morning of June 10, 1907, the Princess Anne Hotel caught fire and burned to the ground. The fire that destroyed the hotel started in the kitchen, supposedly from a defective flue, and within two hours it had engulfed the hotel, the Norfolk and Southern Railroad depot, the bowling alley, a hotel laundry, the engine house, the office of the Virginia Beach Development Company and all of the boardwalk in front of the hotel. There were one hundred and ten guests and employees in the hotel. All were alerted to the fire by a young sergeant of the Richmond Light Artillery Blues, Herman Carl Boschen, who was on his way to the train station when he spotted the flames. He rushed into the hotel to alert guests and staff but was eventually overcome by smoke and had to be carried from the building. Two deaths were initially reported: Emma Clark, an African American chambermaid, and John Eaton, a

steward. Insurance did not cover the entire loss. The hotel safe, which contained thousands of dollars of guest valuables and heavy receipts, was not locked and all contents were lost when the building collapsed. There were unconfirmed reports that an unnamed guest, a friend of the hotel's manager, was also missing. Many prominent guests from different parts of the country took refuge in nearby cottages. Later that day, hotel manager Alexander C. Mitchell (1850–1937), married and the father of five, was so distraught at what had just happened that he tried to kill himself by jumping into the ocean. Mitchell and his family moved as far away from Virginia Beach as possible after the tragedy, settling in Sabinal, Uvalde County, Texas, where he died three decades later. Twenty years would pass before a hotel as grand and important as the Princess Anne was built at Virginia Beach.

Transportation to the Oceanfront had vastly improved before the hotel fire. Though it was competition for the Norfolk and Southern Railroad, the Chesapeake Transit Company started construction of its own rail line to Virginia Beach through Cape Henry in 1901. At that time, the Norfolk and Southern stopped at a point near what is today Sixteenth Street. When Norfolk and Southern saw that Chesapeake Transit's line came down from the north, it pushed its track up to Pacific Avenue and to about Twenty-Fifth Street and then across to the Oceanfront to cut off the new line. Chesapeake Transit superintendent George Lewis could play that game, too. He hid railroad ties and rails where the Cavalier Hotel now stands, and in the cover of darkness he took a work crew, laid a line across the Norfolk and Southern track and continued down the shore near the Princess Anne Hotel. Chesapeake Transit's rail service was open for service in 1903. The Norfolk and Southern was savvy to what Lewis had done. Only a short time passed before it countered and ran a parallel track from Virginia Beach to Cape Henry. After the two railroads merged, retaining the Norfolk and Southern name, the company took up the parallel track. The Norfolk and Southern ran a successful loop from Norfolk to Cape Henry to Virginia Beach and then back to Norfolk again.

The Norfolk and Southern Railroad established the original Seaside Park in 1906. Stretched between Thirtieth and Thirty-Third Streets, Seaside Park was the ultimate beach resort; it had it all. The brainchild of architect/owners Neff and Thompson, who built the north section, it was soon realized that the project was too much for owners Clarence Amos Neff and Thomas Perrin Thompson [Norfolk's future city manager], to manage without bringing in a partner. Harry Hofheimer (1872–1928), a Norfolk clothing merchant, real estate investor and also later owner of the city's Strand and Palace movie theaters, who had built the south section of the park, merged with Neff and Thompson to form the Sea Pine Improvement Corporation, resulting in the consolidated park. Hofheimer died on May 26, 1928, as the result of a car accident in North Carolina. At the time of his death, Hofheimer was also president of State Amusement Corporation, which owned the Arcade Theater just then. Of note, Hofheimer was recognized nationally for his advertising and marketing skill, which he applied to the benefit of his interest in Seaside Park. Seaside continued to be owned by the joint enterprise he had formed with Neff and Thompson until it was sold decades later, in 1944, to Greenco Corporation, owned by Jack Louis Greenspoon (1893–1957), of Virginia Beach, and Dudley Cooper (1899–1996), a Norfolk optometrist and businessman with varied interests, to include Ocean View Amusement Park.

Seaside Park was in business just six years when, on June 1, 1912, the Virginia Beach Casino was added at Thirty-First Street, in the boundary of the park on a patch of land that had been a small beach and the country club that had attracted the first visitors to the shore from the 1880s. Within a short period of time, the casino subsumed nearly every aspect of the park, leading in later years to the entire amusement site being called just "the Casino."

To move people efficiently to the park and new casino, the Norfolk Southern Railroad ran dancing cars to the park to which they gave snappy names like the "One-Step Special" and "Two-Step Express." Boarding the train at Norfolk's Monticello Avenue, patrons rode the train to make the Oceanfront ballrooms and music halls to dance the two-step and turkey trot to old tunes like "O! You Beautiful Doll" and "Alexander's Ragtime Band." The best ballroom at the beach was Seaside's famous Peacock Ballroom, promoted as the largest on the East Coast. The last train did not leave the casino until eleven o'clock in the evening. During the Roaring Twenties, the waltz and two-step were replaced by the Charleston and the Shag. By then the casino was no longer the only place to go. The Jarvis Dance Hall played host to bob-haired flappers and their Rudolph Valentino look-alike dates who danced the night away in a smoke-choked ballroom that shook with great music and laughter. There was no better place for newly married couples to spend their honeymoon than Virginia Beach—planned or not.

Perhaps the strangest Virginia Beach honeymoon, as told by *Virginian-Pilot* columnist Louisa Venable Kyle, took place in the summer of 1890 when the four-masted schooner *Benjamin F. Poole*, of Providence, Rhode Island, ran aground, stuck on the sand between Sixteenth and Seventeenth Streets in view of the Princess Anne Hotel's broad porches. The first three months of marriage for the honeymooners aboard the schooner were quite extraordinary. Matilda M. Lowhermeuller (1869–1963), of Baltimore, Maryland, had married sea captain Hjalmar Marinius Charlton (1873–1939) in July. Hjalmar Charlton was the son of Norwegian sea captain Carl Christensen of Birdby, Norway, master of King Haakon VII's royal yacht. Thus, by the age of fourteen young Hjalmar had gone to sea and within seven years, had sailed around the world. He changed his name to Charlton when he arrived in the United States, where he stayed, and served in the United States Navy during the Spanish-American War. After sailing the *Governor Ames*—at that time the largest clipper ship ever built—around Cape Horn and circumnavigating the globe many more times, he took over the *Benjamin F. Poole*. On one of his many trips up the coast, he encountered one of the most violent storms to ever strike Virginia's coast. The storm of April 7, 1889, produced more than two scores of shipwrecks, including the *Benjamin F. Poole*, which came up so far on Virginia Beach that it would have taken a storm of equal strength to produce high tides sufficient to float her again. For seventeen months the schooner remained beached, becoming a tourist attraction for nearby vacationers and the subject of idle curiosity for locals. In the meantime, Matilda had married Hjalmar and they stayed together on the ship until a storm came along on September 28, 1890, that freed the *Benjamin F. Poole* from the beachhead.

Reflecting on that time decades later, Matilda Charlton told Kyle that the Virginia Beach of yesteryear "consisted of fourteen cottages and two hotels, the elite Princess Anne and the Ocean View, of secondary standard. There was a foot boardwalk," she remembered, "from the Princess Anne, a very sandy walk of about one hundred feet to the vessel in which I lived for three months. The vessel was a very large and beautiful four-masted schooner and during the summer we had many visitors come aboard. Captain [Edwin Harvie] Cunningham [the harbor pilot] [1863–1916] Bernard Holland, Walton Holland, Robert Asa Etheridge [1863–1896] and family [of Portsmouth, Virginia], Mrs. [Wesley Franklin] White [the former Margaret Collins] [1832–1909],[5] Miss Irene White [actually the wife of Robert Etheridge] [1867–1938], Miss Maggie [Margaret White] Trafton [later Hutchins] [1886–1953], Mr. and Mrs. [James Journeay and Anna Frances Cunningham] Cole of Berkley [Norfolk], [James] Journeay Cole [Jr.] [1883–1917] and his sister Mabel [Louise] [later Davis] [1879–1934]." She also recalled that her husband became frightened for her safety when the storm that

freed the *Benjamin F. Poole* thundered into the beach. Thinking that the new storm might be another disaster-in-the-making, Hjalmar wrapped his bride in oilskins and he and Cunningham attempted to escort her from the ship. "The wind was howling and the beach had been cut away at least four feet high. Between the two men I was finally landed at the lifesaving station, where I spent the night. I could hear the roar in the breakers," she told Kyle, "and knowing my husband was aboard the ship, I was almost frantic. To make matters worse, Captain [Edward] Drinkwater of the lifesaving station said: 'She [meaning the *Benjamin F. Poole*] will break up and I will use her cabin panels for a new home.'" The ship did not break up and Drinkwater had to look elsewhere for boards to build his new house. But rather than return to the schooner, Matilda was again wrapped in oilskins and sent off to Norfolk, where she caught a train back to Baltimore. At the age of nearly ninety when Kyle interviewed her in April 1956, Matilda Charlton offered this: "I never thought then that Virginia Beach would ever be the resort it is now." The fourteen cottages to which Matilda Charlton referred so warmly were the summer places and permanent residences of the true pioneers of Virginia Beach.

Back to Bernard Holland. The Holland children—Walton Gregory (1896–1870), Cornelia Randall, David Gregory (1901–1960), Bernard Peabody Jr. (1902–1970), and John Lyttleton (1909–1981)—were not allowed to play further north than the coast guard station at Twenty-Fourth Street because it was what Cornelia described later as too wild. "We played from Rudee [Inlet] to Twenty-Fourth Street. There was nothing there but sandhills, grape vines and marsh; they just [didn't] want [us] in the wilderness—got to keep [us] out of the Desert." There were no houses there just then. "Now further down I don't know just when they used to have what they called Emmerson Station about half way between here [the Oceanfront] and Fort Story. There were a couple of houses [that belonged to] the Coles and the Emmersons. Each [of them] had summer places. They [the Emmersons] came from Portsmouth, they were Portsmouth people," Cornelia Holland remembered. "There was a line that came out from the back around Crystal Lake and it was just around that line that the Coles had their cottage. I couldn't tell you exactly when but we didn't go that far to play. But the Rudee [Inlet]–Twenty-Fourth Street [area] we could roam to our hearts' content. There used to be a big ole sandhill 'bout here back of Seventeenth Street," she continued, "where the bus station [was]. We could pick wild grapes and slide down the sandhill." She remembered, too, that delicious jelly was made from the grapes. "I think they called them fox grapes—they were wild grapes—we used to go out [grape gathering] every fall. But it's grown up so there are not many places you can get them now." Cornelia Holland iterated, too, that Seventeenth Street was the historical "heart of Virginia Beach."

There is so much more than can be written about early Virginia Beach—the limit of space precludes it. But picture a simpler time. When it began, to reiterate, there were just fourteen cottages and two hotels, the Princess Anne and a lesser establishment called the Ocean View. At least one of the cottages was built from lumber that had washed ashore from shipwrecks; the cottage belonged to the family of James Allen—it is gone now. All of them save one are also gone: the 1895 Holland home bought by Cornelius de Witt in 1909 and renamed Wittenzand, Dutch for "white sand," still stands.

As the Oceanfront moved into more modern times after World War I, it was apparent to a new generation of seaside investors that singular dependency on the railroad to move people back and forth would continue to limit growth on the shore. Virginia Beach needed modern roadways and bridges to facilitate the use of the automobile. After the three Laskins[6]—father Jacob Louis (1867–1958) and his sons Elmer Roland (1890–1959) and

Louis James (1893–1981)—real estate developers and otherwise entrepreneurs of Chicago, Illinois, partnered with Louis Siegel and leased and renovated Seaside Park and Casino in 1925, they were quick to equate future success to the ability to move people to the beach by car. At their own expense, they built the first Laskin Road, formerly Thirty-First Street, and deeded it over to the commonwealth of Virginia. Laskin Road was eventually broadened to a four-lane highway but by then the park had disappeared from the surfside scene. Cornelia Holland noted that many people have forgotten the Laskins. "They lost their shirts [in Virginia Beach]. The trouble was they spread themselves too thin instead of concentrating on one area. [...] Then when the [Great] Depression came along it knocked them for a loop. There was a man and his two sons. They built the Pinewood Hotel [Ninth Street on the Oceanfront, opened in 1927]," she recalled, "and the Traymore [Apartments between Ninth and Tenth Streets at the Oceanfront]."[7] From 1926, the Laskins had also built the Roland Court office and theater complex on Seventeenth Street and another apartment building called the Broadmoor Arms at Sixteenth Street and Pacific Avenue. They were busy. "[The Laskins] also developed several houses across [Lake Holly] at Twelfth Street and they paved Seventeenth Street from curb to curb," she said. "But you see by the time they spread out, they became land poor." Just a few years later, a fire swept through Seaside Park's concession buildings in 1934, including the site's popular restaurant. None of it was ever replaced. While the park's swimming pool was still there in 1940, it was subsequently filled in. Seaside's famous combination bathhouse and picnic pavilion was torn down a decade later, in 1950, and after another fire six years later, the casino section was destroyed. The final section of the park was shuttered three decades later, in 1986, and with it went great memories of Virginia's golden shore. All of what the Laskins achieved, whatever losses may have occurred along the way, were stepping stones toward the construction of The Cavalier Hotel.

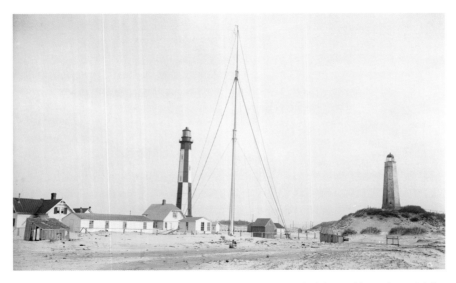

The first work of the new United States government, the first Cape Henry lighthouse (shown here, right) was built of Aquia and Rappahannock sandstone by John McComb Jr. (1763–1853) and was completed in October 1792. McComb was one of the architects involved in the construction of New York City Hall and would also design other lighthouses. The lighthouse's design was based on the 1767 Cape Henlopen Light. The lighthouse was damaged by Confederate forces during the Civil War, but was repaired by Union forces in 1863, who depended on the light for navigation. In the 1870s, concerns about the condition and safety of the old Lighthouse at Cape Henry following a lightning strike that caused large cracks in the structure led to the construction of a new—and taller—Cape Henry lighthouse (left) in 1881, which stands 350 feet to the northeast of the original tower. The old tower remained standing, used as a daymark and as a basis for triangulation. The new lighthouse was fully automated in 1983 and remains in use today. Benjamin Henry Latrobe (1764–1820), arguably the most well-known architect and engineer of his day, visited the old Cape Henry lighthouse in 1798. Latrobe subsequently described it as "an octagonal truncated pyramid of eight sides, rising ninety feet to the light." The old lighthouse is twenty-six feet in diameter at the base and sixteen feet at its top. The new lighthouse is 157 feet tall and was constructed of cast iron and wrought iron, with a more powerful first-order Fresnel lens. The Detroit Publishing Company took this picture of the old and new Cape Henry lighthouses in 1905. *Library of Congress*

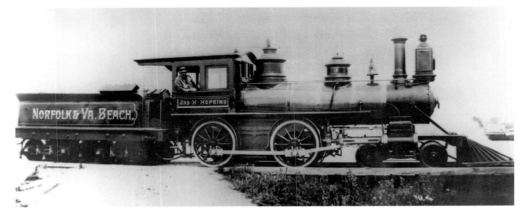

This is the locomotive *James H. Hopkins* belonging to the Norfolk and Virginia Beach Railroad and Investment Company (NVBRRICO). The engine was named for railroad pioneer James H. Hopkins, the president of the Pittsburgh Southern Railway, formed in March 1879 by the merger of the narrow-gauge Pittsburgh Southern Railroad, Pittsburgh Railroad and Washington Railroad. It was converted to a standard gauge in 1883, purchased by the Baltimore and Ohio Railroad (the B & O) on November 20, 1884, and reorganized as the Baltimore and Ohio Short Line Railroad. The picture was taken in 1884. *Edgar T. Brown Collection, Virginia Beach Public Library*

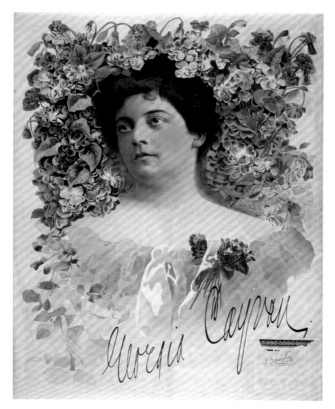

Born in Bath, Maine, Georgia Cayvan attended and graduated from the Boston School of Oratory and first earned a living as a professional fortune teller. She shifted to acting in 1879 when she accepted the role of Hebe in *H.M.S. Pinafore* with the Boston Ideal Opera Company and quickly became one of the country's greatest early actresses, playing the best-known New York City stages and working with Maurice Barrymore in some of her productions. In 1886, Cayvan contracted with Daniel Frohman, becoming the star of the Lyceum Theater in New York City. She toured with her own company, which subsequently include Lionel Barrymore, starting in 1896. She was with the Barrymores at Virginia Beach on holiday in the 1890s, a victim of increasingly poor health. An operation in 1892 had led to her declining physical condition and by the turn of the twentieth century, she was forced to retire to the Sandford Sanitarium in Flushing, New York. She died in 1906. Cayvan is shown in this 1900 Jacob Ottmann Lithographic Company poster. *Library of Congress*

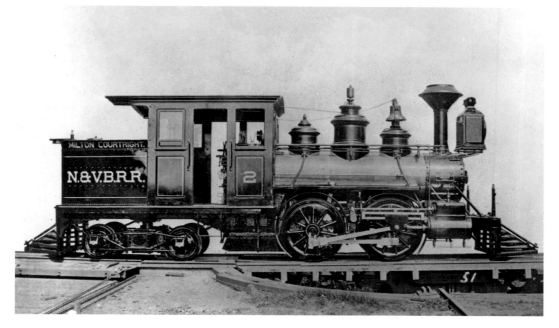

The Norfolk and Virginia Beach Railroad locomotive number two—the *Milton Courtright*—is shown in this 1894 photograph. The engine was named for Pennsylvania-born railroad magnate and civil engineer Milton Courtright, who was, among his many achievements, one of the original and most important figures in building the Chesapeake and Albemarle Canal and who was, for some years, consulting engineer of the New York elevated railroads. *Edgar T. Brown Collection, Virginia Beach Public Library*

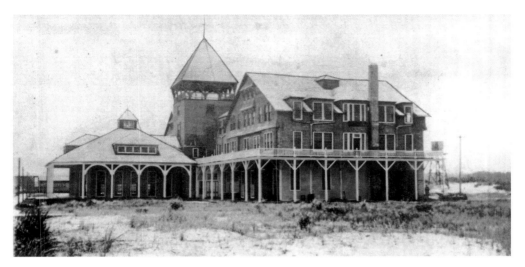

The Virginia Beach Hotel at Fourteenth Street and Atlantic Avenue was the first overnight accommodations hotel when it opened its doors at the Oceanfront in late 1883, although it did not make much of a splash until the start of the second tourist season in late spring 1884. The hotel was modest by comparison to what would follow it on Virginia's golden shore. A railroad and development company reorganization in 1887 ushered in major expansion and improvements to the hotel and a new name. Within a year, the name "Princess Anne" was known far and wide as the place to stay at Virginia Beach. When renovations were complete, the hotel had a new fourth floor and a glass-enclosed veranda for the comfort of off-season visitors. *Edgar T. Brown Collection, Virginia Beach Public Library*

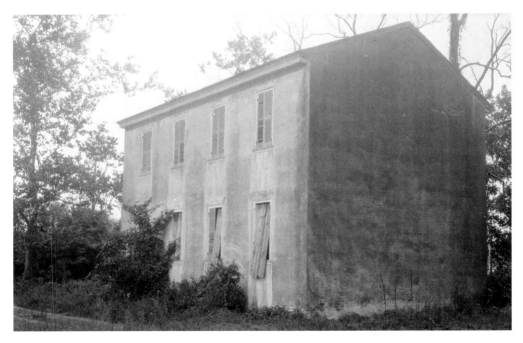

The fourth Princess Anne County courthouse, authorized in 1782 and completed five years later, was located on State Route 165, better known as Princess Anne Road, which becomes North Landing Road at the "Cross Roads." The building served as the county court from 1787 to 1823/4, when a new court building was built at the "Cross Roads," the location of today's Virginia Beach Municipal Center. After its abandonment, the old brick courthouse served as the home of Kempsville Baptist Church from 1826 to 1911. The building was razed in November 1971. *Library of Congress*

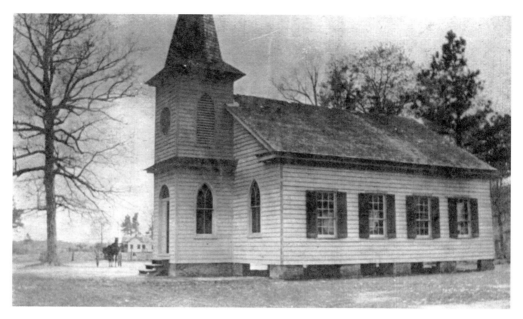

Beech Grove United Methodist Church on what was then Beech Grove (now West Neck Road) in the Pleasant Ridge section is shown in this turn of the twentieth century photograph, *Edgar T. Brown Collection, Virginia Beach Public Library*

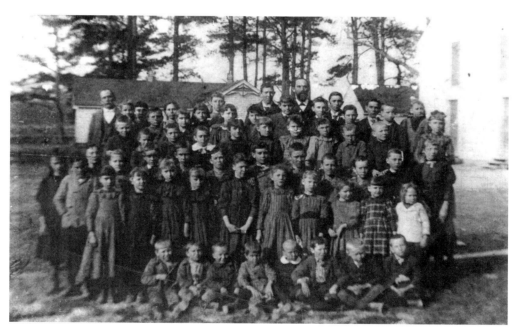

Students and teachers of the old Tabernacle School, located on the Tabernacle United Methodist Church property, are shown in this 1895 photograph (the school building is the backdrop, the church is on the right). Later, one room schools at Tabernacle, Sandbridge, Shipps Corner (now Holland Road) and Beech Grove (now West Neck Road) were consolidated into a two-story wooden structure that was placed beside the one room school (Hickory Bridge Elementary) on the Court House Elementary site. In 1921, Hickory Bridge School became the Princess Anne Graded School and moved into a wooden building across from the Princess Anne County courthouse. That first structure burned in March 1931, and a new brick building was completed eight months later, and it was named Court House Elementary School; this school closed in June 1988. *Edgar T. Brown Collection, Virginia Beach Public Library*

This photograph, dated March 7, 1896, and taken during the winter season along Virginia Beach's Cottage Line, includes (left to right) Thomas Turner, Cornelia Tucker, Isaac Talbot Walke and Virginia "Jenny" Drewry. Despite the cold, the town's budding oceanfront provided social gatherings and plenty of entertainment that drew year-round visitors from nearby Norfolk for evening sojourns and extended weekend stays. *Sargeant Memorial Collection, Norfolk Public Library*

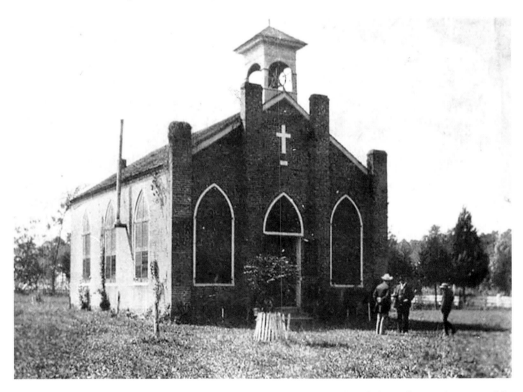

Emmanuel Protestant Episcopal Church, also called Emmanuel Chapel and shown here as it appeared in 1902 in its original Kempsville location, was opened to parishioners on July 4, 1843, and celebrated a century of worship before it burned down on October 12, 1943. The church was rebuilt four years later (and later expanded) as Emmanuel Episcopal Church at its present location on Singleton Way. *Edgar T. Brown Collection, Virginia Beach Public Library*

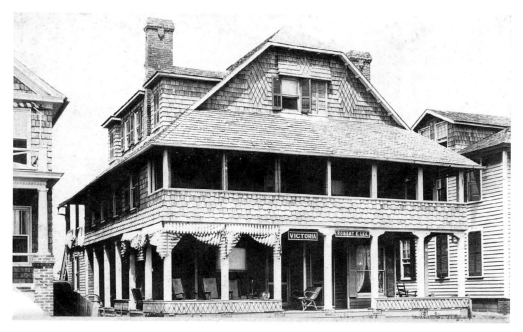

The June 29, 1902 *Richmond Times-Dispatch* carried an advertisement for the Victoria (also called the Robert E. Lee) Cottage (shown here) at Twenty-First Street and the Oceanfront that read: "Desirable parties can secure all the comforts and conveniences of a hotel at cottage prices. Electric lights and call bells, hot and cold baths. Largest and coolest rooms on the beach; splendid cuisine. Orchestra during July and August and germans every evening in the grand ballroom. Daily excursions to fishing grounds. Rooms should be secured in advance." The cottage was managed by Catherine A. "Katie" Woolfolk. *Edgar T. Brown Collection, Virginia Beach Public Library*

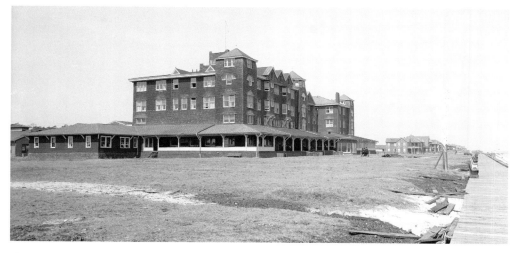

The Princess Anne Hotel, first built at Fourteenth Street and Atlantic Avenue in 1883 as the Virginia Beach Hotel and which made its first big splash at the start of the town's second summer season in 1884, emerged three years after that modest debut with a larger footprint, better accommodations and a new name. During its short-lived existence, the hotel became one of the most popular vacation spots on the East Coast, the unequivocal star attraction at Virginia Beach. To the Princess Anne's north and south were built the first cottages at the beach. Known for its cuisine and dancing as much as its famous roster of guests, the hotel also had a wide bathing beach beyond the old wooden boardwalk (shown here). The Detroit Publishing Company photographed the hotel between 1900 and 1905. The hotel burned to the ground on June 10, 1907. *Library of Congress*

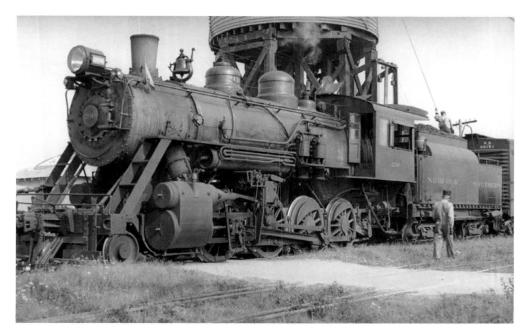

The Norfolk and Southern Railway motor number 206 was stopped at Seaside Park when this picture was taken. The platform was at Thirty-Fourth Street and Pacific Avenue. *Edgar T. Brown Collection, Virginia Beach Public Library*

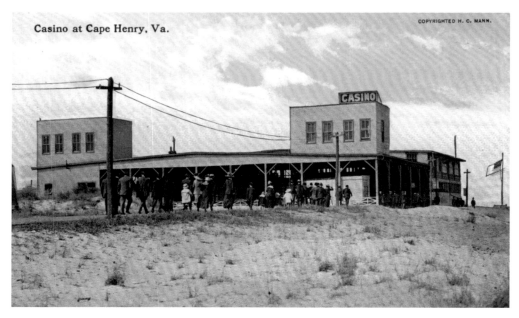

Philadelphia native William John O'Keefe's Cape Henry Casino opened on July 4, 1903, but most of his patrons called it "O'Keefe's Casino." O'Keefe's was built within short walking distance of the old Cape Henry lighthouse and collocated with the rail line. Though O'Keefe's was famous for its Lynnhaven oysters, served raw, roasted or fried, the menu also included Smithfield ham and other delicacies. President William Howard Taft visited the casino in November 1909. O'Keefe (1870–1937) was the proprietor of his Cape Henry casino and a restaurant keeper totaling forty years and worked up to several months before his death. Harry C. Mann took this photograph of the casino in 1910 and Louis Kaufman and Sons of Baltimore, Maryland, made it into a divided-back penny postcard. *Amy Waters Yarsinske*

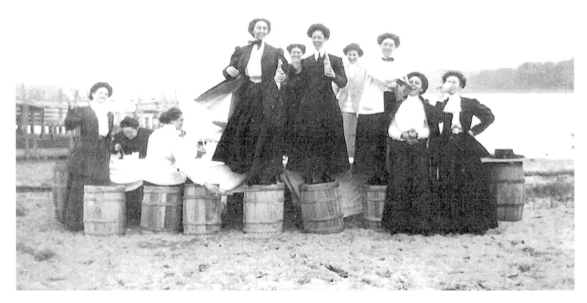

The women shown in this fall 1909 picture taken at Old Donation Farm—also known as Ferry Plantation House, Ferry Farm and the Walke Manor House—were enjoying an oyster roast. *Edgar T. Brown Collection, Virginia Beach Public Library*

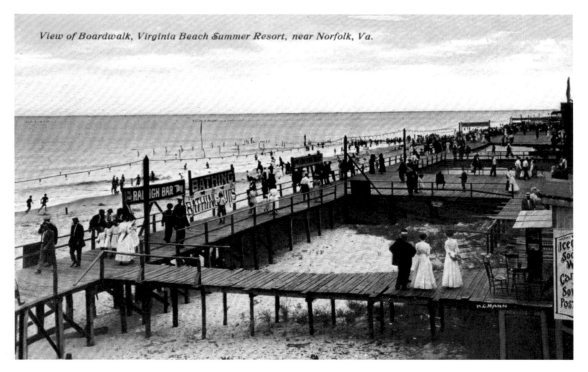

View of Boardwalk, Virginia Beach Summer Resort, near Norfolk, Va.

Harry C. Mann turned one of his finest photographs of Virginia Beach's first boardwalk into a postcard in or about 1910. Mann was standing just above Fourteenth Street looking south when he took the picture. The Raleigh Bar, advertised left, was established after the Princess Anne Hotel burned down in 1907. The bar's owners salvaged the bar that had been in the hotel. *Amy Waters Yarsinske*

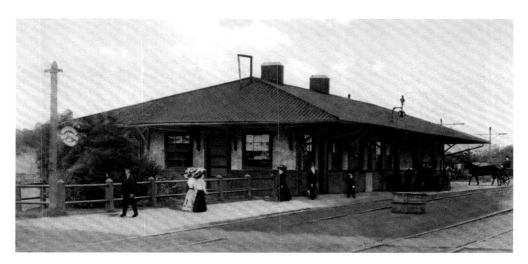

Marshall Parks and his Princess Anne Hotel investors started the Norfolk and Virginia Beach Railroad and Improvement Company to move visitors from Norfolk to the Oceanfront. The first train, operated on a narrow-gauge track, left downtown Norfolk on July 16, 1883, bound for Virginia Beach. The train station at Seventeenth Street and Pacific Avenue (shown here, 1910) became the primary stop for hotel passengers. The railroad became the Norfolk and Southern in 1900, and the track was pushed out to Cape Henry. The Seventeenth Street station was open long after excursion trains stopped delivering passengers to the Oceanfront; it served as a depot for the Virginia Beach Railbus Company and also as a bus station. *Amy Waters Yarsinske*

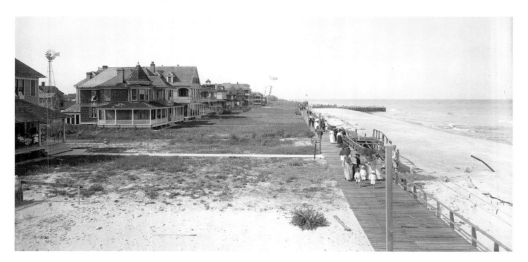

Virginia Beach's Cottage Line was a mix of privately and commercially owned cottages that lent character and distinction to the seashore they fronted. Harry Cowles Mann took this picture in or about 1910; it shows the wooden boardwalk that was first built in 1888. The Arlington Hotel is farthest away, located just south of Thirteenth Street and marked by the American flag flying out front. The Arlington was one of the town's earliest hotels but became a particularly important one after the Princess Anne Hotel burned to the ground on June 10, 1907. The Baptist Church of Virginia Beach bought the Arlington in the 1910s and converted it to a summer retreat. Part of the Atkinson Cottage is in the picture (extreme left) and Burton Cottage is in full view (left foreground). Identifiable cottages beyond Burton include Carrington Cottage, also known as the Mount Vernon; Garwood Cottage, later called the Atlantic Cottage, and the de Witt Cottage. Beyond de Witt was the Glennan Cottage, Arlington Hotel, Booth Cottage, Ferebee Cottage, and the Raleigh Bar. The windmill on the left pumped water for the Holland residence and nearby cottages. Only the de Witt Cottage stands today. The Flume, a device that channeled saltwater into Lake Holly for mosquito control, is on the right, jutting into the ocean near what is today Thirteenth Street. *Amy Waters Yarsinske*

The Flume was completed in September 1890, shown here as it extended from Thirteenth Street into the Atlantic Ocean. The trough was intended to send saltwater by tidal action into Lake Holly two blocks inland in the hope of providing better fishing opportunities for Princess Anne Hotel guests and tamping down the particularly pesky mosquito population that plagued the Oceanfront in the summer months. "The Flume was built like an apron," explained Cornelia Holland years later. "[...] People used to fish off the end of it; it wasn't that long but inside it was built like an apron."[8] Bernard Holland, Cornelia's father, was the one who came up with the idea of the Flume. "[He was the] father of mosquito control in the area."

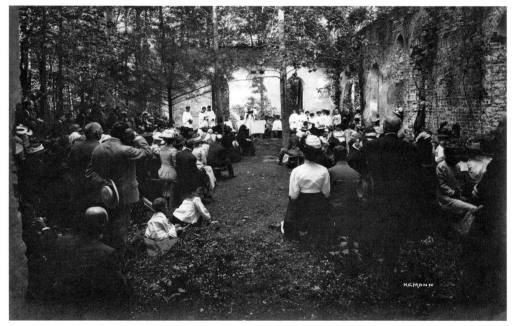

All that remained of Old Donation Episcopal Church were the crumbling walls of this third Lynnhaven Parish when Harry Mann took this picture in 1910. Located on North Witchduck Road, Old Donation was accepted into the vestry on June 25, 1736. After it was abandoned as a house of worship, the church building fell into disrepair; it was then the mid-nineteenth century. Another forty years went by until, in 1882, what remained of it was gutted by a forest fire. To preclude the church's land from becoming state property, Reverend Thurmer Hoggard IV (1819–1902) organized and led faithful parishioners to annual pilgrimages held in the church ruins, one of which is shown here. *Amy Waters Yarsinske*

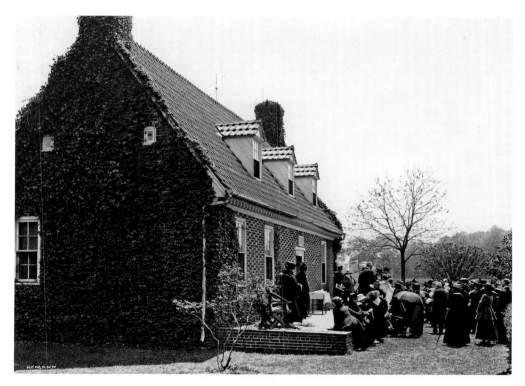

The Adam Thoroughgood House was built about 1719, most probably by Thoroughgood's grandson, Adam III. The initials "Ad. T." on the west wall of the house may have been Adam III's attempt to distinguish himself from a sibling or close family member with similar initials. The house underwent major restoration in 1923 and in the 1950s and has served as a museum since opening to the public on April 29, 1957; it sits on four-and-a-half acres fronting the Lynnhaven River, a far cry from the 5,350-acre headright granted to Adam Thoroughgood, Adam III's grandfather and a member of the Virginia House of Burgesses, in 1635. These photographs of the house were taken during an event held there in the early 1910s. *Sargeant Memorial Collection, Norfolk Public Library*

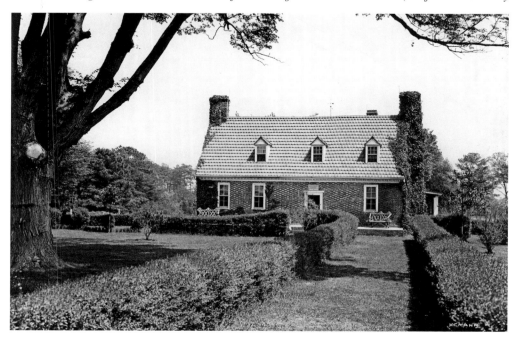

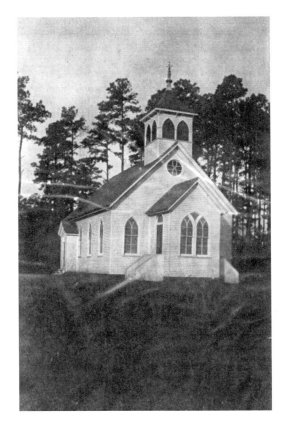
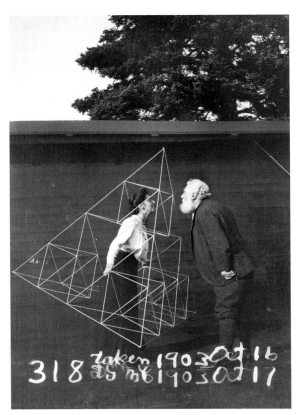

Above left: Oak Grove Baptist Church at the corner of Pungo Ferry and Princess Anne Roads in the Creeds section was the first Baptist church in Virginia. The church was first established as Pungo Baptist Church in 1762. The original building on Pungo Ridge burned nearly forty-five years after it was built. At an undetermined time prior to the Civil War, the sanctuary building was moved. Oak Grove's church history suggests that it may have been moved several times before being located in a grove of red and white oak trees used to tie the horses of congregants. The church shown here, just as the brick church that has sprung up around it, with all of its structural changes and additions, has remained in the same spot. The church took the name Oak Grove Baptist Church in 1856. The picture was taken around the turn of the twentieth century. *Edgar T. Brown Collection, Virginia Beach Public Library*

Above right: Among the famous guests to grace the Princess Anne Hotel, Scottish-born scientist, inventor, engineer, and innovator credited with patenting the first practical telephone Alexander Graham Bell (1847–1922) and his wife, Mabel Gardiner Hubbard Bell (1857–1923), together and on individual holiday, were popular residents at the Virginia Beach shore. Mabel Bell considered the hotel one of her favorite spots, enjoying the company of many friends and their families who also came for a respite by the sea. Alexander Graham Bell, shown here facing his wife, Mabel Hubbard Bell, who is standing in a tetrahedral kite, were photographed on October 16, 1903, at Baddeck, Nova Scotia. Of note, not all of Alexander Graham Bell's excursions to the Virginia shore were for pleasure. In 1901, two years before this picture was taken, he returned to the beach to scout a location for large-kite research, which he recorded in his journal on December 14 thusly: "The shore between Virginia Beach and Cape Henry is desolate and practically uninhabited but [I] could find no place suitable for my purpose because telephone wires on one hand and tall pine trees on the other would interfere with safe landing." Bell's early tetrahedral kites (like the one shown here) were part of his investigation of their application to man-carrying aircraft. These giant kites needed a great deal of open space for Bell to test them. *Library of Congress*

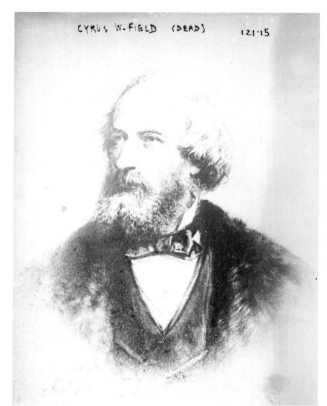

Virginia Beach's first mayor, superintendent of the Norfolk, Virginia Beach and Southern Railroad and a stakeholder in the Princess Anne Hotel Bernard Peabody Holland remembered decades later that one of his favorite guests at the hotel was Cyrus West Field (1819–1892), responsible for the first transatlantic cable. "Field liked to talk," he told an interviewer later. "He used to tell me all about the trouble he had getting the money to put that first cable across the Atlantic. People didn't have faith in it. The first cable broke after three or four months. Then he had a terrible time getting the money to put it back."[9] *Library of Congress*

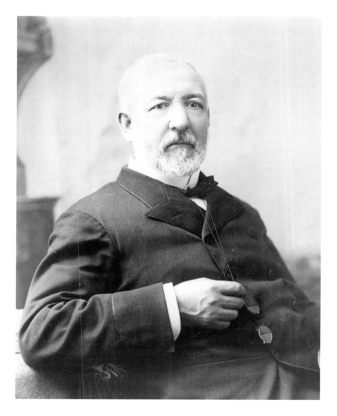

American statesman and Republican politician James Gillespie Blaine (1830–1893), shown in this August 28, 1884 photograph, was a frequent Princess Anne Hotel guest. Blaine, who represented the state of Maine in the United States House of Representatives and Senate, and served twice as secretary of State, one of only two persons to hold the position under three separate presidents (the other being Daniel Webster), also ran unsuccessfully for the Republican presidential nomination in 1876 and 1880 before being nominated in 1884. He narrowly lost the presidential election to Democrat Grover Cleveland. Blaine's presence at the hotel drew fervent attention. "They used to call him 'The Plumed Knight,'" recalled Bernard Holland. "Bobby [Robert Green] Ingersoll thought up that phrase. Bobby Ingersoll was another Beach notable."[10] *Library of Congress*

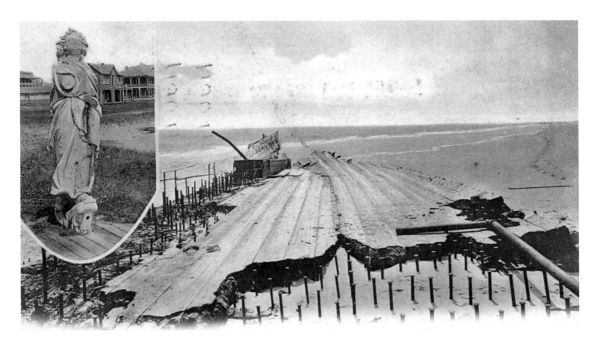

The Norwegian barque *Dictator* was bound from Pensacola, Florida, to West Hartlepool, England, with a full load of lumber when it encountered significant weather off the Atlantic Coast. The ship's master, Captain Jorgen Martinius Jorgensen, made the decision to bring the *Dictator* into Norfolk to make repairs. The barque had just passed the Princess Anne Hotel and reached about Fortieth Street on the Oceanfront when it grounded and started breaking apart on March 27, 1891. Jorgensen's wife and infant son were drowned. Those who perished, including the captain's wife and child, are buried in Norfolk's Elmwood Cemetery. The *Dictator*'s figurehead was brought to shore and erected in front of the hotel as a memorial to those lost. The wreck and figurehead of the Norwegian barque *Dictator* are shown on a real picture penny postcard (above) mailed on September 16, 1907,

and give good indication of the condition of the so called "Norwegian Lady" as it was first displayed at Sixteenth Street on the early Oceanfront boardwalk adjacent to the Princess Anne Hotel. In the photograph left, taken in the early 1910s, a group of young people gathered around the Norwegian Lady figurehead (center) to have their picture taken. When asked how it came to be displayed in this spot, Cornelia Holland recalled later that it was her mother, Emily Gregory Holland, and Princess Anne Hotel general manager Simeon E. Crittenden, who found it among the wreckage floating in the water off the hotel the day after the ship broke up. Crittenden had someone pull it out of the water and set it up at the end of Sixteenth Street, where it remained for sixty years. "But people cut it all up and did all sorts of unpleasant things to it, you know, vandals, and it had a bronze plaque saying what it was and somebody pried it out," she explained. Walton Gregory Holland (1896–1970), Holland's older brother and a building inspector, along with another man, took it down, rolled it in canvas and put it in a city warehouse for safekeeping– so they thought. "When they got ready to put it back up, nobody could find it and nobody would admit to doing anything with it and they never found it. Somebody threw it away." A bronze likeness of the original figurehead was later erected at Twenty-Fifth Street. *Sargeant Memorial Collection, Norfolk Public Library*

"Bobby Ingersoll was here on April 6, 1899," reminisced Bernard P. Holland decades later. "I remember the date because we had a very large storm. The sea was terrific. A little oyster sloop was blown out of the bay into the sea. Next day, the wind went northeast, and blew it back again. We could see it all from the observatory at the top of the hotel. But we couldn't do anything about it." Robert Green Ingersoll (1833–1899), shown in this 1865 to 1880 period Mathew Brady photograph, was one of the foremost orators and political speechmakers of late nineteenth century America and likely the best-known American of the post-Civil War period. When Holland saw Ingersoll the day after the little boat tragedy, he told Ingersoll that the weather bureau had told him the storm passed right over the beach. "Well," said the quick-witted Ingersoll, "I thought the center of the storm was within ten feet of my door." Ingersoll died a few months later, on July 21, at Walston, his son's mansion in Dobbs Ferry-on-the-Hudson, New York. *Library of Congress*

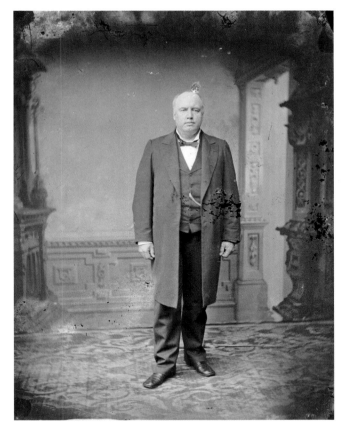

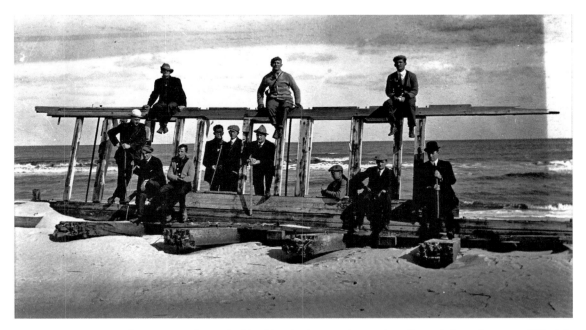

There were more than 220 vessels wrecked (and hundreds more that got into distress) along the coast of Virginia from 1874 to 1915, and more than one hundred lives lost. The group of men shown here are posed on the remains of a shipwrecked vessel along the Virginia Beach shore. The picture was taken in the early 1900s. *Sargeant Memorial Collection, Norfolk Public Library*

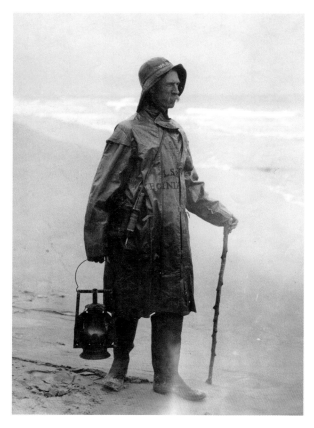

Left: John Woodhouse Sparrow of the old United States Lifesaving Service (shown here) started his career in 1883, and worked as a surfman until his retirement in 1916. Sparrow was born in Virginia Beach on September 13, 1855, to William Thomas and Mary June Stone Sparrow, and historic records indicate that he was a farmer and also possibly a fisherman just before he enlisted with the crew at the Seatack lifesaving station. He was married to Vandalia Gornto. Sparrow died on January 25, 1935, and is buried in the Eastern Shore Chapel Cemetery. *Virginia State Parks*[11]

Opposite above: The 1850s and 1860s were a period of severe storms on the East Coast, causing many shipwrecks. In order to aid victims of these shipwrecks, a lifesaving service was started in 1874, and in the following decade, lifesaving stations were constructed along the coast. Among the first stations built were those at Cape Henry and Dam Neck Mills. A "keeper's house" is believed to have existed at Dam Neck Mills as far back as 1850. In 1878, the Seatack station was placed between these two at the present Twenty-Fourth Street on the Virginia Beach Oceanfront. The property on which the Dam Neck station stood was purchased in 1881 from the commonwealth of Virginia. The stations were numbered from north to south, starting with Cape Henry. The Dam Neck Mills station was thus number 3. The next station to the south was at Little Island and is now a beach house at the far southern end of Sandbridge. The original station, built in 1874, was moved back from the ocean some time during the first twenty years after it was established. This is a turn-of-the-twentieth century view of the lifesaving station at Dam Neck Mills, located ten miles south of the Cape Henry lighthouse. The station was inactive in 1938. In 1951, the commonwealth executed a deed in which the subject property was conveyed to the federal government to enjoin to the United States Navy's anti-aircraft training and test center. *Edgar T. Brown Collection, Virginia Beach Public Library*

Opposite below: The False Cape Lifesaving Station, number five of the United States Lifesaving Service outposts along the Virginia shore, was located on the beach abreast of Back Bay at a site near where False Cape Landing Ocean campsites are today. The building shown here was completed on December 4, 1874, and also included an observation tower and a boathouse. Two men patrolled each night, one walking north and the other south. Since lifesaving stations were located every seven miles, each man walked three-and-a-half miles in either direction to meet a crewman—a surfman—from the neighboring station, where they would exchange a token to prove they had completed their patrol. The first keeper assigned there was Daniel P. Morris on December 11, 1874, according to the United States Coast Guard history. The last lifesaving service keeper was Thomas H. Delon, who served from August 15, 1910, and was still there in 1915, when the lifesaving service merged with the Revenue Cutter Service to form the United States Coast Guard. The station was decommissioned in 1937, and abandoned completed by the coast guard in 1946, at which time it was sold to a private individual. Unfortunately, the building was struck by lightning in 1969 and burned to the ground. *Edgar T. Brown Collection, Virginia Beach Public Library*

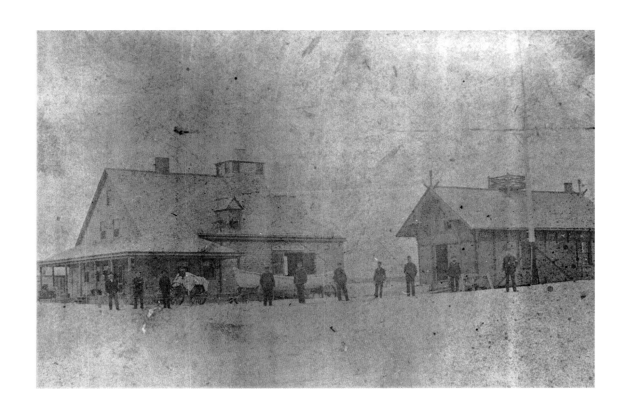

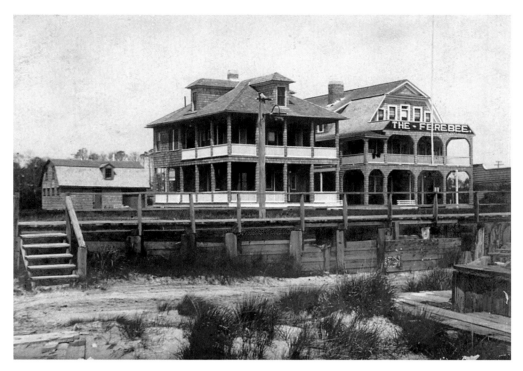

Above: The Ferebee cottage-turned-hotel (shown here, 1908) opened at Fourteenth Street in 1907, the same year that the Princess Anne Hotel burned and was razed. The cottage was purchased from Dr. Emerson Land by Norfolk banker Moses C. Ferebee; his brother, Enoch D. Ferebee, ran the hotel. In 1909, the Ferebees bought the old Princess Anne Hotel bathhouse, adjoining their property (visible right). The heyday of the Ferebee was short-lived. In the 1920s, it was already being leased under other names, to include the Latham and the Surf. *Edgar T. Brown Collection, Virginia Beach Public Library*

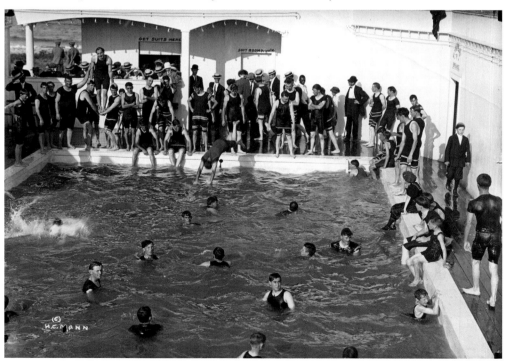

Virginia Beach's first health care facility opened on the west side of Atlantic Avenue and Eighteenth Street in June 1888 on land donated by the Norfolk and Western Railroad. A group of women headed by Katherine Baldwin Myers, wife of Barton Myers, Norfolk's mayor from 1886 to 1888, who provided leadership in the early days of the Virginia Beach resort's development, established an infant sanitarium. Open only in the summer, it offered "fresh sea air and free medical attention for poor children and their mothers" until it closed in 1946. Of note, the sanitarium first occupied a small space in a clubhouse building constructed by Marshall Parks in 1880, also the first structure to be built at the future resort strip. The infant sanitarium is shown on this 1910 period penny postcard. *Robert J. Gilson Collection, Virginia Beach Public Library*

Opposite below: The Groves Bath House, situated south of Seaside Park, had the first saltwater pool at Virginia Beach. Harry C. Mann took this picture in or about 1908. The bathhouse was developed by James Sundy Groves, owner and president of the Virginia Beach Land Development Company, a syndicate that owned much of what was early Virginia Beach. Groves was a Fayetteville, North Carolina native who married the former Lillie Ball Edwards in Lincoln County, Georgia, in the spring of 1881; he soon became a wealthy real estate broker and commercial merchant, with deep pockets and important contacts up and down the East Coast. While he worked largely from Alexandria, Virginia, and Washington, D.C., Groves kept an office in Norfolk, from which he ran his Virginia Beach investment. He also continued to deal produce from the city's Roanoke Square, a trade he learned as a fruit dealer in his youth. Groves first built a part-time residence at the corner of Twenty-Fifth Street and the Oceanfront in 1890 for his family's recreation; he later moved them into the stone cottage at Twenty-Fourth Street after the house was finished in 1906. Lillie Groves gave up the house after her husband died on February 16, 1916, at age fifty-seven at his home in Washington. *Amy Waters Yarsinske*

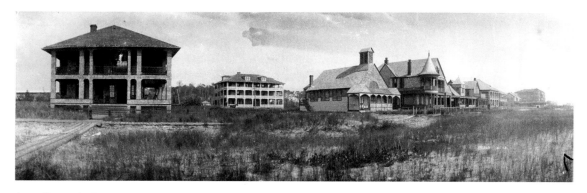

According to the history, it was Robert Morton Hughes (1855–1940), a lawyer; Barton Myers, and Frederick Southgate Taylor (1848–1896), secretary and treasurer of the Norfolk and Ocean View Railroad Company, who first discussed the building of summer cottages for their families at Virginia Beach, and from that initiative the number of interested parties grew to include Francis Milton Whitehurst (1835–1908), the county's first judge, Lucien Douglas Starke (1826–1902), a lawyer, and the Reverend Beverly Tucker (1846–1930), even though Tucker already had a cottage at the beach just south of Twentieth Street. They bought available lots from Charles Mackay, who had purchased the land from the Norfolk-Virginia Beach Railroad and Improvement Company. When all was complete, the men had moved into their vacation properties the same summer the Shoreham opened—the summer of 1888. The cottages were strung along the beach from Eighteenth Street north to the Tucker property. In this early 1910s photograph of the Oceanfront in and around Eighteenth Street, Galilee Episcopal Church is shown center and the infant sanitarium just to the left. Barton and Katherine Baldwin Myers' cottage (far left, prior to dormers being added to the roof line) was built on the north side of Eighteenth Street and the Oceanfront, proudly among the first summer homes to be constructed along the Virginia Beach shore. *Edgar T. Brown Collection, Virginia Beach Public Library*

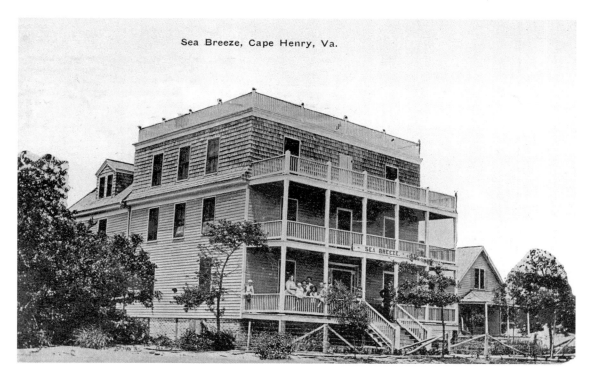

Shown on this penny postcard, mailed on July 26, 1911, is the Sea Breeze Hotel at Cape Henry. Doc William Washburn (1869–1956) owned the hotel, which advertised that it was near the post office, telegraph office, and only ten minutes from the famous fishing grounds of the Lynnhaven River. *Edgar T. Brown Collection, Virginia Beach Public Library*

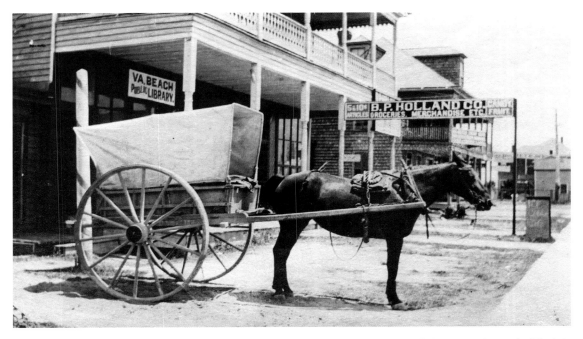

In this 1911 photograph, two landmarks of early twentieth century Seventeenth Street stand out: the Virginia Beach Public Library (foreground, behind the cart) and the Bernard P. Holland Company general merchandise and grocery store. *Sargeant Memorial Collection, Norfolk Public Library*

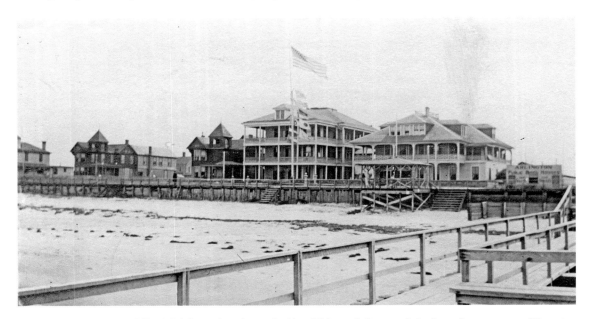

The Arlington Hotel (far right), located on the south side of Thirteenth Street and the Oceanfront was one of Hampton Roads' earliest seaside resorts. After the Princess Anne Hotel burned to the ground on June 10, 1907, the Arlington filled the void, once again becoming the queen of the shore. Though the Arlington's second-life was short-lived, it did not entirely fade away. The Baptist Church of Virginia bought the hotel not so many years after this picture was taken and converted it to a summer retreat. In the years that followed, the former hotel passed from church ownership to private hands. Decades later, Sallie Pickett Corbell (1889–1984), a retired school teacher and daughter of Dr. John D. and Belia Dearing Corbell, sold it to Mary Widgeon Capps,[12] owner of the Surf and Sand Motel, for $66,000 in 1955. *Sargeant Memorial Collection, Norfolk Public Library*

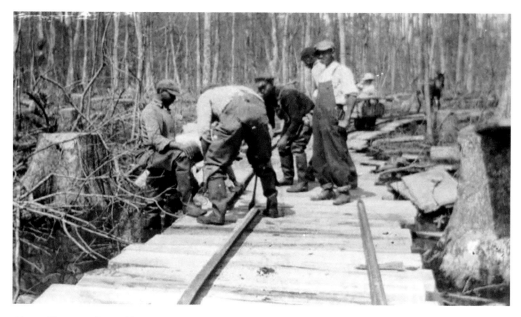

Above: The crew pictured here in or about 1900 was laying train track for the Norfolk and Southern Railroad through Holland Swamp north of Pungo[13] and in the Seaboard District. A 1930 road map of Princess Anne County, which also shows the rail line, indicates that Holland Swamp Road, a dirt road well into the 1920s, stretched into the Kempsville District before threading its way down east of the Princess Anne courthouse area, where it ended and Nimmo Road continued east and North Landing Road went west. A new concrete road (subsequently named Princess Anne Road) from Kempsville to the courthouse had just been completed in 1929, a measure that took traffic off the winding, flood prone, Holland Swamp Road, formerly the primary way to get to the county seat and courthouse complex. The rail line paralleled Princess Anne Road, banking south where it cut over Indian River and Pungo Ridge Roads. Taking a dip south, the track ran east of Pungo Ridge Road, paralleling the road, passing through Creeds on the way to Munden's Point. Of note, Holland Swamp Road[14] is just "Holland Road" today. *Edgar T. Brown Collection, Virginia Beach Public Library*

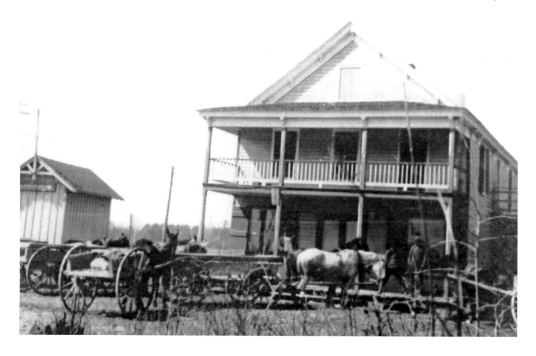

The London Bridge post office, shown in this early twentieth century photograph, was located at the corner of what is today North Great Neck Road and Virginia Beach Boulevard. *Edgar T. Brown Collection, Virginia Beach Public Library*

George Washington Capps (1848–1937) is seated on his funeral wagon. Capps, also a farmer, was the undertaker in the Pungo area. He started out at Capp's Corner, now Pleasant Ridge, and in 1900 bought out John Thomas Malbone (1857–1951), a carpenter, building contractor and also the undertaker at Seaboard and Princess Anne Roads. *Edgar T. Brown Collection, Virginia Beach Public Library*

Opposite below: The origination of the name London Bridge is believed to have started with a small dock or bridge that extended over the Lynnhaven River near a trading post originally established in the seventeenth century by English settlers. The name had little to do with the Virginia Company of London, which was defunct in 1624, when King James I changed the status of Virginia to a royal colony to be administered by a governor appointed by the king. Further, it would take two decades after the first settlement at Jamestown for similar settlement and trade to move down to lower Tidewater. Perhaps the name is more homage to the British homeland of early settlers. London Bridge's boundaries, which have changed slightly over the decades since it earned its name, is bordered on the west by the Lynnhaven River, on the south by Potters Road, on the east by London Bridge Road, and on the north by Wolfsnare Creek. The historic London Bridge Baptist Church, established in 1784, is on Potters Road. The London Bridge area store shown here at the end of the nineteenth century to early twentieth century served what was at that time a firmly agrarian community. *Edgar T. Brown Collection, Virginia Beach Public Library*

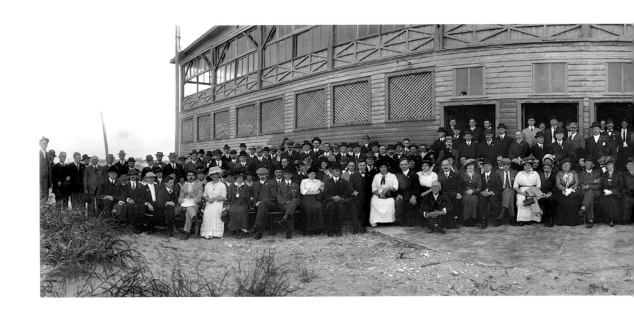

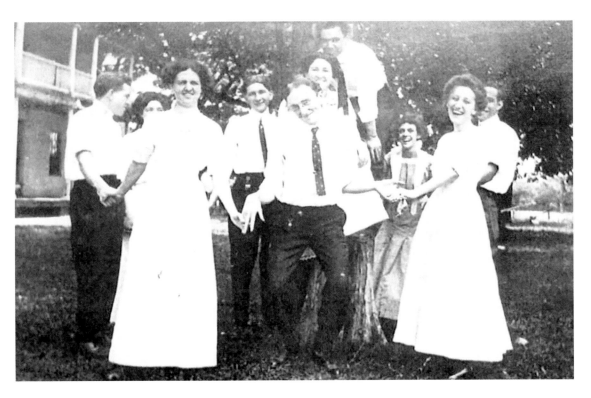

Above: Participants attending the twentieth annual convention of the National Fertilizer Association of America at O'Keefe's Casino (and restaurant) for an oyster roast at Cape Henry were photographed by Harry Cowles Mann on October 8, 1913. *Sargeant Memorial Collection, Norfolk Public Library*

Left: This happy scene from Old Donation Farm—also known as Ferry Plantation House, Ferry Farm and the Walke Manor House—was taken on July 4, 1911. *Edgar T. Brown Collection, Virginia Beach Public Library*

FOLLOWING PAGE:

Above: Taken between 1913 and 1916, this is the congregation of the First Baptist Church of Virginia Beach posed in front of the church on Seventeenth Street at the northwest corner of Arctic Avenue. The church was built in 1908 and torn down in the 1950s after a new church was built at Thirty-Fifth Street and Holly Avenue. The Alhambra Cottage at Seventeenth Street is visible behind the church. *Sargeant Memorial Collection, Norfolk Public Library*

Below: Harry C. Mann took this 1916 panoramic photograph of a convention at the Chautauqua Building, located at Seventeenth Street and Arctic Avenue [the First Baptist Church is behind the building shown here]. The center was built in 1910 and remained in use until 1950 when it was razed to make way for a cinderblock building used as a storefront. The tabernacle (or auditorium) was built by the First Baptist Church to be used in the summer for church related programs. The Baptists held conventions there each summer from 1910 to 1932. *Sargeant Memorial Collection, Norfolk Public Library*

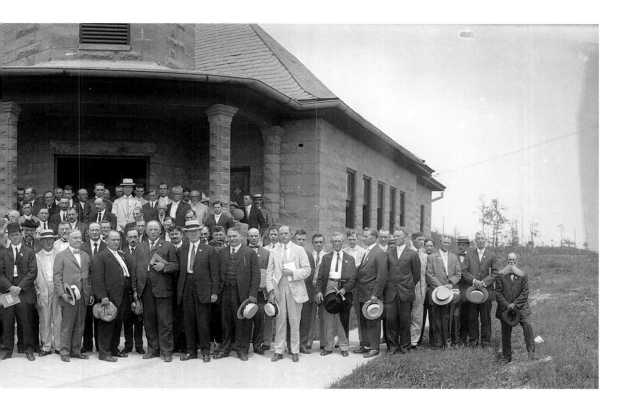

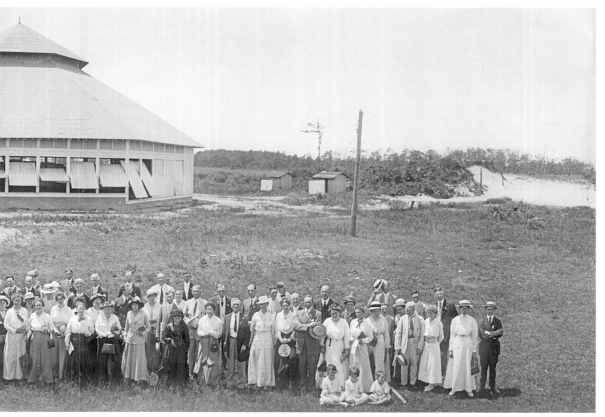

45

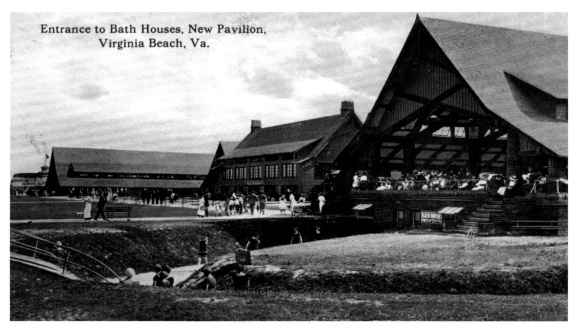

Entrance to Bath Houses, New Pavilion, Virginia Beach, Va.

Norfolk and Southern Railroad built Seaside Park [later called the Old Ocean Casino] on three full blocks from Thirtieth to Thirty-Third Streets; it was opened in 1906 as the ultimate oceanfront resort for the railroad's excursion cars that dropped passengers at the park's station. Additional buildings and amusements, including a casino, were added to the park. Seaside Park's bathhouses, located beneath the picnic pavilion on the right, were state of the art for the period. This postcard was used in 1914. *Amy Waters Yarsinske*

Opposite above: Harry Mann took this picture of the beach entrance from Seaside Park's bathhouses in or about 1910. Behind the flag is a sign advertising the Slide for Life, billed as a thrilling and exciting ride. The slide was rigged with a harness that carried bathers down a long wire into the surf; it cost just a nickel for one ride and a quarter for six. *Amy Waters Yarsinske*

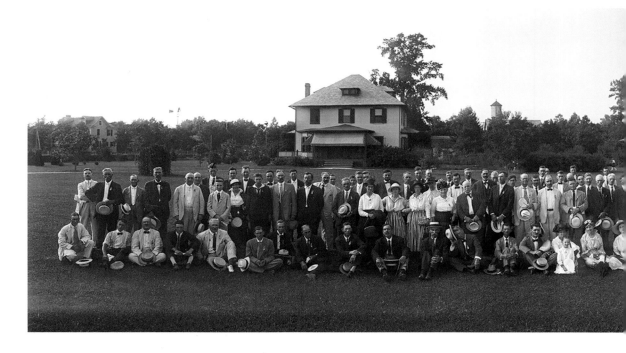

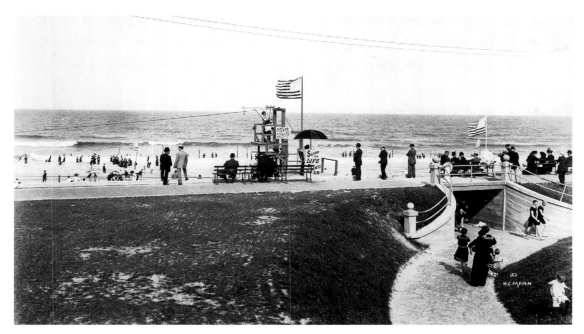

Below: To assist truck[15] farmers, the Southern Produce Company in 1905 petitioned the Virginia General Assembly to establish an experiment station in the lower Tidewater region. The state agricultural board selected a site in what is today Virginia Beach, near Diamond Springs. First construction began in 1906. This station researched all phases of truck farming, including demonstration test plots, conducting soil tests, and providing agricultural services to farmers. The station sponsored annual picnics for farmers and their families, held on the station grounds. This panoramic photograph of a group assembled at the Virginia Truck Farm Experiment Station, today the Hampton Roads Agricultural Experiment Station, was taken in 1915 by Harry C. Mann. Between 1908 and 1911 several buildings were constructed on the property (left to right): the director's residence (large house), barn and water tower (in the tree line), and the office and laboratory building (center, right). The greenhouse (white frame and glass building far right) was completed in 1911. The station is located on Diamond Springs Road. *Sargeant Memorial Collection, Norfolk Public Library*

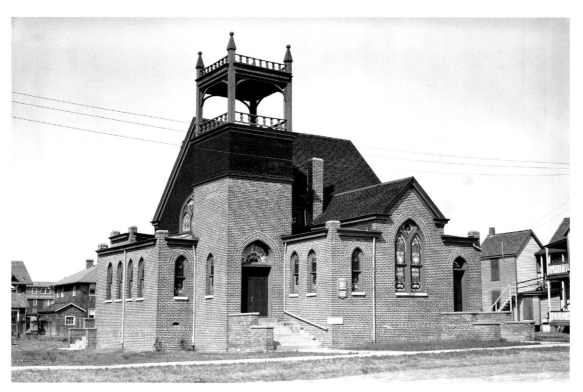

Methodists, too, had worshipped at Union Chapel but by 1912 there were enough faithful members to build a church of their own. The cornerstone for a new Methodist church was laid at Eighteenth Street and Pacific Avenue, completed the following year and declared debt free two years later. The building shown here was razed in 1952, when construction began on the new church complex that still occupies a majority of the block between Eighteenth and Nineteenth Streets. The picture was taken in 1919. *Sargeant Memorial Collection, Norfolk Public Library*

Opposite page: The photograph (top) shows the old Nimmo School Number 2, located on the Mount Zion Church grounds. The picture was published as part of a November 3, 1946 *Journal and Guide* article showing rural African American schoolhouses. Nimmo School students in grades one to seven gathered for a group photograph in 1922 (below). *Edgar T. Brown Collection, Virginia Beach Public Library*

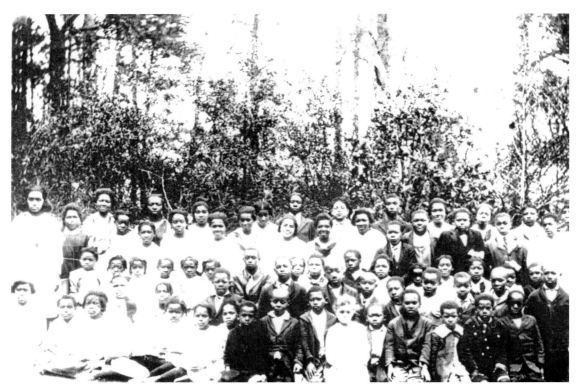

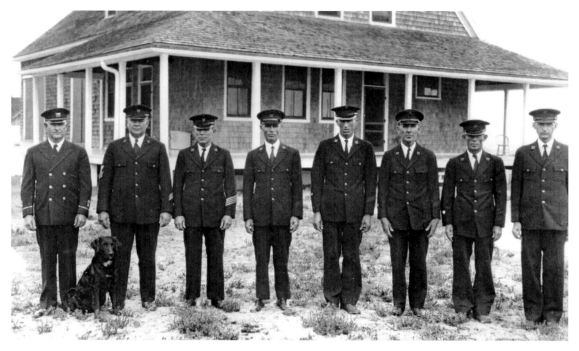

Shown here is a crew of the lifesaving station at Dam Neck. The station was built sometime in the last decade of the nineteenth century and stood until 1958. *Edgar T. Brown Collection, Virginia Beach Public Library*

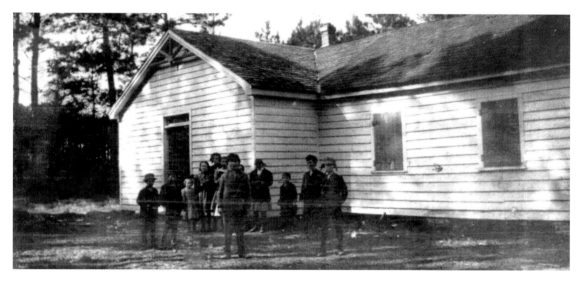

Documentation indicates that Princess Anne County had a long tradition of public education dating back to the mid-nineteenth century. Due to the lack of adequate transportation and the sporadic residential development just then, one-room schoolhouses were used for children of all ages, races and incomes. In 1900, in fact, all forty-three of the county's schools were one-room yet on the eve of World War II, just seven remained in the county. The twentieth century signaled the end of the one-room schoolhouse with the construction of a consolidated school in 1908 putting more students from the community in one, much larger, building. Plans were adopted to build, per this history, a five-room school in Oceana, replacing schools at Cape Henry, Seatack, Oceana and Virginia Beach. The new school opened in the fall of 1908 and added the county's first high-school instruction.[16] The rural Muddy Creek School, with some of its students playing in the yard, was photographed in the first decade of the twentieth century. *Edgar T. Brown Collection, Virginia Beach Public Library*

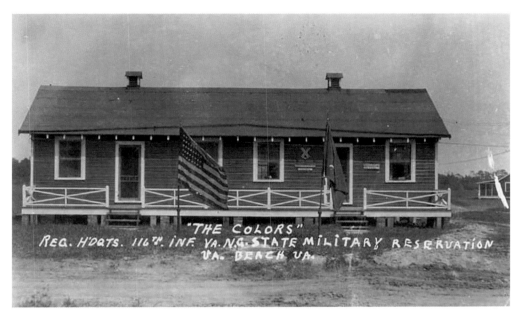

This is the regimental headquarters for the 116th Infantry of the Virginia National Guard at the State Military Reservation, photographed with the colors posted at some point prior to the First World War. *Edgar T. Brown Collection, Virginia Beach Public Library*

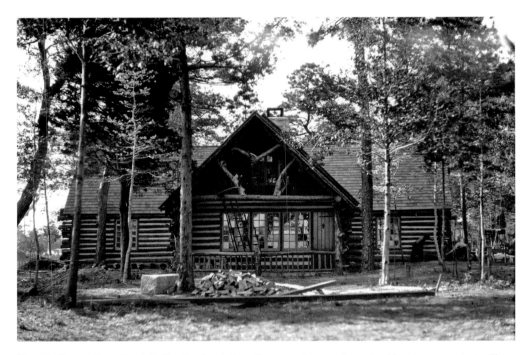

Historically, southern Virginia Beach attracted northern sportsmen who arrived by steamer or train. There were over one hundred outdoor sporting clubs and lodges established between the 1870s and 1920s in a one-hundred-mile-long-area from Back Bay to Currituck Sound and the marshy reaches of both.[17] The clubs were built in walking distance of nearby farms and often tucked within groves of trees like the Croatan Club shown here. Hunting and fishing typically took place miles from the lodges. The Croatan Club, a private hunting and fishing club located south of Rudee Inlet, is pictured as it looked in the early 1920s. *Sargeant Memorial Collection, Norfolk Public Library*

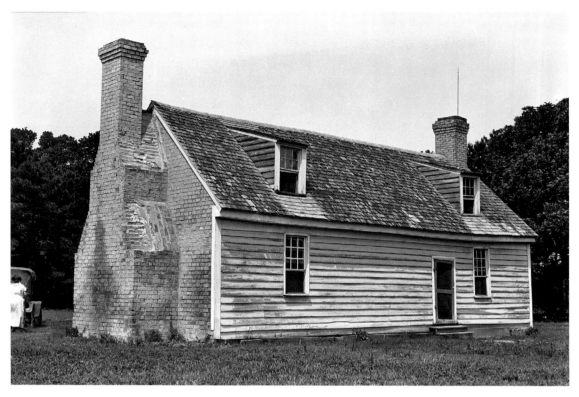

The Philip Huggins House (top), photographed on July 18, 1923, was located near Virginia Beach Boulevard in the London Bridge section. The house was purportedly built in the early eighteenth century on land in the Huggins family prior to 1692. In the additional two photographs, taken a decade later by Frances Benjamin Johnston (1864–1952), an African-American man stands next to the chimney of the house while the second shows an interior stairwell. Johnston documented the house, which is no longer standing. *Sargeant Memorial Collection, Norfolk Public Library* (top), *Library of Congress* (bottom)

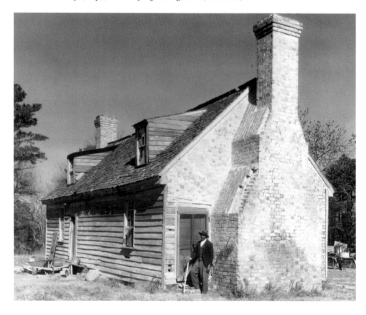

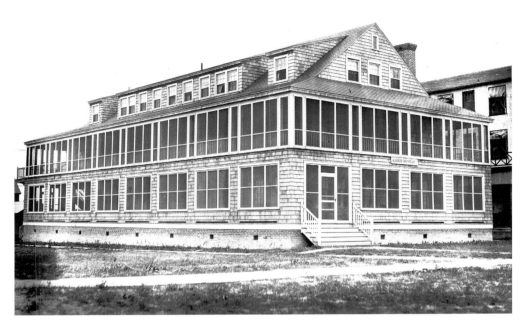

In 1926, two doctors who had been associated with Katherine Baldwin Myers' infant sanitarium opened the Seaside Infant Sanitarium on Twelfth Street and Atlantic Avenue, shown here as it looked in the 1920s. *Sargeant Memorial Collection, Norfolk Public Library*

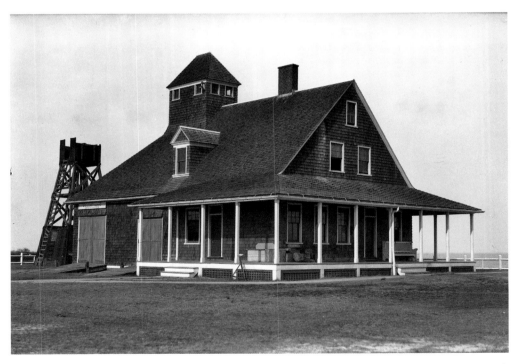

The United States Life Saving Station Number 2, also called the Seatack Life Saving Station, at Twenty-Fourth Street and Atlantic Avenue at the Oceanfront, is shown in this 1921 photograph. *Sargeant Memorial Collection, Norfolk Public Library*

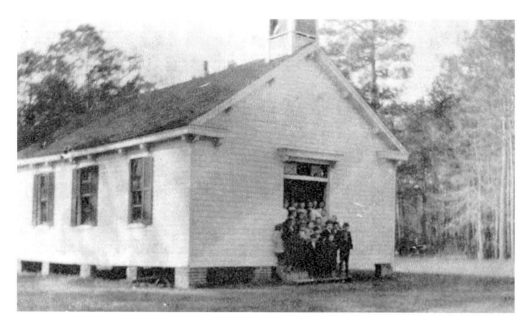

The W. E. Biddle School (shown here), a wooden building erected between 1910 and 1911 on what is today Independence Boulevard near its intersection with Haygood Road, was named in honor of a prominent citizen who was instrumental in getting the school built. William Etheridge Biddle (1856–1915), the son of Phillip W. and Rebecca Etheridge Biddle and the husband of the former Anna Butt, owned a large farm in the Kempsville section. W. E. Biddle School was the precursor of Bayside School. In the second photograph, taken in the 1920s, students of the school assembled in front of the building to have their picture taken. A teacher is standing far left. *Edgar T. Brown Collection, Virginia Beach Public Library*

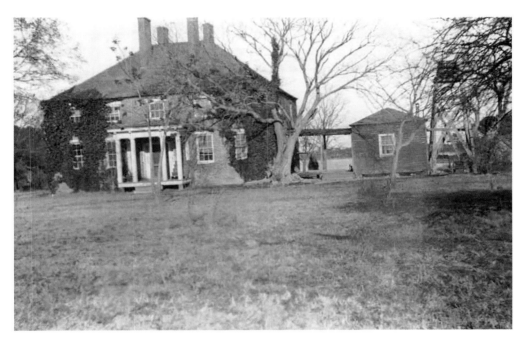

White Acre, the home of Judge Benjamin Dey White (1868–1946), was located in the Bayside section on the Lynnhaven River between the Adam Thoroughgood and Lynnhaven Houses. The photograph (above) was taken in 1911. Subsequent additions were made to the manor house and the yard, to include the hand riven juniper picket fence (below), which the judge salvaged from what he believed to be the Muddy Creek property of Grace Sherwood[18] (1660–1740)—the Witch of Pungo—and installed it on his property. The fence surrounded Dey's rose and perennial gardens. Judge White presided over the Twenty-Eighth Circuit Court for thirty-eight years based in Portsmouth but which also covered Norfolk, Norfolk and Princess Counties, serving as an attorney and judge until his death. He accumulated an extensive library, the largest in Princess Anne County, which held valuable Princes Anne County deeds and records. From this wealth of information, Judge White became known as one of the best authorities on the history of Princess Anne County. Additionally, he was the senior warden at Old Donation Church during its reconstruction in 1916. He was subsequently celebrated as the first citizen of the county. *Edgar T. Brown Collection, Virginia Beach Public Library*

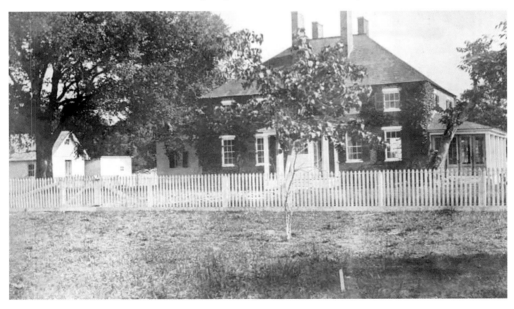

The J. B. Murden and Son general merchandise store, located on Virginia Beach Boulevard in the London Bridge section, is pictured as it looked in 1920. Joseph Benjamin Murden (1878–1953), a farmer and merchant, was also the London Bridge section's postmaster, a position he first assumed on March 7, 1914. *Edgar T. Brown Collection, Virginia Beach Public Library*

Just before the start of World War I, in 1916, ninety-two Virginia Beach residents became charter members of the Princess Anne Country Club, shown in this 1921 picture, located at 3800 Pacific Avenue (and Thirty-Eighth Street). But it would not be until after the war, on June 3, 1919, that a newly formed board authorized construction of the clubhouse building. By year's end, the contractor had been hired and the club opened on July 24, 1920. In front of the club on Pacific Avenue was the Seapines Station, a stop on the Norfolk Southern Railroad line that ran along the Oceanfront. The club had a car named "The Vance" that it chartered for morning and afternoon express service to and from the station as a convenience to the membership and their guests. The club was originally built in Spanish-style and was at the start of its first summer season when this photograph was taken. *Sargeant Memorial Collection, Norfolk Public Library*

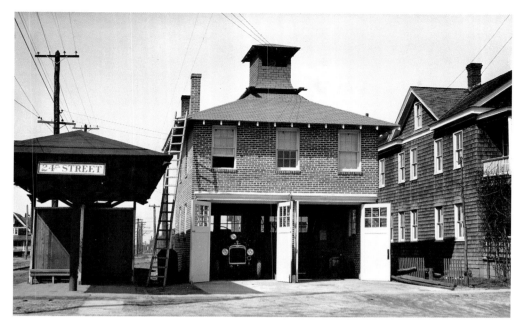

The first Virginia Beach Fire Department fire station (shown here in the early 1920s) was located at 211 Twenty-Fourth Street. Other landmarks identified in the picture include the Twenty-Fourth Street train stop (left) on the Norfolk Southern Railroad line to the bay. *Sargeant Memorial Collection, Norfolk Public Library*

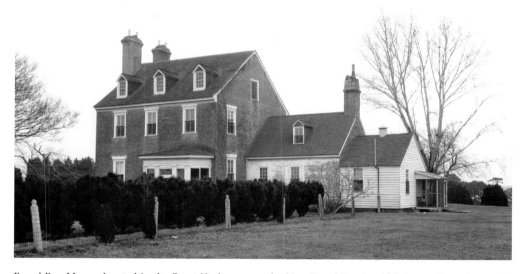

Broad Bay Manor, located in the Great Neck area overlooking Broad Bay in old Princess Anne County, is purportedly the oldest extant European-built home in the southeastern United States. Thomas Allen built the small center section of the larger house between 1640 and 1660 of Flemish bond brick on land granted to him by John West during his tenure as governor of Virginia under the crown (May 7, 1635 to January 18, 1637). The larger manor house (left) was constructed in or about 1770 by Lemuel Cornick, overpowering the small house built by Allen. Dr. Enoch Dozier Ferebee (1797–1876) acquired the property in the mid-nineteenth century and three generations of his family[19] resided there until it was acquired by John Benjamin Dey (1874–1957), a prominent truck farmer and community leader, who purchased it in 1916 and lived in the house until his death; it remained in the Dey family until 1970. The 415-acre Broad Bay Manor estate was among the most picturesque in the county at the time this picture of the home was taken on July 18, 1923. *Sargeant Memorial Collection, Norfolk Public Library*

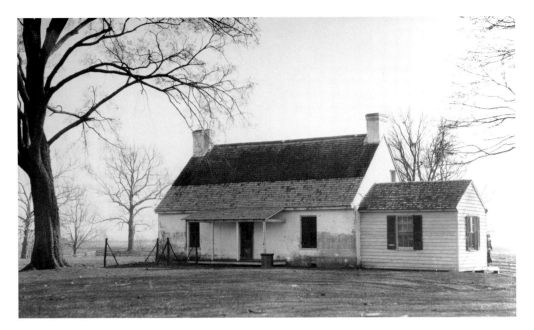

Above: This 1691 period coachman's house was the last standing structure on Fairfield Farm (also called Fairfield Plantation), located in the Kempsville section of what was then Princess Anne County and shown as it appeared in 1924 (minus dormers added later and with the frame addition still present). Fairfield Farm, the centerpiece of a sprawling plantation that enveloped much of the land between Kempsville and Great Bridge and sat off the road, a turnpike, named thusly the Kempsville-Great Bridge Road just then, was constructed and owned by Anthony Walke in the seventeenth century. The manor house burned down on a windy day in March 1865. Norfolk builder and developer Woodrow W. Reasor bought what was left of the 390-acre farm tract on November 2, 1967. The "little white house" was demolished shortly thereafter. Beyond it, on a high spot and out of view, were the disintegrating headstones of the Walke family. *Sargeant Memorial Collection, Norfolk Public Library*

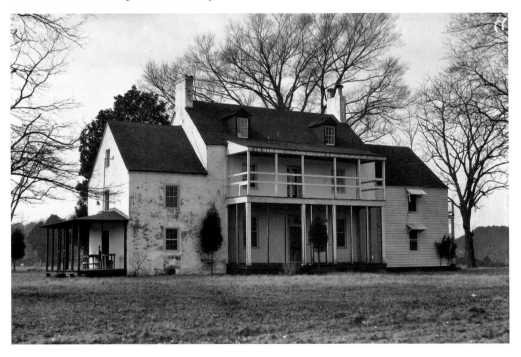

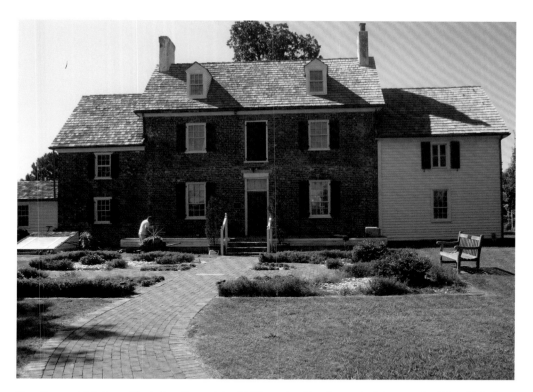

The site on which Ferry Plantation House (also Old Donation Farm) was sited dates to Savill Gaskin's ferry operation, which he started in 1642 as the second ferry service[20] in lower Virginia to carry passengers on the Lynnhaven River to the nearby county courthouse and to visit other plantations on the waterway. A cannon used to signal the ferry, which had eleven total stops along the river. The house is oriented northeast southwest toward the western branch of the Lynnhaven River. The north façade—the riverside—(also shown here) serves as the home's main entrance. Note the absence of the porch, likely built by Charles Mitchell Barnett at the turn of the twentieth century (it is also in the 1911 photograph of revelers on the riverside of the home) from the earlier photograph. Barnett (1869–1940) was a Scottish-born steamship agent and his family retained ownership for over three decades. Just in front of the house on the north side is a brick cistern (left) that was discovered during an archaeological investigation. A freshwater spring still releases water into the cistern as it did when the house was constructed. Several nineteenth century artifacts were found beneath the house in the crawlspace and preliminary investigation found what is believed to be the foundation of the earlier manor house. Subsequent digging indicated that the new house was built on the edge of the original home's foundation. This is the house as it looked when photographed on October 10, 2010. *Rlevse*[21]

Opposite below: Ferry Plantation House, for many generations best known as Old Donation Farm and shown here on the riverside elevation in 1924, is located in its namesake Old Donation Farm section of the former Princess Anne County. The site has been occupied since 1642 and the current house (shown here) dates to 1830 and was built with slave labor. The building has been attributed to George McIntosh. The exterior is Federal style three-course American bond brickwork; all of the bricks used in its construction were salvaged from the ruins of William Walke's mansion, which stood from 1751 to 1828, when it was destroyed by fire. The 1780 southeast wing (left) was adapted from an earlier kitchen outbuilding to be joined to the new construction. The northwest frame wing (right) was added in 1850 to expand the house to include a best parlor on the first floor and a bedroom on the second floor. The exterior was originally covered with oyster stucco (seen here) that was removed in the late 1980s when the masonry was repointed. The property, which has also been called Ferry Farm and Walke Manor, was added to the Virginia Landmarks Register (Virginia Historic Landmark) in 2004, and the National Register of Historic Places in 2005. *Sargeant Memorial Collection, Norfolk Public Library*

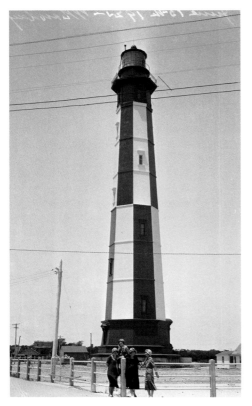

(Left to right) Georgia Riddle (later Chamblee) (1900–1967), of Morganton, Burke County, North Carolina; Mary Shepard Parker (later Edwards) (1901–1995), the daughter of Surry and Mary Odom Parker, a native of Pinetown, North Carolina, but living at Wallaceton, Virginia, just then; Sarah Dundas Boren (later Jones) (1900–1980), of Pomona, in Guilford County, North Carolina, and Marion Cooper (later Fesperman) (1903–1994), of Waycross, Ware County, Georgia, posed in front of the new Cape Henry lighthouse on June 15, 1925. Parker and her friends went to school together at and graduated from Salem College, a liberal arts woman's college in Winston-Salem, North Carolina. Riddle, Parker and Boren graduated in the class of 1922, and Cooper finished two years later. *Surry Parker[22] Photograph Collection, State Archives of North Carolina*

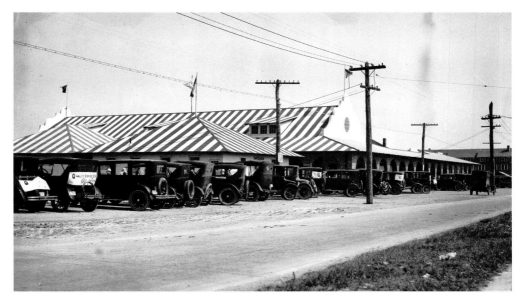

The New Ocean Casino, situated between Fourteenth and Sixteenth Streets and Atlantic Avenue, was photographed in August 1925. The building was originally constructed as part of a seaside entertainment complex that included a casino, bathhouse, and saltwater swimming pool. In the late 1950s, the New Ocean Casino's dance hall was renamed the Peppermint Beach Club and became one of the most popular venues for rock and roll performers on the East Coast. When it closed as a music venue in 1994 and was torn down the following year, it still had the shingle-style façade that had featured so prominently on the turn-of-the-twentieth-century Oceanfront. *Sargeant Memorial Collection, Norfolk Public Library*

II

TOWN AND COUNTRY

Twenty years had gone by since the Princess Anne Hotel had burned down and still the Oceanfront did not have a grand hotel. Certainly, it was not that the idea had not been batted around—it had. Plans were discussed and architects had drafted plans. All of the plans up to that point were sited on the old Princess Anne Hotel property and, to preclude the same fiery disaster, utilized concrete fireproof construction. All of these plans also involved bonds purchased by the public to fund the new hotel. While the first suggestion was to resurrect a hotel nearly identical in scale to the Princess Anne Hotel, the goals eventually shifted to a larger, more upscale hotel that reflected the rapid growth of Virginia Beach.[23]

By the time The Cavalier Hotel was on the drawing board, the era of local, haphazardly designed and constructed hotels was coming to a close. The Roaring Twenties brought an expectation of higher end hotels being cost effective and profitable for the owners while also having a more predictable level of service and amenities for guests. This meant design changes such as dining rooms and convention space grouped around a central kitchen for efficiency while constructing an individual bathroom for every guestroom. Shops were also incorporated into hotels to combine profit opportunities for the hotels while also offering a greater variety of services to those booking stays in commodious hostelries. These concepts were codified in Ellsworth M. Statler's treatise titled simply "The Statler Idea" and which served as the foundation for much of modern hotel management and heavily influenced hotel design in the 1920s and 1930s. A leading national architectural firm that embodied these concepts during the 1920s was George B. Post and Sons, which served as the primary architect, perhaps more consultant, on many hotels across the country, to include The Cavalier. There were few hotels in Virginia just then to compare with The Cavalier in either design or amenities, with many still advertising showers down the hall and basic dining facilities. Some of the most prominent in existence the year The Cavalier came on line were the Monticello in Norfolk, the Jefferson in Richmond, the Patrick Henry in Roanoke, the Hotel Stonewall Jackson in Staunton, and the Hotel Roanoke. But none of these, according to The Cavalier's National Register of Historic Places nomination form, offered the number of amenities and level of service comparable to The Cavalier.

The architects for The Cavalier Hotel were the regionally known and prolific firm of Neff and Thompson. Neff and Thompson was active in Virginia from 1902 to 1932. Clarence Amos Neff was an architect and engineer who began his career in Norfolk in 1898 after earning his architecture degree from Columbia University; he was active until 1952. Neff also served as president of the Norfolk Federal Savings and the Princess Anne Country Club. Thomas Perrin Thompson, an 1896 graduate of Georgia Institute of Technology who

also completed post-graduate engineering work at Cornell University, was Neff's partner from 1902 to 1932. Thompson began the process of dissolving the partnership in 1933 when it became clear he would be moving into a new role of public service. Thompson was Norfolk city manager from 1934 to 1938. As Neff and Thompson, the partners designed about six hundred projects, including many office buildings, personal residences, country clubs, and large-scale commercial projects. Some of the most prominent and still extant buildings attributed to them by facility and the date on Neff and Thompson's plans include the Monticello Arcade (1906–1907), Maury High School (1909), the Virginia Theater [now Granby Theater] (1915), the Naval Operating Base (1917) and the Seaboard Air Line Railway Building (1926–1927), all in Norfolk, and the Country Club of Virginia clubhouse (1907–1909) in Richmond. Clarence Neff was the primary architect for the early campus of the College of William and Mary extension [now Old Dominion University] in Norfolk, including the main education building (1935) and Foreman Field (1935–1936). He also designed Granby High School (1939) and Center Theater and Arena Municipal Auditorium (1943). Additionally, a number of prominent commercial buildings still stand, including many in Norfolk. In Neff and Thompson's plans for The Cavalier Hotel, the high point was the still relatively new concept of reinforced concrete construction. Neff and Thompson pioneered this construction method in Hampton Roads, utilizing it as early as 1906 in the Monticello Arcade. Also, the unusual V-shape of the Seaboard Air Line Railway Building can be seen as a precursor to The Cavalier's Y-shaped design just one year later. The builder of The Cavalier was Roland Brinkley of Baker and Brinkley, a builder for many years in the region who died on June 14, 1951. The Cavalier was the firm's most important project even though it had completed numerous and impressive commercial projects, especially in Norfolk. The best known of the contractor's portfolio preceding The Cavalier was the now demolished City Market, which dominated an entire city block in downtown Norfolk for decades. Brinkley also served for many years on Norfolk's board of zoning appeals and lived in the city for over fifty years after moving from Nansemond County [now the city of Suffolk], Virginia.

The official process of creating the new hotel started in 1925 with the organization of the Virginia Beach Resort and Hotel Corporation. On the eve of the 1926 season, the cornerstone was about to be laid for a new luxury hotel that was going to be built seven stories high on the top of a dune in the Seapines section of the resort at the end of Forty-Second Street. The hotel did not yet have a name. The Norfolk newspapers ran a naming contest to make sure that when it did open the name on the birth certificate was the right one. After many submissions, the names were narrowed to the Algonquin, the Crystal, the Sea Pine, the Linkhorn and The Cavalier [with a capital "T" for emphasis]. More than two months before the cornerstone laying, on March 5, 1926, a name was publicly announced: The Cavalier. The May 29, 1926 afternoon edition of the Norfolk newspaper, reporting on the cornerstone ceremony, remarked that the event was not only symbolic of the resort's "coming of age" but also of the commonwealth's significant progress since the turn of the century. This was the birth of the hotel that would later become the undisputed "aristocrat of Virginia's seashore."

While the ceremonies laying the cornerstone were brief, the speeches of those in attendance were not. Richard Dickson Cooke (1880–1958), chairman of the board of directors and a well-respected Norfolk attorney, presented the trowel to Virginia lieutenant governor Junius Edgar West (1866–1947), a Suffolk, Virginia native, and John Henry Brownley (1861–1938), chairman of the committee that organized the hotel campaign and the vice president of Ames and Brownley department store, delivered the level and square. Norfolk mayor Stockton Heth Tyler (1874–1943) who presided over the ceremony and Cavalier Hotel Corporation president

Samuel Leroy Slover (1873–1959) presented the copper capsule that held several hotel and local history souvenirs to be tucked inside the cornerstone. After the stone was in place and the level and square applied, West delivered his address, titled "Virginia in the Future." Thomas P. Thompson, former president of the Norfolk-Portsmouth Chamber of Commerce, delivered the only other speech, keeping his remarks to Norfolk's pride and confidence in Virginia Beach, and demonstrating the very different stature and relationship of Hampton Roads communities in the early twentieth century. Further support for the hotel was evidenced by the financial support of out-of-town developers Jacob Laskin and his sons, and partner Louis Siegel.

Less than a year after the cornerstone laying, The Cavalier Hotel opened with one hundred-and-ninety-five rooms, none of which was very large by today's standards. A week's worth of events was planned to celebrate the hotel. The festivities opened with a ceremony and evening dinner and entertainment. Samuel Slover presided with Norfolk mayor Tyler as they announced the completion of the project and the more than two million dollars raised through one thousand stockholders. James Leslie Kincaid (1884–1973), president of the American Hotels Corporation, was also in attendance. Kincaid declared The Cavalier to be "the finest resort hotel in America, and I have seen them all. I have known from the start that Virginia Beach, with its natural beauty, offered an exceptional opportunity for a high-class resort hotel."[24] There were daylight fireworks depicting life-sized Cavaliers on horseback to accompany the first official flag raising at the hotel. Thomas P. Thompson was toastmaster at the evening soiree that included a beefsteak dinner, elaborate decorations, a jazz band and the unveiling of Saks Fifth Avenue bathing "costumes" modeled by young women around the new saltwater swimming pool. Virginia governor Harry Flood Byrd (1887–1966), in attendance for the hotel's April 4, 1927 debut, called it "the best resort hotel in America." The hotel soon became famous from one end of the East Coast to the other. By the time Frank Blackford wrote about it over four decades later in the June 27, 1971 *Virginian-Pilot*, he observed that the hotel was a sign of an America dramatically changed from the days when the hotel was first opened. "Today's guests," he wrote, "are not interested in big name bands or service in the grand, old style." But when it opened, it was grand. The Cavalier was the biggest news in Hampton Roads in a generation and to prove it, seven thousand people toured the hotel on the first day, on April 6, 1927, it was made available for public visitation.

From its opening festivities, it was clear that The Cavalier was intended for the elite, and this exclusion had several manifestations. The cost alone was prohibitive to all but a small catchment of the population that could afford the accommodations. But the hotel was also closed to African Americans and people of the Jewish faith. The former exclusion stood in stark contrast to the fact just then that most of the hotel staff was African American. The Cavalier set aside a dining room for chauffeurs only, and waiters dressed in knee britches and stiff collars reminiscent of Colonial Williamsburg attire. On Sunday evenings, the predominantly black wait staff stood in the lobby singing negro spirituals. The prejudices pervasive in early to mid-twentieth century society were publicly muffled by the constant presence of the rich and famous courted by The Cavalier, just as its predecessor, the Princess Anne Hotel, had done before it. From presidents of the United States to captains of industry and entertainment, The Cavalier played host to them all, including John Calvin Coolidge Jr., Herbert Clark Hoover, Harry S. Truman, Dwight David Eisenhower, John Fitzgerald Kennedy, Lyndon Baines Johnson, Richard Milhous Nixon, Gerald Rudolph Ford and James Earl Carter, and then ambassador to China George Herbert Walker Bush, later the forty-first president of the United States. There were also first ladies Edith Bolling Galt Wilson, a Cavalier regular, and Eleanor Roosevelt, who visited with the Girl Scouts. Then there were the rest—too many to name them all—but here are a few: iconic American author F. Scott

Fitzgerald and his wife, the former Zelda Sayre, dubbed by her husband as "the first American flapper"; entertainers Judy Garland, Bette Davis, Jean Harlow, Betty Grable, Frank Sinatra and Fatty Arbuckle, and Hank Ketchum, creator of the *Dennis the Menace* cartoon. In its glory days, Charles "Buddy" Rogers' band played, and in between sets he courted Mary Pickford, America's silver screen sweetheart and top box office draw. They were married from 1937 to 1979, when she died. But Rogers was just one of the big band leaders to play The Cavalier. There were others, including Russ Carlyle, Sammy Kaye, Les Brown and his Band of Renown, Benny Goodman, Vaughn Moore, Cab Calloway, Harry James, Jimmy Dorsey, Woody Herman, Artie Shaw, Glenn Miller and Lawrence Welk. The hotel became one of the largest employers of bands in the United States.

While most of The Cavalier's guests were more taken by the view of the Atlantic Ocean from their room, Will Rogers was not. Coming down to breakfast one morning, he was heard to quip that "Harry K. Thaw killed the wrong architect." He was referring, of course, to New York architect and married man Stanford White, whom Thaw accused of spoiling their shared mistress Evelyn Nesbit before he shot him to death on the roof of Madison Square Garden on June 25, 1906.

The Cavalier came to be in much the same way as all of the other hotels and amusements on the Oceanfront: Norfolk investors, the railroads and East Coast passenger shipping lines put up the money to build it. Most of the hotel's guests in the first years it was open arrived by train. The Cavalier Special took on passengers daily in the Midwest and delivered them to the hotel's doorstep. The Norfolk and Western Railway's moto was "The Cavalier to The Cavalier," referring to a dedicated gas turbine powered passenger train by that name that offloaded passengers at the hotel's private depot. Even the walk to the hotel got a little bit easier. Back in 1926 construction began on a new concrete walk; it was finished the following year. After the concrete was poured for this walkway, the term "boardwalk" still attached, just as it had done to its wood predecessor. But it did not go far enough down the beach to reach The Cavalier. In 1928, a consortium of beach business and property owners formed the Virginia Beach Walkway Corporation to extend the concrete walk from Thirty-Fifth Street up to Fiftieth Street. The new portion of the boardwalk was christened and opened to the public on May 26, 1928.

When Prohibition ended on December 5, 1933, and the sale of wine and beer was finally permitted again, Cavalier general manager James Sidney Banks (1898–1989) stocked up on eighteen thousand dollars of wine. But his clientele, it was observed, had been brought up on white whisky and home brew and were not prepared for the finer wine and beer being offered at the hotel. Banks had to sell the wine to a local grocery store to pay off the hotel's wine bill.[25] Banks' hopes of bringing his well-heeled guests up to par on what constituted fine wine and other alcoholic beverages though dashed just then was a temporary condition. He took it all in good humor and pressed on.

In early 1927 in anticipation of the opening of The Cavalier, it was announced that the radio station WSEA would be launched as "the voice of The Cavalier." The five-hundred-watt station was located on the first floor of the hotel and run by the Radio Corporation of Virginia. The station could be heard initially for several hundred miles and eventually was broadcast nationally carrying the many bands that played at the hotel. "We were the third place in the country—the first two were the Roosevelt and the Paramount—to have coast-to-coast radio broadcasts," remembered Banks in the summer of 1971. "On June 10, 1927, Mayor Tyler of Norfolk, radioing from The Cavalier's radio station WSEA became the first American to extend radio congratulations to Charles A. Lindbergh [returning to the

United States after his famed transatlantic flight]. We always opened [the broadcast] with 'Carry Me Back to Old Virginia.'"[26]

Early on, The Cavalier was also called the "Cavalier on the Hill" for the massive sand dune that pushed it far above the rest of the resort strip; it was more than a bricks-and-mortar experience from day one. For decades, the owners of the hotel also held the option to much of the land around it, including homes in Cavalier Shores. Before World War II, most patrons stayed for at least ten days if not longer and enjoyed activities in the hotel's entertainment rooms and outdoor sporting opportunities. The hotel opened the Cavalier Beach Club on Memorial Day 1929 to the music of the McFarland Twins, who had earlier been the saxophonists for the Fred Waring Orchestra. This hotel beach club became the undisputed model for all beach clubs that opened on the Virginia Beach Oceanfront. Before the war, in 1935, Professional Golf Association (PGA) Hall of Famer Sam Snead won the Virginia Open on the Cavalier Golf Course. By this time, the hotel was touted as Virginia Beach's largest industry. Without question, it employed more people and paid more taxes than any other enterprise on the Virginia shore.

When it was later named to the National Register of Historic Places, The Cavalier was at last recognized as the most iconic building in the city, representing its development from a sleepy seaside town to a nationally known beach resort. This excellent example of Jeffersonian inspired Classical Revival architecture is the last of the historic, pre-World War II beachfront hotels in the city, and represents an era of American history which has nearly vanished. Of importance, what made The Cavalier rare compared to other grand, large city hotels of the era was its site overlooking the Atlantic Ocean and its dominance over the then simple town of Virginia Beach. The embodiment of this period of American history, and this elite level of entertainment and hotel service in such a unique location as compared to other contemporary grand hotels set The Cavalier apart—and it was never surpassed during the height of its prewar glory.

Down at the shore and interior reaches of what is today split by Route 60 [Shore Drive] the effort to preserve Cape Henry's rich biodiversity, first observed and documented more than four hundred years ago, began nearly two hundred years before the establishment of the Virginia Seashore State Park Association on July 2, 1931. In truth, this early effort was intended to keep Cape Henry from being swallowed up by wealthy landowners who had applied for patents on several thousand acres of land. A 1770 petition to the British colonial administrator and council of state by Princess Anne County residents, and referenced in several historic accounts that document this action, referenced "a point of land called Cape Henry, bounded on the east by the Atlantic Ocean, on the north by the Chesapeake Bay, and on the west and south by part of the Lynnhaven River and Long Creek, chiefly Desart [sic] Banks of Sand unfit for Tillage or Cultivation." This was an area that was a common fishing ground before 1770. Fishermen have been described as camping in the sand hills and cutting timber for firewood from the Desert; this was, after all, how they made a living. But they could no longer fish there if Adam Keeling—whose home was located near the mouth of Long Creek—and others succeeded in securing patents in the Cape Henry Desert. This was more protest than petition. Fishermen argued that patents would hurt the fishery, and thus they requested that no patents be granted so that "the Land remain a Common for Benefit of the Inhabitants of the Colony in General for Fisheries and other public uses." But their petition went nowhere just then. The Revolutionary War intervened. Further consideration of their protest was quickly dropped.

We are left to wonder today how much the Virginia Seashore State Park Association was informed of this earlier effort to set aside thousands of acres of Cape Henry as public land

when its members set out to preserve this richly historic and ecologically vital transition zone as a state park more than one hundred and sixty years later. Benjamin Burroughs spearheaded the association's effort to keep the land from developers and businessmen who would have surely subdivided and built on it. Property was acquired by donation and purchase. This remarkable act of preservation conjures Norfolk historian Rogers Dey Wichard's observation of many years ago that the land to which people belong always helps to form their character and influence their history. Seashore State Park [now First Landing State Park] remains an extraordinary gift that took eighteenth century protest and twentieth century determination to come to fruition.

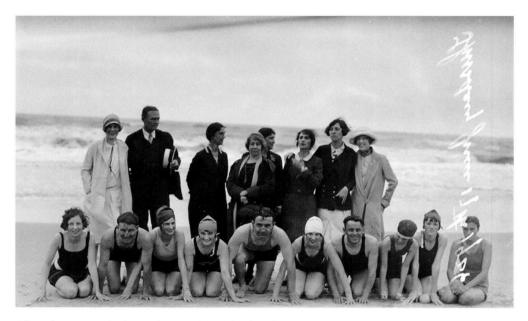

A large house party had moved out to the sand and surf at the Virginia Beach Oceanfront when this picture was taken on June 17, 1926. Pictured here standing (left to right): Ella Aston (later Rhodes) (1903 – 1961), Mary Shepard Parker's Salem College alumni; Alec Taylor; Mary Shepard Odom Parker, the wife of Surry Parker; Louise Mathilde de Maison, born in France in 1868 and a French teacher in Norfolk (she never married); Elizabeth Brownley Odom Hunter, Mary Shepard Odom Parker's sister, the wife of Dr. Henry Holmes Hunter Jr., whose "Thin Cottage" at the Oceanfront was home base for summer vacations; Mary Shepard Parker, Surry Parker's daughter and a teacher; Mary Whitehurst (later Stratton), another Salem College alumni, and Georgia Riddle, Mary Shepard Parker's friend and fellow Salem College graduate. Those kneeling are (left to right): Lois Efird (1900 -1961), a Salem College friend and graduate who grew up in Winston-Salem, North Carolina, and died there, never married; Silas Martin Whedbee (1901 – 1996), of Hertford, Perquimans County, North Carolina, and a graduate of the University of North Carolina Chapel Hill; Elizabeth Walton Parker (later Roberts), Surry Parker's twenty-two-year-old daughter and a teacher; Patty Riddick Hunter (later Clarke), the Hunters' twenty-year-old daughter; Robert Shelton White, of Hertford, Perquimans County, North Carolina, Duke University graduate and naval officer; Margaret "Peg" Landon; Ray West, who also attended Duke University; Jane Odom Parker (later Bosman), Surry Parker's twelve-year-old daughter; Katherine Cheek Hunter (later Marshall), the Hunters' seventeen-year-old daughter, and Margaret Byrd Riddick "Peggie" Parker, Surry Parker's seventeen-year-old daughter, never married. *Surry Parker Photograph Collection, State Archives of North Carolina*

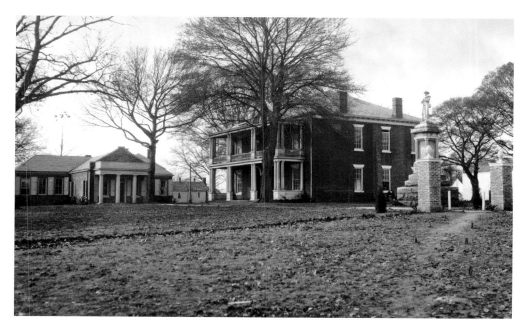

These 1927 photographs show the Princess Anne County clerk's office (left) and courthouse (right) and also the front elevation of the courthouse. The courthouse, the sixth and last location of the county seat, was completed in time for the January 1823 session of county court. The buildings are located on Nimmo Parkway in the Virginia Beach Municipal Center complex and sit at the geographic center of the city. Of note, due to extensive renovations and additions that took place after the consolidation of smaller independent city of Virginia Beach and Princess Anne County on January 1, 1963, to form the new city of Virginia Beach, the courthouse could not be added to the Virginia Landmarks Register. Those changes specifically "restored" the buildings shown here to Georgian-style, modeled after Williamsburg, Virginia structures that had been erected around it in the city hall complex. The Confederate monument (far right) in the top photograph and just inside the walkway gate to the courthouse was erected on November 15, 1905, to honor the service of the county's Civil War soldiers and sailors. *Sargeant Memorial Collection, Norfolk Public Library*

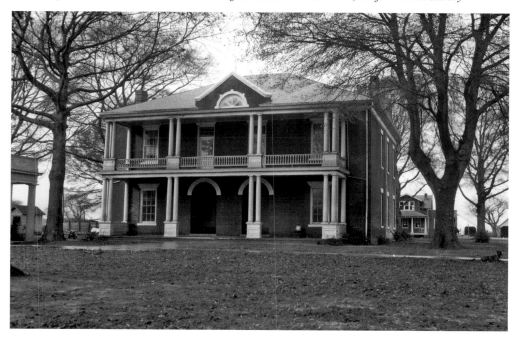

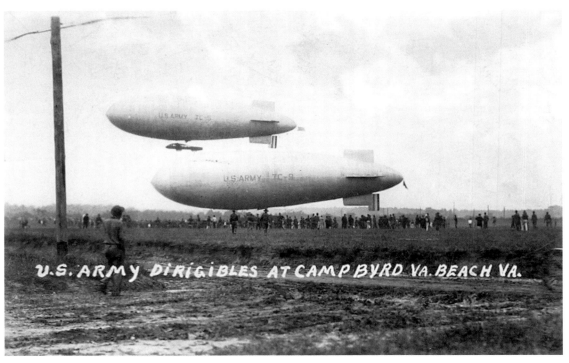

U.S. ARMY DIRIGIBLES AT CAMP BYRD VA. BEACH VA.

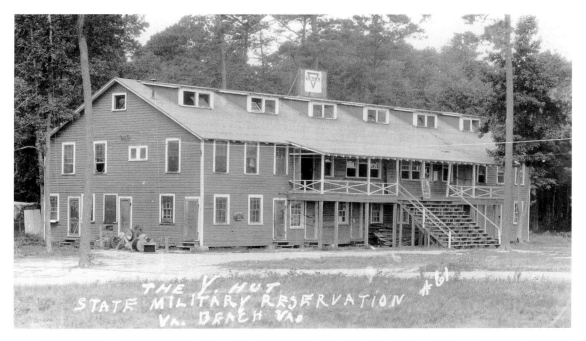

This is the Young Men's Christian Association (YMCA) "hut" at Camp Byrd. *Edgar T. Brown Collection, Virginia Beach Public Library*

Opposite above: The Lynnhaven Country Club, photographed between 1925 and 1927, was located from 1920 near the present-day Willis Furniture (formerly Willis Wayside) site in the Thalia[27] section. The club was the successor to the Hebrew Country Club (perhaps also called the Suburban Club), started in 1917 by members of Ohef Sholom Temple and situated in Norfolk County near Ward's Corner at the intersection of Granby Street and Little Creek Road. Within three years, the club moved and changed its name to Lynnhaven Country Club, which like the Ward's Corner site, had a golf course. But this club, too, was short-lived due in large measure to the German-Jewish community's difficulty in supporting the Ghent Club in Norfolk and a sprawling club operation at Thalia.[28] The clubhouse burned down. But in 1939, Robert and Marion Steinhilber bought a one hundred-acre tract of land in what was still rural Princess Anne County and built their Thalia Acres Inn on the foundation of the once beautiful club building shown here. *Sargeant Memorial Collection, Norfolk Public Library*

Opposite below: The first iteration of Camp Pendleton was laid out in 1911, with construction beginning in 1912, as the State Rifle Range for the use of the state militia. Between 1922 and 1942, it was named after the then serving governor of Virginia (and several to follow), being firstly named Camp Trinkle (1922–1926), then Camp Byrd (1926–1930), Camp Pollard (1930–1934), Camp Peery (1934–1938), and Camp Price (1938–1942). During both world wars, the base was federalized. In World War I it was used by the United States Navy for coast artillery training and during World War II it was controlled by the United States Army, who first applied the name Camp Pendleton. This real picture postcard shows army airships TC-5 and TC-9, stationed at Langley Field, setting down at Camp Byrd, putting the time frame between 1926 and 1930. Most of the airships flown by the United States Army Air Service in the 1920s and 1930s were the TC-class shown here, used for coastal patrol duty because the army had long maintained just then that it held the primary responsibility for coastal and harbor defenses of the United States. *Edgar T. Brown Collection, Virginia Beach Public Library*

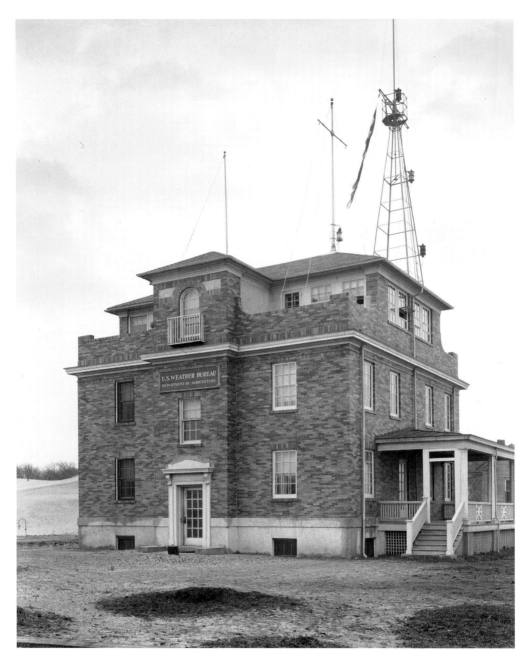

On the waterfront forward of the Cape Henry lighthouses and photographed as it looked in 1925, is the third weather station, this one the United States Weather Bureau,[29] Department of Agriculture facility, completed in 1918 to become the primary reporting center for observers, supplanting the second station constructed there in 1901, which was subsequently used by assistant observers and additional operating space. Frank Upman, a Washington, D.C. architect, designed the building, which was occupied until May 1969. Of note, what is today the National Weather Service (NWS), tasked with providing weather forecasts, warnings of hazardous weather, and other weather-related products to government agencies and the public for the purposes of protection, safety and general information, is part of the National Oceanic and Atmospheric Administration (NOAA) branch of the Department of Commerce. The agency was known as the United States Weather Bureau from 1890 until it adopted its current name in 1970. The weather bureau came under the agriculture department until 1940, when it was moved to commerce. *Sargeant Memorial Collection, Norfolk Public Library*

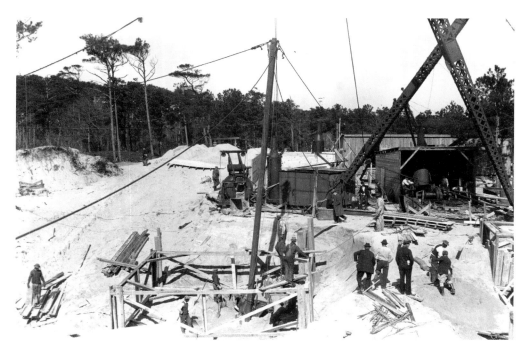

In this February 1926 photograph, the digging of the foundation for an as-yet-unnamed hotel at Virginia Beach was underway. Shortly thereafter, on March 5, 1926, a name was chosen: The Cavalier Hotel. Official groundbreaking ceremonies were held on May 9, and thirteen months later, the seven-story Cavalier Hotel opened. *Sargeant Memorial Collection, Norfolk Public Library*

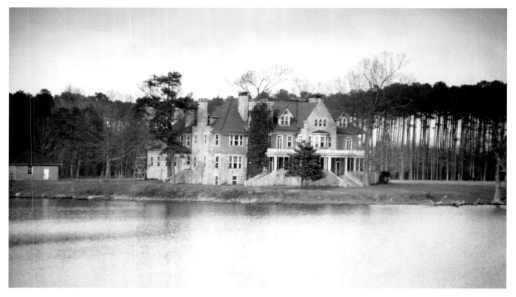

The home of Dr. John Wesley Miller-Masury, located at the end of Fifty-Second Street on Crystal Lake, was designed by Arnold Eberhard and built between 1906 and 1908. The two-and-a-half story, L-shaped stone-and-slate dwelling has two distinctive hipped roofs with dormers, which intersect at a three-story castellated tower. At the time the photograph was taken on March 31, 1926, the mansion was known as Lakeside (1906–1935), the name that Miller-Masury had given to his home. From 1936 to 1939, the building played host to the Crystal Club, a gambling casino and nightclub, and after that was renamed Greystone Manor (1942 to present). The house was added to the National Register of Historic Places in 1997. *Sargeant Memorial Collection, Norfolk Public Library*

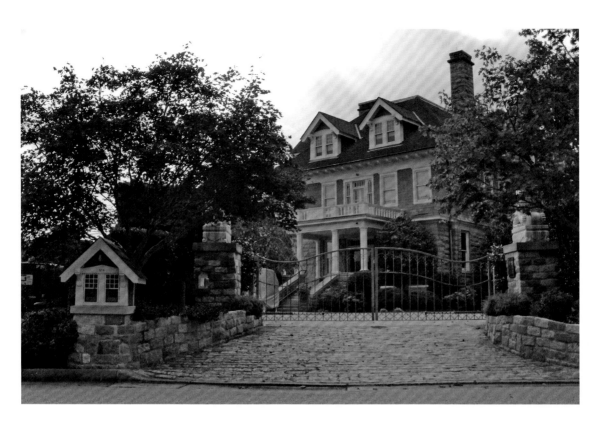

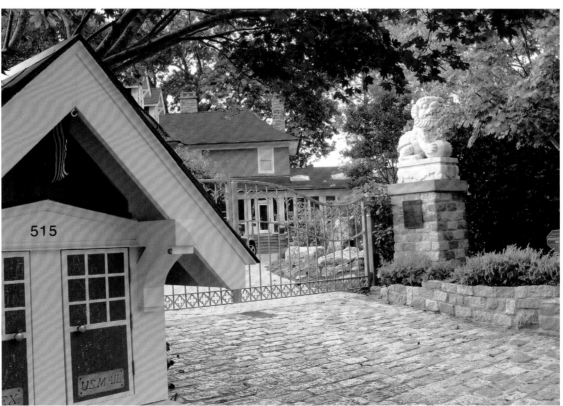

Lakeside (later Greystone Manor) was built by Dr. John W. Miller-Masury, heir to the Masury paint fortune. He was actually descended from the Masury family through his mother, but his father, Frederick Lewis Miller, changed his last name to Miller-Masury after marrying the daughter of John W. Masury. The company then became "John W. Masury & Son." John Miller-Masury earned his medical degree from Columbia University, and in October 1905, he and Martha Lewis Miller, of Boston, were married in Norfolk. The following month, Miller-Masury paid Susan Uber $21,000 for approximately 100 acres of the Ubermeer property that had been platted into 241 lots. He was later able to purchase several lots and a railroad right-of-way that had been sold to Uber prior to 1905, bringing his holdings to about 130 acres. The property boundary ran east-west along present-day Fifty-Eighth Street, south along the ocean, westward along Fifty-First Street to the east side of Crystal Lake, and then northward to Fifty-Eighth Street. The historic marker for the house is located at the gate, shown in this September 30, 2012 photograph. *Sue Corcoran*[33]

Opposite above: The Dr. John W. Miller-Masury House, first known as Lakeside and located on Wilder Road[30] at the western end of Fifty-Second Street, on the east side of Crystal Lake, about ten blocks north of the resort area, was designed in the Scottish baronial style by Norfolk architect Arnold Eberhard. The large house took two years to build and is approximately 12,000 square feet. In building the house, Miller-Masury made it the centerpiece of a self-sufficient estate complete with its own electric power plant, windmill, a water heater capable of handling one thousand gallons, fruit orchards, vegetable gardens, and stables. According to local lore, he was also part owner of the "Green Hornet," a trolley car that ran from Virginia Beach to Cape Henry. The trolley stopped at the entrance to Lakeside. The picture of the house (shown here) was taken on September 30, 2012. *Sue Corcoran*[31]

Opposite below: Eberhard's masterpiece and Miller-Masury's home represents one of the few examples of Scottish baronial style architecture in Virginia, synthesizing elements and materials of the earlier gothic revival with the more formal massing and symmetry of colonial revival. The house is also remembered for its role as the Crystal Club, a gambling casino and nightclub that flourished from 1936 to 1939. Crystal Club represented one step in the development of Virginia Beach from a sedate oceanfront resort in Princess Anne County to a booming city that attracts vacationers from all over the East Coast and Canada. The stone piers that mark each end of the circular driveway to the house were added by later owners of the house William and Almira Wilder. The Wilders also named the estate Greystone Manor. This picture of the gate was also taken on September 30, 2012. *Sue Corcoran*[32]

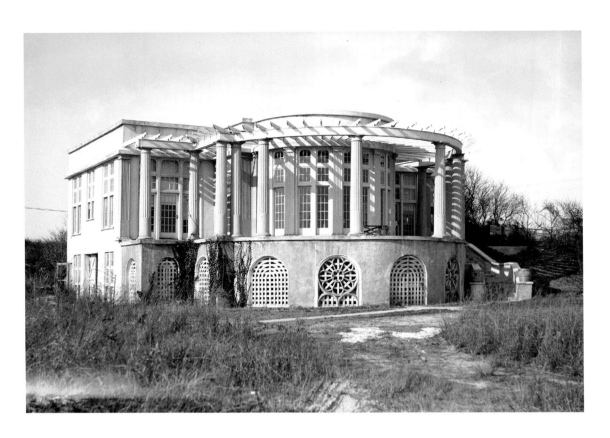

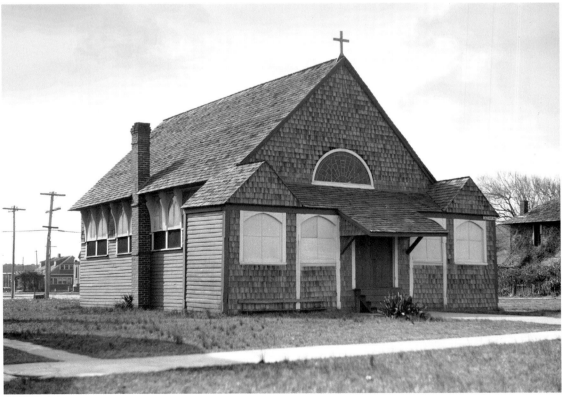

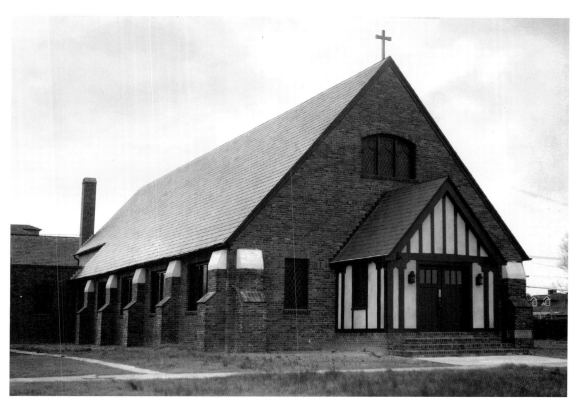

Shortly after the first picture of Galilee Episcopal Church was taken in the spring of 1926, it was moved and the sanctuary shown here was built in its place. In June 1955, the church building was sold and the congregation moved to its present location at Pacific Avenue and Fortieth Street. The building pictured here was purchased by the Evangelical Lutheran Church of the Good Shepherd, which occupied it until 1964, when they, too, moved to another site. The two-building Kona Kai Hotel was later built on the site. *Sargeant Memorial Collection, Norfolk Public Library*

Opposite above: The summer house of Lena Hancock Price (1868–1964), the widow of United States Navy commander[34] Claude Bernard Price (1868–1922), is shown as it looked on March 31, 1926. The house, located at Forty-Ninth Street, was later known as the Dunes Club. Of interest, the Shoreham Cottage was at one time owned by the Prices. *Sargeant Memorial Collection, Norfolk Public Library*

Opposite below: Like other houses of worship that sprung up at the Oceanfront, there was much contemplation and planning that preceded construction. Such was the case for the future Galilee Episcopal Church. In mid-July 1888, a small group of vacationers met for Sunday morning services led by the Reverend Beverly Dandridge Tucker, who would later become the bishop of the Episcopal Diocese of Southern Virginia. According to the church's history, those gathered that day spoke of what mattered most in life, coming to the conclusion that "within three years should be erected a chapel or place of public worship for all Christian faiths, regardless of creed." The non-denominational Union Chapel was built just then at Eighteenth Street between the Oceanfront and Atlantic Avenue in 1891 (shown here as it looked on March 31, 1926) on land donated by the Norfolk-Virginia Beach Railroad. Five years later, in 1896, it was purchased by the Episcopal church and became a mission of Eastern Shore Chapel, which named it Galilee by the Sea. The original building was moved to the rear of the property near Atlantic Avenue and renamed Tucker Hall when the new church building was built on the same property. *Sargeant Memorial Collection, Norfolk Public Library*

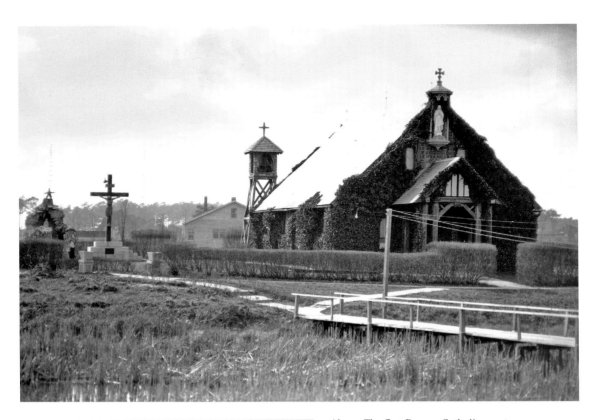

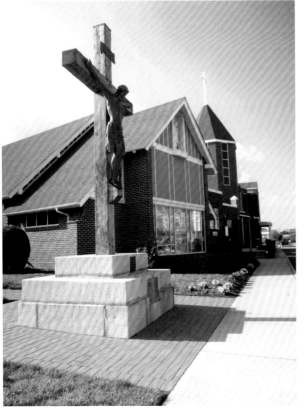

Above: The first Roman Catholic sanctuary in Virginia Beach, Star of the Sea Catholic Church came to fruition after the Right Reverend Denis Joseph O'Connell, the first Irish-born Catholic bishop of the Diocese of Richmond, met in the home of Mary Holly Rudolph, the widow of William Bernard Rudolph,[35] with residents interested in starting a new parish. The meeting took place in March 1914. The church was located just then at Arctic Crescent and Fifteenth Street (next to Lake Holly) on land donated by James S. Groves, president of the Virginia Beach Development Company. Star of the Sea's cornerstone was laid on June 4, 1915, by Father Philip P. Brennan, the parish's first pastor, and the dedication was held on August 8 of that year. The picture of the church shown here was taken on March 31, 1926. *Sargeant Memorial Collection, Norfolk Public Library*

Left: In the decades since Star of the Sea Catholic Church made its first appearance at the Oceanfront, it has been rebuilt and significantly enlarged at its present location on Pacific Avenue, photographed by Nicholas D. Heyob, on March 22, 2012. *Nicholas D. Heyob*[36]

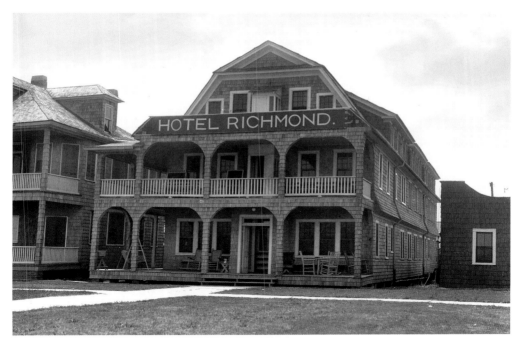

The Hotel Richmond, photographed in the 1920s and later known as the Surf Hotel, was located on Fourteenth Street and the Oceanfront. *Sargeant Memorial Collection, Norfolk Public Library*

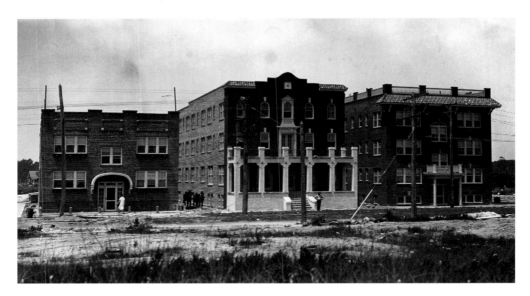

At the south end of Virginia Beach, entrepreneur Joseph Wesley Gardner built the two-story George Washington Apartments (left), three-story Martha Washington Apartments (right), and Martha Washington Hotel (center) on Atlantic Avenue and Eighth Street, all one block off the Oceanfront (shown here, 1926). At first, Gardner left a large gap between the apartment buildings. Seeing opportunity, he filled the gap with the sixty-one-room Martha Washington Hotel, which was nearing completion when this picture was taken in 1926. Soon after the hotel and surrounding site work was finished, Gardner dropped "George" from the first apartment building and rebranded the entire complex the Martha Washington Hotel and Apartments. Though Gardner's hotel and apartments stood for decades after they were first built, they later succumbed to the first round of modern resort hotels that eclipsed the cottages, apartments and early motels that dotted the Oceanfront. *Sargeant Memorial Collection, Norfolk Public Library*

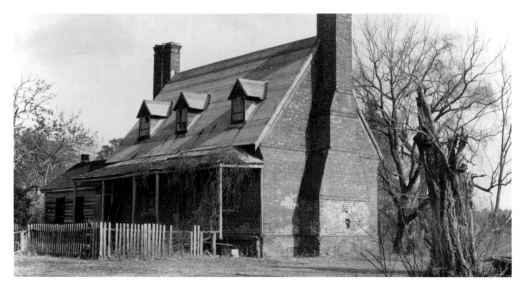

Built in or about 1725, Lynnhaven House is an example of eighteenth-century lower Tidewater Virginia vernacular architecture. The house was first built by Francis Thelaball, a middling plantation owner, for his family. Constructed of brick in English-bond pattern, the house sits on a finger of land near the Lynnhaven River. For many years it was referred to as the Wishart or Boush House. The residence came into the Boush family in 1795 when William Boush, son of Frederick Boush, bought the property from Thomas Wishart and Porcia, his wife, at Little Creek off what is today Independence Boulevard on Wishart Road. This picture of the house was taken in 1926. The house remained a private residence until 1971 when it was bought by Preservation Virginia (formerly the Association for the Preservation of Virginia Antiquities). Later, it was acquired by the city of Virginia Beach. Remarkably, eighty-five percent of the home's original materials remain intact. The house is on the National Register of Historic Places as a National Historic Landmark. *Sargeant Memorial Collection, Norfolk Public Library*

The cornerstone of the Cavalier Hotel was laid (shown here) on May 29, 1926. Virginia lieutenant governor Junius Edgar West was the keynote speaker for the ceremony. *Sargeant Memorial Collection, Norfolk Public Library*

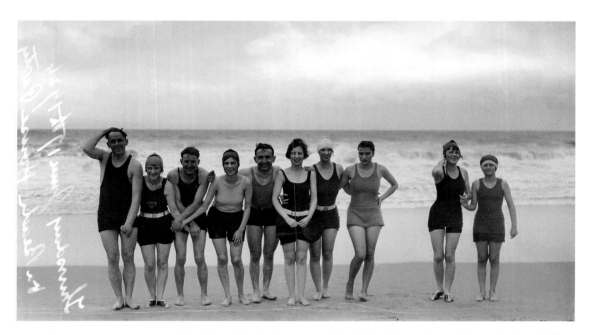

This happy group stayed at "Thin Cottage" during their June 1926 visit to Virginia Beach. Pictured (left to right) are Ray West, Patty Riddick Hunter (later Clarke), Silas Martin Whedbee, Elizabeth Walton Parker (later Roberts), Robert Shelton White, Lois Efird, Margaret "Peg" Landon, Margaret Byrd Riddick "Peggie" Parker, Katharine Cheek Hunter (later Marshall), and Jane Odom Parker (later Bosman). *Surry Parker Photograph Collection, State Archives of North Carolina*

The large group of young men and women shown in the accompanying photograph stayed at this seaside cottage, located within walking distance of Seaside Park and just off Atlantic Avenue and the boardwalk (the end of which can be seen in another photograph in the Surry Parker collection). The cottage is pictured here with Dr. Henry Holmes Hunter Jr.'s car parked out front on June 30, 1926. The Hunters were living in the Whaleyville section of what was then Nansemond County (now Suffolk), Virginia, and rented what they called "Thin Cottage" at the Oceanfront in the summers. The Hunters were close friends of Surry Parker's family and their children are among those pictured (along with a number of Salem College graduates who graduated before, with and after Mary Shepard Parker and were bound by their alumni status). *Surry Parker Photograph Collection, State Archives of North Carolina*

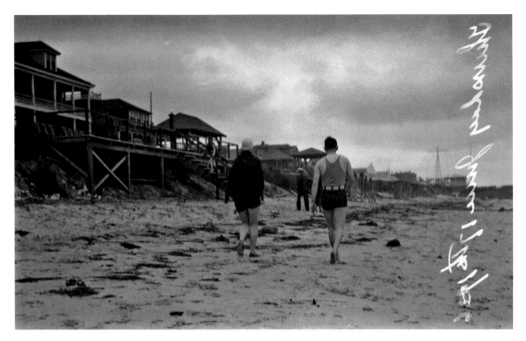

In this photograph, taken on June 17, 1926, "Thin Cottage" guests head down the beach in the vicinity of Twelfth Street. The Flume, located where Thirteenth Street is today, is far right. This device, installed in the last decade of the nineteenth century to curb the mosquito population in Lake Holly, ran to the ocean. The New Ocean Casino (upper right down the beach, to the left of the Flume), which opened in 1924 between Fourteenth and Sixteenth Streets (the site of the old Princess Anne Hotel), offered a picnic pavilion, dance hall, bathhouse and amusements. *Surry Parker Photograph Collection, State Archives of North Carolina*

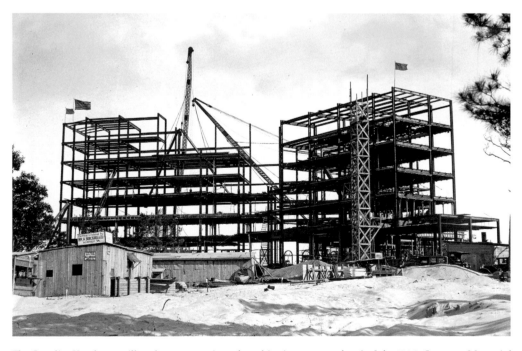

The Cavalier Hotel was still under construction when this picture was taken in July 1926. *Sargeant Memorial Collection, Norfolk Public Library*

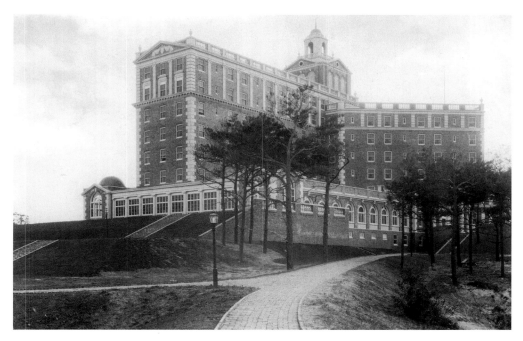

The Cavalier Hotel was constructed of cement-covered steel for fireproofing and then sheathed with over half a million bricks, the most ever used for one building in Virginia at that time. The Cavalier represented the epitome of class and sophistication. Opening ceremonies were held on April 4, 1927, and continued in the week that followed, to include a banquet three days later featuring the Ben Bernie Band. Colonel Samuel Leroy Slover (1873–1959), president of the Cavalier Hotel Corporation, and Virginia governor Harry Flood Byrd (1887–1966) presided over the evening's celebration. *Amy Waters Yarsinske*

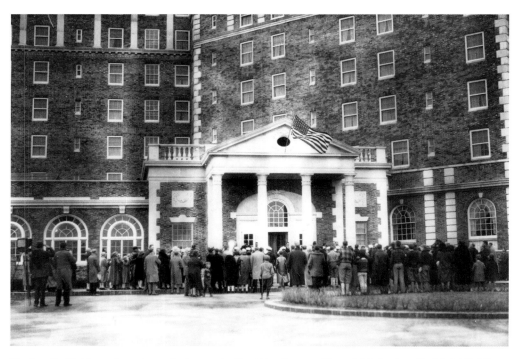

The Cavalier Hotel grand opening took place on April 4, 1927. *Sargeant Memorial Collection, Norfolk Public Library*

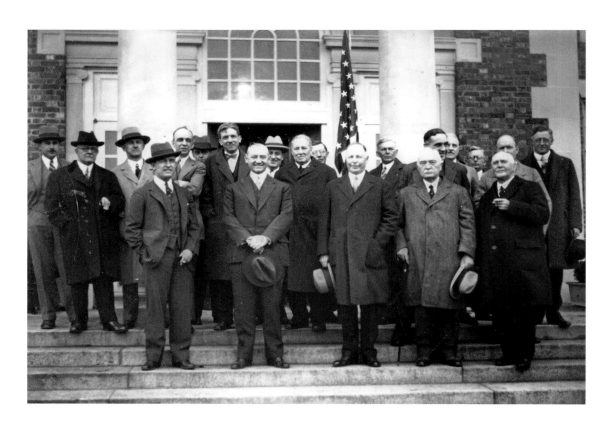

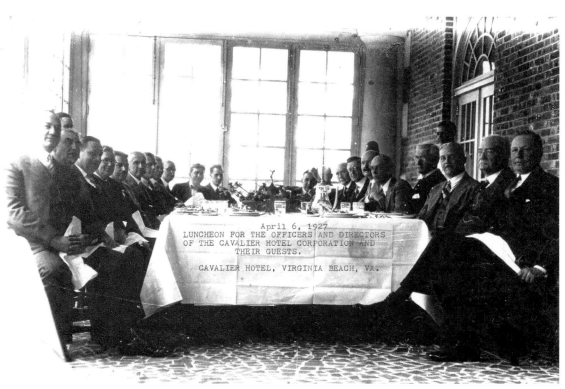

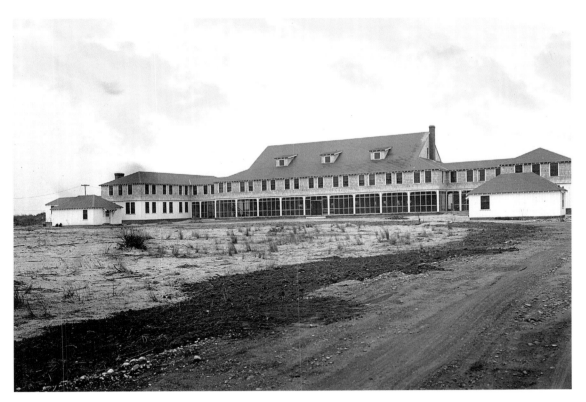

The Knights Templar Club on Third Street and the northeast corner of Shore Drive (then Bay Shore Drive) at the foot of old Great Neck Road and pictured here as it looked in June 1927, was built two years before and designed by Norfolk architect Randolph Maury Browne (1888–1936). The Knights Templar used the building for only two years. The building changed hands and names several times in the decades to follow. In the year this picture was taken, it had become the privately-owned Hygeia Club but this name faded quickly. Later, it was known as the Bay Shore Beach Club. By 1936 it was a dance hall called Club 500 and during this time it became a popular venue for big bands to play. Nine years later, in 1945, it was purchased by African American businessmen and turned into Seaview Beach Resort, one of the largest and best beach resorts for African Americans on the East Coast. In the early 1960s, the property was sold again and by 1965 the building had been torn down. *Sargeant Memorial Collection, Norfolk Public Library*

Opposite above: The directors and officers of the new Cavalier Hotel, along with some of the hotel's guests during the grand opening, posed for this picture on the front steps on April 4, 1927. Colonel Samuel Leroy Slover, president of the Cavalier Hotel Corporation, is standing in the front row, third from left (hand in his jacket pocket). *Sargeant Memorial Collection, Norfolk Public Library*

Opposite below: A luncheon was held for the officers and directors of the Cavalier Hotel Corporation and their guests on April 6, 1927, at the hotel. *Edgar T. Brown Collection, Virginia Beach Public Library*

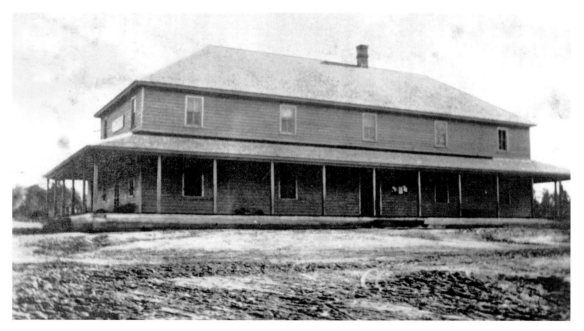

The two-story Capps and Land general store at the intersection of Princess Anne and Indian River Roads—what many locals call "downtown Pungo"—is shown in this photograph from the 1920s. The store was first built by Kermit Land and Enoch Capps, who lived across Princess Anne Road from one another in the Pungo section, in 1908. John E. Munden III (1933–2016) took it over in 1961 and owned the iconic storefront for forty-eight years. *Edgar T. Brown Collection, Virginia Beach Public Library*

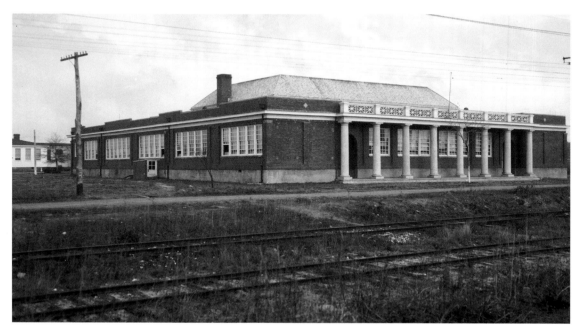

After the original wood-frame high school building at Oceana was rendered obsolete in 1926, the school building shown here was opened in the fall of that year adjacent to the Norfolk Southern railroad tracks. The building was not long on the scene. Two years later, just after school let out for summer, it was destroyed by fire, making this 1927 picture of this iteration of Oceana High School one of the few that exist. A new two-story high school building replaced this one in February 1929. *Sargeant Memorial Collection, Norfolk Public Library*

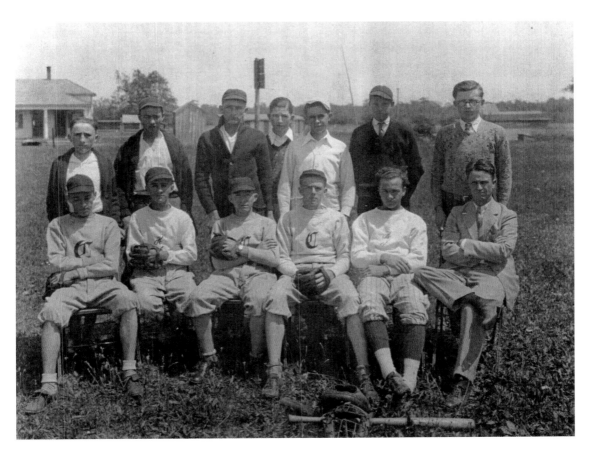

Above: The Creeds baseball team is shown in this undated, 1920s period picture. *Edgar T. Brown Collection, Virginia Beach Public Library*

Right: The 1927/8 fifth grade class of Creeds School posed with teacher Grace Belle Ackiss (later Parker) (1901–1990). The first Creeds school building, in what remains the largely rural southeastern section of today's city of Virginia Beach, was constructed in 1848 and known as Blossom Hill. The second school building, backdrop for this picture, was built in 1908, five miles south of the present-day Creeds Elementary School[37] on Princess Anne Road. *Local Schools Collection, Virginia Beach Public Library*

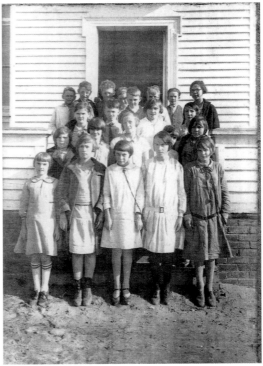

William Lee Hall, of Cleveland, Ohio, stood at the base of the old Cape Henry lighthouse (left), next to the old lighthouse with the new lighthouse as backdrop (center), and on the Cape Henry shore (right), on April 25, 1927. Hall previously owned a cartage business but managed an electrical supply company at the time these pictures were taken. *Surry Parker Photograph Collection, State Archives of North Carolina*

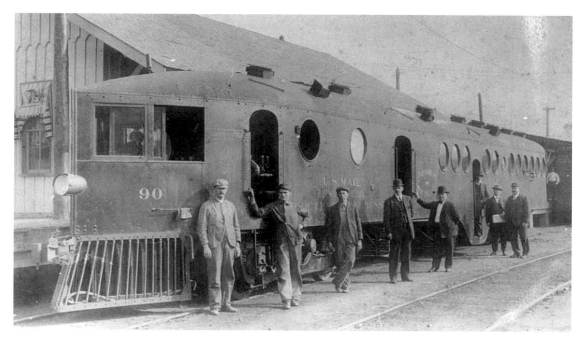

Taken in 1918, this photograph shows the gasoline-powered car called "The Scooter," operated by Norfolk Southern Railroad. The car made the run from Norfolk to Munden Point from 1910 to 1929, and was electrified in 1923 to the end of its service on that track. The Scooter was taken out of active service six years later, in 1935, and later scrapped. *Edgar T. Brown Collection, Virginia Beach Public Library*

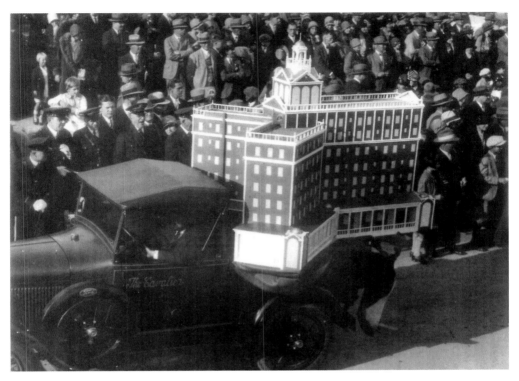

A model of the Cavalier Hotel was displayed on the back of a 1929 Ford pickup for a parade held the same year. *Edgar T. Brown Collection, Virginia Beach Public Library*

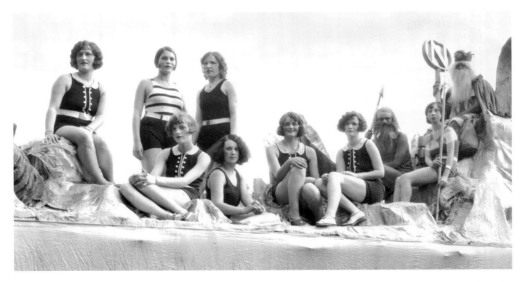

This float with King Neptune and an entourage of bathing suit beauties was taken at Virginia Beach in the 1920s. But the annual Neptune Festival celebrated today did not get its start until 1973, when it was created by Virginia Beach Chamber of Commerce president and RK Chevrolet founder Richard Kline to celebrate the city's heritage. More than fifty thousand people attended the first festival that year, with seafood selling out before the festival ended. Actor Lyle Waggoner, a star of *The Carol Burnett Show*, was the grand marshal of the first parade. The festival was named for Neptune, the Roman god of the sea. King Neptune's grand parade is an important part of the event, perhaps a nod to the earliest celebrations like the one shown in this photograph. *Sargeant Memorial Collection, Norfolk Public Library*

#2907 Va. Beach Radio Compass House
Dec 6 21 Cont 4321 Looking NW

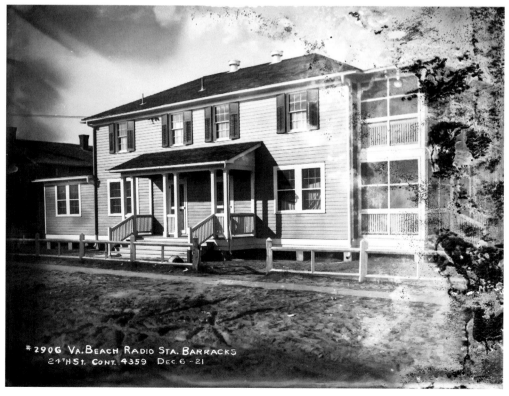

#2906 Va. Beach Radio Sta. Barracks
24th H St. Cont. 4359 Dec 6 - 21

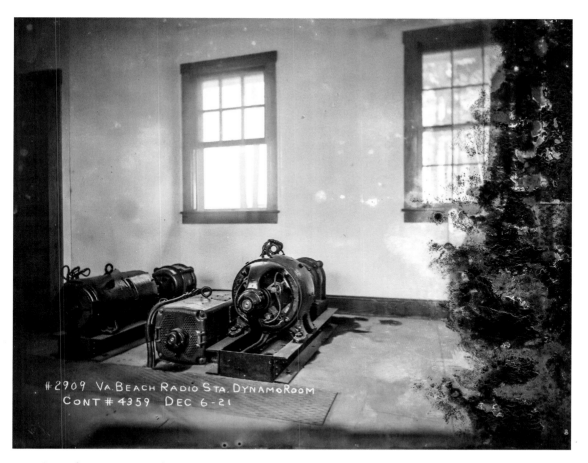

#2909 VA. BEACH RADIO STA. DYNAMO ROOM
CONT # 4359 DEC 6-21

Located at Virginia Beach's Twenty-Fourth Street, this is the United States naval radio station dynamo room, pictured on December 6, 1921. *National Archives*

Opposite above: This picture, looking northwest, of the naval radio compass house and watch tower at Twenty-Fourth Street was taken on December 6, 1921. The Greenlee, an early hunting club, is the building to the right of the tower. The turreted Tait cottage is to the right of the Greenlee. Norfolk businessman James Cowan Tait (1859–1919) built this stone cottage at Twenty-Fifth Street and Atlantic Avenue in 1906. The Tait family used the cottage part-time but rented it out to James Sundy Groves, the president of the Virginia Beach Development Company and his family before another Norfolk businessman, Garrett Smith, turned it into the new Princess Anne Hotel in 1922, just after this picture was taken. The Greenlee later became the Breakers Hotel. *National Archives*

Opposite below: Radio compass stations were divided into two classes: single stations, operating independently and furnishing a single bearing. These stations were located with the view of giving service to ships at a distance of not over 150 miles from the station, and the other class covered harbor entrance groups. All stations in harbor entrance groups were connected to and controlled by the master station; all stations of this group took bearings simultaneously and these bearings were then transmitted to the ship requesting them by the control station. The purpose of these stations was to lead mariners to the light vessels off harbor entrances. The barracks of the naval radio station at Twenty-Fourth Street, photographed on December 6, 1921, is shown here. *National Archives*

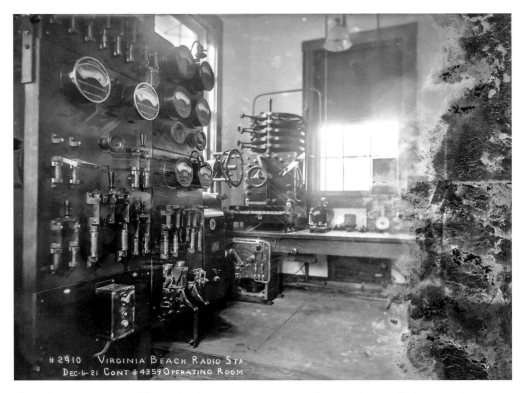

This is the operating room of the naval radio station at Twenty-Fourth Street, photographed on December 6, 1921. *National Archives*

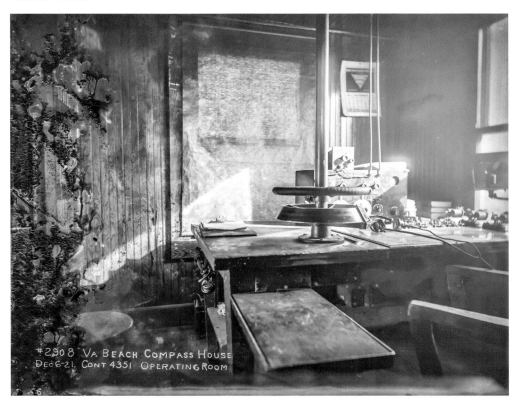

The Cape Henry relay towers of the naval radio compass station are shown in this picture looking northeast on October 9, 1928, taken from the same direction. Where only one radio compass station was available, the mariner would fix his position by two or more bearings from the station with the distance run between, or might use the bearings as a line of position, or as a danger bearing. Or the bearing might be crossed with a line of position obtained from an observation of an astronomical body to establish a fix. In a word, the naval radio compass towers were "important" and Virginia Beach was a harbor entrance station in the Chesapeake Bay entrance group. The other Virginia station was at Hog Island. *National Archives*

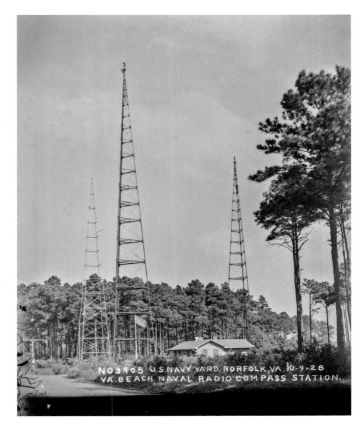

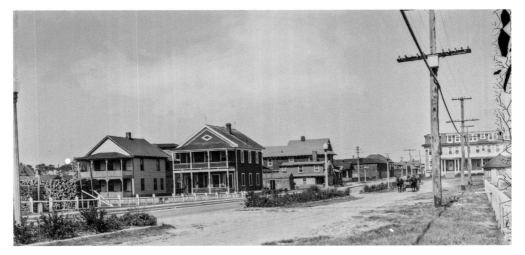

The naval radio compass station tower relocation at Twenty-Fourth Street, shown in this October 9, 1928 picture, was taken from Atlantic Avenue looking over to the site (left). The station was out of frame (right) behind the fence. The second Princess Anne Hotel at Twenty-Fifth Street and Atlantic Avenue is visible beyond the horse-and-buggy (right). Timbers are stacked high (left) for use during foundation work on the towers. Cornelia Holland recalled later that the Women's Municipal League beautified Atlantic Avenue, which can be seen here. This effort had first taken place, three years before this picture was taken. "They made in the center of Atlantic Avenue—all the way down there—long concrete [beds and filled them] with flowers. The street lights [which came with the beds] were in the middle of the street, not to the side,"[38] she said. The beds went down several blocks of the street. *National Archives*

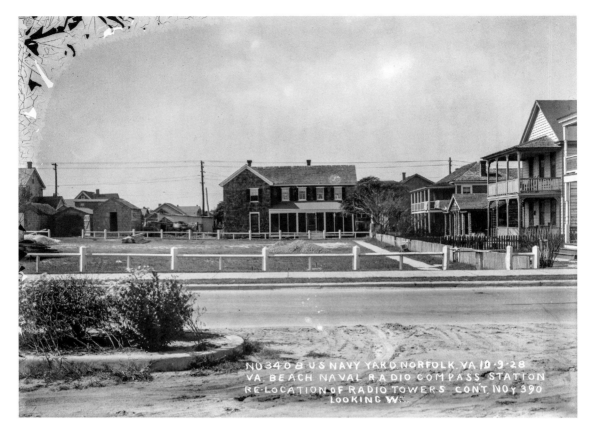

This view of the tower relocation site at Twenty-Fourth Street and Atlantic Avenue looking west was also taken on October 9, 1928. *National Archives*

Opposite page: Naval radio tower construction at Virginia Beach was the subject of these two photographs taken on November 1, 1928. Two towers were erected on the site. This was difficult construction work that required digging through underground springs and quicksand. The land on which the navy built the towers was titled to the United States Coast Guard across Atlantic Avenue at Twenty-Fourth Street just then [visible in the picture below (with the crane)]. Less than seven years later, on March 15, 1937, a new post office was opened beneath the towers. In the photograph below, the perspective is looking across Atlantic Avenue to the coast guard's lifesaving station. *National Archives*

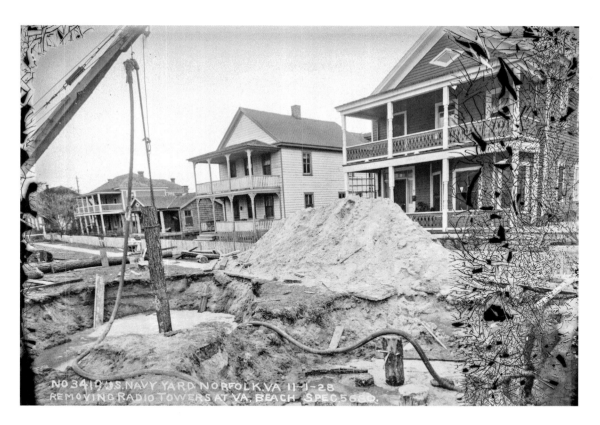

NO. 3419 U.S. NAVY YARD NORFOLK, VA. 11-1-28
REMOVING RADIO TOWERS AT VA. BEACH. SPEC. 5689.

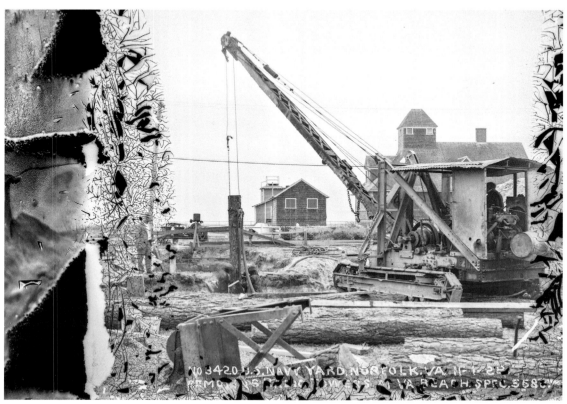

NO. 3420 U.S. NAVY YARD NORFOLK, VA. 11-1-28
REMOVING RADIO TOWERS AT VA. BEACH. SPEC. 5683

In a January 2, 1926 navy department bureau of engineering memorandum to the chief of naval operations, the radio compass station at Virginia Beach was assigned as a strategic asset for enemy direction finding and tracking. The bureau was of the opinion that if only two or three strategic compass stations were located on each coast, the transmitting facilities necessary to communicate between the ends of the long base lines thus established would be too large for the amount of service usually required of such transmitters, and considered that a larger number of stations more closely distributed along the coast afforded easier means of inter-communication, a much greater chance of detecting and locating an enemy, and a larger factor of safety for standby purposes in the event of casualties. The United States naval radio compass station operations building at Virginia Beach is shown here as it looked on December 5, 1928. *National Archives*

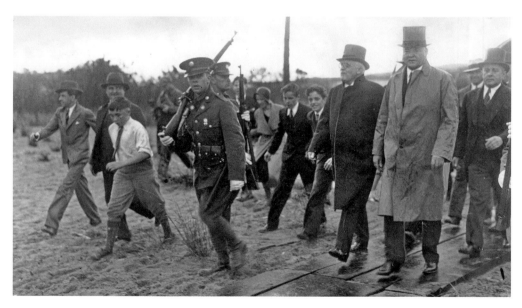

President Herbert Clark Hoover (right, in tan topcoat foreground) (1874–1964) joined Virginia governor Dr. John Garland Pollard (left, also in a top hat) (1871–1937) at the Cape Henry Day celebration on April 28, 1931. *Amy Waters Yarsinske*

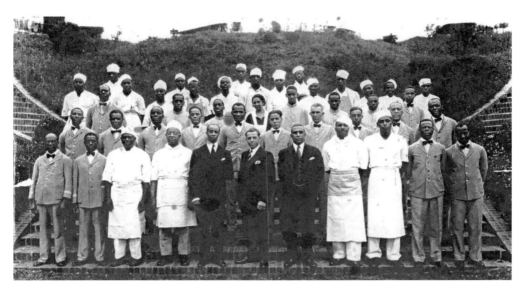

Cavalier Hotel workers posed for this photograph taken between 1930 and 1937. *Edgar T. Brown Collection, Virginia Beach Public Library*

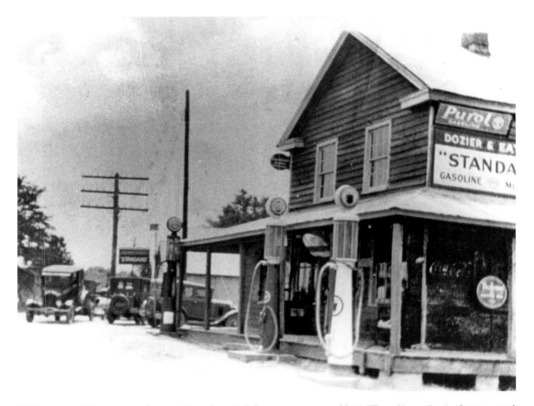

The Dozier and Eaton general store, shown here in July 1931, was owned by William Henry Dozier (1893–1960) and Edward Lee Eaton (1893–1959), the latest in a string of successful owners of the Pungo building that had been there since 1874. In 1919, the store was bought by county commissioner of revenue and farmer Frederick Augustus McAlpine Burroughs (1885–1978), and years later, after Dozier and Eaton was gone, it became Brock Brothers General Merchandise. The building was razed in April 1987 to make way for the Red Barn convenience store. *Edgar T. Brown Collection, Virginia Beach Public Library*

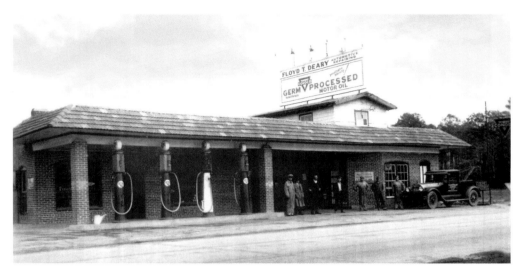

Floyd Theodore Deary (1892–1969) first opened a gristmill and garage in London Bridge in 1919, the latter trade he learned working with and boarding at the home of Joseph B. Murden. Just two years later he relocated to Virginia Beach Boulevard (shown here, 1931) and opened the Floyd T. Deary automotive repair shop and gas station that also had Princess Anne County's first welding shop. The business shown here was sold in 1946 and he subsequently opened a heavy equipment repair shop back in the London Bridge section. *Edgar T. Brown Collection, Virginia Beach Public Library*

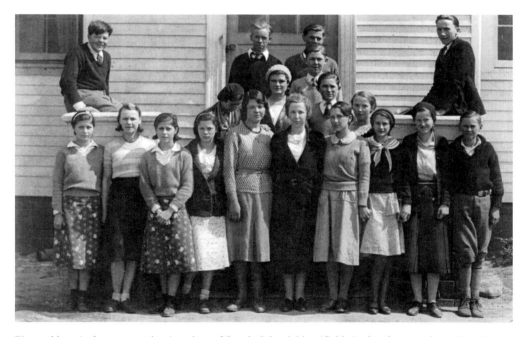

Pictured here is the 1931 graduating class of Creeds School. Identifiable in the photograph are Meta Louise Luxford (1905–1970) (front row, center), the teacher, and Harold James (first row, far right) and Marvin Lovett (top, right). Luxford was born and raised in Pungo, the daughter of Dr. Thomas Booker and Meta Moore Luxford. After graduating from Maury High School, she received a bachelor of science degree from Madison College (now James Madison University) and a master's degree from the University of Virginia. She served as an elementary and secondary teacher, elementary principal, supervisor of elementary schools, and director of instructional personnel for the Virginia Beach City school system. The Louise Luxford Elementary School is named in her honor. *Edgar T. Brown Collection, Virginia Beach Public Library*

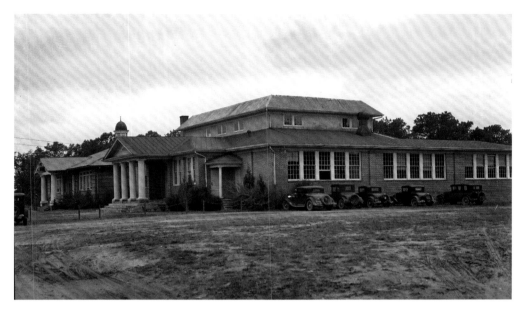

The old Kempsville elementary and high school on Jericho Road is shown in this October 9, 1931 photograph. *Sargeant Memorial Collection, Norfolk Public Library*

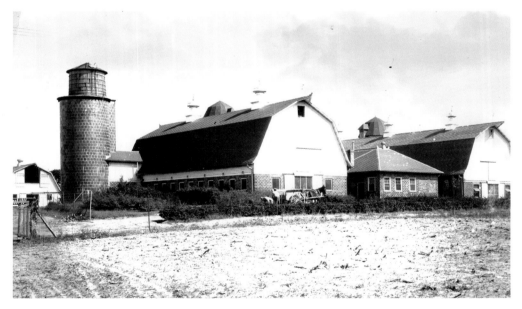

The primary 305-acre Bayville Farm, also known in its lengthy history as Church Point Plantation and Bayside Plantation and once one of the last working farms in Virginia Beach, fronts on Shore Drive and First Court Road. The property extends close to 9,000 feet on Pleasure House Creek, a major tributary of the Lynnhaven River. The barns and outbuildings at Bayville Farm, a dairy operation, are shown in this October 10, 1931 photograph. Charles Franklin Burroughs (1871–1960), a successful Norfolk businessman and later the chairman of the board of Royster Guano Company, bought Bayville Farm in 1919 for farming and oyster harvesting purposes but quickly branched into dairy. Fourteen years later, in 1933, Burroughs acquired the property at Church Point Farm and the combined 500 acres became Bayville Farms (in the plural). Many of Burroughs' farm hands and dairy drivers lived in the adjacent neighborhood now called Beechwood. During the Second World War, German prisoners of war from Camp Ashby in the nearby Thalia section worked at the dairy. *Sargeant Memorial Collection, Norfolk Public Library*

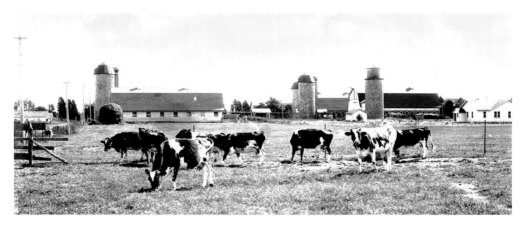

The barns and outbuildings of Bayville Farm, Guernsey cows in the foreground, were photographed on October 10, 1931. After the dairy farm became unprofitable, the Lester family decided to move forward with converting the farm into an eighteen-hole golf course, which was permitted in the 1982 historic easement on the property, amended in 1993 to clarify the use of the land for this purpose and to place a soft limit on the amount of permitted golf course buildings and structures. The Bayville Golf Club opened in 1995. *Sargeant Memorial Collection, Norfolk Public Library*

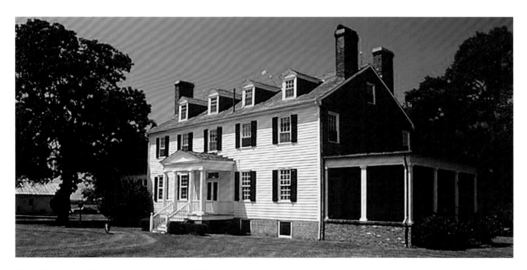

Peter Singleton II contracted with Jacob Hunter in 1826 for the erection of a house at Church Point Plantation, as he called it, on lands inherited from his father, Isaac Singleton, and grandfather, John Thoroughgood. The manor house at what later became known as Bayville Farm was completed the following year. Singleton may never have lived in the house. Deeply in debt, perhaps due to his gambling, he sold the plantation in 1828 to James Garrison of Norfolk for five thousand dollars. The Garrisons called the farm Bayside Plantation. In 1844, they, too, mortgaged the farm to finance further construction. The house was a two-story, five-bay, double-pile frame structure with brick ends and a basement laid in three-course American bond. The structure also had a pedimented tetra-style Roman Doric order porch at each entrance and four interior end chimneys. The house remained in the ownership of Charles Franklin Burroughs from 1919 to 1960, and at the time of his death passed to his son, Charles Franklin Burroughs Jr., and then to Harry Thomas and Calvert Tyler Lester.[39] In August 2007, the manor house was accidently destroyed by fire. At the December 2007 Virginia Board of Historic Resources (VBHR) board meeting, the VBHR voted to amend the historic easement to remove VBHR as a coholder because of the loss of the manor house. While the Bayville Farm property had been added to the National Register of Historic Places in 1980, it was delisted in 2008. This picture of the house was taken after the property was named to the National Register of Historic Places. *Calvert Walke Tazewell Historic Landmarks Collection, Virginia Beach Public Library*

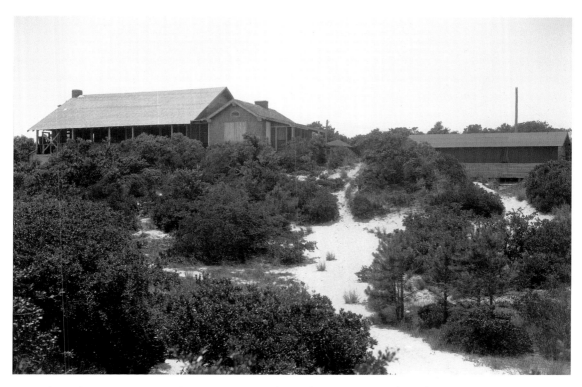

This is the Young Women's Christian Association (YWCA)'s Camp Owaissa (above), a summer camp for girls and young women, overlooking the Chesapeake Bay near Chesapeake (also called Chic's) Beach. In the second picture, girls attending the camp are shown in the water in front of the camp facilities (below). Both pictures were taken by Charles S. Borjes on July 28, 1932. *Sargeant Memorial Collection, Norfolk Public Library*

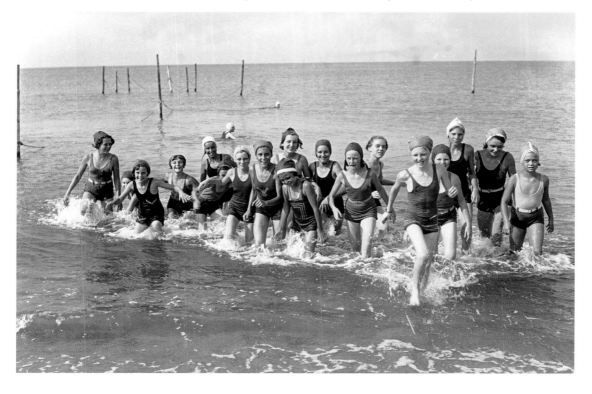

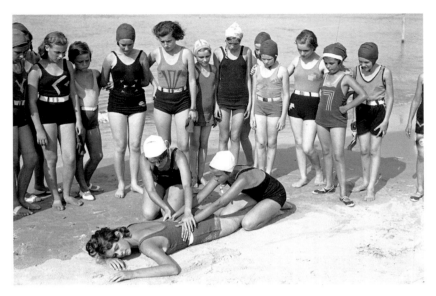

A group of young girls attending the Young Women's Christian Association (YWCA) Camp Owaissa at Chesapeake (popularly called Chic's) Beach watched Caroline Willis (the "victim"), Florence Siebert (kneeling left), a counselor, and Suzanne Taylor (kneeling right) demonstrate resuscitation of someone who has experienced drowning. Girls age seven to eleven participated in the two-week program shown here. The camp offered a regular schedule of swimming, dancing, games, and sports. Among the activities were opportunities for rowing, crabbing, music, handicraft and hiking. The girls also put on a play called *Snowdrop*, the title role played by Constance Dean with Betty Funk as the queen, Katherine Fitzgerald, the prince, and Jane Skelton, the mirror. Charles S. Borjes took this picture on July 28, 1932. *Sargeant Memorial Collection, Norfolk Public Library*

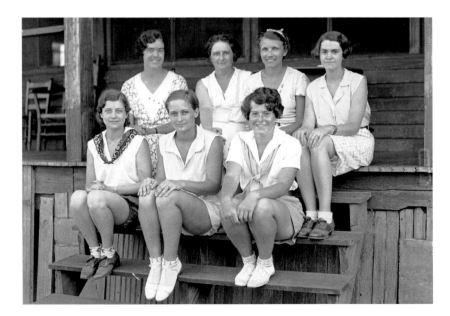

Charles Borjes took this picture of Camp Owaissa staff counselors on July 28, 1932. Those pictured on the first row (left to right) include Helen LeGrande, Modena Lewis, and Florence Siebert. Seated on the second row (left to right) were Ruth Langley, Aleck Creech, and Nancy Robertson. There is one unidentified. *Sargeant Memorial Collection, Norfolk Public Library*

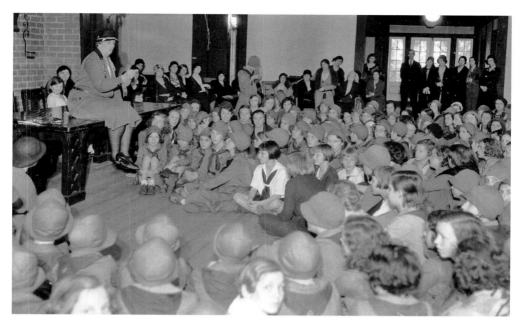

National Girl Scouts of America president Sarah Birdsall Otis Edey (1872–1940) (seated on the table) addressed a group of Girl Scouts at the Norfolk Country Club on Hampton Boulevard near the Lafayette River [in Norfolk, Virginia], on January 15, 1932 (above). She was in the city to plan the eighteenth National Convention of Girl Scouts that was to occur that October at the Cavalier Hotel. The October 7, 1932 photograph (below) was taken during the convention. Edey, a prominent New York City resident and published poet, was a leader in the women's suffrage movement, most notably recognized for her work with the Girl Scouts of America. She was active in the Girl Scouts from 1919, holding many different positions, including first editor of the *Girl Scout Leader* magazine. She was national president from 1930 to 1935. *Sargeant Memorial Collection, Norfolk Public Library*

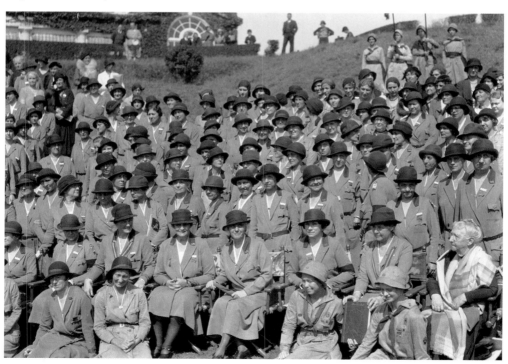

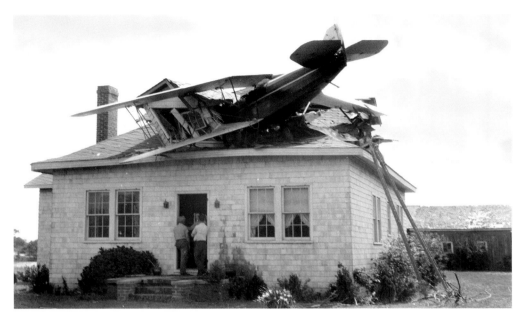

Above: Chester Orton Smith, pilot and railroad mail clerk, along with his passenger, William Leroy Holland, crashed Smith's Travelair biplane into the roof of Paraskevi Paulias Christopolous' cottage in Chesapeake (also called Chic's) Beach on May 5, 1933. Smith suffered a cut on his left cheek but no one else was injured. Though Paraskevi Christopolous was outside when the crash occurred, her daughter and a friend were on the first floor of the house. Harden David "H. D." Vollmer took the picture. *Sargeant Memorial Collection, Norfolk Public Library*

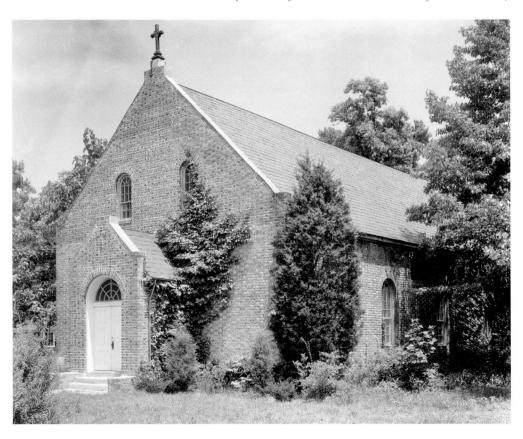

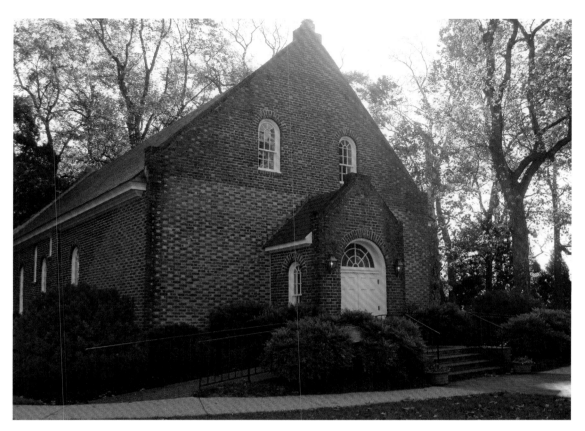

After the commonwealth of Virginia passed a law that churches and chapels formerly owned by the Church of England and not used within a calendar year reverted to the ownership of the commonwealth, congregants from Emmanuel Episcopal Church made annual pilgrimages to the church to hold services. A fire had all but destroyed the church in 1882 and it was just then that Reverend Thurmer Hoggard IV took over the responsibility of holding services. In 1911 an organization was founded to raise funds to rebuild Old Donation Church. Through the enthusiastic and tireless efforts of the Reverend Richard Alfriend and Judge Benjamin Dey White, construction began in 1912. Restoration of the church was completed in 1916, and Old Donation was, once again, open for services. The church's bell tower was erected in 1923. Old Donation underwent major repairs in the 1960s to ensure the building's structural integrity. It was during this time that the slate floors were installed. These renovations were completed in 1966. The church is shown in this October 16, 2010. *Rlevse*[40]

Opposite below: Old Donation Church, in the Lynnhaven Parish, was photographed by Frances Benjamin Johnston (1864–1952) between 1933 and 1939 as part of the Carnegie Survey of the Architecture of the South, which commissioned Johnston to document often vanishing historic resources across the southern United States. The church shown here, which originally dated to 1736, fell into ruin and was restored before she took the picture. The only case of ducking a witch recorded in Virginia occurred at Ducking Point in this parish in 1698. The site of the first parish church (not this one) is not known. The second church fell into the river after a canal had been cut allowing strong current from the Chesapeake Bay to flow into the formerly calm waters that surrounded the building and burial yard. *Library of Congress*

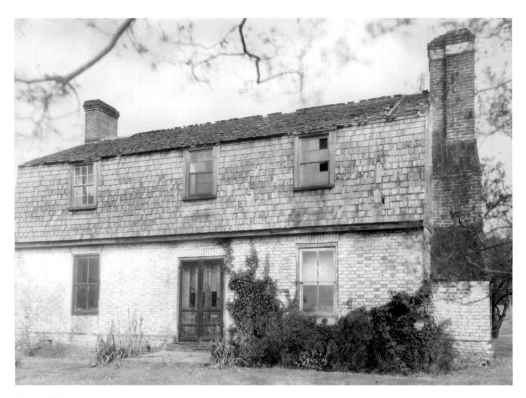

The Weblin House belongs to a small but architecturally significant collection of pre-Georgian vernacular farmhouses of old Princess Anne County, now the city of Virginia Beach. This group includes the Thoroughgood House, the Wishart House, the Keeling House, and several others that have been destroyed but are preserved in photographs and other documentation. The earliest of these houses are characterized by their hall-and-parlor plans and end chimneys, both interior and exterior. This distinctive arrangement evolved from the late-medieval farmhouses of the western and upland regions of England, and was employed by the many Virginia settlers who came from those areas. The adaptations of this usual one-story form led it to be called the "Virginia style." The Weblin House was for a long time the only one of its type in the vicinity to preserve its rural setting. When it was added to the Virginia Landmarks Register and the National Register of Historic Places in the spring and fall, respectively, of 1974, it was cited for the home's contrast between surrounding pastoral farmland and the heavy urbanization that had begun to subsume most of the modern city of Virginia Beach, thus increasing just then the value of the Weblin farm as an historic landscape. The house has since been surrounded and overtaken by the Cypress Point development. Frances Benjamin Johnston took this photograph of the Weblin House between 1933 and 1939 as part of the Carnegie Survey of the Architecture of the South. *Library of Congress*

Opposite below: Between 1774 and 1924, the Weblin House and surrounding farm passed through over a dozen owners before being acquired from James W. Overstreet by railroad engineer-turned-dairy farmer Herbert Cass Moore. By the time Moore bought the house (shown here, September 30, 2012), the farm around it had been whittled down to just 33 acres; Moore added another 180 acres to provide ample room for his dairy operation. Mary Moore Williams, who was born in the house in 1925, recalled in an April 19, 2010 *Virginian-Pilot* article: "There was an old cemetery behind the house, and I remember looking at the gravestones," she said. One stone remains clear. "It read, 'As you are now, I once was. As I am now, so you shall be,'" she said. "That made quite an impression on me."[41] When Williams' father died in 1982, the farm was divided. Herbert Cass Moore Jr. was given the house. After his death four years later, his widow, Dorothy Makinson Moore, gave it to the Virginia Historic Preservation Foundation. "Dorothy is buried there beneath the magnolia tree," Williams told the *Pilot*. "We always thought we had the right of first refusal [if the foundation chose to sell it], so we were very surprised when we read in the papers that it had been sold." The house was quietly conveyed to developer Gian Petersen in November 1997. *Sue Corcoran*[42]

The exact construction date of the Weblin House (detail perspective, Frances Benjamin Johnston) at Moore's Pond and Weblin Farm Roads is uncertain but research indicates that it was built by Thomas Lambert in the 1670s on a 750-acre land grant he received in 1648. Lambert's tract, in turn, was part of the 1643 patent to Cesar Puggett, from whom Puggett's Neck takes its name. The house (as it is today) takes its name from Lambert's son-in-law, John Weblin. The elder Weblin left the house and surrounding 175-acre farm to his son, John Weblin Jr., in 1686. The farm was sold by the Weblin family to John and Nathaniel Hutchings in 1719, remaining in the Hutchings family until 1751, when it was acquired by Robert Moseley. The Moseley ownership (1751–1774) was the period during which the gambrel roof most likely replaced the original gable roof (indicated in the Johnston photograph shown here). *Library of Congress*

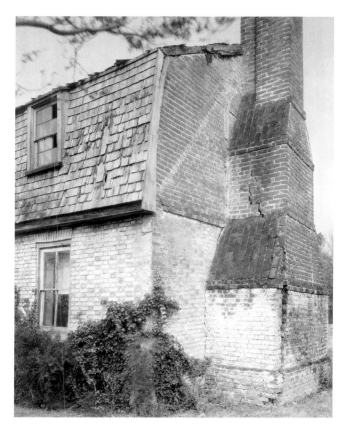

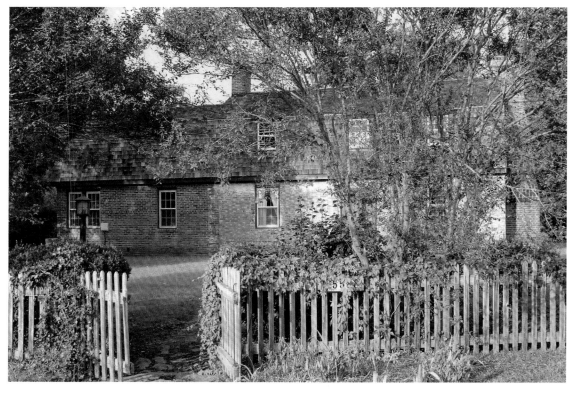

William Earl "Wild Bill" Mehlhorn (1898–1989) teed off at the second annual Cavalier Open Tournament at the Cavalier Country Club golf links on April 2, 1934. Mehlhorn played on the Professional Golfers' Association (PGA) tour in the organization's salad days and was considered at his best in the decade preceding the Cavalier tournament. Mehlhorn often wore cowboy hats on the course, thus his nickname "Wild Bill." He won twenty times on the PGA tour but never won a major championship. Statistically, only a handful of golfers won more often on the tour without claiming a major and Mehlhorn's best finish was runner-up to Walter Hagen at the PGA championship in 1925. The professional golfers who played in the Cavalier's second annual tournament drew one thousand spectators. *Sargeant Memorial Collection, Norfolk Public Library*

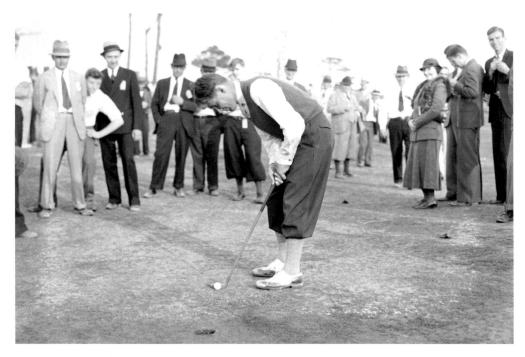

Paul Scott Runyan (1908–2002) was one of the world's best players when he participated in the second annual Cavalier Open Tournament; he won two PGA championships and is a member of the World Golf Hall of Fame. Runyan was about to putt during the second annual Cavalier Open Tournament on April 2, 1934, when this picture was taken. *Sargeant Memorial Collection, Norfolk Public Library*

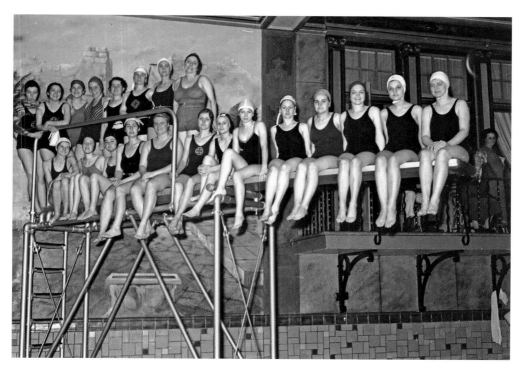

Members of the girls' division of the Norfolk Swimming Club were photographed by H. D. Vollmer sitting on the diving board at the Cavalier Hotel on April 16, 1934. *Sargeant Memorial Collection, Norfolk Public Library*

The fifth annual Cavalier Horse Show, held at the Cavalier Hotel on April 21, 1934, was attended by (left to right) Mary Hunter Davis and Marion Carter Furr, wife of Carlton Harris Furr. *Norfolk-Ledger Dispatch* photographer Harden David "H. D." Vollmer took the picture. *Sargeant Memorial Collection, Norfolk Public Library*

Margaret Patricia Duane (1908–1981), of Louisville, Kentucky, the daughter of a distiller (her father) and horse breeder (her mother), participated in the fifth annual Cavalier Horse Show on April 21, 1934, and is shown in this H. D. Vollmer photograph from the event. *Sargeant Memorial Collection, Norfolk Public Library*

Also in attendance at the fifth annual Cavalier Horse Show was Frances Ferguson (1910–1977) (shown here), the only daughter of highly regarded Norfolk, Virginia architect Finlay Forbes Ferguson and the former Helen Atkinson Evans. She married James Allen Carney on July 17, 1937, and was well known for her leadership role in the Irene Leache Memorial, which would become the origin of the Norfolk Museum of Arts and Sciences, now the Chrysler Museum of Art. The picture was taken by H. D. Vollmer. *Sargeant Memorial Collection, Norfolk Public Library*

This May 1, 1934 photograph shows participants in the Kempsville High School May Festival. The Queen of the May is seated center. *Shirley Wolfe Jones Collection, Virginia Beach Public Library*

Participants in the April 26, 1935 Cape Henry Day shown here (left to right) included: Blanche Adams Chapman; United States Army captain Henry Meyers, of Fort Story; Rebecca Priscilla Cabell, wife of James Branch Cabell; Massachusetts lieutenant governor Joseph Leo Hurley; Lillian Webb Mayo Naylor; Virginia governor George Campbell Peery; Nelle Beedy Calfee; United States Army colonel Russell Potter Reeder, of Fort Monroe; Norfolk mayor Walton Robert Lawson Taylor; United States Army brigadier general Joseph Powell Tracy, commandant of the Chesapeake Bay coastal defense district, and Eunice Ensor Holland. The event was organized just then by the Daughters of the American Colonists to commemorate the first landing of English settlers in April 1607 (the future founders of Jamestown). *Sargeant Memorial Collection, Norfolk Public Library*

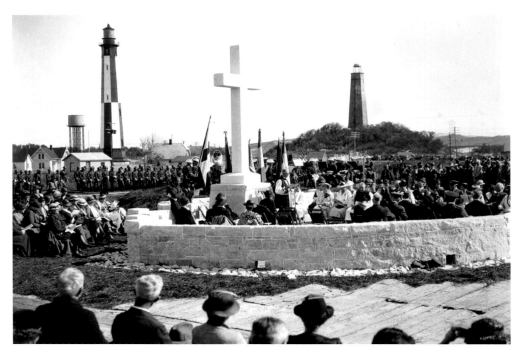

The day's events of April 26, 1935, were punctuated by an unveiling ceremony (pictured here) for the new granite First Landing Cross at Fort Story, erected by the National Society of the Daughters of American Colonists. *Sargeant Memorial Collection, Norfolk Public Library*

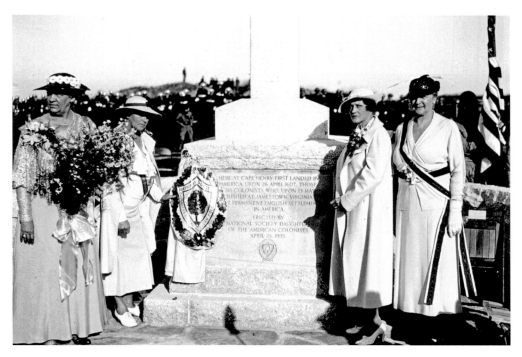

The April 26, 1935 Cape Henry Day importantly included the presentation of a new granite First Landing cross to commemorate the events of 1607. Those participating in the unveiling of the inscribed plaque, located at the bottom of the cross, included (left to right) Nelle Beedy Calfee, Rebecca Priscilla Cabell, Blanche Adams Chapman, and Lillian Webb Mayo Naylor. *Sargeant Memorial Collection, Norfolk Public Library*

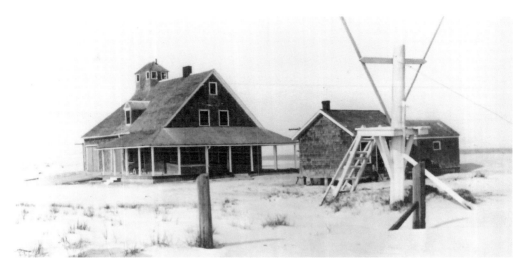

The False Cape area got its name because the land mass at this point on the coast resembled Cape Henry but instead lured boats into shallow waters. False Cape Lifesaving Station was photographed on April 29, 1935. The view is looking northeast. *Virginia State Parks*[43]

On July 2, 1931, the Virginia Seashore State Park Association was charted in Norfolk under the leadership of Benjamin Burroughs, who lobbied for the Cape Henry site for a state park. At the National Conference of State Parks held in Virginia Beach on May 4–6, 1932, the proposed park site at Cape Henry was hailed *not* for its association with the landing of the first English settlers, but for its geological evolution. Cape Henry was described as being a large sand spit formed by sand being moved by waves and shore currents northward. As the sand pushed northward, it formed a back swamp, which trapped shoal water between the mainland and the oceanfront. Areas within the so-called Cape Henry Desert were also manipulated by wind and storms. On August 8, 1933, the Cape Henry Syndicate donated one thousand acres of land to the Virginia State Commission on Conservation and Development for the creation of Seashore State Park. At the same time, the syndicate offered the remaining portion of the lands to the commission for $260,000 but a valuation of the property reduced that figure to $158,000. An additional 2,383 acres of land were added on October 2, 1934. The bathhouse at the Cape Henry bathing beach at the not-yet-opened Seashore State Park (now First Landing State Park) is shown here as it looked on May 10, 1935. There was a boardwalk that ran along the frontage of the bathhouse. *Sargeant Memorial Collection, Norfolk Public Library*

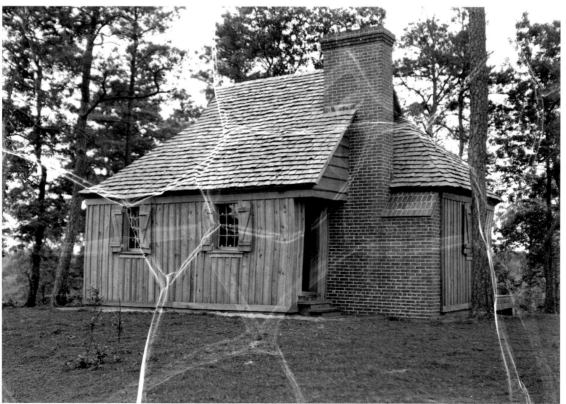

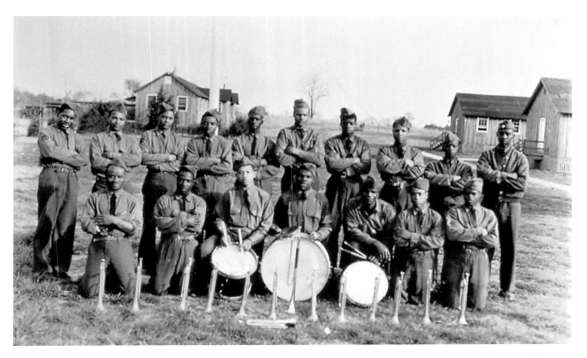

New Deal-era Civilian Conservation Corps regiments—often called President Franklin Delano Roosevelt's "tree army"—began arriving at Seashore State Park in October 1933, their first task to build their own barracks and establish a camp. From that time through February 1934, two additional CCC regiments arrived for a total of some 600 young men, typically ages seventeen to twenty-five, living in three camps of 200-men each, working to improve the park. One of those camps was subsequently set aside for the African American men who had joined the corps and began matriculating to their new duty station at the park. While initially focused on the first 1,000-acre tract, after the additional land was acquired in 1934, they worked that area, too. With the additional acreage, the corps was required to cut more trails through the so-called "Desert." By 1937, ten miles of trails had been cut of the final 19.35 miles of trails that exist today. In return for their labor, the CCC program provided food, clothing, medical care, and educational opportunities for men caught in the financial distress of the Great Depression. The CCC disbanded in 1942 in response to recruitment efforts for World War II. This is an African American CCC camp band from that time period. *Virginia State Parks*[44]

Opposite above: While the park was not officially dedicated until June 15, 1936, beach facilities were debuted on the date this and other pictures shown here were taken (more than a year in advance). A long line of automobiles trailed down Route 60—today's Shore Drive—to enter the Cape Henry Beach (the ocean side of the state park) that May 10, 1935, documented in many photographs taken by the Norfolk newspapers, to see the new state park for the first time. *Sargeant Memorial Collection, Norfolk Public Library*

Opposite below: Tucked in the Seapines, the grove of pine trees that ran behind the Cape Henry dune line, was this cabin, photographed on May 10, 1935, and accessible to the bathing facilities at the new Seashore State Park (now First Landing State Park). The cabin—number two—is one of only five cabins that survive today and which were built by the Civilian Conservation Corps (CCC). *Sargeant Memorial Collection, Norfolk Public Library*

The men of the Civilian Conservation Corps cleared undesirable growth, cut in roads and trails, and built bridges over the marshlands on the trails. Additionally, they erected the big "H" complex and the six original cabins. There are five surviving CCC period overnight cabins—numbers 1, 2, 3, 4, and 6—still standing in First Landing State Park, and one built in 1990—number 5—to replace a CCC cabin that burned down. The cabins are board-and-batten sided with complex roofs. Cabin number four was photographed at First Landing State Park (formerly Seashore State Park) on August 17, 2012. *Virginia State Parks*[45]

Norman Lewis Claiborne, originally from Powellton, Brunswick County, Virginia, and a former Seashore State Park Civilian Conservation Corps member, attended the grand opening of the new trail center at First Landing State Park on January 3, 2013. *Virginia State Parks*[46]

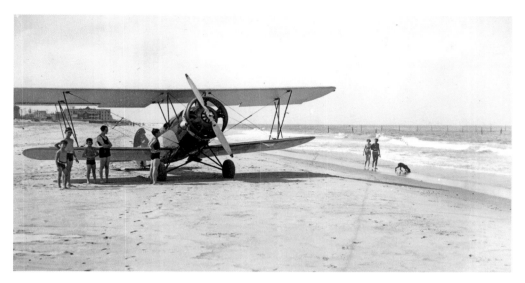

A daredevil pilot landed his airplane on the Oceanfront beach just beyond the boardwalk on June 23, 1935. At that time, it was not unusual for a stunt flyer to land on a beach and offer rides for a small fee to curious onlookers. This aircraft had a fancy red and white paint scheme. Charles S. Borjes took the photograph. *Sargeant Memorial Collection, Norfolk Public Library*

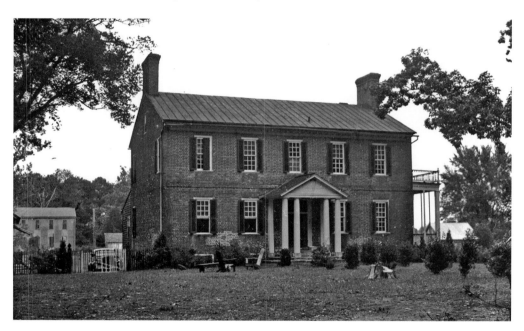

Pleasant Hall, located on Princess Anne Road in the Kempsville section of the former Princess Anne County, is Georgian architecture of the second period and though inscribed with the date 1779, confirmed by a dated brick below the water table on the front wall of the residence, further research subsequently indicated that British loyalist George Logan built the house between 1769 and 1770; Logan also built a new mercantile just east of the house at that time. Further, Singleton acquired the land from James Tenant, who owned it after Logan, who returned to Scotland after announcing his support for the king and mother country. Later, it was Singleton who gave the plot immediately behind the house for the Princess Anne County courthouse, which was erected in the 1780s, and stood until its ruins were demolished in 1972. Pleasant Hall is a Virginia Historic Landmark and was added to the National Register of Historic Places in 1973. The picture was taken on September 9, 1935. *Sargeant Memorial Collection, Norfolk Public Library*

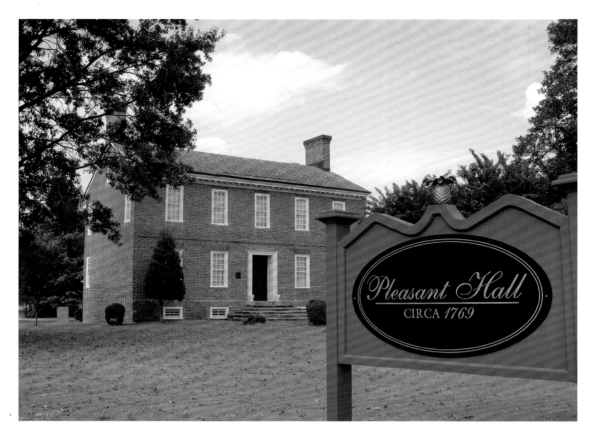

Peter Singleton I's Kempsville home, Pleasant Hall (shown here, September 30, 2012), was restored to the original configuration of the residence. In November 1929, the Daughters of the American Revolution (DAR) erected a historic marker in front of the house to document the November 15, 1775 skirmish at Kempsville that claimed the life of minuteman John Ackiss and handed the British a victory. John Murray, Lord Dunmore, briefly used George Logan's home as his headquarters, thus another layer of proof that the home was constructed prior to the brick placed by Peter Singleton to mark his ownership of the property. The Singletons sold the property in 1804, and it passed through numerous owners during the nineteenth century. But in 1905, it was acquired by Dr. Robert Edward Whitehead (1872–1945), a family physician, whose heirs continued to own it decades after his death. *Sue Corcoran*[47]

III

THE WAR YEARS— AND BIG CHANGES

The rise of dictators in Germany and Italy to the hegemonic ambitions of Imperial Japan reflected a world in such upheaval by the end of the Great Depression that the American military had begun a protracted planning effort to site potential installations in and around the Hampton Roads region, already home to key navy, army and state military reservations. Taking a look back at the beginnings of the navy's interest in what would soon become an auxiliary airfield at Oceana, we know that in the 1880s, a whistle stop named Tunis was the only oasis of civilization on the Norfolk and Southern Railroad [later Norfolk Southern Railroad] spur between the city of Norfolk and the popular amusements and resort atmosphere of the Virginia Beach Oceanfront. Everything in-between was sprawling farmland that divided Princess Anne County like a patchwork quilt. Farmhouses, dependencies, country stores and a couple of schoolhouses and other public buildings dotted the landscape. Near Tunis—the next to last rail stop to the oceanfront—a small community had sprung, growth that prompted residents to give it a name more fitting to the train's ultimate destination along Virginia's golden shore. The hamlet of Tunis was rebranded Oceana in 1891, and it was here that the navy would come decades later to carve out an airfield.

Pause the Oceana story here. History informs that the navy's first look at Virginia Beach for a major seaplane patrol base happened less than two decades after Tunis was renamed Oceana. Earlier in the twentieth century, just as the navy was trying to establish a major naval station on the East Coast—what became Naval Operating Base Norfolk—in 1917, it was recognized that the sea service also needed to develop a series of seaplane patrol bases extending from the northeast coast of the United States down to Florida. The navy's new Norfolk footprint and the bid to add aviation components were the outcome of the Navy Appropriations Act dated August 21, 1916, which called for the appointment of a Commission on Navy Yards and Naval Stations, also called the Helm Board for chairman rear admiral James Meredith Helm (1855–1927). Captain Mark Lambert Bristol (1868–1939), director of naval aeronautics, gave his highest recommendation to creation of coastal air bases in his annual report, also dated 1916. While the board did not comment on naval aviation in its first round of reporting, it was in agreement with Bristol that a substantial air station should be built on the lower Chesapeake Bay.

Commission files indicate Bristol initially proposed Cape Henry and Lynnhaven Inlet as possible locations for seaplane patrol bases, considered critical to the protection of America's shores from enemy submarines and the protection of shipping lanes from the same. The Joint Army and Navy Board on Aeronautic Cognizance was appointed to focus on aviation and educate the Helm Board to the value of tactical air bases. Before the cognizance board could act, the chief of naval operations circumvented the proceedings and asked navy secretary Josephus Daniels (1862–1948) for patrol stations up and down the East and Gulf Coasts and Canal Zone. Hampton

Roads made the cut and Daniels added a proviso creating the Naval Reserve Flying Corps (NRFC), a group of student naval aviators primarily from Harvard University who had begun their training at aviation pioneer Glenn Hammond Curtiss' aeronautical station at Newport News, Virginia, on May 19, 1917, and who would comprise the nucleus of seven students designated as Naval Air Detachment Hampton Roads. With Daniels' instruction came the end of navy pilot training at Curtiss' facility on August 28 of that year, and the construction of a newer, better aviation camp collocated with the navy's new operating base at the former Pine Beach, specifically on acreage that had played host to the 1907 Jamestown Tercentennial Exposition.

Back to Oceana. More than two decades after Bristol considered Cape Henry and Lynnhaven Inlet as possible sites for seaplane patrol bases, in 1938, with the threat of war on America's doorstep once again and the United States Navy limited to one air station and two grass auxiliary fields for aviation practice in the Norfolk, Virginia operating area, Rear Admiral Patrick Neison Lynch Bellinger (1885–1962), then commander in chief of Naval Air Force Atlantic, received orders to locate four additional airfields in proximity of Naval Air Station Norfolk. Bellinger's effort to secure auxiliary airfields had been a work in progress for nearly three years when the worst that could have happened did. On December 8, 1941, the United States Congress declared war on the Empire of Japan in response to that country's surprise attack on the American naval base at Pearl Harbor, Territory of Hawaii, the prior day. The declaration was drafted an hour after President Franklin Delano Roosevelt delivered his remarkable "Day of Infamy" speech. Following the United States' declaration, on December 11, Japan's allies, Germany and Italy, declared war on the United States, and the United States reciprocated, bringing the United States fully into the Second World War.

With a new sense of urgency, naval personnel descended quickly on the mud flats of auxiliary landing field Oceana, hastily building a series of nineteen Quonset huts to accommodate 32 officers and 172 enlisted men. At the peak of the war, the remote and largely inaccessible auxiliary landing field was commissioned Naval Auxiliary Air Station Oceana on August 17, 1943. This was just the beginning. As retired captain Dexter Cleveland Rumsey II later put it, Bellinger's marching orders came down "because they had so damn many pilots to train so fast." Two decades after the war, Rumsey commanded Naval Air Station Oceana.

The land chosen for the new navy airfield was juxtaposed between the village of Oceana and the Princess Anne County courthouse, an area enveloped by five thousand acres of farmland from which the navy began the arduous work of carving out an air station. The navy's choice of this vast tract was purposeful. With low population density and plenty of elbowroom, the tract made the perfect location for a military airfield. From auxiliary airfield to master jet base, Oceana would become a significant example of an air station that had a city grow around it, not the other way around.

The backstory of the navy's search was not without bumps in the road. When Bellinger went looking for outlying practice fields to support Naval Air Station Norfolk ahead of the Second World War, it was quickly determined that land with sound grass airstrip potential could not be located. Bellinger and his staff then took out area maps and pinpointed more practical opportunities to prepare proper runway surfaces on existing and potential airfields under consideration. The navy needed more than one outlying field. Though the Bureau of Aeronautics hesitated to go along with the idea it quickly came to the conclusion that Bellinger's suggestion of added cost and better end product was worth the effort.

An auxiliary landing field, first couched as an outlying practice field, was planned for Princess Anne County—now present-day Virginia Beach—as early as 1938. The navy's pick of farmland around the whistle stop enclave at Oceana met all the requirements Bellinger had worked so hard to find. The community had only one small sawmill operation and thousands of acres of farmed and forested land. The commercial development consisted of two or three small neighborhood

food stores, a restaurant and three service stations, with a local post office located inside one of the grocery stores. The town had little economic importance other than its few stopping-off points for local residents. The five thousand sprawling acres between the Oceana community and Princess Anne County courthouse looked like the best place for a military airfield.

Before land acquisition started, the Department of the Navy in Washington, D.C., working closely with local navy leadership, directed the Home Owners' Loan Corporation to appraise the land the navy wanted to buy for the outlying airfield at Oceana, and other like airfields and a dive-bombing practice area in Princess Anne County. The land mapped out for the Oceana airfield was connected with State Route 635, better known as Potters Road, running east and west approximately parallel with the north line of the property appraised, by a road or right of way one hundred feet wide from east to west and extending from the northeast corner of the property being appraised north 11° 13′ west 1817.96′ on the easterly line. The entire area was cleared farmland, subject to cultivation. Located one-half mile southwest of the Oceana community, which was situated on U.S. Route 58—Virginia Beach Boulevard—12 miles east of the east corporate limits of the city of Norfolk, and two and one-half miles from the Atlantic Ocean, the land mass chosen by the navy was, indeed, remote just then and level.

The navy had settled on land that belonged to John W. and Dean S. Potter and their heirs. Potter farmland formed the nucleus of an air station-in-the-making. The purchase price for the original 328.95-acre tract was $35,000, $32,895 of which was deposited with the December 18, 1940 filing of the declaration of a taking under the law of eminent domain, followed by the balance with interest paid the following year on or about December 2, 1941, as stated in a letter from the judge advocate general of the navy. While legal jockeying continued behind the scenes, the navy began construction of asphaltic concrete runways and aprons on December 31, 1940, completing them in November 1941, just days before the Empire of Japan's surprise attack on Pearl Harbor. These runways were only twenty-five hundred feet long, which seemed sufficient enough for the navy's squadrons of propeller-driven bombers, fighters and torpedo planes.

When the United States entered the Second World War, Hampton Roads—and certainly the nascent airfield at Oceana—was abruptly thrust to the forefront of planning, training and outfitting aircraft carriers for combat in both the European and Pacific theaters of operation. Carrier aircraft groups trained at Naval Air Station Norfolk—permanently and temporarily assigned—but it quickly became cramped quarters. Outlying auxiliary air stations and landing fields went to top priority and while they were not intended—at least not on paper—to leave men and aircraft in remote locales with temporary living and working facilities, that is what happened. Immediately after the United States entered the war, navy personnel threw up Quonset huts to house and service officers and enlisted men, and provide maintenance facilities for aircraft. The first "permanent" building to rise over the Oceana mud flats was a wood frame structure used as an ambulance garage and caretaker's quarters. Operational facilities soon followed, including better aircraft parking areas, an ordnance magazine, a dive-bombing target, and a 312,000-gallon fuel storage tank, especially important for an outlying field so far removed from Naval Air Station Norfolk. Nearly two years into the war, the Norfolk air station had become the hub for a series of outlying airfields, to include Chincoteague, Whitehurst, Reservoir, Oceana, Pungo, Fentress, Monogram, and Creeds, Virginia, and also Elizabeth City, Edenton, Manteo, and Harvey Point, North Carolina. With such an extensive area of responsibility, a new command—the Naval Air Center Hampton Roads—was established on October 12, 1942, under Captain James Marshall Shoemaker[48] (1895–1983), the fifteenth and eighteenth commanding officer of Naval Air Station Norfolk, to coordinate operations within the Norfolk area. The outlying fields were used for training, patrol plane operations, practice bombing and aerial gunnery.

At the beginning of the war, administrative authority at outlying airfields, including Oceana, was initially delegated to the senior squadron commander on site. As the number of bombing, fighter and torpedo squadrons increased exponentially to meet training syllabuses for aircrews headed overseas, the fighter community, in particular, began transitioning from NAS Norfolk's Chambers Field to Naval Auxiliary Air Station Pungo and what was, just then, Naval Auxiliary Landing Field Oceana. It was the spring of 1942 and already Oceana was hopping with activity—or at least trying. Buildings were still sparse and the demand for more was high. The war was less than six months old and Oceana was only able to accommodate eighteen land-based aircraft at any given time—it was cramped quarters. By May 1942, barracks for an additional two dozen officers and 132 enlisted men were ordered for each of the five outlying airfields under Norfolk's administration, to include Creeds, Fentress, Monogram, Oceana and Pungo. Fentress and Pungo also got concrete runways. Later, in November that year, the navy built out four additional fields. Harvey Point, a seaplane base, added barracks to accommodate two thousand men, a timber hangar and two seaplane ramps. Chincoteague, an airfield that would continue to play a role in Oceana's history for years to come, was fitted out with barracks for four hundred men and a storehouse.

Few knew just then that the outlying field at Fentress would be—in part—responsible for the three-inch newspaper headlines announcing United States Army Air Force lieutenant colonel James Harold "Jimmy" Doolittle's infamous raid on Tokyo, Japan, that took place on April 18, 1942. Doolittle's raid was first conceived, planned and tested in the Norfolk operating area as a joint army and navy mission. There are many stories about how all of this happened but it was first put forward by Captain Francis Stuart "Frog" Low, a member of Fleet Admiral Ernest Joseph King's staff in Washington, D.C. Low was in Norfolk on January 10, 1942, checking on the progress of the USS *Hornet* (CV-8)—the aircraft carrier that would eventually carry Doolittle's raiders—that was being finished at Newport News Shipbuilding and Dry Dock Company and had nearly reached the point of sea trials in the Chesapeake Bay. As Low's flight took off from NAS Norfolk and the pilot turned toward Washington, it was just enough of a wide bank for Low to catch a glimpse of army—actually highly likely navy Consolidated PB4Y-1 Liberators (the equivalent of an army B-24)—practicing takeoffs and landings on the outline of an aircraft carrier deck at Fentress. Low informed Admiral King.

The striking distance for naval aircraft launched from an aircraft carrier was typically three hundred miles but, the range of an army bomber launched from a carrier deck dramatically changed this estimate. Low pointed to the fact that the army's North American B-25C Mitchell could be loaded on board a carrier and launched successfully against the heart of Japan. After meetings with General Henry Harley "Hap" Arnold, the army air force chief of staff, Low and King, a plan was approved and the operation proceeded with test flights on the *Hornet*, Captain Marc Andrew "Pete" Mitscher, commanding. Mitscher and Doolittle rounded out the few men who knew the particulars of the mission. Less than three months later, and after intense training on a practice field painted up like Fentress, Doolittle and his sixteen Mitchells rose from the deck of the *Hornet* to bomb mainland Japan, striking targets in Tokyo, Yokohama, Kobe, and Nagoya. Of the crew members on this raid, eight were captured and of that number three were tortured and beheaded by their Japanese captors. Some survivors ditched their aircraft off the coast of China or bailed out over the Soviet Union.

Located south of Oceana, Naval Auxiliary Air Station Creeds supplanted Norfolk's pilot training. Creeds was established before Oceana on July 18, 1940, but there was nothing built of any significance on the site until April 2, 1941, when a runway was completed and barracks began to spring up from farmland chosen by navy planners to develop a training field. This significant outlying landing field was commissioned as an auxiliary airfield on April 5, 1943,

also before Oceana. Lieutenant (junior grade) Louis Osceola Mercer (1908–1988) was the officer-in-charge of Creeds and it was during Mercer's tenure and shortly after the upgrade to auxiliary air station that more barracks were completed to billet forty additional officers and two hundred enlisted men. Fighter Squadron One (VF-1), commanded by Lieutenant Commander Charles Laurence de Berniere Crommelin, reported for practice shortly thereafter. VF-1 was followed by Composite Squadron Fifty-Two (VC-52), Bombing Squadron Eight (VB-8), Fighter Squadron Thirteen (VF-13) and Bombing Squadron Fifteen (VB-15) in what remained of 1943. The following year, in 1944, Composite Squadrons Fifteen (VC-15), Ninety-Five (VC-95), and Forty-Two (VC-42) rotated to the Creeds airfield. Of note, VF-13 Black Cats was established on November 2, 1943, disestablished on October 20, 1945, and was the first navy squadron to be designated VF-13. The squadron, equipped with the F6F-5 Hellcat, formed part of Carrier Air Group Thirteen (CVG-13), assigned to the USS *Franklin* (CV-13).

For the first year-and-a-half of the war, Oceana remained an auxiliary landing field. During this time, it was often in competition with NAAS Pungo for money, men and aircraft. Twenty-four navy squadrons used the 441-acre Pungo auxiliary air station during World War II, to include TBF and TBM Avenger torpedo and F4F and FM Wildcat fighter squadrons. Most—not all—of these squadrons were bound for escort carriers. While Pungo drew resources away from Oceana during the war, the navy shut it down in 1946 and sold the property to Atlantic Flight Services because the location was perceived too remote to be practical. One of the earliest proposals for the Oceana auxiliary landing field was put forward by Captain Shoemaker, who recommended the navy share the field with army fighter squadrons. The cost of Shoemaker's proposal approached $3 million. The Bureau of Yards and Docks approved this expansion and, on January 18, 1943, released funding to begin work. While facilities construction had started, on February 15, command of the auxiliary landing field was assigned to Naval Air Center Hampton Roads. This reassignment changed everything.

A March 6, 1943 memorandum from the Bureau of Aeronautics planning division urged secretary of the navy approval of funds for the construction of facilities to increase Oceana's capacity. Under this revamped expansion plan, Oceana would be able to support sixty-four aircraft, the equivalent of three squadrons, and enough barracks space to accommodate 132 officers and 824 enlisted men. At the time this proposal was made, Oceana was only able to handle eighteen airplanes. To achieve much of this expansion, it was clear that the Potter farmland was the first stepping stone to a larger air station. The navy surveyed land around the existing airfield for acquisition and more acreage was appraised as early as 1940. The land, some of which continued to be farmed long after the navy acquired it, was best suited to general farming and truck cultivation. To the appraisers, it was clear that the absence of a marketing cooperative had cost truck farmers in the area a fair price for their produce at market. Many of the fields were unharvested because the anticipated price for the crop was too low. Appraisers took notice. While truck farming had waned, hog raising and fattening, a more recent use of the land just then, was showing greater profit.

Beyond the Potter farm, the navy acquired several hundred acres of Frank P. Whitehurst's land. Whitehurst had a truck farming operation that, unlike those of several of his neighbors, was profitable, largely because he was not trying to sell his crops locally. Instead, Whitehurst built a warehouse adjacent to the Norfolk Southern Railway right-of-way at Oceana and moved his produce to markets outside Hampton Roads. While there had been some inducement to build homes on the small lots along road frontage in the area, it had not affected the Potter farm, the primary tract the navy wanted to continue the expansion of the airfield.

In late spring 1943, the navy moved forward with expansion of Oceana's runways on some of its newly purchased farmland, also owned and farmed by John W. and Dean S. Potter

and their families. Though the sale was contested during condemnation proceedings, the navy temporarily suspended operations at Oceana on April 9 to get construction underway. Acting secretary of the navy James V. Forrestal asked the United States attorney general to initiate condemnation proceedings under *United States of America v. 863.7 acres of additional land situated in Princess Anne County for the expansion of the Oceana outlying field.* Forrestal's request, made July 13, 1943, had the force of several acts of Congress behind it. The taking of additional Potter farmland was instituted pursuant to these acts, approved March 27, 1942 [Public Law 507, Seventy-Seventh Congress], August 6, 1942 [Public Law 700, Seventy-Seventh Congress], and March 11, 1943 [Public Law 20, Seventy-Eighth Congress], joined with compelling takings law approved by Congress on February 26, 1931 [36 Statute 1421]. The navy department agreed to pay fair market value of $108,500 for the farmland, $102,500 of which was paid to the Potter family and the remainder to buy the 100-acre Fannie C. Colonna tract. With this substantial growth and the promise of more to come, Oceana was commissioned an auxiliary air station on August 17, 1943. Lieutenant Jesse Arthur Fairley[49] (1907–2006) was Oceana's first commanding officer.

Decades after Fairley retired from the navy, he observed that even he had received noise complaints from the sparsely populated Oceana community. "One lady was hollerin' about noise," he recalled. "I told her, 'Lady, would you rather hear these planes taking off and landing or bombs dropping on your head?' Never heard from her again."[50] Residents were generally unprepared for the sound of the engines of large navy bombers like the Consolidated PB4Y-1 Liberator and PB4Y-2 Privateer, and bombing, fighter and torpedo planes. Rather than share the field with the army, as Shoemaker proposed, the navy decided to use it for three squadrons of Liberators and Privateers—sixty-four aircraft—which used Oceana through the fall of 1943. The navy's patrol bombing squadrons, first called bombing squadrons, proved unsuited to Oceana's tarmac and runways, which could not take the weight of the Liberators and Privateers at that time. The Liberators and Privateers were used primarily for antisubmarine warfare and convoy escort duty. Among the heavy bomber squadrons—largely Liberators—that used Oceana was Bombing Squadron One Hundred Twelve (VB-112), established at NAS Norfolk on August 8, 1943, as part of Fleet Air Wing Five (FAW-5). VB-112, under the command of Lieutenant Commander Josef M. Gardiner, spent two months at Oceana. Bombing Squadron One Hundred Thirteen (VB-113), established August 18, 1943, and also part of FAW-5, trained there until December 28, 1943, and was under the command of Lieutenant Commander Louis W. Mang. Bombing Squadron One Hundred Fourteen (VB-114), established at Norfolk on August 26, 1943, and also an FAW-5 squadron, trained at Oceana from October 14 to December 21, 1943. Lieutenant Commander Lloyd H. McAlpine commanded VB-114. Each of these squadrons played an important role in the Battle of the Atlantic, the war in Europe, and eventually the fight for control of the Pacific.

With the exception of the Fentress auxiliary landing field and Oceana, the navy was already taking administrative steps to shutter remaining outlying fields, to include Creeds, where Mercer had been succeeded by Lieutenant (junior grade) William Michael Miano on June 28, 1943. Creeds had grown, if only in the short term, and was closed on October 15, 1945. Lieutenant (junior grade) Franklin G. Parker Jr. was Creeds' last commanding officer. Yet while all of these auxiliary airfields were up and running, as Bellinger put it best, his planes and pilots—most of them trained at one of these outlying and largely temporary bases—could be found in the fight "from Dunkeswell to Dakar and from Reykjavik to Rio"[51] with additional assignments to Greenland, Panama, Ascension Island, Trinidad, the Azores and many points in eastern and Moroccan sea frontiers.

The squadrons that reported in and out of Oceana often did so quickly, remaining just a few weeks. While some pilots lived at Oceana, others were stashed at Fentress and Pungo—residence of Lieutenant Commander David McCampbell's Fighting Fifteen—while others found uncomfortable quarters at Creeds. McCampbell, the navy's legendary top ace of all time, billeted with his fighter pilots at Pungo. The Fighting Fifteen considered themselves lucky when they saw the living conditions of the rest of Air Group Fifteen at Creeds, the furthest away from the town of Virginia Beach—twenty miles, give or take—and between what was then desolate North Landing River and Back Bay. McCampbell's counterpart and commanding officer of Bombing Squadron Fifteen (VB-15), Lieutenant Commander Irvin Lowell "Ike" Dew (1910–2006),[52] was quartered at Creeds in November 1943 with his dive-bomber pilots and their Curtiss SB2C-1C Helldiver aircraft. With its one-frame nose hangar, a handful of frame shops, a barn converted to ready room, and nearly nonexistent administrative space crammed inside already overcrowded Quonset huts, Creeds had worse living and working conditions than Oceana or Pungo. Creeds' canteen was not exactly stocked with items in high demand like liquor, cigarettes and other tobacco products. Despite the drawbacks, Creeds afforded VB-15 a lot of flight time. During the Bombing Fifteen's first month quartered there, it racked up 2,900 flight hours and used so much fuel that Norfolk naval authorities investigated.

Married pilots found places to live in the town of Virginia Beach and some of Princess Anne County's smaller hamlets, commuting to their auxiliary airfields by automobile and often various forms of transportation made available by their command. Creeds had a command car and an old milk truck but neither survived the war. The car was wrecked into a tree and the milk truck met its end along an unknown stretch of country road. Nearly all of the auxiliary fields in Princess Anne County were close enough to the now gone Pine Tree Inn, opened in 1928 on Virginia Beach Boulevard near Lynnhaven Road. McCampbell and Dew—and their pilots—were regulars there. Enlisted men went to what they called the Chamber Music Society of Lower Hut Seven (on the airfield), which had nothing to do with music and everything to do with a good party. At the Oceanfront, The Cavalier Hotel and also many of the other hotels and cottages that dotted the resort strip were converted to and otherwise patronized by navy and army personnel. After the federal government notified The Cavalier's hotel management on October 3, 1942, that the aristocrat of the Virginia shore would be needed as a radar training school for the navy, nearly all of the hotel space was converted to this purpose. The navy moved in quickly, converting every available space, to include the indoor swimming pool, into classroom space and quarters. The hotel's chefs were kept on to feed navy men who arrived in great number for critical training.

In a short period of time, Oceana completed four 6,000-foot runways, which afforded Carrier Air Groups Thirteen, Sixteen, Eighty, Eighty-Two, and Eighty-Seven, and thirteen squadrons that used it for practice in 1944 ample space to work. Fairley turned over command of NAAS Oceana to Lieutenant Commander William L. Brantley on February 18, 1944, but Brantley left this post on March 9, having served less than three weeks. Brantley was followed by Commander Frank E. Deam, who left on September 27, 1945. Significant improvements were made while Deam was in charge, to include lighting of the runways and taxiways in March 1944, and that June, a mobile radar intercept-training unit was established for the purpose of instructing pilots in fighter direction operations. Then came the Great Atlantic hurricane that passed through Hampton Roads on September 14, 1944, which inflicted considerable damage to Oceana. The storm produced winds in excess of 100 miles per hour, causing heavy damage to buildings all over the base. In the process of rebuilding, the navy opted to also construct new barracks, hangars and aviation support facilities to accommodate the influx of new

squadrons. Construction was nearly complete by March 1945, just in time for Oceana to bump from three to eight tenant squadrons. Among the new buildings was a prefabricated steel arch hangar, a large brick bachelor officer quarters (BOQ), and a station administration building.

While Deam oversaw much of the late-war growth of the base, he also watched the uptick in carrier-based squadrons that crowded Oceana in the final months leading up to the Japanese surrender. Carrier Air Groups Three (CVG-3), Sixteen (CVG-16), Eighty-Nine (CVG-89), Ninety-Four (CVG-94), Ninety-Five (CVG-95), One Hundred Fifty-One (CVG-151), and One Hundred Fifty-Three (CVG-153) had reported along with their squadrons. Oceana received seven bombing fighting squadrons—a new type—in the waning months of the war, to include Bombing Fighting Squadron Three (VBF-3), which reported from the Pacific theater on May 12, 1945, and trained from the auxiliary air station starting in late July of that year in the Vought F4U-1D/-4 Corsair. The Corsair had become a staple aircraft at Oceana by 1945. With the exception of Bombing Fighting Squadron Sixteen (VBF-16)—a Grumman F6F-3 Hellcat squadron—the Corsair was flown by six of the seven VBF squadrons assigned to Oceana for training, in addition to VBF-3, to include VBF-89, -94, -95, -151 and -153. Despite the popularity of the Corsair, it was the Hellcat that populated the majority of all fighter squadrons that passed through Oceana in the last year of the war. Among the bombing squadrons it was the Curtiss SB2C-4, -4E, -5 and -5E Helldiver. With the war drawing to a foreseeable close in the Pacific, the torpedo squadrons reporting to Oceana were still flying the Grumman TBF-1C and TBM-1C Avenger.

In the decades that followed the Second World War, the air station and the community around it grew with naval aviation. The nascent auxiliary air station grew so fast that less than a decade after the war, the navy built additional runways and training facilities. The evolution of Oceana postwar sent a clear message that it could no longer function as a subordinate to any other air station. The secretary of the navy redesignated Oceana a naval air station on April 1, 1952, a move that ultimately laid the foundation for development of the master jet base.

Ground was broken for the relocation of the air station to the south side of the field—where it is today—on August 24, 1952. This redevelopment spelled the end of the old north station, of which only a couple of Quonset huts remain. With the introduction of jet aircraft, Oceana's relative isolation and lengthy runways made it well positioned to become the home station of the navy's tactical air squadrons. Plans to designate Oceana the navy's East Coast master jet base were put into full effect in 1953 after the navy determined that airspace and airfield facility restrictions precluded Naval Air Station Norfolk from serving that role. Numerous contracts were awarded for the erection of buildings on the south side of the air station, to include a hangar, parachute loft, administration building, line shacks, crash and salvage buildings, magazines, supply facilities, transportation garage, operations building, heating plant, infirmary, galley, high-speed jet refueling pits and an enlisted man's club. Even today, Oceana has the longest runways in Hampton Roads and thus remains capable of handling emergency traffic during periods of extreme inclement weather. In its history, particularly at various times in the 1950s, Oceana's runway was the only military landing field open between Charleston, South Carolina, and Dover, Delaware, during a weather-driven emergency.

Dedication ceremonies were held on June 4, 1957, naming the field after Vice Admiral Apollo Soucek, who was a record-breaking high-altitude test pilot—setting a series of flight altitude records in 1929 and 1930—earning him the title of "the navy's test pilot admiral." Soucek also served in World War II, receiving the Silver Star, and was commander of Carrier Division Three during the Korean Conflict, ending his career as the chief of the Bureau of Aeronautics.

Decades later, Naval Air Station Oceana has grown to become one of the largest and most advanced air stations in the world, comprising 6,820 acres, to include the Dam Neck Annex.

Obstruction clearances and flight easements total an additional 3,680 acres. The air station's four runways, three measuring 8,000 feet in length and one measuring 12,000 feet, are designed for high-performance aircraft. Aside from its military function, NAS Oceana was an alternative landing site for the National Aeronautics and Space Administration's (NASA's) space shuttle until that program ended in 2011. Each space shuttle abort landing site was chosen because the runway was of sufficient length to provide adequate distance for the slowing-down of a returning spacecraft. Of note, as a master jet base, Oceana must maintain one or more satellite bases at all times. Oceana has Naval Auxiliary Landing Field (NALF) Fentress, located thirteen miles south of the air station in Chesapeake, Virginia, and has operational control of Chambers Field on Naval Station Norfolk [formerly Naval Air Station Norfolk].

After World War I, Fort Story,[53] established in 1914 when the Virginia General Assembly ceded the first 343.1 acres of beachfront to the federal government for an army base, was designated a harbor defense command on June 9, 1925, and as the events of the "war to end all wars" became history, the fort began a period of postwar inactivity that lasted until the beginning of World War II. This was not an uncommon scenario for a World War I period fortification, many of which had been erected with great haste across the country. But the term "inactivity" to describe them is, in many respects, misleading. The activity level at Fort Story during the Great Depression was steady with the New Deal Civilian Conservation Corps (CCC) programs that moved in to stabilize the post's expansive sand dunes collocated with the battery and also expand the railroad system to quadrate World War I period eight- and twelve-inch railway guns to firing locations at the south end of the fort. The army had completed its reevaluation of the nation's coastal defense fortifications by 1940. The Harbor Defense Board recommended that all coastal defense facilities be fitted with sixteen-inch guns as their primary defensive weapon, thus broadening the range of shore guns to twenty-five miles. The six-inch guns were retained as secondary armament. The board allocated two sixteen-inch batteries supplemented with a pair of six-inch modern batteries for Fort Story. Since the gun emplacements had to be built, there was extensive work that had to be done. The 71st Coast Artillery Regiment (anti-aircraft) and the 246th Coast Artillery Regiment, a Virginia Army National Guard unit called to active duty, arrived at the post in August and September of 1940, respectively.

In 1941, prior to America's entry in World War II, changes came swiftly to Fort Story. The headquarters of the army's harbor defense command was moved from Fort Monroe in Hampton, Virginia, to Fort Story, more land was acquired [a process that added to land purchased prior to World War I] and two additional harbor defense installations were added. The navy maintained a harbor entrance control unit at the fort, keeping tabs on shipping and potential enemy threats above and below the water's surface. Also, after the war broke out, a twenty-four-hour operational intelligence watch manned the harbor entrance post established by the navy in the 1918 weather bureau building. The post acted as the "eyes" for the intelligence nerve center in joint operations at Naval Operating Base Norfolk.

An aggressive building program began to fill in the Fort Story military reservation. Additional barracks were built and construction of emplacements for direct fire weapons and searchlights took place in quick fashion. Private property down the shore at Virginia Beach was acquired to place these direct fire weapons in strategically advantageous locations. Before World War II, the fort had been divided into sections. Parcel A encompassed the main part of the base between the east gate and the lighthouses and contained Battery Pennington, the railroad artillery, the fort's early temporary batteries, and searchlights. Parcel B took in the west end of Seventy-Second Street off of Atlantic Avenue and contained the Emmerson fire control towers. Parcel C was just beyond it in the area of Sixty-Seventh Street and was the site of several fire

control towers. Parcel D folded in the area of west gate and is the site of the mine casemate and fire control tower. Parcel E was adjacent to west gate and contained the Examination Battery and the Granite fire control towers.[54] The number of troops arriving at Fort Story was so great that roads leading in and out of the gates were "jam packed" with troop carriers, equipment on trucks, and the civilian population trying to go about their daily business. To rectify this problem, Brigadier General Rollin Larrabee Tilton (1888–1977), the commanding general of the harbor defenses of the Chesapeake Bay headquartered at Fort Monroe (1941–1946), convinced Virginia governor James Hubert Price to close the portion of Atlantic Avenue running through the post. A bypass was built through Seashore State Park [now First Landing State Park]. The large land acquisition that occurred two years into the war was followed by the installation of several additional sixteen-inch guns. Further, parcels A, D and E were no longer separated because Cape Henry was now part of the army reservation. While there had been coast artillery batteries consisting of four sixteen-inch M1920 howitzers emplaced at the fort since 1922, those "several additional" sixteen-inch guns were four navy Mark II guns, installed during the war. These guns, along with matching batteries at Fort John Custis, established in 1940 on property that is now part of the Eastern Shore of Virginia National Wildlife Refuge, and Cape Charles, Virginia, were intended to safeguard the entrance to the Chesapeake Bay from enemy naval forces. In addition to the guns emplaced on the fort, a minefield was laid off of Cape Henry.

Three years into the war, in 1944, Fort Story began to transition from a heavily fortified coast artillery garrison to a convalescent hospital for returning combat veterans. By the time it closed on March 15, 1946, the hospital had accommodated more than thirteen thousand patients. Also that year, the first amphibious training at Fort Story began with the arrival of the 458th Amphibious Truck Company and army DUKWs, colloquially known as "Ducks," a six-wheel-drive amphibious modification of the two-and-a-half-ton six-by-six army cargo truck that saw heavy service in both World War II and the Korean Conflict. Designed under military auspices by Sparkman and Stephens and General Motors Corporation (GMC), the DUKW was used for the transportation of goods and troops over land and water. This familiar sight at Fort Story excelled at approaching and crossing beaches in amphibious warfare attacks and was intended only to last long enough to meet the demands of combat. Surviving DUKWs, of note, have since found popularity as tourist craft in marine environments. Per the manufacturer record, the term DUKW is not an acronym but rather the original GMC nomenclature, the manufacturing code for the military wheeled amphibious landing craft: D stood for the year 1942, U for utility (amphibious), K for all-wheel drive, and W for two powered rear axles. Also, advanced equipment was tested and used on the post's beaches such as the BARC [Barge, Amphibious, Resupply, Cargo], the world's largest amphibious vehicle at that time. Fort Story would eventually maintain all fourteen BARCs in the army inventory. The gigantic vehicles were ninety-eight tons with tires more than nine feet in diameter with four-foot diesel engines. The BARC could carry up to one hundred tons of cargo on land or water.

The war had been over just three years when the fort, which had had the heaviest armament on the East Coast through much of World War II, was officially transferred to the Transportation Training Command at Fort Eustis, Virginia, and subsequently designated an army transportation corps installation for use in training amphibious and terminal units in the conduct of logistical-over-the-shore (LOTS) operations. Fort Story had lost its relevance as a coastal defense post, commensurate with that of the coast artillery corps, by the end of the war. The fort's gun emplacements were removed from service within the four-year period following the end of World War II and former ammunition bunkers were later converted to storage.

As tensions with the former Union of Soviet Socialist Republics (USSR) evolved into another

cold war in the postwar period, the army established surface-to-air guided missile systems around major cities in the United States, those primarily viewed as primary targets if the Russians were to launch intercontinental ballistic missiles on coastal and interior American targets. Project NIKE, which started during World War II, in 1944, when the War Department demanded a new air defense system to combat the equally new jet aircraft. Each launch site had three parts, separated by at least one thousand yards. One part (designated C) of about six acres contained the integrated fire control (IFC) radar systems to detect incoming targets (acquisition and target tracking) and direct the missiles (missile tracking), along with the computer systems to plot and direct the intercept. The second part (designated L), took up about forty acres and held one to three underground missile magazines each serving a group of four launch assemblies and included a safety zone. The site had a crew of one hundred and nine officers and enlisted men who ran it continuously. One launcher would be on fifteen minutes alert, two on thirty minutes and one on two-hour alert. The third part was the administrative area (designated A), which was usually collocated with the IFC and contained the battery headquarters, barracks, mess, recreation hall, and motor pool. The actual configuration of the NIKE sites differed depending on geography. Whenever possible, it is known that the sites were placed on existing military bases or National Guard armories, otherwise land had to be bought to set them up. The Norfolk Defense Area included headquarters facilities at Fort Monroe, the Ballentine School in Norfolk, Reedsville/South Norfolk, Cradock/Portsmouth, and Newport News. The world's largest navy base at Norfolk received an extensive air defense network. The army placed NIKE sites [service dates in brackets] at N-02 Fox Hill, Virginia [1955–1963]; N-25/29 Fort Story [1957–June 1971]; N-36 Kempsville [1955–1964] on land that was initially in Princess Anne County, later controlled by the city of Virginia Beach Parks and Recreation Department and used as a storage yard; N-52 Deep Creek/Chesapeake [1955–April 1974], later home to the Chesapeake Alternative School; N-63 Suffolk/Nansemond County [1955–November 1964], which was later redeveloped into high-end single-family housing; N-75 Smithfield/Carrolton [1955–June 1961], later the Isle of Wight County Park referred to as NIKE Park; N-85 Denbigh/Patrick Henry [1955–April 1974], part of Newport News, Virginia, and on the property controlled by the Peninsula Airport Commission, and N-93 Spiegelville/Hampton [1955–1963] on the grounds of what became the United States Army Reserve Center. Sites N-25, N-52 and N-85 were modernized to fire the NIKE Hercules missile. Site N-63 held the distinction of being the last to operate NIKE Ajax, being deactivated in November 1964. Both regular army and Virginia Army National Guard units contributed to the manning of the sites. During this period of time Fort Story was declared a permanent installation on December 5, 1961, and less than a year later, on July 1, 1962, it was redesignated a Class I sub-installation of Fort Eustis, on the Virginia Peninsula.[55] The fort's major command unit was the Fourth Transportation Command [Terminal C] with its two transportation battalions.

During World War II, the navy grew its footprint in what is today Virginia Beach beyond the airfield at Oceana. In April 1942, the navy started the Little Creek amphibious training base, located twelve miles northeast of Norfolk off what was then the Ocean View-Virginia Beach scenic highway. With the navy in a hurry to get men trained and into combat, its building program moved fast, beginning with a waterlogged bean field on one of the Whitehurst family farms when the first navy truck rolled up on July 16, 1942, with a load of lumber and equipment to start developing the area into the first camp. Buildings were completed at a rate of five per day. The navy's rush was understandable. The sea service's war planners foresaw landing tens of thousands of American troops on foreign beachheads under intense enemy fire. New methods and techniques of getting them there had to be developed, and the navy needed a place to do it. Thus, training of men in the art of amphibious assault began with that first soggy bean field.

These were, after all, the salad days of the war and mud and confusion combined with military urgency meant there was no time to wait to get the base up and running. During the early phases of the war, the base was, in truth, a combination of farmland and swamps. Four areas were carved out: Camps Bradford and Shelton, United States Naval Frontier Base, and Amphibious Training Base. The camps were named for the former owners of some of the land taken by the navy.

The Amphibious Training Command, attached to the United States Atlantic Fleet headquarters at Norfolk, was officially operational on August 1, 1943. The Little Creek Naval Amphibious Training Base [also known as "Little Creek"] was set up to train crews for landing ships medium [LSMs], land craft vehicles [LCVs], landing craft utility [LCU], landing craft mechanized [LCM], and land craft vehicle, personnel [LCVP] boat crews. The naval frontier base was a forwarding depot for personnel and supplies in the European and Mediterranean theaters of operation. Camp Bradford was first used as a training base for navy Seabees but in 1943 this mission evolved to train crews for the landing ships tank [LSTs]. There was also an armed guard training center established on October 15, 1941; its purpose was the training of officers and enlisted men to man gun crews on board merchant vessels. In 1943, an armed guard center was also established at Camp Shelton.

The Little Creek base's history[56] informs that the early days of were hard ones. Techniques for training had to be developed from scratch. Facilities for the upkeep of equipment as well as living facilities and work areas for personnel would be called primitive, just as they were at the navy's airfields across southeast Virginia, to include Creeds, Oceana and Pungo, among others. Roads and utilities were crude at best. Those assigned to the new base found it difficult to keep white uniforms clean in the summer because the water had foreign matter that left residue that discolored clothing. There was no hot running water. Little Creek personnel worked long hours in the humid, blistering heat of a Hampton Roads summer and the wet, penetrating cold of the region's winters. They worked, by all accounts, in mud and sand. Improvements were slow in coming but eventually, at least, they did and the base began to take shape.

At the end of the war, the Amphibious Training Command trained over 200,000 naval and 160,000 army and marine corps personnel, and the base's armed guard training center trained some 6,500 officers and 115,000 enlisted men. The four former Little Creek bases [not yet consolidated to one large base] were partially inactivated at the end of the war. Shortly thereafter, however, the four bases at Little Creek, because of their central location on the Atlantic coast, excellent and varied beach conditions, proximity to the naval facilities of Norfolk, berthing facilities for amphibious ships through the size of LSTs, and other advantages, were consolidated into the present installation and renamed the Naval Amphibious Base, Little Creek with a commissioning date of August 10, 1945; it was designated a permanent base the following year. With this consolidation and restructuring, the former amphibious training base became Annex I, the frontier base Annex II, and Camps Bradford and Shelton Annex III. At the end of 1945, these annexes covered over 1,800 acres and four thousand yards of Chesapeake Bay beachfront to continue amphibious training.

The navy's Little Creek amphibious base did not stop evolving and has grown over the years, developing into a strategic expeditionary command that has since become the fastest-growing naval installation in Hampton Roads, known today as Joint Expeditionary Base Little Creek-Fort Story[57], created under the joint basing initiative calling for the combining of military installations that share a common boundary or are proximal to one another, in this case two bases, one navy, one army, linked by Route 60 [Shore Drive] and common training objectives and opportunities. There, too, navy, marine and army reserve personnel use its training facilities, all coordinated through the Naval and Marine Corps Readiness Center situated on the Little

Creek base. Today's 2,120-acre expeditionary base is the largest of its kind in the world and is the major operating station for the United States Atlantic Fleet's amphibious forces.

At the southern end of Virginia Beach, the navy developed the Fleet Air Defense Training Center at Dam Neck. The center was named for the 1881 lifesaving station established there on a very desolate stretch of beach where once stood two-post grain windmills called Dam Neck Mills. The installation covers over 1,100-acres of highlands, marshes, coastal beaches and sand dunes, to include 3.2 miles of beach fronting the Atlantic Ocean. In the first year of the war–1941–navy lieutenant commander Philip Daly Gallery (1907–1973) was sent to Dam Neck to organize an antiaircraft school. Gallery's activity was officially established on April 4, 1942. Dam Neck would also gain an aircraft carrier training unit and Bureau of Ordnance test center during the war. Like Little Creek, Dam Neck was built quickly, originally housing just a firing line, one control tower, one office and one shop. Some might observe that it was far behind Little Creek because Gallery's operation had no quarters or messing facilities when the first arrivals started showing up. In short order, the first barracks building, a mess hall and classroom space were built. Gallery's staff consisted of himself and one other officer and roughly forty enlisted men he had recruited from the Norfolk Naval Shipyard and the Norfolk Naval Station piers–anyone he could grab up who showed some interest in going through antiaircraft training would do. While Dam Neck's future looked bleak as it went inactive in the four years following World War II, it hung on.

Dam Neck remained commissioned throughout the post-World War II period and was subsequently enlarged after the Korean Conflict as a training center to include training of combat systems operators and maintenance technicians. One notable former tenant was the Naval Guided Missile School (NAVGMSCOL), which provided training for the Polaris, Poseidon and Trident I Backfit submarine-launched ballistic missile (SLBM) systems and various surface missile systems. The name of the base, long remembered as Fleet Combat Training Center Atlantic [and just "Dam Neck"], in 2004 was reorganized and renamed Training Support Center Hampton Roads to align it with the contemporary navy's "Revolution in Training." The actual training activity is the Center for Surface Combat Systems, which is headquartered in Dahlgren, Virginia. The Dam Neck base supports, as its name suggests, the training mission. Dam Neck remains the navy's only open-ocean, live-firing training facility featuring major caliber weapons. Notable among Dam Neck's tenant commands are the United States Naval Special Warfare Development Group (DEVGRU), Tactical Training Group Atlantic, and Combat Direction System Activity (CDSA) Dam Neck. The base is also home to the Navy and Marine Corps Intelligence Training Center. When joint basing took effect, Dam Neck was made an annex of Naval Air Station Oceana.

After the Second World War, Princess Anne County and the town of Virginia Beach ushered in a new era fed by transportation improvements and a construction boom. The war also left the county with four permanent military reservations–three federal and one state–that continue to mark its landscape today: Joint Expeditionary Base Little Creek-Fort Story, Naval Air Station Oceana, Fleet Training Support Center Hampton Roads [formerly Dam Neck Fleet Training Center],[58] and the State Military Reservation [Camp Pendleton]. Popular Oceanfront mainstays made improvements to keep up with the surge in new population and the return of vacationers in the postwar period.

By the middle of the twentieth century, it was widely acknowledged that both Princess Anne County and the new, smaller second-class city of Virginia Beach had not done enough to maintain a connection to their respective histories, some going so far as to suggest to county and town leadership that they not be swayed so readily to change place names and that, given the pressure to develop large land tracts, they spare irreplaceable old homes and preserve the cottages and storefronts that lent so much character to the Oceanfront. But stark reality stared

back at those who cried preservation; many of the county's prize estates and old places were already gone, erased from the landscape and replaced by new neighborhoods and strip malls. But at Virginia Beach, it was a different story altogether. In retrospect, The Cavalier Hotel and the rest of the Oceanfront's old places were at dire risk by the mid-1950s, even if no one realized it just yet. Along Atlantic Avenue and on streets running parallel from the Oceanfront, the constant drone of construction equipment and the steady chorus of hammers signaled another new building going up. But they were not just hotels. Sprinkled in between were theaters, nightclubs, restaurants, storefronts, a bowling alley and a skating rink, as well as a few public buildings. The Virginia Beach Theater at Twenty-Fifth Street and Atlantic Avenue, opened in July 1946, was the handiwork of William C. Crockett and David Pender, who owned two additional cinema houses at the Oceanfront. Down on Thirty-Fifth Street and Atlantic Avenue, a two-story building with storefronts on the first floor and eighteen apartments upstairs was being completed. At the northwest corner of Nineteenth Street and Atlantic Avenue, a branch of the National Bank of Commerce was coming up next to a host of other new establishments.

Going back to the end of World War II, it was clear that progress had won. Tens of thousands of soldiers, sailors and airmen came home to the United States from duty overseas; many of them had already become familiar with Virginia Beach as a place where they had done a tour of duty, while others recalled it as a place to go on military leave. Still others remembered prewar Virginia Beach. Town and county leaders, anticipating the postwar business boon, agreed to pool municipal funding. Close to two million dollars was spent to improve and construct a better resort for all of those "seasonal interlopers." Mid-century modern hotels and motels were planned and built. Popular Oceanfront mainstays made improvements to keep up. Seaside Park [by then also called the Old Ocean Casino] launched a round of refurbishment projects that added a new bathhouse—the largest in Virginia—and a new concession building to the boardwalk. This building boom prompted Russell Austin McCoy Jr. (1911–2003), supervising engineer for the town of Virginia Beach, to observe that the rate of construction in 1946—one year—far exceeded the cumulative building made in the decades leading up to World War II. This amazing surge started with the building of the Bank of Virginia Beach in the spring of 1945, just after the war in Europe was declared over. The Oceanfront began to take on a very different appearance.

When The Cavalier was returned to its owners by the navy at the end of the war, former general manager James Sidney Banks came back, too. Banks had managed The Cavalier since 1930, but the job he had ahead of him to put back what the navy had dismantled was monumental. Improvements to The Cavalier were followed by clean up and reopening of the Cavalier Beach Club, the Cavalier Lodge, the stables and the Cavalier Yacht and Country Club. Of note, Pullman had discontinued rail service to the hotel and patronage had dropped through the floor. The automobile had become the preferred transportation mode. The Cavalier-Jefferson Corporation,[59] the owner and operator of The Cavalier Hotel just then, and of which Banks was president, made the decision to transfer the deed to the hotel. The hotel and its surrounding property subsequently gave way to two emerging corporations: Cavalier Hotel Corporation and Northwest Development Company. Banks remained president of the Cavalier-Jefferson Corporation and the Cavalier Hotel Corporation in the reorganization. But he gained a new vice president in Gene Bishop Dixon (1917–1974), a Dillwyn, Virginia industrialist and the owner of Kyanite Mining Corporation. Banks' Cavalier Hotel Corporation retained title to the hotel, beach club, inn, lodge and garage, and Northwest Development Company got all the rest, including the Cavalier Golf and Yacht Club, completed in 1930 as the Cavalier Country Club, and a three-hundred-foot strip of land that adjoined the hotel and extended from the Oceanfront

back to Holly Road. Northwest leased its holdings to Cavalier. We know from a civil action filed by Cavalier-Jefferson Corporation in the United States District Court for the Eastern District of Virginia against the Connecticut Mutual Life Insurance Company, decided on February 5, 1954, that the corporation struggled to balance and discharge existing indebtedness of the corporation in the postwar period and that it had an extensive improvement project on its Jefferson Hotel property that strained the corporation's ability to resolve issues at both hotel properties. Banks would later sell his interest in the hotel to Dixon in 1961, making Dixon the sole owner.

Back at The Cavalier, a new set of challenges lay ahead. A devastating fire damaged The Cavalier Hotel's fifth floor in May 1969. The hotel remained open while expensive repairs were made. Dixon organized a new group of investors, mostly local men to include Carroll Arthur Rutter Jr. (1934–2016), an attorney and founder of his own firm [now called Rutter Mills LLP]; Thomas Clark Broyles, an attorney and partner [now of counsel] with Kaufman and Canoles; Laverne Charles Burlage (1923–2011), cofounder of the Virginia Beach Council of Civic Organizations, a member of the seven-man steering committee that facilitated the merger between the second-class city of Virginia Beach and Princess Anne County, and the owner of The Breakers, a hotel on Twenty-Fifth Street in the mid-1960s before he opened the first chain hotel in Virginia Beach—the Holiday Inn—on the same site[60], and Gerald Leslie Lavenstein (1925–1972), a realtor who became an investor. Banks named James Myron Renfrow as The Cavalier's new general manager. Renfrow took the job knowing that his biggest task was to keep the hotel solvent at the peak of the national recession. The economy at that time was not destined to let him succeed. By 1973, Dixon had opened the Cavalier Oceanfront, at which time the original Cavalier, rebranded Cavalier on the Hill, was closed. The Cavalier Oceanfront was built eleven stories high over the beach; it is now gone. A year after The Cavalier was shuttered, Dixon held a public auction of the hotel contents. "They had come to pick at the old lady's bones," wrote Bob Lipper in the December 15, 1974 *Virginian-Pilot*, as bargain hunters, memorabilia collectors, businessmen and secondhand furniture dealers looked through priceless mementoes, goods, furnishings and hotel equipment for a deal. "These people," observed Lipper, "walked through the lobby quietly, then drifted into the Cavalier Room, the Colonial Room, the Garden Porch to poke with a certain degree of reverence through the heirlooms of an age left behind when we discovered neon and the interstate highway." After it was empty, it stayed that way. The property on which it was built was not for sale.

"It made me sad when they closed it," observed James Sidney Banks after The Cavalier was no more. "I think it's still the queen of the Beach." The Cavalier on the Hill would not be closed long. The community that had grown up with it and around it missed the aristocrat terribly, and it was reopened in 1976. This was a reprieve from obscurity that everyone was glad to see—even though it did not last.

Going back to that day at The Cavalier auction is instructive. Auctioneer Maury Riganto told Lipper something that none of us should forget: "The Cavalier *is* Virginia Beach." As he watched a continuous flow of The Cavalier's memories walk out the door, he pointed and said again, "That's the Beach. When you say The Cavalier, that's Virginia Beach." Three women who attended Riganto's auction were awestruck by it, even though the hotel was not looking its best. One of the women, from Virginia Beach, wanted to show her friends from Massachusetts "the queen of the Beach" before what she and everyone else believed would be the last time. "All the stars were here," she was heard to tell them. One of the Massachusetts women stepped toward the front steps and looked up at The Cavalier. "This used to be a hotel?" she asked, hesitating. "My God, what a hotel," the grandeur of it shining through despite creeping vines, unkempt grounds and building. What happened to Cavalier

on the Hill in 1973 signaled an ongoing change of fortune for many of America's finest old hotels and attractions after World War II. They had become the unwanted victims of culture and economy. Many of them closed because the land on which they were built was more valuable turned into a shopping center. That the Cavalier on the Hill was able to prevail since 1927, to include more than one near-death experience, is the exception, not the rule.

Just as surely as a way of life was changing at the Oceanfront in the wake of World War II, so was a way of life enjoyed for centuries in Princess Anne County, where the population spiked dramatically between 1950 and 1956. County planners published the numbers: the 42,000 residents who lived there in 1950 had nearly doubled to 82,500. This was a ninety-six percent increase in population, all of it attributable to what would eventually be characterized as rampant, uncontrolled growth. Down at the Oceanfront, the rush to develop open space had greater impact because there was less of it with which to work; buildings would have to come down before new ones could go up. The character of the resort was slowly being chipped away. Increased property values meant higher taxes.

"I have watched the opening of a tract of land between the southern border of Seashore State Park and the northern shore of Crystal Lake at Virginia Beach," wrote Louisa Venable Kyle in the November 11, 1956 *Virginian-Pilot* and *Portsmouth Star*. "I have been particularly interested because it explains some of the writing of [Captain George] Percy and the adventurers who landed near Cape Henry on April 26, 1607; it proves there was a wide inlet from the ocean into what is now Crystal Lake and on into Linkhorn Bay." This was the Gordon Hume property, a one hundred-and-thirty-acre tract that had stayed as naturally beautiful and pristine as the park next-door. But she was worried, in retrospect, about the future of such an important tract in the face of the land grab that was going on beyond the already developed Oceanfront. What would happen, she must have wondered, if it were developed and the distinctive series of high ridges that went up from sea level about one hundred feet—running east and west and rising abruptly from low, marshy areas—was suddenly gone. The growth around them was already so dense that the height of the ridges, the undulation of their rise and fall into untouched marshes, was near imperceptible.

There had been, centuries ago, a wide inlet between Cape Henry and The Cavalier Hotel, an opening clearly marked on Augustus Herman's 1673 map. Crystal Lake was part of this inlet. A creek connected it to Linkhorn Bay through Broad [also called Battses] Bay before it continued on to the Lynnhaven River and from there to the Chesapeake Bay, making the land on which sit First Landing State Park [formerly Seashore State Park], Fort Story and the Chesapeake Bay shore east of Lynnhaven Inlet an island. Though it was closed by coastal storms long ago, it was a low-lying section between the old Avenue C and Sixty-Sixth Street that kept the ocean from entering Crystal Lake and remaking the inlet. The only breach reported of any significance in the twentieth century occurred during the 1933 hurricane. The sea rushed in and back out again. But had there been no homes and no streets there, the ocean might once again have opened up a hole in the shore to Crystal Lake, just two blocks inland.

The English who explored here in 1607 took safe harbor in Crystal Lake. The name closely associated with this lake should be familiar: Stratton's Creek. An early settler named John Stratton was granted one hundred-and-fifty acres of land between the east and south bay at Stratton's Creek in 1640. There was also an island in Broad Bay called Stratton's Island, renamed Lovett's Island. An early description of his property indicated that his tract was "nigh the head at the farthest side of the pine standing on the south side and running north, down the creek and easterly into the woods toward the sea." The 1695 map located in the Library of Congress offers confirmation that this would be the opening from Linkhorn Bay into Crystal Lake.

None of the ancient topography mattered much until developers carved out subdivisions and the county cut roads and built bridges to facilitate vehicular traffic. Then it became the top topic of conversation. As developers started to disturb the shore to build, nearby residents started to notice the difference in the sand. Sand on the sea side, dug down far enough, brings up clay. This was not the case on Stratton's Creek. After digging here, only sand and more sand rose to the surface. This was the history of Stratton's Creek in the eighteenth and nineteenth centuries: it would regularly fill up with sand, and swamp marshland narrowed it until by the middle of the 1930s only a canoe or shallow-bottomed rowboat could navigate from Crystal Lake to Linkhorn Bay. But there was no one living there just then to complain. The only known house in the area was built about 1845 as a farmhouse.

Norfolk attorney and developer Hugh Davis bought his first parcel in what would become the Bay Colony subdivision in 1937. Bay Colony was built on the south side of the old creek on land that had once been owned by farmer William H. Rainey, son of John Shepherd and Nancy Padon Rainey. Three years after his father died in 1858, his mother married Thomas Keeling Cornick, and together he and Cornick continued to work the land. William Rainey died in 1914 at age seventy-three, long before he would have seen his farmland gobbled up for development. As Bay Colony was developed on the south side of the old creek, the name Stratton's Creek was changed to Rainey's Gut, which entered Rainey's Pond, now Crystal Lake.

Land development on Crystal Lake's north shore led to the widening of the narrows between the lake and bay by the 1940s. Between the hills the English called mountains, deep canals were cut fifty to one hundred feet wide. A decade later, in the 1950s, there was little doubt left that the "swampy areas" dredged by developers for these deep canals were actually spring-fed creeks that flowed into the original inlet. This all occurred around the area now called Princess Anne Hills, where wildflowers blanketed the steep inclines to the water below, and giant pines, cut to complete construction, lay strewn along the builder's access road to his new canals. "It was not hard to visualize," wrote Kyle, "Indians creeping through these woods to spy on the white men who had just landed from their strange large canoes for one felt far from civilization and the flat coastal beaches."

Princess Anne Hills gave up its name to the development carved from it. Charles Freeman Gillette (1886–1969)—already nationally recognized as one of the premier landscape architects associated with the restoration and re-creation of historic gardens in the upper South and especially Virginia—spent a lengthy period of time walking the land and studying it before drawing a plat that he believed would not conflict with the natural beauty of the original Princess Anne Hills. Gillette could have drawn all day and still not conjured a plan that could protect this area. It had already been forested for project lumber and had unnatural canals dug through it in the place of spring-fed creeks; the landscape had already been touched and thus permanently damaged. Further development in the 1950s that continued aggressively forward for more than two decades later leveled Princess Anne Hills. All of the trees were cut down in wide swaths, sparing only a few for new homes positioned strategically on the water, dividing the land into square lots.

More than a quarter century before all of this development at Bay Colony and Princess Anne Hills occurred, Kathleen Eveleth Bruce wrote a letter to the Norfolk newspapers in 1925 in which she begged that the Virginia Beach resort make use of names of historical significance in the designating of its place names. A few commercial property owners accepted her recommendation and named their establishments thusly, but mostly her suggestions fell on deaf ears. Fast-forward thirty years later, remarked Kyle, and the Princess Anne Hills development would blanket the subdivision with historic names. Roads running along the lakeshore and over the ridges were given names like Susan Constant, Godspeed

and Discovery Ridge, for the three small ships that brought the English settlers to the Cape Henry shore in the spring of 1607. Sadly, after the "ridge" was worn down and no longer detectable, the word was dropped from the name of Discovery Road.

Less than a decade after war's end, in 1952, the resort town of Virginia Beach was designated a city politically independent from Princess Anne County, although the numerous ties between the two municipalities remained strong. The change was perceived, in large measure, as part of a larger reorganization of the boundaries and structures of nearly all of the counties, cities and towns in southeastern Virginia that continued for nearly a quarter century from the designation of the town of Virginia Beach to a small incorporated city. But Virginia Beach's new status would not last long. A little over a decade later, small city and big county merged, an action born largely out of self-preservation. In the years leading up to the January 1, 1963 merger, Princess Anne County had lost much of its western land area to the city of Norfolk, which began an aggressive annexation campaign after it adjoined all of the northern part of Norfolk County. The merger of the county with Virginia Beach prevented Norfolk city from annexing more of, if not all of, the county, which it expressly sought to do, almost up to the day the merger was announced. Today, nearly all of the area formerly called Princess Anne County when it was formed in 1691 is now located in the city of Virginia Beach. The only exceptions are the land area that had been the northwest section of county that became part of Norfolk via annexation and a land swap agreement between the two cities that took place in 1988. After the 1963 consolidation, the new and much larger city was divided into seven boroughs: Bayside, Blackwater, Kempsville, Lynnhaven, Princess Anne, Pungo and Virginia Beach.

Virginia Beach reached a major crossroads when it came to the construction of roads and bridges. The development surge was accompanied by a population uptick that overwhelmed existing roads and bridges in and out of the resort area in the 1950s and 1960s. Roads were woefully inadequate, and there were no bridges in locations that desperately needed them. After the opening of the Hampton Roads Bridge-Tunnel on November 1, 1957, Virginia Beach reaped the benefit of increased tourism but still needed better infrastructure to accommodate the rush of vehicular traffic bound for the Oceanfront. There was no Virginia Beach-Norfolk Expressway [today I-264] to shoot them down to the shore, at least not yet. The old John A. Lesner Bridge that was first opened as a drawbridge across Lynnhaven Inlet in 1927 was particularly antiquated, and it was raised so often to allow pleasure craft to pass that lengthy backups occurred on both sides of the bridge. Three decades later, in 1958, a new raised bridge span replaced the drawbridge [later the eastbound lanes]. Nearly a decade later, in 1967, the addition of what became the westbound lanes was completed and opened to traffic. The twenty-first century has brought further changes to this important span. Though rehabilitation and maintenance extended the life of the bridge for decades, the harsh marine environment caused extensive corrosion of portions of the existing structure that indicated to the commonwealth of Virginia Department of Transportation and the city of Virginia Beach that it needed to be replaced. Construction of twin replacement bridges started in the spring of 2014, affording the state and city the opportunity to make safety improvements for the traveling public, to include vehicular, pedestrian and bicycle, and enhance the aesthetics, open space, landscape and architecture of the Shore Drive corridor. The new and improved Lesner Bridge also eases the traffic flow from the marked increase in permanent population density to vacationers making their way to and from the Oceanfront.

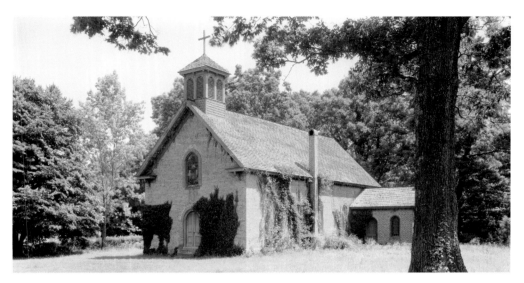

The third Eastern Shore Chapel of Lynnhaven Parish, photographed by Frances Benjamin Johnston in 1930 as part of the Carnegie Survey of the Architecture of the South, was located at the far end of Great Neck as it extended south of Oceana, on lands granted in 1657 to William Cornick, son of Simond Cornick, who arrived in the Virginia colony in 1650. William Cornick's home, called Salisbury Plain plantation, was acquired by the United States Navy in 1952—with the chapel—for the expansion of Naval Air Station Oceana. The chapel was built within half mile of Salisbury Plain plantation by builder Joseph Mitchell. Construction was completed on March 12, 1754/5. After the navy acquired the property, it was condemned and disassembled, and a new Eastern Shore Chapel conforming as much as possible to the blueprints of the old structure was rebuilt at the chapel's present site on Virginia Beach's Laskin Road. *Library of Congress*

The Bible and chalice set shown here were used in the Chapel by the Sea (name of the church is on the Bible cover) that once stood on the Dam Neck beach. These items are now kept at the Eastern Shore Chapel on Laskin Road. The chapel's history started in the summer of 1889 when the original church was under construction near the Dam Neck Mills Lifesaving Station, built of wood from the wrecked three-masted ship *Agnes Barton*. In 1929, the facility was no longer being used as a church. The rector of Norfolk's Christ and Saint Luke's Church bought the building, moved it a short distance from the lifesaving station and it was then used as a summer camp for Christ and Saint Luke's girls. The former chapel building is believed to have been destroyed by the 1933 Chesapeake-Potomac hurricane. *Edgar T. Brown Collection, Virginia Beach Public Library*

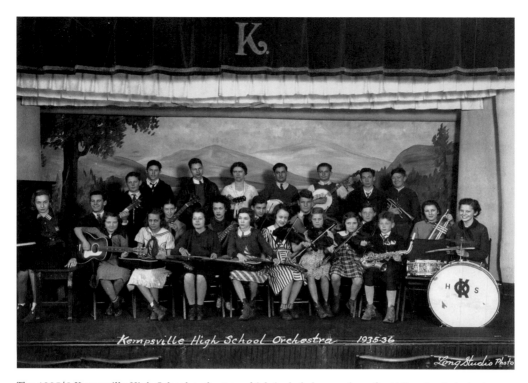

The 1935/6 Kempsville High School orchestra, which included a number of middle school students, was photographed by Long Studio. Identifiable students in the first row (left to right) include Ethel Mae Broun, Evelyn Mae McKown, Shirley Frances Wolfe, Susan Katharine "Susie" Whitehead, Betty Jervis, Frances Charles Phillips, Doris Elizabeth Wolfe, Eula Lee Jervis, Kenneth Dahl Broun, Lorraine Denney, Edna [no last name]; second row (left to right) James Earl Krahenbill, unidentified, Katherine Carr Phillips, Richard George Broun, Percival Leonard "Percy" Longworth, Tommy Lane; third row (left to right) unidentified, Clarence Day, unidentified, Lucille Furcron Smith (music director), Johnny Mann, Billy Mann, Harvey Edward "Eddie" Frizzell, and Cecil Frizzell. Smith was a ticket agent for Norfolk Southern Railroad before she became the secretary to the Kempsville High School principal, clerk and matron and the music director. *Shirley Wolfe Jones Collection, Virginia Beach Public Library*

Opposite above: This is the Lesner Bridge over Lynnhaven Inlet after a snowstorm on February 16, 1936. Charles Borjes took the photograph. The bridge, named for John Adam Lesner (1868–1938), a Norfolk County native who twice served as a Democrat member of the Senate of Virginia (1908–1916 and 1923–1938), was first built in 1927 as a drawbridge (as shown here); it was not until thirty-one years later, in 1958, that the drawbridge was replaced with a high-level bridge to ease the congestion of vehicular and boat traffic over and through the Lynnhaven Inlet. Lesner was a major advocate for the construction of a modern highway system in the commonwealth of Virginia. In his private sector life, he was the president of the Mutual Federal Saving and Loan Association, with offices in Norfolk, Virginia. *Sargeant Memorial Collection, Norfolk Public Library*

Opposite below: A gathering of local members of the Virginia General Assembly was held on September 24, 1937, at the East Ocean View [Norfolk, Virginia] home of state senator John Adam Lesner. All politicians in this photograph represented areas within Virginia's second congressional district. Those pictured (front row, left to right) include Delamater Davis (Norfolk City); Edward Thomas Humphries (Norfolk County); Lesner (Norfolk City); Harry Branham Davis (Princess Anne County); John Mills Britt (Southampton County), and Edward Jordan Taylor (Suffolk City and Nansemond County). Pictured in the back row (left to right) are George Curtis Hand (Norfolk County); Vivian Llewellyn Page (Norfolk City); Robert Frederick Baldwin (Norfolk City), Edward Lebbaeus Breeden Jr. (Norfolk City); Allie Edward Stakes Stephens[61] (Isle of Wight County); Richard Willing Byrd Ruffin Jr. (Norfolk City); Edward Everett Holland (Suffolk City), and Major McKinley Hillard (Norfolk County). This group was formed to work together on key issues affecting their communities. *Sargeant Memorial Collection, Norfolk Public Library*

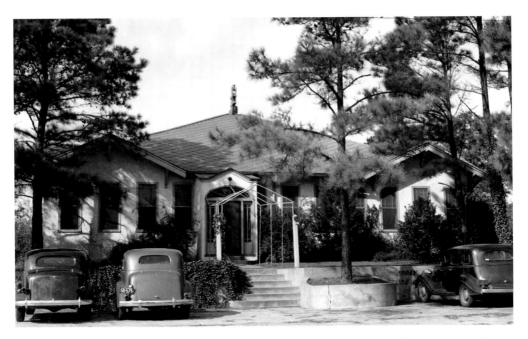

The Pine Tree Inn, pictured here on October 7, 1936, was built in 1927 and opened the following year on Virginia Beach Boulevard near Lynnhaven Road by contractor Joseph Eley Causey Davis (1878–1932) and the former Maud Moore (1879–1942), who started out on the same site in 1922 with a smaller restaurant called the Lynnhaven Inn. The second generation of Davises to own the Pine Tree Inn was James Edwin Clayton Davis (1911–1986) and his wife, the former Marian Styron McLean (1913–1983), active in the restaurant until their deaths. The restaurant had a remarkable seventy-three-year run before it closed. The building was razed in January 2001 to make way for a convenience store and gas station. *Sargeant Memorial Collection, Norfolk Public Library*

The Tidewater Horse Show was held at Carolanne Farms in the Kempsville section of the city (then Princess Anne County) when this picture of a horse and rider waiting to participate in a jumping event was taken on October 16, 1936. *Sargeant Memorial Collection, Norfolk Public Library*

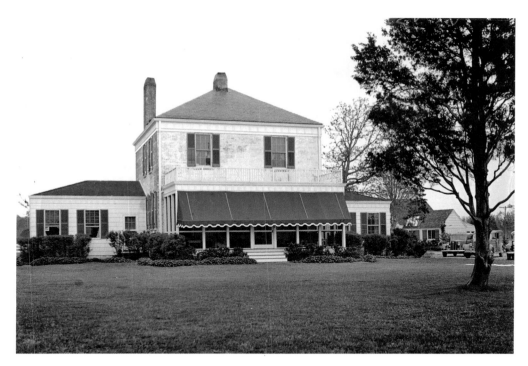

The Bay Colony Club on South Bay Shore Drive in the Bay Colony section of the city is pictured as it looked on May 8, 1937. The club was a residential hunt club, meaning that members and guests could secure overnight accommodations to hunt, recreate and relax, and attend social functions. *Sargeant Memorial Collection, Norfolk Public Library*

The newly constructed Princess Anne County Training School for African Americans, located at Cleveland Street and Witchduck Road in the Euclid section is shown in this January 4, 1938 Charles Borjes photograph. The Works Progress Administration (WPA) funded facility had four classrooms, a 400-seat auditorium, a principal's office and library. The dedication took place in October 1937. The school was later expanded in size and renamed Union Kempsville High School in 1962. Seven years later, in 1969, the facility was closed after the implementation of city-wide integration of the Virginia Beach school system. The architects of the original building were the Norfolk firm of Rudolph, Cooke and Van Leeuwen. *Sargeant Memorial Collection, Norfolk Public Library*

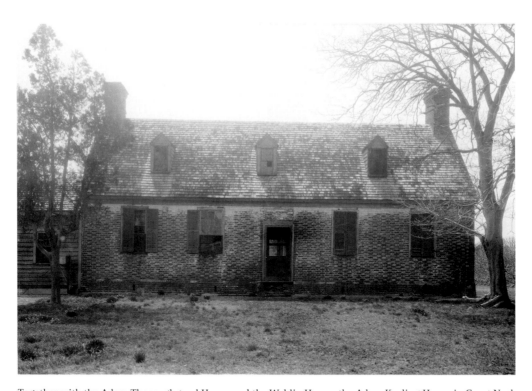

Together with the Adam Thoroughgood House and the Weblin House, the Adam Keeling House in Great Neck Point represents improvements in gentry housing in the Chesapeake in the first decades of the eighteenth century. Dendrochronological analysis suggests the Keeling House was constructed around 1735, and the presence of a central passage place the building at the forefront of the status-bearing houses that had two stories and plans two rooms deep seen throughout lower Tidewater. Of interest, it is significant that in the several generations of Keelings associated with the house, the first names of Keeling heirs alternate between Thomas and Adam. Thus, it is highly likely that the house standing today was not the house left to the second Adam Keeling by his father Thomas, who died in 1714/5, mentioning a "house." The second Adam Keeling died in 1771, leaving his property (and the house shown here) to his grandson, the third Adam Keeling. Given the scientific dating of the house, it is still "the Adam Keeling" house, just not the first Adam Keeling, son of the first Thomas Keeling and godson of Adam Thoroughgood. William Harry Bagby took this picture of the east elevation of the Keeling house on March 29, 1934, as part of the Historic American Buildings Survey (HABS) of the property. Architectural details distinguishing the Adam Keeling House include Flemish bond brickwork with glazed headers and glazing that forms rakes in the upper gables as well as paneling on the interior that features ceiling-height pilasters on either side of the fireplace and a stair with a closed stringer, classical balusters, molded stair nosing, and a pulvinated frieze. *Library of Congress*

Opposite page: The Adam Keeling House and surrounding parcel were sold to George and Jane Syer in 1938. The Syers hired architect Mary Ramsal Brown to design a modern kitchen to be added to the south gable-end of the house. This addition accesses the main floor of the original house through one of the original closets to either side of the chimney. Electricity and plumbing were added to the original house for the first time, and a small bathroom was placed at the top of the stairs. The Syers also added a detached garage close to the street, accessible to the house by a long brick walkway bordered today by large shrubs. The property, which had been 362-acres before Charles Consolvo bought it from John Avery and started selling off smaller plots in 1890, was further divided into residential lots during the Syers' ownership, many of which were sold to the couple's friends and acquaintances. A substantial number of homes now built around the Adam Keeling House were constructed in the 1940s and 1950s. The Syers renovation and additions were photographed on March 31, 1938, just as the work was getting underway (above) and showing some progress (below). The Syers sold the house in 1955. *Sargeant Memorial Collection, Norfolk Public Library*

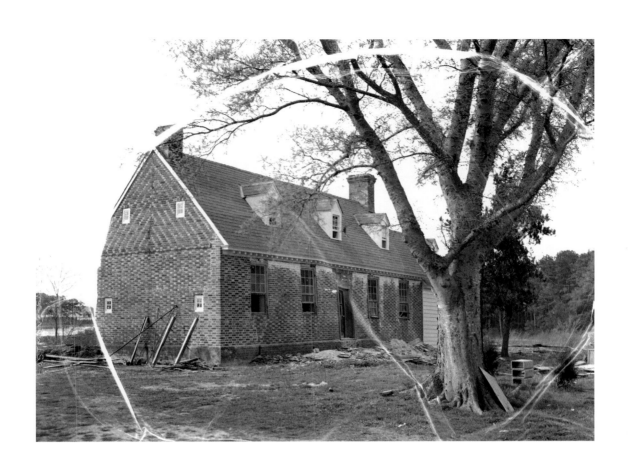

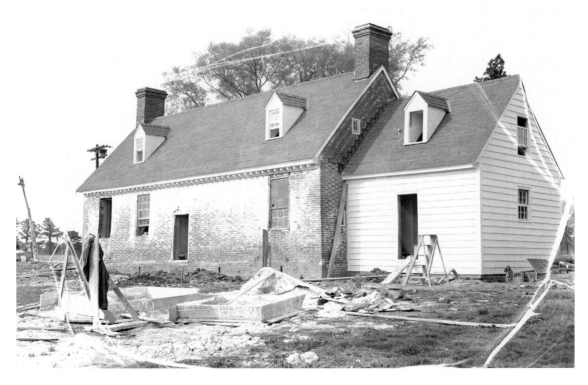

Truck farmer Luther Winslow Saunders (1888–1983) and his son Jack (John Kenneth), of Princess Anne County (now Virginia Beach), displayed a blacksnake they spotted crossing the highway in front of their car. At that time, the snake, measuring seven feet, two inches, was believed to be the largest of its species captured in the county. The picture was taken on August 13, 1938. *Sargeant Memorial Collection, Norfolk Public Library*

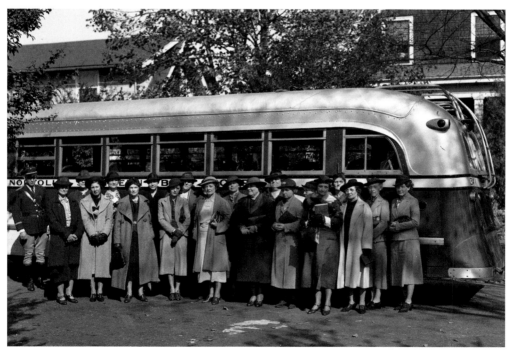

The Tidewater Tuberculosis Hospital Association formed in 1930 to fund-raise and build a hospital in Princess Anne County. Fund-raising, planning and construction took longer than anticipated but the hospital had been dedicated before this October 18, 1937 photograph was taken. The group of women shown here were preparing for a fund-raising trip in the Larchmont section of Norfolk to raise money for the newly-built Tidewater Victory Memorial Hospital for tuberculosis patients, located near Thalia Creek. *Sargeant Memorial Collection, Norfolk Public Library*

On November 23, 1937, a small group toured the newly completed Tidewater Victory Memorial Hospital in the county's Thalia section. Those pictured here (left to right): Dr. Irl Cephas Riggin, of Richmond, Virginia, a state health commissioner; Marion Parry Crosby, of Norfolk, a member of the hospital committee; Vernon Gaskins Eberwine, of Suffolk, Virginia, acting president of the Tidewater Tuberculosis Hospital Association, and Rufus Parks, of Princess Anne County, another committee member. *Sargeant Memorial Collection, Norfolk Public Library*

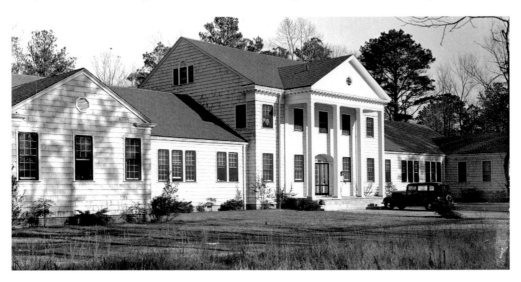

The newly renovated Tidewater Victory Memorial Hospital is shown in this January 7, 1939 photograph. The hospital was short-lived. Patients did not do especially well in the area's well-known humidity. The commonwealth of Virginia took over the hospital just over two years later, in 1941, at the start of World War II, and leased it to the United States Army as a prisoner of war camp for Germans captured in North Africa and also those saved from sunken U-boats. The camp was built around the former tuberculosis hospital. In 1950, Willis Wayside, a furniture store, opened here. A little over three decades later, the property expanded into a shopping village known as Wayside Village Shoppes, anchored by Willis Furniture Company. *Sargeant Memorial Collection, Norfolk Public Library*

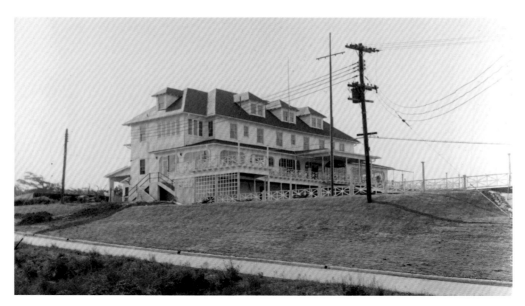

The Terrace Beach Club corporation was chartered in January 1938 and quickly acquired the former Princess Pat Hotel on Atlantic Avenue between Sixty-Seventh and Sixty-Eighth Streets, which it renovated and reopened in time for the summer season that year. The Terrace Beach Club was photographed on May 7, 1938, after renovations had been completed. During World War II, the club housed military personnel. After the war, it returned to a private club. Today, the building is part of the Association for Research and Enlightenment (ARE) campus. Of note, the Princess Pat Hotel had been built in 1928 as a hospital and sanitarium for the use of renowned psychic Edgar Cayce; it was called the Cayce Hospital for Research and Enlightenment. In a roundabout way, the club repatriated to a former steward. *Sargeant Memorial Collection, Norfolk Public Library*

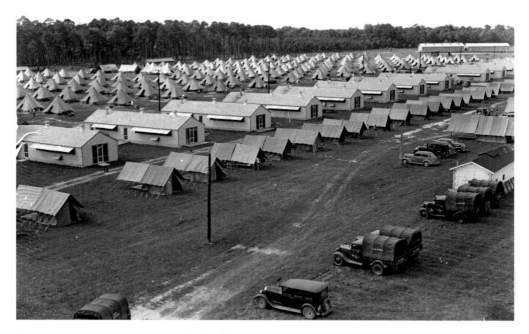

There were over 200 tents set up at the Virginia state military reservation—Camp Pendleton—to hold about 1,200 officers and men with the Virginia National Guard's 116th Infantry when this picture was taken on July 11, 1938. The infantry unit arrived at the camp for two weeks of intense training. *Sargeant Memorial Collection, Norfolk Public Library*

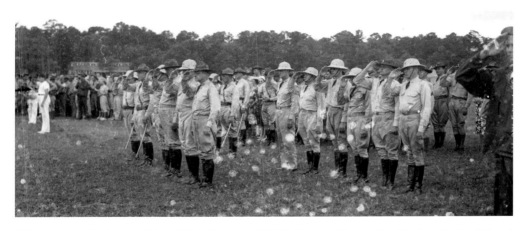

Officers and enlisted men of the 116th Infantry and 246th Coast Artillery of the Virginia National Guard staged a joint parade and review on July 22, 1938, at the state military reservation, where the infantrymen were encamped. The state military reservation is today known as Camp Pendleton. *Sargeant Memorial Collection, Norfolk Public Library*

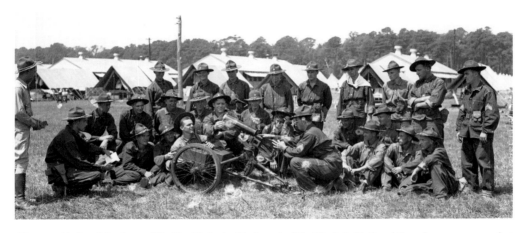

Above and below: Members of the First Infantry Regiment of the Virginia National Guard were encamped at the state military reservation (now called Camp Pendleton) for two weeks of training when this picture was taken on August 15, 1938. *Sargeant Memorial Collection, Norfolk Public Library*

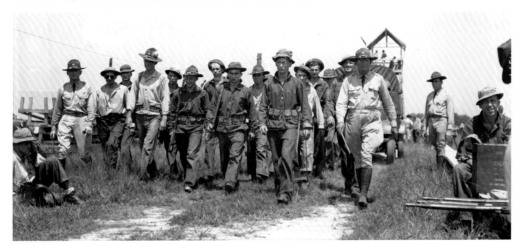

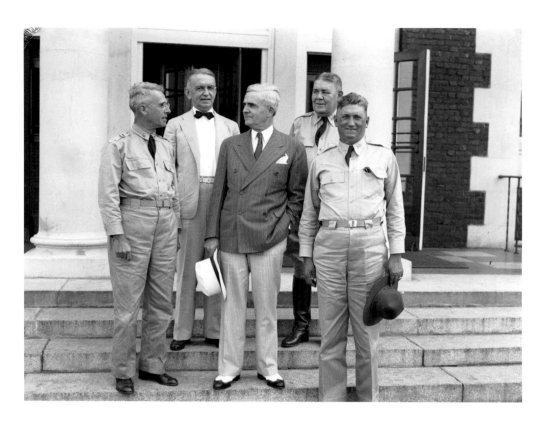

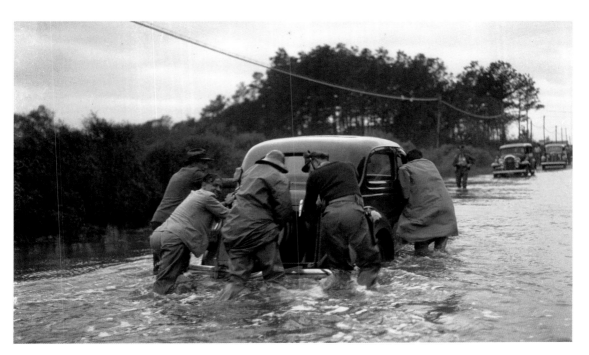

Photographers and police officers helped push Arthur Edward Scott's car out of the water on flooded Virginia Beach Boulevard [Route 58] on April 17, 1939; he was nearly to the Oceanfront when his car became trapped in high water. The first hard-surfaced road from Norfolk to Virginia Beach, Virginia Beach Boulevard opened in July 1921. "The Boulevard," as it became widely known locally, was a major factor in the growth of the Oceanfront and adjacent portions of the former Princess Anne County (consolidated with Virginia Beach in 1963) as automobiles replaced streetcars and trains as a preferred mode of travel. Scott (1913–1977) began his press career at the age of thirteen as a copyboy for the *Washington Times-Herald*. From 1934 to 1955, Scott served as a news photographer for International News Photos and Wide World Photos. Scott first covered the United States Congress in 1935 as a photographer for the *Washington Times*. From 1955 to 1974, Scott worked as a photographer for the Republican Senatorial Committee (1955–1964) and the Replublication Policy Committee (1964–1974). In 1975, the year the Senate Historical Office was created, Scott became the United States Senate's first photo-historian. *Arthur Edward Scott Photograph Collection, George Mason University Libraries Special Collections and Archives*

Opposite above: Virginia governor James Hubert Price (1878–1943) was in Virginia Beach on August 26, 1938, to review the First Infantry Regiment of the Virginia National Guard at the state military reservation. Pictured on the steps of the Cavalier Hotel, after a luncheon hosted by Colonel Clifford Cabell Early, of the United States Army, are (left to right) Colonel John Fulmer Bright, commander of the First Infantry, a physician and also the mayor of the city of Richmond, Virginia, from 1924 to 1940; Virginia National Guard colonel [inactive] William Mauzy Kemper, the governor's executive assistant; Governor Price; Virginia adjutant general Samuel Gardner Waller[62], and Colonel Early. Price had just been inaugurated the fifty-third governor of Virginia on January 19, 1938. *Sargeant Memorial Collection, Norfolk Public Library*

Opposite below: Max and Gilbert Reuben Friedman show off a string of twelve largemouth bass they caught at Lake Smith on October 6, 1938. Max Friedman (1895–1984), born in Russia, served in the American Expeditionary Forces, Twenty-Ninth Division, Company B 112th Machine Gun Battalion during World War I and belonged to an elite postwar survivor group called "The Last Man's Club." According to Laura Friedman Buzard, Gilbert's daughter, the men in the club purchased an expensive bottle of wine to be consumed by the last man alive. Max Friedman owned Buffalo Confectionary on Norfolk's East Princess Anne Road. Gilbert Friedman (1925–2014), served in the United States Army's Thirty-Sixth Infantry Division during World War II, for which he was awarded two Bronze Stars, two Purple Hearts, and the Combat Infantry Badge. He also toured with the division band (he played the saxophone). He was the owner and president of M & G Sales, the army-navy store on Norfolk's Granby Street, for over fifty-seven years. *Sargeant Memorial Collection, Norfolk Public Library*

Charlie and Marion Forbes opened their first retail outlet to sell their famous peanut brittle and saltwater taffy at Virginia Beach in 1933 but the Great Atlantic hurricane that year destroyed it within a month of the store opening. Undeterred, the couple opened a new outlet in a converted two-car garage on Atlantic Avenue and Seventeenth Street in 1939 (shown here) that belonged to Carrie Williams Morrison, the widow of Dr. Edgar Harold Morrison. At that time, they also expanded their candy making to include fudge, pecan logs, sea foam, jellies and many other confections. *Amy Waters Yarsinske*

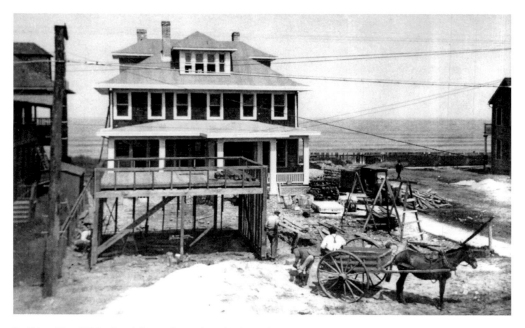

Dr. Edgar Harold Morrison's house, located on the Oceanfront at Seventeenth Street, supplied the garage (shown here under construction) that became the site of Charlie and Marion Forbes' candy store. Morrison, in addition to being a physician, had extensive real estate holdings in Virginia and North Carolina. The most valuable of his properties were in the town of Virginia Beach, consisting of houses and lots used for both residential and business purposes. He also owned two large farms in North Carolina and a residence in Tarboro in Edgecombe County. Morrison died on April 2, 1936, at the age of sixty-one. *Edgar T. Brown Collection, Virginia Beach Public Library*

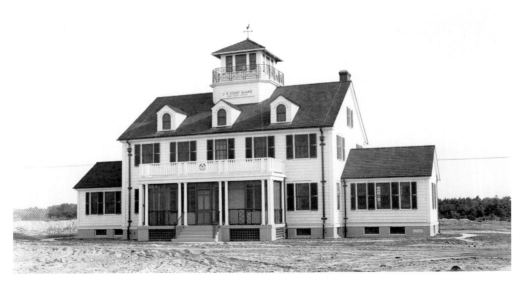

The United States Coast Guard Cape Henry Station, completed in or about 1925, is shown in this July 17, 1939 photograph. The station made the local newspapers because it was torn down shortly after the picture was taken. The station was determined to be inviable in 1938, after the army informed the coast guard that it was in the firing line of coast artillery guns at Fort Story. An identical replacement building[63] and new boat house were built on the coast guard military reservation at Little Creek between 1938 and 1939. *Sargeant Memorial Collection, Norfolk Public Library*

The town of Virginia Beach annexed the area west of Holly Road known as Linkhorn Park [on Linkhorn Bay] in 1923 and also the area north to Forty-Second Street. This aerial photograph, taken seventeen years later, in 1940, shows a still largely undeveloped Linkhorn Park on the east side of Little Neck Creek, west of the Cavalier Hotel. *Sargeant Memorial Collection, Norfolk Public Library*

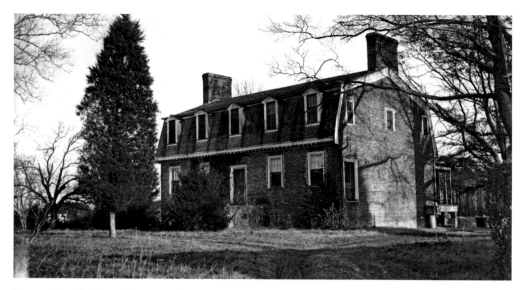

Thomas Carroll Mason (1900–1979), an employee of the Norfolk and Western Railroad who lived in the London Bridge section, took this photograph of the Francis Land House (also called Rose Hall) in 1940. The house, built between 1805 and 1810 on the Pine Tree Branch of the Lynnhaven River and once surrounded by hundreds of acres[64] of farmland, was the home of Francis Land VI, a wealthy plantation owner from a prominent line of Francis Lands and Land family of Princess Anne County. While the architecture of the house is Georgian, the interior is Federal. The exterior walls are double-depth Flemish bond brickwork. *Sargeant Memorial Collection, Norfolk Public Library*

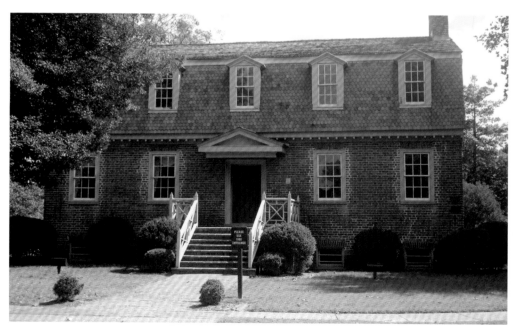

The restored Francis Land House, located on Virginia Beach Boulevard, is shown in this September 18, 2010 photograph. The city of Virginia Beach purchased the house in 1975 and opened it as a historic house museum in 1986. The house is furnished with a mix of period antiques and reproductions to interpret the period that Francis Land VI and his wife, the former Mary White, and daughters Mary Elizabeth Land and Anne White Land, were in residence between 1805 and 1819. The house was listed on the Virginia Landmarks Register (Virginia Historic Landmark) and National Register of Historic Places in 1975. *Rlevse*[65]

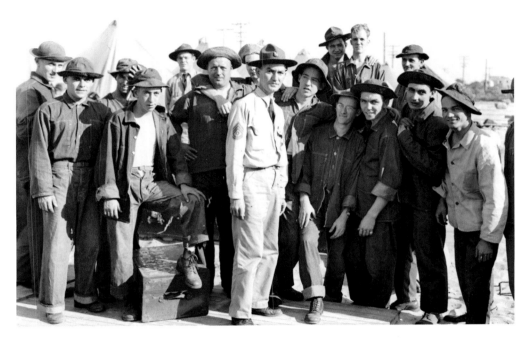

Soldiers from the army's 246th Coast Artillery Corps are shown at Fort Story in this Charles Borjes September 19, 1940 photograph. The former Virginia National Guard unit, consisting of three Coast Artillery Corps regiments, was there to participate in coastal defense training. They were housed in 133 eight-man tents for ninety days while the forty-five-temporary barracks were being built for the 1,400 men. *Sargeant Memorial Collection, Norfolk Public Library*

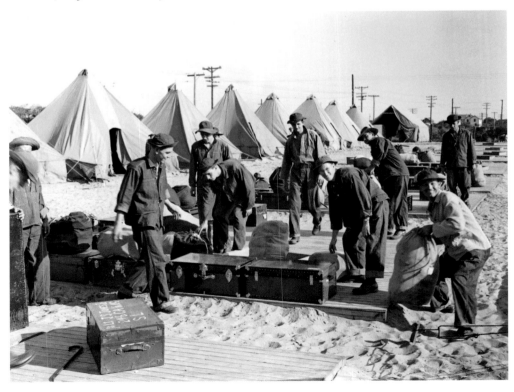

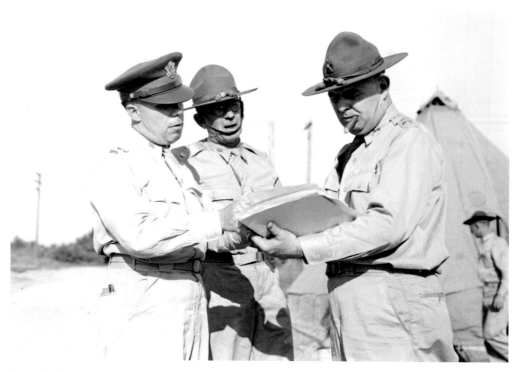

Taken by Charles Borjes, also on September 19, 1940, Fort Story officers (left to right) Lieutenant Martin Walter Richwine Jr., of the 246th regimental staff; Lieutenant Colonel Dale Durkee Hinman[66], commanding officer at Fort Story and of the 71st Coast Artillery Corps, and Lieutenant Joseph S. Jones Jr., commander of the battery, are shown in the photograph. *Sargeant Memorial Room, Norfolk Public Library*

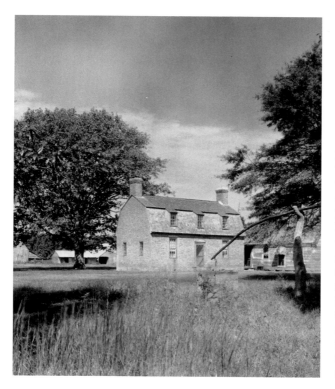

The Jonathan Woodhouse Plantation, on Princess Anne County Route 632 near Nimmo, was documented for an Historic American Buildings Survey on November 11, 1940. The date brick for the home is marked "W. W. P. 1760." The compact, Dutch gambrel-roofed building was so pleasingly designed that not even the once dilapidated frame kitchen wing (visible in the photograph) detracted from the original home's proportions. The old delicately pink Flemish-bond brick walls taper at the ends beneath the roof so gently pitched as to appear curving. The entry door was constructed between narrow windows topped with flat brick arches, and three dormers cast their shadows on the lower roof. Several Jonathan Woodhouses lived in this house, all descended from Captain William Woodhouse and his wife Pembroke. *Library of Congress*

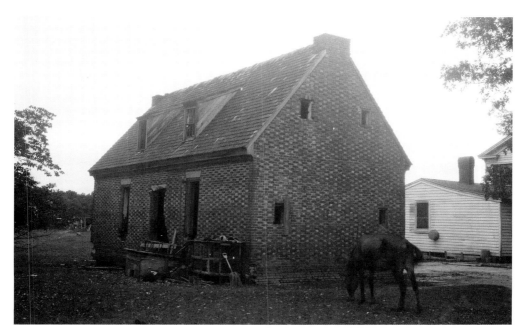

Eastwood, also known as the Smith Estate and located on Great Neck Lake in the London Bridge section, was photographed by Thomas Tileston Waterman and recorded for an Historic American Buildings Survey on November 11, 1940. The house dated to the early eighteenth century. Occupants of the home included William Aitchison, a merchant who did business in Norfolk and owned this estate, which he purchased from Captain John Willoughby. The elder Aitchison died in 1776, and his tombstone, though located, displayed a coat of arms too worn to be made out. Aitchison had represented the Norfolk Borough in the Virginia House of Burgesses from 1759 to 1761. Aitchison's son, also William, noted in the codicil of his will, drafted in 1804, that John Lovett, of Princess Anne, had bought Eastwood. The early eighteenth-century home was in ruinous condition when documented. Of the mantels that were in the house, one was cut down and the other re-erected in a newer home nearby. *Library of Congress*

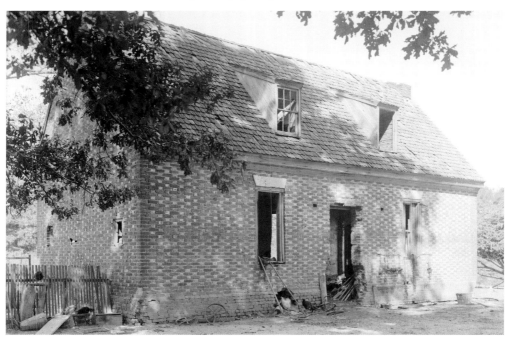

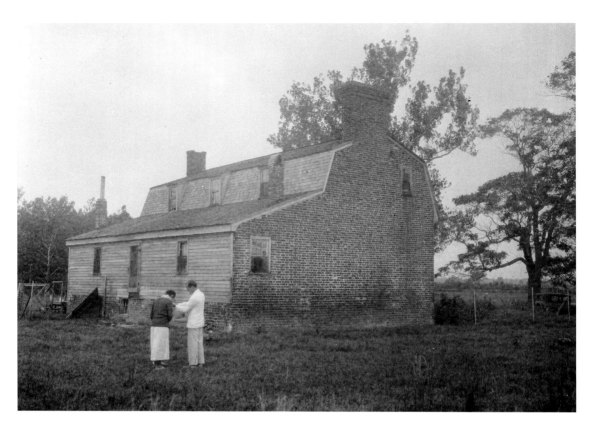

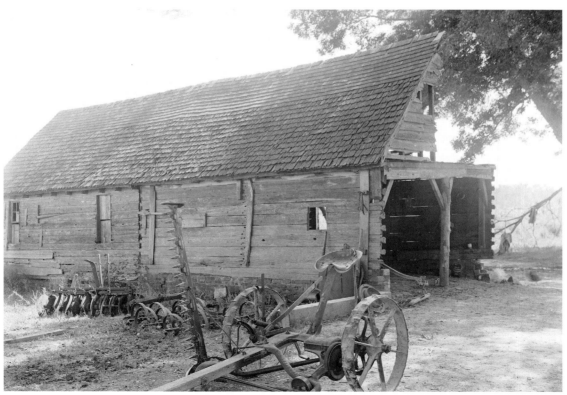

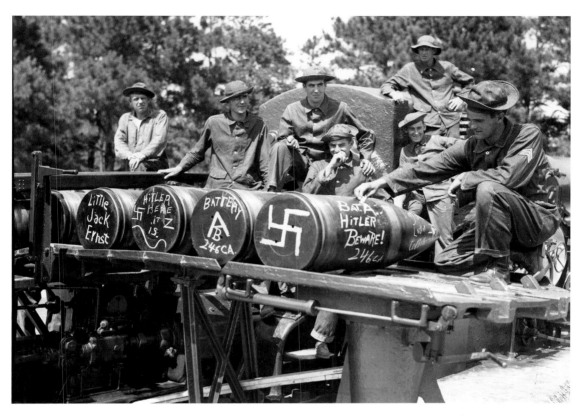

During exercises at Fort Story on June 10, 1941, soldiers of Battery A (the Walke Battery), 246th Coast Artillery Regiment of the Virginia Army National Guard personalized one-ton projectiles for use in their sixteen-inch Howitzer gun. *Sargeant Memorial Collection, Norfolk Public Library*

Opposite above: Though the elder William Cornick began construction of Salisbury Plain plantation before his death in 1700, he would not finish it. One of William Cornick's two surviving sons, Joel, married Elizabeth Woodhouse and their children were Endomion, Nimrod, William, Joel, Henry and Prudence. When Joel Cornick made his will in 1727, he left the plantation to his son Joel, given to him by his father in 1692. With this devise, the father Joel imposed on his son Joel the responsibility of "[...] finishing the house I am now building." This was the house shown in this picture near Eastern Shore Chapel, which took three generations of Cornicks to be completed. The property remained in the Cornick family until after the death of Captain John Cornick, son of John and Amy Keeling Cornick, in 1859, when under his will, the place was sold. After two centuries, only the burying ground remained in the Cornick family. Salisbury Plain, near Oceana, was photographed in or about 1940 as part of an Historic American Buildings Survey. *Library of Congress*

Opposite below: The Brock Farm quarters, built about 1793, was in a state of ruin when it was documented on May 29, 1941, as part of an Historic American Buildings Survey (HABS). Located near Nimmo, it was an example of a plank house frequently seen farther west in Virginia and North Carolina but unusual, if not unique, in Princess Anne County. The structure was partially unroofed in the hurricane of 1933 and, when visited in 1938, had not been repaired. The building was one-story high with a loft in the gable roof. All walls were of planks about three inches thick. These were probably sawn, and the ends were dovetailed together. The plank walls rested on a brick foundation wall, laid in Flemish bond. There was evidently never a framed floor, the earth probably having been tamped to an even surface. It was noted that the sill piece that rested on the brickwork was deeply worn at the door where people stepped on or across it to the floor below. The entire structure was constructed without iron. There were no nails or metal hinges. *Library of Congress*

On November 6, 1941, Lieutenant Commander Philip Daly Gallery (1907–1973), received orders to report to the "antiaircraft range, Norfolk," yet no one could tell him anything about his new duty station. He did some checking and discovered that the navy was in the process of building two small frame buildings near a coast guard station about five miles south of Virginia Beach on the Atlantic Coast. This was the start of Dam Neck's antiaircraft training and test center. wThe base originally had a firing line, one control tower, one magazine, one office and one shop. There were no quarters or messing facilities. On April 4, 1942, the activity was officially commissioned with Gallery (shown here) as commanding officer. The first barracks building, a mess hall and early classrooms were completed, and the staff consisted of two officers and approximately forty enlisted men. The picture was taken on August 2, 1941. Gallery, who rose to the rank of rear admiral, retired in 1958. *Naval History and Heritage Command*

The newly constructed government recreation center, to be operated by the United Service Organizations (USO), was informally opened at Eighteenth Street and Arctic Avenue over the January 30–31, 1942 weekend and is shown in this photograph taken the following February 6 for the newspapers. The new club was the largest in the United States when completed and its program activities involved nightly attractions in a huge arena and theater. Prior to construction of this building, the USO occupied temporary quarters in the infant sanitarium at Eighteenth Street and Atlantic Avenue. *Sargeant Memorial Collection, Norfolk Public Library*

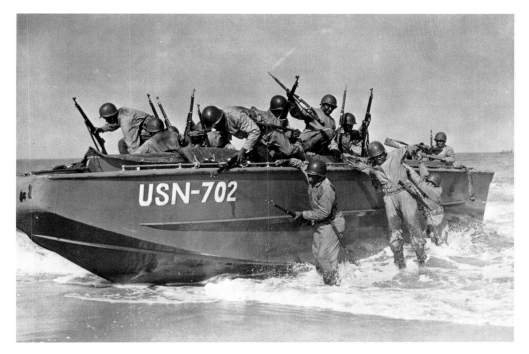

Members of an African American naval construction battalion (also called Seabees) trained at Camps Allen and Bradford during the Second World War [today areas of Little Creek Amphibious Base]. In this 1942 photograph, they practiced landing tactics as well as general military drill. *National Archives*

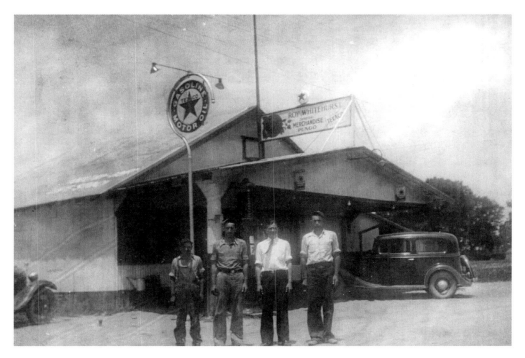

Roy Swanson Whitehurst's Pungo general merchandise store and Texaco station in Pungo is shown in this picture, taken in or about 1941. Pictured here (left to right) are Marvin Edward Lovitt (1916–1999), Roy Whitehurst (1905–1980), Roy Lee Lovitt (1913–1979), and a man who is unidentified. *Edgar T. Brown Collection, Virginia Beach Public Library*

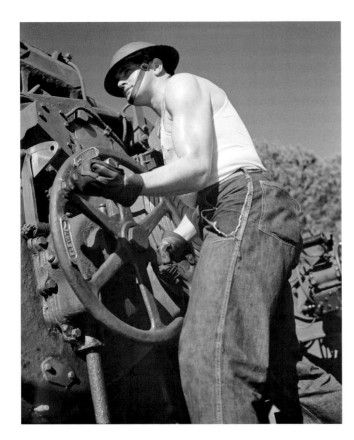

Left: In this March 1942 Alfred T. Palmer photograph, one of Uncle Sam's fighting men at Fort Story is shown adjusting the range on one of the giant coast artillery guns that lined the Virginia Beach shoreline during the Second World War. *Library of Congress*

Below: Fort Story coast artillerymen operate an azimuth instrument, to measure the angle of splash in sea-target practice. The picture was taken by Alfred T. Palmer in March 1942. *Library of Congress*

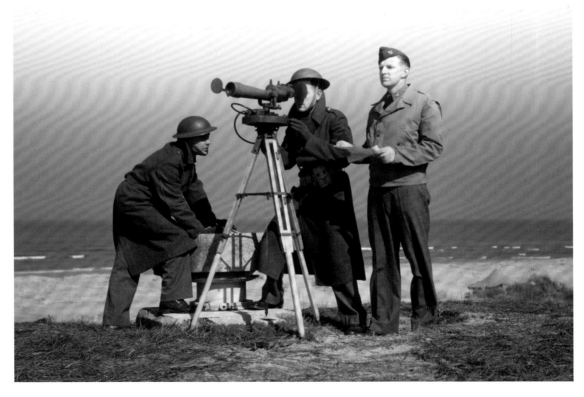

In this coast artillery plotting room at Fort Story, officers who direct the firing of the big guns were photographed by Alfred T. Palmer in March 1942 as they worked out gunnery problems. *Library of Congress*

The new Kempsville High School, shown here on May 14, 1942, was, like its predecessor, on Jericho Road. After a new high school was built in 1966 off of Kempsville Road, the old school was subsequently repurposed as part of Kemps Landing Magnet School. In 2016, it was converted to the 525 Historic Kempsville Apartments, a luxury apartment complex [with an address fronting Kempsville Road]. As part of the conversion, developer Jack Pope preserved much of the old building and tried to build around original walls and other structures. *Sargeant Memorial Collection, Virginia Beach Public Library*

Left: Admiral Royal Eason Ingersoll (1883–1976), commander in chief, United States Atlantic Fleet, stood on the beach at Cape Henry to watch the Operation Torch task force standing out from Hampton Roads, Virginia, en route to North Africa on October 24, 1942. Operation Torch, the Algeria-Morocco Campaign, commenced that November 8, with three task forces landing on the beaches near Casablanca on the Moroccan Atlantic coast; near Oran in western Algeria, and near Algiers, more than 250 miles to the east in Algeria. *Naval History and Heritage Command*

Opposite page: German prisoners of war worked at the Weaver Fertilizer Company plant, where they earned money for use in their prison camp's canteen. They were being held at Camp Ashby in the Thalia section of old Princess Anne County off Virginia Beach Boulevard. Most of the men were from General Irwin Rommel's Afrika Korps. The pictures were taken by H. D. Vollmer on April 6, 1944. *Sargeant Memorial Collection, Norfolk Public Library*

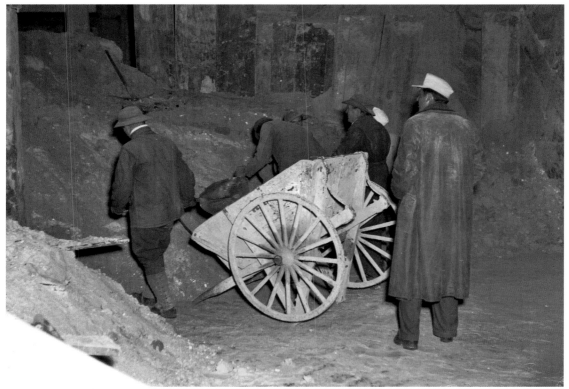

This is a landing craft personnel (ramp) (LCP(R)) operating off Camp Bradford, Little Creek, Virginia, during amphibious training exercises, between 1943 and 1944. Note the rubber inflatable boats it is carrying, which the LCP(R) launched for trainees to paddle ashore to the objective. *National Archives*

Despite the war and even the difficulty posed by the intense security around Camp Ashby, the German prisoner of war compound, horse races continued in the Thalia section. The picture shown here [of a cart race] was taken in 1944. *Edgar T. Brown Collection, Virginia Beach Public Library*

The Cavalier Shores neighborhood was developed as part of the four-thousand-acre project that included Bay Colony, what is known today as the Cavalier Golf and Yacht Club and, of course, the feature attraction: The Cavalier Hotel. Within a decade of the hotel's opening, Cavalier Associates divided part of the Cavalier properties into the exclusive neighborhood of homes and cottages of Cavalier Shores, connected to the hotel and beach club by brick walkways, landscaped gardens and tree-lined pathways. Bridle paths and alleys provided easy access to the back of residences in this development. Residents of the neighborhood were invited to enjoy the amenities of the hotel. Mother Nature struck this neighborhood hard near the end of World War II. Tornado damage to Nancy Pearson Patterson's Cavalier Shores cottage is shown in this Charles Borjes August 2, 1944 picture. Patterson (1880–1947) was the widow of cotton and textile magnate Samuel Finley Patterson who died unexpectedly on May 28, 1926, of a heart attack at his home in Roanoke Rapids, North Carolina, just a week after his election as president of the American Cotton Manufacturers Association. He was just fifty-nine years old. Of note, Samuel Patterson was also an active trustee and officer in the Cotton Manufacturers Association of North Carolina and the Southern Cotton Manufacturers Association. Patterson's third wife, the former Nancy Nyshe Pearson[67] was born in Northampton County, North Carolina, and married him in Portsmouth, Virginia. The couple had one child, Mary Blythe Patterson (later Schneider) (1915–1951). After his death, she and Mary Blythe lived in Norfolk before moving to temporary quarters at the Virginia Beach cottage (shown here) at Raleigh Drive [later changed to Forty-Fourth Street] and the Oceanfront. *Sargeant Memorial Collection, Norfolk Public Library*

Naval Auxiliary Air Station Oceana North Station's enlisted barracks were awash in mud when this picture was taken March 1, 1945. An assortment of inverted gull wing Vought F4U-1D Corsairs and Grumman F6F Hellcats are parked on the flight line. *United States Navy*

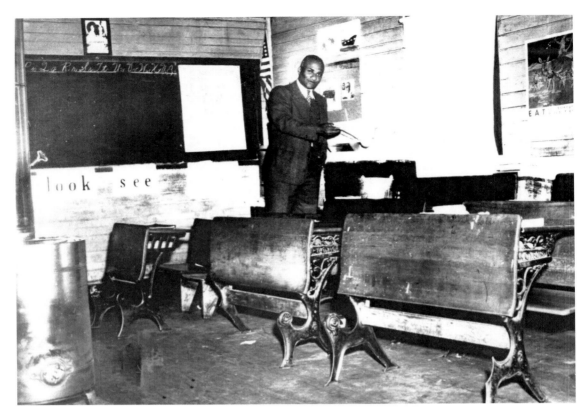

The Blackwater School, a one-room school used by African American children, is shown in these exterior and interior photographs, also published in the November 3, 1946 *Journal and Guide*. William Frances Taylor Jr. (1905–1972), a funeral director and chairman of the Joint Citizens Committee, stands by a drinking water bucket and holds up a dipper used by all of the students (top). *Edgar T. Brown Collection, Virginia Beach Public Library*

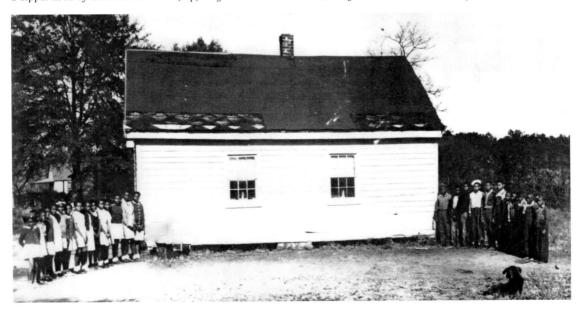

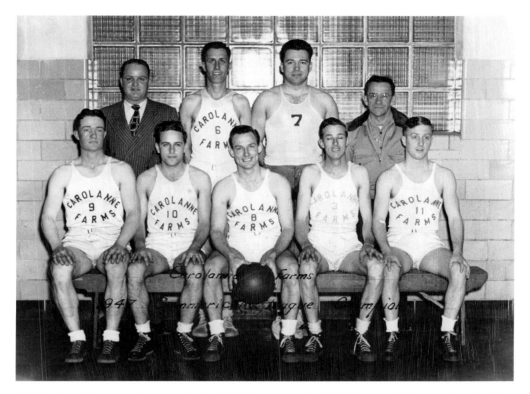

The Carolanne Farms men's community basketball team won the 1947 Commercial League championship. The team, made up of men from the Carolanne Farms section of what was then Princess Anne County, played in the Norfolk Recreation League. *Sargeant Memorial Collection, Norfolk Public Library*

The Lake Smith fishing station provided rowboats for rent (shown here). The area surrounding the lake—and adjacent Lake Lawson—was largely rural and dominated by working farms at the time this picture was taken on June 13, 1947. *Sargeant Memorial Collection, Norfolk Public Library*

This oblique aerial photograph of the Seaview Beach Amusement Park was taken on July 11, 1947. At the time the picture was taken, it was a prominent African American seaside destination used by local residents as well as out of town visitors. The park played a vital role in the social life of the Hampton Roads black community. The former Knights Templar Club was acquired and renovated for $100,000 between 1944 and 1945 to become the park shown here. The park opened on May 30, 1945, to much fanfare. This picture further shows the additional renovation work done to the park from 1946 to 1947. The park saw major African American musicians and bands during its operation, to include Louis Armstrong, Buddy Johnson Band, Jimmie Lunceford, Tiny Bradshaw, and the Sweethearts of Rhythm. Seaview shut down in 1964 due to financial difficulties and was razed in February 1966. *Sargeant Memorial Collection, Norfolk Public Library*

Opposite page: At the dawn of the twentieth century, three-quarters of the cleared land in lower Tidewater was utilized for truck farming, referring to the large-scale production and distribution of crops by road or rail. Farmers in Princess Anne and Norfolk Counties became leaders in the truck farming industry. With improved transportation facilities to northern cities, the market expanded beyond the region and Delmarva to the entire northeast United States. Over half of all greens and potatoes consumed on the East Coast came from these two counties from that time for decades to come. Potatoes from Thalia [in old Princess Anne County] truck farms were being processed, bagged and transported by flatbed truck when these pictures were taken in 1948. *Sargeant Memorial Collection, Norfolk Public Library*

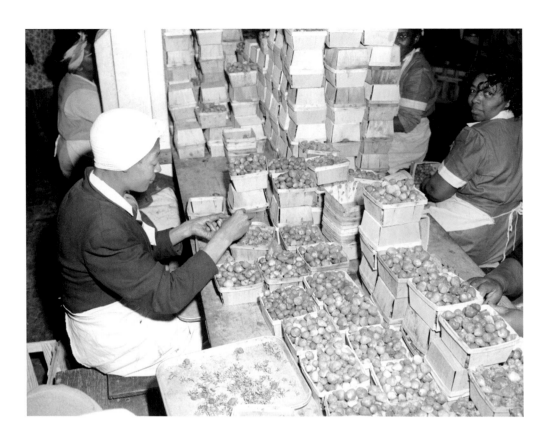

The ferry *Delmarva* was unloading automobiles, trucks and trailers when this picture was taken in 1948 at the Little Creek terminal in what was, at that time, Princess Anne County. The *Delmarva* was built for the Virginia Ferry Corporation in 1933. "Delmarva" stands for Delaware ("Del"), Maryland ("Mar"), and Virginia ("Va"). *Sargeant Memorial Collection, Norfolk Public Library*

Opposite above: With the seasonal nature of truck farming, Princess Anne County farmers were dependent on farm labor not only for the harvesting of such crops as strawberries but also seeing that the crops were properly package for market. The women shown here were packing local strawberries for shipment inside a warehouse in old Princess Anne County. The picture was taken on May 6, 1948. *Sargeant Memorial Collection, Norfolk Public Library*

Opposite below: The ferry *Princess Anne* was in the dry dock at Little Creek terminal when this picture was taken in 1948. The *Princess Anne* was built for the Virginia Ferry Corporation in 1936. *Sargeant Memorial Collection, Norfolk Public Library*

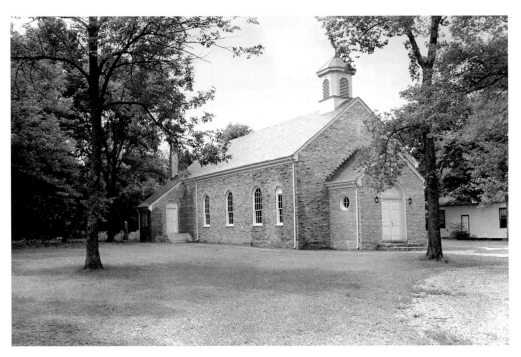

The Emmanuel Episcopal Church, located on Singleton Way in the Kempsville section of the city, is shown here as it looked on July 18, 1947. *Sargeant Memorial Collection, Norfolk Public Library*

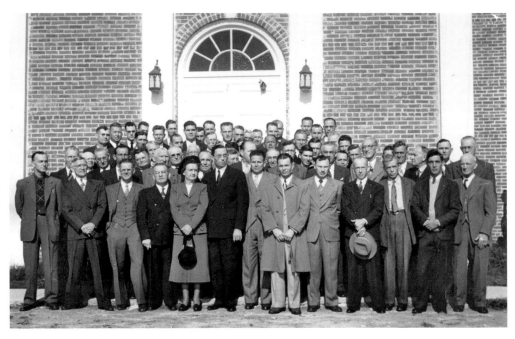

Members of the London Bridge Baptist Church, located on Potters Road, were photographed in front of the church in December 1949. The congregation was first established in 1784 as an outreach effort by members of the Pungo Baptist Church, now Oak Grove[68] and the oldest Baptist church in Virginia, dating to 1762. London Bridge Baptist bought the land on which the church sits today in 1809 and has since built a series of sanctuaries on the property, to include the oldest part of today's church, built in 1948, a little over a year before this picture was taken. *Edgar T. Brown Collection, Virginia Beach Public Library*

IV

THE WAY WE WERE

"Walking up and down Virginia Beach twenty years ago [in 1965] you were sure to run into lots of people from home. That doesn't seem to happen much anymore," lamented Ray Lucian Garland, of Roanoke, Virginia, a sixteen-year veteran of the Virginia General Assembly and part-time Virginia Beach resident in an August 7, 1985 *Virginian-Pilot* editorial. "Still, the crowds come, from where I am not exactly sure." Had the Virginia Beach so affectionately called "Virginia's front porch" by Hampton Roads chronicler and literary folk hero Guy Raymond Friddell Jr. (1921–2013) been altogether lost by the end of the twentieth century? Garland sentimentalized his memories of the beach when he recalled it lined with modest hotels with grand names like Albemarle Hall and Trafton-Chalfonte—"all nice, cool porches, wicker chairs and broad lawns," he remembered. "The price of your room included meals, and you dined family-style on fried chicken, candied yams, green beans and peach cobbler." Eating together helped guests get to know one another, making them one big family. Without televisions in the rooms, the hotels' large parlors and porches became harbingers of great conversation, games and stopping off points for guests from other establishments along the boardwalk. "It was another world," Garland observed, "and on the whole, I think, a stronger and better world."

Today, that "front porch" of yesteryear is gone, to answer the question. "I can't blame people for wanting to grab a piece of it, and grab they are at a pace that takes your breath away," Garland offered. "They suspect, I guess, that God stopped making oceanfront land some time ago and has no plans to resume production." Virginia Beach was just a two-square-mile resort area and less than eight thousand residents when tallies were taken in 1962. But Princess Anne County was another matter. The county that surrounded tiny Virginia Beach was two hundred and fifty-six square miles and was still largely agrarian in character. The merger one year later created what became the largest city in Virginia and soon all of those quaint front porches with their wicker chairs and stirring stories became warm memories of another time and place. "That's progress, you know,"[69] said Cornelia Holland, rocking on the front porch of the house her father built and watching a very changed world beyond it. She knew then that there was no reason to sugarcoat the past. Her father would not have done that either. Bernard Holland once said that Virginia Beach, from its halcyon days, was plagued with "high seas, low beach, mosquitoes and politicians"[70] in no particular order.

Twenty years after the Virginia Beach merger with Princess Anne County, the architects of the plan that resulted in, beyond creating the largest city in the state, landlocking neighboring Norfolk, stood in the glow of candelabras sipping champagne and reminiscing. "It must have taken some real salesmanship to put it through," then lieutenant governor

Richard Joseph Davis Jr. (1921–1999), a Portsmouth native, said to Sidney Severn Kellam, of the January 1, 1963 event. "A classic piece of political maneuvering,"[71] Davis surmised. "I reckon it was," replied Kellam. "That's exactly what it was." Kellam was the undisputed political boss in the county prior to the merger and the city after it was consummated. He conceived of and executed the merger behind closed doors. "My influence came from the people," he said just then. "Nobody can be head of a machine. It's all in the hands of the people." Well, not exactly.

In April 1960, Sidney Kellam stroked a backroom deal with the Norfolk City Council, still controlled by Mayor William Frederick "Fred" Duckworth (1899–1972), that offered the possibility of a merger between what would become Virginia Beach and Norfolk. Kellam vowed not to pursue changes in state annexation laws while Norfolk agreed to cease and desist annexation of further Princess Anne County land for the next five years. Both sides agreed to study the possibilities of transforming the Hampton Roads cities and counties—all of them—into one super-government. Meanwhile, Kellam and his politically powerful Virginia Beach and Princess Anne County allies took advantage of a subtle change of state law that allowed for the merger of the small city and big county, one that permitted the enjoining of the municipalities but only if they mutually agreed to put the merger up as a referendum and public vote. The consolidation could not begin until voters in the two jurisdictions approved the merger, and the merger charter was passed by the Virginia General Assembly. On January 4, 1962, voters overwhelmingly approved the merger, and that following February 28, the charter was approved by Virginia lawmakers. The ten months that followed was left to local leadership to make the merger a reality. Ivan Mapp, the county commissioner of revenue, directed the merger executive committee, which met with the Virginia Beach City Council and the Princess Anne County Board of Supervisors. The committee established special committees to address issues from revision of real estate taxes to upgrading street signage. The final joint session of this committee was held on December 28, 1962, just a few days before the merger became official. Embedded in the committee discussions were controversial issues such as boundaries and water supply.

"The proposed merger of Princess Anne County and the small town of Virginia Beach is probably one of the most historically damaging moves that has ever been incurred by the city of Norfolk,"[72] recalled former Norfolk city councilman and mayor Roy Butler Martin Jr. (1921–2002), in his later years. Looking at the cost incurred after annexing part of Princess Anne County prior to Kellam's April 1960 offer, the Norfolk City Council was receptive to his plan to stop further annexations and establish the five-year-hiatus. When Kellam proceeded down the path of the county merger with little Virginia Beach "it came as a shock to all of us at the Norfolk City Council." The reaction to the Kellam proposal while lauded in the county and Virginia Beach was panned by Norfolk, which attempted several political maneuvers to bring Kellam's merger to a full stop, to include advertisements that expressed what Norfolk thought about the merger and how it might affect all involved. Kellam was not moved. Rather, he pressed the previous idea of merging the diverse Hampton Roads municipalities into one super-government, arguing that he practiced what he preached on regional governance by executing the Princess Anne County merger with Virginia Beach. The relationship between Kellam and his Norfolk peers cooled considerably after the merger proposal went public and it can arguably be characterized as dropping through the floor once it was a done deal.

"When the proposed merger of Princess Anne and Virginia Beach came about, I felt all the more that the merger of those two should include Norfolk," Martin opined. He even

went so far as to put the idea in front of his fellow city council members in early November 1961. Martin wanted to fund a study to investigate the feasibility of a three-way merger, including the initiation of meetings with the political leadership of each jurisdiction in early 1962. The council voted unanimously to authorize Mayor Duckworth to arrange a meeting between the governing bodies of the two cities and the county. But in late October 1962, Norfolk used a four-page newspaper advertisement to inform—and dissuade—Princess Anne County residents that the merger with Virginia Beach was a mistake that might threaten the progressive vitality of the Hampton Roads area. The backlash was swift. Both merger parties accused Norfolk of interfering in matters that were none of its business and in further communication with their representatives, Norfolk City Council learned that the advertisement's intent had sorely backfired.

In a follow-up editorial, Kellam's reaction to Martin's three-way-merger plan was a stinging rebuke of Duckworth, Martin and the entire Norfolk City Council. "If Norfolk is going to dictate the pattern of growth in the area, then there is no use meeting on a possible three-way merger," he wrote. "But if it's to the benefit of all our citizens, I am confident that the governing bodies could sit down and talk." A few days later, on November 10, 1962, the *Virginian-Pilot* editorial board offered this: "Mr. Martin has caught the city by surprise. He seems to clearly have caught Princess Anne County and Virginia Beach by surprise. If it seems likely, he also has caught his own colleagues by surprise. It is easier to understand," the *Pilot* continued, "the unusual reaction on the council advertisements of October 28 and 29 and its unanimous agreement now with the Martin proposal." But the editorial went further to note: "So the Martin proposal is an altogether fresh and imaginative approach, strikingly different in spirit and in content from the ideas and attitude of the council's formal statement in its advertisement."

The *Virginian-Pilot*'s editors held out more optimism for Martin's plan than should or could have been expected from the political behind-the-scenes maneuvers being put on by Kellam and his city of South Norfolk peer and political boss Charles Brinson Cross Jr. (1914–1988), to form the independent cities of Virginia Beach and Chesapeake, respectively. Even after the mergers were "done deals" in the Virginia General Assembly—certainly due to Kellam's and Cross' wheeling and dealing—the proposed three-way merger still came up at a meeting held by the city of Norfolk at the Pine Tree Inn on Virginia Beach Boulevard near Lynnhaven Road. At the end of the meeting, Kellam and Duckworth met jointly and held a press conference and it was then that Kellam took the position that he would be amenable to discuss such a merger when all parties could sit down as equals. In fewer words than Kellam used that day, he wanted a piece of the Norfolk power pie. Duckworth was not smiling. In truth, the press conference proved that the Pine Tree Inn meeting had been nothing more than a passing formality from which there would be no agreement. Further, Kellam and his constituency had no intention of considering a three-way merger unless residents in both the county and city demanded it—an unlikely prospect. Kellam had too much political capital to lose if he conceded to Norfolk's overture. What he may not have counted on was Norfolk's next move.

Ahead of the anticipated referendum vote, Norfolk mayor Duckworth presented an ordinance to the Norfolk City Council that made it clear to all that the water contract with Princess Anne County had elapsed and the city would no longer issue permits for new water lines into the newly created city of Virginia Beach. Duckworth's proposed ordinance was passed by a margin of five to one on December 5, 1961. Only after it was further reviewed and discussions were held between councilmen Martin, Linwood Perkins and Sam Theodore

Barfield (1918–2008) was the ordinance defeated. "I in no sense voted to cut off water [as the motion stated]," Martin remarked the following day. "I thought we were looking for information to determine whether we could or not." Barfield claimed the same. Duckworth's official motion, recorded in the minutes of the council, stated:

> I move that we request the city manager and city attorney to investigate the water matter and if my findings are correct, that they notify the city of Virginia Beach that we will discontinue the water supply as of December 31, 1962, provided they [Virginia Beach and Princess Anne County] become a city.

Councilman Lewis Lee Layton (1899–1981) appeared to have understood the motion perfectly. "My understanding was that the mayor was requesting that if he was correct in his findings, that Virginia Beach would be notified of the termination of the water contract." Duckworth's only public comment on hearing about the confusion was terse: "That was the motion and they voted for it." He later told a *Virginian-Pilot* reporter that the council was being "charitable in that we're giving them thirteen months' notice" of the cutoff. The Norfolk City Council continued to deliberate the motion, ultimately coming up with two versions of it, the first the mayor filed with the city clerk and the other a close reading of the motion interpreted by Barfield and also filed in the clerk's office. Duckworth's version added only this line "the expiration of the contract" after the date December 31, 1962, the day before recognition of the new city of Virginia Beach in the commonwealth. Barfield's take was the one recorded in the council minutes—and his own hand—that day. The *Virginian-Pilot* editorial page confirmed Barfield's version in a December 7 op-ed on the issue. "This is different language from the motion which Councilman Barfield said yesterday he obtained early in the day from the city clerk," the *Pilot* editors wrote. "It is different in intent, purpose, and scope from the intent and purpose which Councilmen Martin and Perkins said yesterday they had in mind when they voted." Better yet, interjected the newspaper editorialist, the Norfolk City Council should have been asking itself "how this confusion originated, why two versions of the Duckworth motion are in circulation, and whether other pertinent details and circumstances need explanation." Kellam was perhaps wondering the same thing.

Mayor Duckworth issued a formal statement for the record that made clear his understanding of Norfolk's obligation—or not—to supply water to another city. In a bristling barrage aimed at Kellam, he said: "I would think that [future city councils] would take a long, hard look at proposals to increase our present investment in our water system to encourage the development of a city which has been formed for the explicit purpose of preventing the expansion of the city of Norfolk." Duckworth's perspective was drawn from decades of experience dealing with the Princess Anne County political machine, of which Sidney Kellam had risen to the top. In the final paragraph of his rebuke, published in the December 6, 1961 *Virginian-Pilot*, Duckworth fired both barrels: "If the city is shut off from any possibility of expansion by the proposed consolidation of Virginia Beach and Princess Anne County, I would think that any city council charged with the protection of the city's [Norfolk's] interests would decide that it was not in the interest of the city to worry about the water supply of a competing rather than a cooperating area outside the city."

In retrospect, that this ordinance did not succeed avoided black eyes all around. Further, had it been allowed, Virginia Beach could not have developed so quickly and fully as it has today. Of note, while the county did not have a water system of its own and relied solely on Norfolk, which billed water to county residents and businesses at double the city rate,

the small town and later city of Virginia Beach benefited from preexisting contracts with Norfolk and had its own water distribution system within corporate limits and in the parts of the county to the town's north. Virginia Beach sold its water to customers, despite the ownership of its own distribution system, at a little over twice the price-per-thousand-gallon rate it paid Norfolk for the water, thus there was no advantage to the town's [later city's] residents. Just a couple of days after the initial vote to cut off water to county residents, a four-man majority of the Norfolk City Council, consisting of Martin, Barfield, Perkins and Paul Thomas Schweitzer (1903–1976) publicly went on record to oppose the original council vote per Duckworth's motion.

In the years to come, Martin would meet several times with Sidney Kellam about a further merger between Norfolk and Virginia Beach, and the water supply issue, which turned out to be the most enduring subject ever discussed between the two cities. Kellam, who had taken a dominant position in Virginia Beach politics, nearly always replied the same about a merger, his arm around Martin's shoulders: "Roy, I think there's a possibility about this and I'm going back and talking to my boys about it." Martin, in turn, never heard another word about it from Kellam. A tentative agreement was reached seven years after the first dust-up over the water supply issue. Norfolk city manager Thomas Ford Maxwell (1909–1987) and his Virginia Beach counterpart, Roger McDonald Scott (1936–2009), reached an agreement to set up a water commission for the two cities; this never materialized. Firstly, neither manager could articulate whether it should be a water commission or a water and refuse commission. Secondly, before the issue made it before Norfolk City Council, Maxwell resigned as city manager and his successor, George Robert "Bob" House Jr. (1928–1982),[73] had come to the city from Chesapeake, where he had just started a water system. "Bob felt that every community should control its water system and he was not anxious to see this agreement between Virginia Beach and Norfolk enacted," said Martin. "It never came up again during my remaining years on council." As for Scott, who had grown up in Winston-Salem, North Carolina, and graduated from Mars Hill College and Virginia Polytechnic Institute and State University (VPI), in 1965 he had been recruited from his position of assistant city manager in Albany, Georgia, to Virginia Beach by Russell Hatchett to be the new city's first assistant city manager. On July 1, 1968, Scott was promoted from a field of fifty-two applicants to become the city's second city manager and at the age of thirty-one, he was recognized as the youngest city manager in the nation for a city with a population greater than 100,000 and during his tenure the city grew to become the largest city in the state.

In the middle of the political maneuvering that continued between Virginia Beach and Norfolk the Chesapeake Bay Bridge-Tunnel was built that would also have a profound impact on both cities. From the early 1930s to 1954, a private corporation managed and scheduled ferry service between Virginia's Eastern Shore and the Norfolk and Virginia Beach area. With the number of ships, to include the number of passengers and vehicles they transported, increasing steadily, the Virginia General Assembly created the Chesapeake Bay Ferry District and the Chesapeake Bay Ferry Commission as the governing body of the district; this subsequently evolved into the Chesapeake Bay Bridge and Tunnel Commission. The commission was authorized to acquire the private ferry corporation through bond financing, improve existing ferry service and implement a new service between Virginia's Eastern Shore and the Hampton and Newport News area. Two years later, in 1956, the general assembly authorized the ferry commission to explore the construction of a fixed crossing. Results of the study indicated a crossing was feasible and recommended a series of bridges and tunnels. In the summer of 1960, the Chesapeake Bay Ferry Commission sold $200 million in revenue bonds

to private investors. Monies collected by future tolls were pledged to pay the principal and interest on these bonds. Construction contracts were awarded to Tidewater Construction Corporation, Merritt-Chapman and Scott, Raymond International, Peter Kiewitt and Sons, and American Bridge Company.

No local, state or federal tax money was used in the construction of the Chesapeake Bay Bridge-Tunnel. On April 15, 1964—just forty-two months after construction began—the bridge-tunnel opened to traffic and ferry service was discontinued. Although individual components of it are not the longest or largest ever built, the bridge-tunnel is unique in the number of different types of structures it includes. Additionally, according to the bridge-tunnel's history, construction was achieved under the severe conditions imposed by hurricanes, nor'easters, and the unpredictable nature of the Atlantic Ocean. The bridge-tunnel was officially named the Lucius J. Kellam Jr. Bridge-Tunnel in August 1987, to honor the man who steered the project from drawing board to reality. Eastern Shore native and icon of regional and state politics Lucius James Kellam Jr. (1911–1995) was the first chairman of the Chesapeake Bay Bridge and Tunnel Commission when it was formed in 1954 and remained in that position until 1993—a thirty-nine-year-run. But while named for Kellam, to preserve the structure's identity and name recognition it continues to be known as the Chesapeake Bay Bridge-Tunnel.

As the decade was fast coming to a close, Norfolk mayor Martin had not yet given up hope of an amicable merger. In the war of personalities between Martin and Sidney Kellam, this subject never took a holiday. When he could not make headway with Kellam, Martin approached Virginia Beach mayor Frank Amiss Dusch (1897–1984), hoping for a sliver of hope that Dusch might invite the merger. Martin made a pitch to the Virginia Metropolitan Areas Study Commission on June 6, 1967, that called for revamping the state's annexation procedures in a recommendation that specified the abolition of the existing processes and aimed to create a state commission to consider annexations presented via the newly formed State Division of Planning. In truth, Martin was proposing annexation by commission rather than the courts, specifically what had been a three-judge panel that had in years past ruled against Norfolk when, in 1962, the city tried to annex additional areas of Princess Anne and Norfolk Counties. Norfolk state delegate John Raymond Sears Jr. (1921–2005), while not opposed to Martin's plan, suggested that the commonwealth create a boundary commission to study the issues and understand the implications for all Virginia municipalities. When Kellam found out about Martin's proposal and Sears' suggestion, fearing a hostile takeover by Norfolk, he asked Dusch for the floor at the June 13, 1967 Virginia Beach City Council meeting. "A commission," Kellam opined, "[would] bring about such ill feelings among the people that it would, in my opinion, end metropolitan cooperation among our communities." That year, the Virginia Beach-Norfolk Expressway [now Interstate 264] opened, carrying tens of thousands of vehicles a day to and from Virginia Beach and beyond.

Between 1960 and 1990, the population of the combined county and city grew from 77,127 to 393,069 residents, an increase that was certainly palpable by the end of the 1970s, at which time the city added one thousand new residents per month. More people came at a high price. To clear the way for high-density neighborhood sprawl, bigger and better schools, high-rise hotels and shopping centers, the wrecking ball was hard at work. Treasured landmarks and old homesteads were razed at an alarming rate. Preservationists and historians alike wrote postscripts for prized historic houses and what remained of old places—many of them ruins—like Fairfield, the Princess Anne County ancestral home of Anthony Walke I, located in the city's Kempsville borough. Up to that point, in the broad expanse of what had

been the county, some of the nation's oldest homes and coveted landmarks had survived the ebb and flow of fortune. Concealed far down the former county's rutted roads, deep in the folds of lush green woods and, sometimes, stashed away on a lonely finger of land along the Lynnhaven River were the brick-and-mortar relics of the county's first inhabitants and generations of those who followed. Even abandoned ruins standing in a foursquare of oaks were eerily beautiful. So were all of the family graveyards, with tombstones choked with weeds and stones standing silent watch.

The story of Fairfield is a textbook case of what happens when community stewardship of a historic resource fails in the face of aggressive development. But it was clear, then as much as it was more than a century before, that Fairfield was especially important. Nineteenth-century writer William S. Forrest described the best homes in southeastern Virginia as those "old ante-revolutionary residences in the counties of Norfolk and Princess Anne." But as he moved through his narrative, Forrest really only wanted to address Fairfield. Though no longer standing, it is believed that its driveway started on Kempsville Road just south of Princess Anne Road. The manor house was the centerpiece of a very large plantation that extended on either side of Princess Anne Road south and west. This was, indeed, the home of Anthony Walke I, a man of distinction and character, whose parents were Thomas Walke, appointed a colonel by the royal governor and also a member of the Virginia House of Burgesses, and Mary Lawson, daughter of Colonel Anthony Lawson of Lawson Hall. When Thomas Walke died in 1692, he left Anthony I the plantation near Kempsville that we came to know as Fairfield. Walke's will indicated that the Georgian brick house was built between 1750 and 1760 on land first purchased in 1697. Anthony Walke's descendants owned the home until it was destroyed by fire in 1865.

Most of the county's late eighteenth century homes, including Anthony Walke's, reflected the growth of the planter class since the period of first settlement. A strong, diversified agricultural base made them wealthy and thus able to build larger, more stylized houses than their predecessors. Many of these early plantation manors follow the square, symmetrical and more formal Georgian plan, with a gracious center hall. On the exterior, these homes have distinctive medium-pitched roofs and minimal roof overhang. But perhaps the most distinctive Georgian feature is the use of large, dual exterior brick chimneys. The entrance to the Fairfield property was described as half a mile from Kempsville, with the old mansion set about a quarter of a mile from the entrance to the Kempsville-Great Bridge Road. "This Dutch roof relic of antiquity," as Forrest called it, had walls more than four feet thick for some distance above the ground. The interior walls and ceilings were heavily adorned with wainscoting constructed of black walnut, and its passage exceeded any description of spacious, dotted as it was with architectural flourishes uncommon in county manor homes of the period. Walke had built the house with brick from England, and with marble mantels, a brass door knocker and doorknobs.

As old Princess Anne farmer and storekeeper John Ivy Herrick—in fact one of the oldest residents of the county when he died in 1931 at age eighty—described the hugeness of Fairfield's parlor and noted the coat of arms over a hand-carved mantelpiece in the dining room. When they spoke to Herrick for their 1931 narrative on old Princess Anne County homes, Sadie Scott and Vernon Hope Kellam observed that Herrick faltered and then said, "I've been in all the rooms. I was at the funeral of David Walke [Anthony Walke's descendant]." Fairfield has been further described as an almost baronial establishment, with liveried black servants, as well as blacksmiths, wagon makers, saddlers and tradesmen brought from England to ply their trades.

Anthony Walke I died on November 8, 1768, at Fairfield and was laid to rest in the family cemetery on the ridge behind the house. From Walke family historian Calvert Walke "Bill" Tazewell, we know that the burying ground at Fairfield was about two hundred yards from what was later identified as the coachman's house and perhaps other servants' quarters behind the manor house. The cemetery ran to the rear and right of it. This reverent space was at one time enclosed by a brick wall, which had long since disappeared when the property was acquired for development centuries later. Horatio Cornick Hoggard told Tazewell that the Fairfield property passed out of Walke ownership to a man named Sanderlin. Jonathan Sanderlin, born in Camden County, North Carolina, and married to Princess Anne County native Sarah Gornto, the daughter of Philip and Jane Eliza Petty Gornto, farmed the old Walke plantation until his death just after the turn of the twentieth century; his family continued to farm it several years after he died. Sanderlin used the cemetery wall to enclose his hogs; Tazewell observed that this had uprooted many of the Walke tombstones. Anthony Walke's headstone was particularly elaborate for its period and had been fashioned from marble. Tazewell noted, too, that it had very heavy marble foundations, probably a single slab. On the upright side was another slab with an inscription. Perhaps the weight and ground settlement did the damage, or maybe it was the hogs, but the foundation of his tomb had sunken into the ground. If it had been one slab, it was now broken, the inscription in three parts but still legible.

Storekeeper John Herrick told passersby in the fall of 1914 that just before the end of the Civil War a fire started in a pine wood between Kempsville and Fairfield. The fire got quickly out of control and destroyed the mansion. Another account of the fire stated that it happened in March 1865, when a spark from the chimney set the roof on fire. But the later account was unattributed. Herrick lived in an imposing brick house, set back in a grove of trees that county legend indicated had been the home of Kempsville Tory George Logan, who entertained John Murray, Lord Dunmore, Virginia's last royal governor. This would be the late Peter Singleton I's Pleasant Hall. As a young man, Herrick was thus living in proximity when the actual fire took place and was old enough at the time it occurred to remember the night it happened.

Regardless of how events unfolded, when the smoke cleared all that was left standing of Fairfield plantation were a few outbuildings, including what for many years was the coachman's house. At the beginning of the twentieth century, this was the only "house" remaining on the property, occupied just then by an African American overseer and his family. Across the Kempsville–Great Bridge Road was a large brick home that had belonged to James Walke. The coachman's house, also affectionately called "the little white house," was allowed to deteriorate over time. "It really doesn't look like much anymore," opined Helen Crist, writing about the house on February 17, 1972. She described wide holes in the steep roof and weeds growing high around the structure. The house as it was then bore no resemblance to the house that Crist and others had visited just two years earlier. Worse yet, she wrote, "its fate was doubtful then, as new homes sprang up like mushrooms in Kempsville. There were many then who wondered what would become of the historical house." This "little gem of a house" was a one-and-a-half-story, sharp-roof building made of hand-molded bricks laid in the Flemish bond method. In its later life, the house was whitewashed, making this feature unnoticeable. But more importantly, it was all that was left of Fairfield, the plantation that was just as significant in those salad days of the county as those with names like Lawson Hall, Greenwich and Rolleston.

At one point, Crist and little white house supporters all believed that developer Woodrow W. Reasor—who had bought the 390-acre tract in November 1967 from the heirs of James

Carey Hudgins for slightly more than $1.5 million—might renovate it; after all, he had already begun the process but had suddenly stopped. What was left, she observed, was "an embarrassment to us all, because it stands as a monument to the past about which nobody did anything. There are those who look at it, shaking their heads and feeling somehow, a sense of guilt, a guilt of omission."

Reasor's role in preservation of the little white house is spotty. "I bent over backwards," he told Crist, "on this house. I offered it a year ago [1971] to the historical society for $10,000, the price of the lot, if they would restore it." The historical society did not have the money, he said. The upshot of Reasor's story, later learned by Crist, was that he never made any such offer to the historical society and the society never contacted him to make an offer. Reasor was ultimately unsuccessful in finding a buyer for the little white house at Fairfield. He built the Fairfield neighborhood over the footprint of Anthony Walke I's plantation, including the little white house. This Virginia Beach development today lies on the west side of Kempsville Road, south of Kemps Landing Elementary School and north of Kempsville Colony subdivision; it also extends west to a finger of the eastern branch of the Elizabeth River. This neighborhood, too, is the textbook example of a residential development laid out in a complex pattern of streets that defy logic. The development is filled with curved streets and cul-de-sacs that fan out at irregular intervals to cut down on traffic noise and to divert the view of passersby from looking at one house and yard after another. "Look closely at the small pile of bricks," Helen Crist opined in June 1972, as it was all that was left of the once vast Fairfield plantation. "Perhaps it will serve," she offered just then, "as a reminder to those interested in preserving historical homes and areas here, that action is necessary to prevent total destruction of our heritage."

The loss of the last bit of Fairfield was tragic. But sometimes saving the main structure on a historic property does not preserve the historic landscape—the property that envelops the house and on which there were additional quarters, carriage houses, barns and support structures. This was the case with the Ferry Plantation House [also called Old Donation Farm and Ferry Farm], situated on land that played an important role in county history from the 1600s as a secondary site for ferry service that identifies the property today, which is only half to three-quarters of a mile from Old Donation Church. Thomas Martin sold the property to Anthony Walke II, who eventually willed a larger property to his son, William Walke, who married Mary Calvert. From historic records, we know that the third courthouse, also the first brick courthouse in the county, was collocated here with the 1751 Walke mansion, built in the lifetime of William Walke and tragically destroyed by fire in 1828. William Walke died on January 1, 1795, and was buried a few hundred yards from the house. The current house dates to in or about 1830. Today, we appreciate the remaining house as an excellent example of Federal farmhouse architecture built by slave labor and once covered in a sheath of oyster shell stucco. This home was partly rebuilt with bricks salvaged from the ruins of the Walke mansion.

Fast forward more than one hundred-and-fifty years from the building of Ferry Plantation House. Situated on a thirty-three-acre peninsula at the end of Pembroke Boulevard, the farm became the target of an upscale residential development. Two developers—F. Donald Reid and Jerry Womack—planned to build thirty-nine single-family homes on the site that they had bought in late 1986 from the estate of Ethel H. Howren. Reid, who was also a member of the Virginia Beach Planning Commission, took advantage of a new open-space zoning law that made it feasible for him to retain the Ferry Plantation House and a limited amount of space around it. When the city council initially approved Reid and Womack's subdivision

plan, it required that the house not be demolished or used as a residence, that a long-term use and maintenance plan be developed and that four acres of open space around it be declared a city historical and cultural district. According to a September 10, 1987 *Ledger-Star* report, before the rest of the farm was bulldozed and built up they agreed to hosting and then financed archaeologists from Colonial Williamsburg Foundation to document the site. What they found was extraordinary. "We have rarely, if ever, come across such a well-preserved volume of material," according to Dr. Marley R. Brown III, the director of archaeological excavation and conservation for the foundation. "Hopefully, this site will communicate how important such findings can be." The Ferry Plantation property turned out to be one of the best archaeological finds in Hampton Roads.

"I hope that the planning department and the city can work on a more comprehensive and systematic approach," Brown continued, speaking of the need to identify and save historic sites. Another state archaeologist, Dr. E. Randolph Turner III, later the director of the Virginia Department of Historic Resources Tidewater Regional Office, agreed. He believed that what made Ferry Plantation House so unusual was not its setting but rather the fact that it was excavated at all. "What you have here is a time capsule." The archaeological dig at Ferry Plantation produced more than fifty thousand artifacts, including pieces of European pottery, locks, keys, coins, bottles, animal bones and utensils. They also located the filled-in basement near the manor house that is believed to be the remains of an eighteenth-century tavern that once stood near the courthouse. Archaeologists could tell by what they unearthed that tavern owner Anthony Walke II was wealthy because of the pieces of expensive porcelain and bone-handled utensils they found. Knives and forks, they observed, were relatively rare in the colonial period, thus "a bone-handled set would have been a big deal," Brown observed. Certainly, those involved in the Ferry Plantation dig hoped that their findings would encourage the city of Virginia Beach to consider a local historic preservation law. Robert Hunter, who headed the dig, agreed. "The rest of the community now sees that archaeology is not the main obstacle to development," he remarked. "It can enhance the value of the property."

After the dig was completed, the tavern basement was refilled and a road built over it. The tens of thousands of artifacts pulled from the property were stored at the archaeological project center at the College of William and Mary. Curtis Moyer, an anthropology lecturer at the college, was quoted in the April 10, 1989 *Virginian-Pilot*, speaking of the Ferry Plantation site: "It's the most awe-inspiring collection from that period I've seen. It's got a little bit of everything. Normally, you'd have to go to many sites to acquire all this range of material." He gave some examples of the curious items that would require further study, like sturgeon bones. "Our sturgeon don't run up the river anymore," he explained. Hunter and his colleagues pulled the bones out of the ground in August 1986, according to the report. Underfunded, the study of the artifacts stopped. But development of the Ferry Plantation property moved forward. The house is today situated in the middle of the Old Donation Farm subdivision's one-and-a-half-acre open space. After the initial phase of development was completed, Old Donation Farm's homeowners' association agreed to maintain a buffer of only fifteen feet around the home in exchange for the group's use of the house as a meeting place after restoration. Meanwhile, Ferry Plantation House sat neglected and isolated on its tiny patch of the subdivision.

More than a decade would pass after the archaeological dig that uncovered the farm's treasure-trove of colonial Princess Anne's past and any attempt to save the manor building. With the house in dire need of restoration, a group of citizens jumped in and formed the Friends of Ferry Plantation House. Through their hard work and lobbying for the property,

it was deeded over to the city of Virginia Beach in June 1996; it remains a work in progress. "To me this is the most significant historical site in Virginia Beach," observed Councilwoman Barbara M. Henley, in the July 26, 1996 *Virginia Beach Beacon*. The councilwoman was one of the earliest to voice her support of the farmhouse's preservation.

Nearly a quarter century before, Helen Crist hoped, like Reasor, that those who believed so fervently in historic preservation would do less talking and more acting to save the last bit of Fairfield and other treasured pieces of the city of Virginia Beach's past. "Maybe they will work harder," she wrote in 1972, "to spare them the same fate." There was even a threat just then to Peter Singleton I's Pleasant Hall, Reasor said at the time. "They're letting that go, too." But Pleasant Hall was spared and is today on the national and state historic registers. Sadly, that would not be the outcome for the little white house at Fairfield. Just before it came down, Crist speculated that there would be two kinds of people watching: misty-eyed onlookers asking themselves "How in the world did it happen?" and others, seeing it go, who would say "Good riddance. It's no loss; it was old anyway." The following month, Fairfield's little white house was marked for demolition. When she called Reasor to find out what was happening, he told her that a contract had been signed and that a builder would soon tear down the house. The regret that so many had after the house fell to a bulldozer was palpable. No doubt the generations of Walkes buried up on the ridge behind the house were equally disappointed. After all, they could not have imagined what might replace their elegant house and sprawling plantation. All in all, by comparison, Ferry Plantation House got lucky—it is still standing.

As the years clipped by, Cornelia Holland opined of the change she witnessed: "Well, it's growing up much more now than it ever did before or has it always been in a state ...? Well, it's growing up much more now. It's too fast. They're destroying all the attractiveness of it. They're making it be so violently commercialized that people, it's not the place..." she continued. When asked if it was about the money to be made, she replied. "That's it, then they don't care. When her father was mayor, there was not as much trouble with developers. "The [land was] being sold more for home sites. There was very little commercialism. There was the pavilion down there at Tenth Street and it was more open but that was around Eighth to Tenth Streets. The pavilion had all kinds of amusements [and] picnic pavilions."[74] Holland decreed this rapid growth a travesty—and it was—not just to her but to those of her generation who could articulate the passage of time beyond the nostalgic, of what had been good and bad development in the city for the most critical decades of the twentieth century. Certainly, what she described along the Oceanfront strip in the postwar period had happened too fast, without regard to preserving anything of the past. In other parts of the city, it had another name: uncontrolled growth.

A January 26, 2011 *Virginian-Pilot* article's title rang sadly familiar: "Huge Virginia Beach Church Gets OK on Development." Kempsville Presbyterian Church, which bought a five hundred-and-nineteen-acre tract of the John Brown farm from real estate developers Steve and Art Sandler in 2009, had secured the Virginia Beach City Council's unanimous approval to build out the site according to the church's proposed plan at the council's January 25 meeting. Not everyone liked the project, including one member of the council, but after church leaders objected to planning guidelines for the tract, hired a lawyer and started to lobby council members to vote in their favor, the council acquiesced. The church got its way.

The victim this time was the last vestige of the old John Brown farm. The Brown tract is located near the city's municipal center in an area that Virginia Beach city planners have designated a transition area, a 4,700-acre swath of land that separates the city's rural south

from its urban north. Aggressive development is not part of the plan for the transition area. In his redress of the council's church vote, Virginia Beach mayor William D. "Will" Sessoms, however, was clear: "This is a plan, and it's all about trying to come up with guidance for future development and plans do change."

Councilwoman Barbara Henley, representing Virginia Beach's rural south, including the Brown tract, and who had so ardently supported the preservation of Ferry Plantation House, leveled her objection to the church's plan for the open space. Kempsville Presbyterian's much-publicized development strategy promoted a scheme to hold back a seventy-acre parcel for church use and sell off the rest of the land for mixed-use development, including medical, office, institutional and retail use.

"Unfortunately," Henley opined in the January 16, 2011 *Virginian-Pilot* before voting *for* the Kempsville Presbyterian plan, "the church plan calls for urbanized development." She observed that the church's project was the equivalent of plopping two Lynnhaven Malls into what has long been pastoral open space threaded with narrow country roads. Lynnhaven Mall is 1.17 million square feet. Two Lynnhaven Malls equates to 2.34 million square feet. Church officials informed council that they envisioned *four* million square feet of development on the Brown tract. Picture the end result. One resident did. The *Pilot* quoted Dawn Flora, a North Landing Road resident, who rightly observed that Brown farm open space was "such a gem for the city." Flora went further to say, "You don't want to lose that. Everyone has their rights [the church], but as a whole you want to be cautious because once it's gone, it's gone."

Planning staff and then city manager James K. "Jim" Spore stood by the growth guidelines for the transition area. City planners had earlier informed the council that half of Kempsville Presbyterian's land should remain undeveloped as open space and that the total project should be capped at two million square feet. But the council's compromise on the Brown tract softened the language of the planning department's guideline for the transition zone and the property in question. Council's approval did not hold the church to the guideline to maintain open space on half of the land. The square footage restriction was still included but had been substantially watered down. Further development on the site might be permitted if road improvements were made. As further enticement, the church publicly stated that the development of the tract would bring immense financial return to the city of Virginia Beach.

Additional revenue in city coffers does not buy a better quality of life for the people who live in the city. With every loss of open space, with every loss of a historic site, a little more of Virginia Beach's heritage and community character is lost. Money cannot buy them back. Lacking the political will to encroach the Green Line, the only area of compromise is the transition area. Certainly, the council's vote to allow the Kempsville Presbyterian's development plan to proceed opened the door going forward to any developer who might want to bargain the same terms on a future project. Once Pandora's box is opened, it is impossible to close.

The September 17, 2010 *Virginian-Pilot* reported that Virginia Beach identified eight parts of the city that council and staff determined were due for a makeover; six of them fell along the old railroad corridor proposed just then for light rail extension. The objective in these strategic growth areas was specified as intense urban-style development, going vertical with high-rise buildings to take advantage of limited developable land in the city's urban north. Lacking a redevelopment authority, the city is otherwise dependent on a landowner's willingness to sell his land to a private developer. This has been the Virginia Beach development model for decades. What happened to the old John Brown farm followed

the model. Strategically situated between Naval Air Station Oceana and its outlying landing practice field, Naval Auxiliary Landing Field Fentress, seven miles southwest of Oceana in the city of Chesapeake, the Brown property that the Sandlers bought and banked for later development was once a large working farm.

Property and genealogical records indicate that the first John Brown in Princess Anne County was born in England in 1654 and died in the county, on his farm, in 1702. Subsequent generations of Browns continued to farm cotton and live off the land, which remained in the family through much of the twentieth century and for a brief time in the 1950s and 1960s was turned into a popular strawberry farm operated by Paul and Russell Brown. Most of the old Brown farm was sold for development beginning in 1983, and Centerville Elementary School was built on part of the farm the following year. The residential communities of Southgate, Hunt Club Forest and Chelsea Place were also developed on Brown land. Each development, school and church that pops up on any parcel of the old Brown farm has fallen within a tender buffer intended to safeguard the city's rural south, dotted with farmers' fields and horse farms, from the unchecked growth in the urban north.

When Virginia Beach first introduced the Green Line to the city in 1979, the objective was to stop unplanned, ugly sprawl that had, according to an August 21, 1996 *Virginian-Pilot* editorial, "spread like poison ivy through the northern part of the city, straining services and outpacing roads, sewers and water." The population explosion in the city's urban north cut a deep swath into early iterations of the Green Line, that crazy quilt of farms and open space that includes Princess Anne Courthouse, Lynnhaven, Pungo, Creeds, Blackwater, Sandbridge and Croatan, as well as lesser-known sections of southern Virginia Beach.

The city long ago ran out of clear land for new construction above the transition area and Green Line to satiate the demand of its bread-and-butter industries: real estate, defense and tourism. Virginia Beach is arguably the manifestation of textbook suburban sprawl. The city's housing boom in the 1970s, 1980s and 1990s produced miles of strip malls, big box stores and car dealerships that gobbled up massive acreage across its urban north. The footprints of nearly all of these massive commercial developments were accompanied by acres of unattractive parking lots. After taking in the scene, one reporter asked residents back in 1972 to picture Virginia Beach as a giant Monopoly board: "Then consider how it has grown or how the game began."

The game began with John Aragona, a land developer who bought property off Virginia Beach Boulevard near Chinese Corner in 1954—nine years before the Princess Anne County and city of Virginia Beach merger was consummated—and built single-family homes on it. For a man who earned as little as $1.50 a day when he came to the United States in 1923, it was a big payday to land on Aragona Village, following the Monopoly analogy; he made $2 million and history, too. Aragona Village, completed in 1956, was the first planned subdivision between the city of Norfolk and the Atlantic Ocean. As we know today, it was not the last. By the early 1970s, Virginia Beach was one of the fastest-growing cities in the commonwealth, with a population already over 200,000 in March 1972. When compared to the United States Census figure of 172,000 for 1970, this indicated the addition—at minimum—of 14,000 people per year to the city's population.

Aragona foresaw the growth; he bought three additional farms in the county before the merger. County planners saw it, too, and predicted that Princess Anne's population would eventually exceed that of Suffolk. Three years after Aragona Village sprung from a farmer's field, planners' projections came true: a one-thousand-acre Bayside development added fifteen thousand residents to the county census. Aragona Village was just the template

for more to come. Planners began to change the housing mix and diversified the county's subdivision plan to include single-family, duplexes, apartments, townhouses, schools and religious buildings. Many of the city's planned unit developments built at the end of the 1970s and into the 1980s were self-sustaining, self-contained communities that provided commercial, recreation and community resources as part of the overall residential plan. The city's uncontrolled growth soon became the number one topic during election cycles, boundary disputes and meetings. The problem had become clear: infrastructure and city services had fallen behind the demand created by rampant development.

Remarkably, too, hundreds of middle class black families moved into formerly all-white subdivisions of the city in or around 1966 with hardly a ripple of racial tension. "Virginia Beach should be held up as the model community in the South in integration," said Robert Otis Clapp, who added that his fair housing group had practically "worked itself out of existence."[75] The effort to move middle-class black families into previously all-white neighborhoods was started by Charlie Lovelace DeJournette (1924–2004), a black realtor with offices in Norfolk just then. DeJournette located homes in white residential areas and used the Tidewater Fair Housing group to invite the public to accept their new neighbors. DeJournette's movement was aided by several factors: politicians who provided full support; a broad-based white community accepting of integration and the federal housing mandates that came with it; black property owners who maintained their houses, and a public-school system that integrated without any issues.[76] Most of the black families relocating to Virginia Beach held white-collar jobs and the majority of them came from Norfolk. But unlike the attempted integration of Norfolk's Coronado neighborhood years before, there were no unexplained fires on black property owners' lawns, no racial slurs or epitaphs, just neighbors being good neighbors to one another without the inner-city racial tension from which most of them had fled. The success of Virginia Beach's integration was certainly aided by reasonably priced housing in new residential subdivisions that seemed to materialize overnight.

In other parts of the city, most especially the Great Neck section, the community's character and landscape underwent dramatic change starting in the middle of the 1970s. The 482-acre Broad Bay Manor development, situated near Frank W. Cox High School, was developed as an upscale neighborhood, one of several that would soon pop up along both sides of Great Neck Road. Most of the homes in this area were sited on lots of one to one-and-a-half to three acres or larger. Broad Bay Manor was carved out of the farm that had once been owned by truck farmer John Benjamin Dey, for whom the elementary school built on this tract was named. The development of these neighborhoods left remarkably less open space and pushed greater population density into parts of Virginia Beach that had heretofore been sparsely populated. This kind of development was shocking to former Princess Anne County power brokers who had largely engineered and ensured the county's merger with the second-class city of Virginia Beach years before. "Who are all these people coming to Virginia Beach by the thousands each year?" asked a puzzled Sidney Kellam when interviewed for a June 23, 1977 *Ledger-Star* story. No one seemed to know the answer. The only certainty seemed to be their number: the aforementioned one thousand new neighbors per month. Suddenly, the close-knit Princess Anne family tree was becoming an amalgam of people from all over the United States and all over the world. Virginia Beach's Oceanfront was just the same and in all respects development married up to Cornelia Holland's pointed description. Locals were becoming scarce by the end of the 1970s, a fact noticed by old timers like Holland and part-time residents like Ray Garland.

After he retired from the navy in 1972, former Naval Air Station Oceana commanding officer captain John Ellsworth Ford (1922–1998) became a Virginia Beach real estate developer and

construction company executive. As a young naval aviator, Ford first laid eyes on Oceana in 1955, three years after it had been designated a naval air station, and taken aboard its first jet aircraft. The air station's neighbors had just then begun to complain about jet noise and an occasional accident. Residential development was just starting to crop up on a country road here, a country road there. The air station was still isolated, surrounded by farm after farm, with a few homes built on either side of the railroad track near the shuttered Oceana High School. After Ford took over as Oceana's commanding officer on September 4, 1970, everything had changed. Noise complaints had intensified, and so had the development tightening around the air station.

"He was among the first strident voices calling for curtailment of development around the base," wrote the *Virginian-Pilot*'s Steve Stone after Ford's death in 1998. "Just as he had arrived, a major developer 'had built a little establishment of houses off the southwest end of Oceana.'" The subdivision was Magic Hollow, juxtaposed close to the end of Oceana's principal runway and built practically in the jet wash of the air station's complement of A-4 Skyhawks, A-6 Intruders and F-4 Phantoms that thundered by. Ford realized that most of the people complaining about jet noise had moved into the noise zone long after the air station rose from the mud flats of Princess Anne County nearly a decade and a half before it was designated an air station on April 1, 1952. He asked Virginia Beach City Council to curtail growth around Oceana. The members listened but did nothing. Unwilling to stop lucrative development deals from going through or get involved in owners' rights issues, the council turned a blind eye to Ford's request; what he was asking was not good business for the city.

Ford was later incredulous when the city of Virginia Beach permitted the development of Lynnhaven Mall. The mall was constructed, he opined, "in one of the most dangerous places they could [have built it] in the vicinity of the Oceana airfield." Aircraft bound for Oceana's runway make a downwind, 180-degree turn before landing just as they get on top of the mall. "In the whole pattern of launching and recovering aircraft, that is one of the danger points," he observed and Stone reported. "It doesn't mean that a crash is going to happen here; it just means that that's a place where it's more likely to happen."

The navy responded to encroachment by exercising an abundance of caution over residential, recreational and commercial enterprise in its flight paths. A September 12, 2004 *Virginian-Pilot* report indicated that in Virginia Beach the navy had repeatedly notified the city of potential development problems in the Oceana crash zone. From 1975 to six months into 2004, the Virginia Beach City Council ignored navy objections in nearly three out of every four votes, based on a review of navy letters and city records. But the navy also offered little or no resistance to housing developments in low- and medium-jet noise zones, and certainly within the clear zone—the "most likely" crash site to the runway—around Oceana until 2003. Go back to what Ford stated with regard to Lynnhaven Mall. Then go back to the description of Kempsville Presbyterian's mixed-use development plan for the old Brown farm. The church's land fell squarely in the middle of the flight path between Oceana and Fentress but because there was no residential use proposed, Oceana's spokeswoman just then, Kelley Stirling, called it "compatible" with the navy's interest.

In truth, neither the navy or the city of Virginia Beach offered substantive resistance to residential and commercial development under Oceana's flight path until it was learned on December 22, 2003, that land encroachment issues, such as those plaguing Oceana, should be considered in the next round of base closures. The Oceana air station subsequently became the target of the 2005 federally mandated Base Realignment and Closure (BRAC) Commission. After reading BRAC decisions to close several key naval air stations, some members of the Virginia Beach community strongly lobbied to have the navy's F/A-18 Hornet aircraft

reassigned to Oceana from Naval Air Station Jacksonville, Florida, and in so doing vowed to curb residential and commercial encroachment under Oceana's flight path. The BRAC Commission added Oceana to the military's list of endangered bases on July 19, 2005. The seven-to-one vote stunned state and local officials, many of whom had predicted that the commission would not put Oceana into the mix of bases targeted for closure; it is, after all, the navy's East Coast master jet base and Virginia Beach's largest employer.

The commission order that came to the city in December 2005 provided detailed directions to implement new rules intended to halt development in certain areas around Oceana, known as Accident Potential Zone 1 [or APZ-1], a 1,600-acre area that the navy determined was incompatible with flight operations. The one issue that remained a challenge to the city was the order to roll back encroachment by incompatible uses in APZ-1 and the clear zone. The BRAC order stated clearly that the city was to "purchase and condemn" incompatible use property in the APZ-1 areas around Oceana for the purpose of preventing further encroachment. In its best effort to satisfy this requirement without going through the protracted process of condemning 3,400 homes, the city adopted new zoning laws on December 20 to preclude future incompatible development.

Despite the city's quick move to satisfy BRAC instruction, in early 2006 the Pentagon warned the state and city of Virginia Beach that their efforts to limit residential and commercial development near Naval Air Station Oceana "may not fully address" the demands of the BRAC Commission. The likely reason for this warning was clear. While the city plan, on paper, called for controlling and rolling back incompatible development of the land beneath the flight path between Oceana and Fentress, which it called the Oceana Land Use Conformity Program, it also sped up the process for commercial development—of which, again, the Brown farm tract was a recent example. The city's "added commitment" to make the Oceana program work included provisions for faster development approvals; waivers of development fees and utility hookup fees; tax and economic development incentives, and facilitating the purchase, exchange and lease of property. At that point, arguably it became clear that how long Oceana might remain viable in Virginia Beach was largely dependent on the city honoring its commitment to roll back existing encroachment and mitigate further residential and commercial development under the air station's flight path. Certainly, recent history would indicate that commercial development continued in the corridor of concern and with unanimous approval of the city council.

Down at the Virginia Beach resort, keeping tourists coming back between Memorial Day and Labor Day has come at an equally high price. There is little hint of the small-town charm displayed in pictures of the old cottages, hotels and inns that once stood lockstep on the beach from the turn of the twentieth century. New hotels, entertainment venues, retail shops and restaurants took their place in rapid succession. The rule, not the exception, afforded historically and culturally significant buildings little consideration before being razed. The threat to the city's historic and cultural resources continues today. Conservation and adaptive reuse of treasured pieces of old Virginia Beach did not, in large measure, ever come to fruition in any organized fashion. The large number of significant structures and landscapes in the county and down at the Virginia Beach Oceanfront before World War II versus the comparably small number of historic properties granted a reprieve from the wrecking ball since the last half of the twentieth century is evidence enough that preservation was not a priority.

When the iconic Peppermint Beach Club was razed on March 6, 1995, two important pieces of Virginia Beach history went with it: the building itself and the club that was its last tenant. The 1907 shake-clad building at Fifteenth Street and Atlantic Avenue was among

a handful of surviving examples of Virginia Beach's shingle-style buildings, popular from the 1880s; in 1924, it became the home of the New Ocean Casino, which gave its address as between Fourteenth and Sixteenth Streets. The Peppermint Beach Club was opened by Pennsylvania native Chester Louis Rodio.

Rodio was one of those returning World War II airmen who came home with the dream of starting his own business. He moved to Virginia Beach in 1949, when Atlantic Avenue was still just a few hotels, boardinghouses and restaurants. Here, he opened his first restaurant—the Doll House—on the corner of Fourteenth Street and Atlantic Avenue, where he sold the best hot dogs and chili at the beach. He eventually engaged in many other successful restaurants and clubs, including the Golden Garter, the Moonraker, Laskin Road Seafood and the Upper Deck Restaurant. But the business for which he would be best remembered is the original Peppermint Beach Club, known as the "Home of Beach Music" and the place that started the public dance hall craze at Virginia Beach in the 1960s. The club regularly billed popular regional rock-and-roll headliners like Bill Deal and the Rhondels, Sebastian and the House Rockers, and Little Willie and the Impressions.

Just before the Peppermint Beach Club was razed, an auction of the club's contents was held on February 9, 1995; it was there that Vick Sands, who had once booked musical talent for Oceanfront clubs, told *Virginian-Pilot* reporter Tom Holden what the Peppermint embodied. "It's the memories; that's it, the memories. If you could somehow write about the people who met here, who fell in love and who are now grandparents themselves, man, that would be a great story. It's all about the memories." John Vakos, who once managed the long-gone Top Hat on Twenty-Ninth Street and Atlantic Avenue, was there, too. When he saw Sands, Vakos offered this: "There's a lot of history here. There are businessmen from all over Tidewater who once played here." While the Top Hat was replaced by the Ocean Front Inn, the Peppermint was torn down for a parking lot.

In the two years before the Peppermint's last call, the Oceanfront lost the Avamere, a charming 1950s-era hotel famous for its front porch rocking chairs, laidback southern hospitality, and its neighbor the Halifax Hotel and, farther down the strip, the 1944 Sea Escape Motel. But the most significant loss of all was the Virginia Beach Civic Center, better known as "the Dome." Built in 1958 on Pacific Avenue between Nineteenth and Twentieth Streets, the city's first civic center was based on the design work of Buckminster Fuller and held the distinction of being the first aluminum geodesic dome constructed in the continental United States. In 1963, it was named the Alan B. Shepard Jr. Civic Center in honor of the *Mercury 7* astronaut and former Virginia Beach resident.

The Dome opened at the dawn of rock-and-roll, and as we were reminded in Roberta Thisdell's June 30, 1993 *Virginian-Pilot* retrospective, it played an important role as "midwife to the British Invasion, psychedelic, Motown, surf, heavy metal and just a little punk." For a place that could only seat one thousand, concerts by legendary performers Chuck Berry, Johnny Mathis, Ray Charles, the Beach Boys, Diana Ross and the Supremes, Jimi Hendrix, The Who and the Rolling Stones were close-up affairs. Hendrix, The Who and the Rolling Stones blew the doors off the place. Before it was torn down in September 1994, the Dome was considered nationally as one of Virginia Beach's most important buildings, a status that could not save it from the wrecking ball. A parking lot also took its place. "Very little is left along the Oceanfront that even hints of times gone by in Virginia Beach," observed newspaper columnist Mary Reid Barrow the following spring, after the Dome was gone.

There is an old saying that a man is largely what his memories are and what has happened to Virginia Beach has left us with little more. The Virginia Beach of yesteryear is all but

gone and the fabric of that old Princess Anne County crazy quilt has been torn apart many times over the pace of uncontrolled growth that continues to spread like poison ivy over the city. We might understand better what happened to our beloved Virginia Beach if we could go back and have a just one more chat with city native and raconteur Cornelia Holland. Fortunate for us all, she spoke to those who did that for us over her lifetime. Bill Morris wrote about her in his June 13, 1980 *Virginian-Pilot* column. In it she offered this insight: "People ask me why I stay. Well, they've torn down everything. If I sold this house they'd have it torn down by eight o'clock the next morning. I stay because it's home." She was almost ninety years old when she died on February 12, 1988. Oh, and she was right about her house: it was razed after her death.

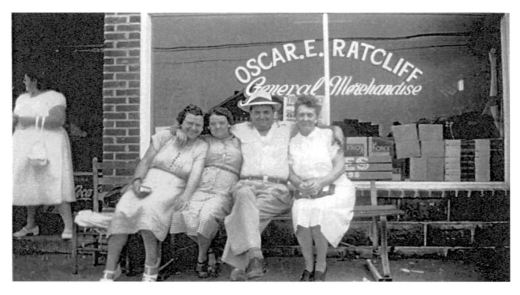

Oscar Earl Ratcliff (1893 – 1957) opened a general merchandise store at the corner of Virginia Beach Boulevard and London Bridge Road after World War II. This Beaufort County, North Carolina native had many jobs before opening his own business, from clerking for the Pender's grocery store chain in Portsmouth and Norfolk, Virginia, before he joined the United States Army at the start of World War I to joining the federal service to work posts in Washington, D.C., and Fort Story until the end of 1945. He was married to the former Edna Van Wagenen (1901 – 1965), seated second from the left next to Oscar Ratcliff's old friend Louis Lester Darden (1903 - 1966), who managed a Norfolk grocery store. The picture was taken in or about 1950. *Edgar T. Brown Collection, Virginia Beach Public Library*

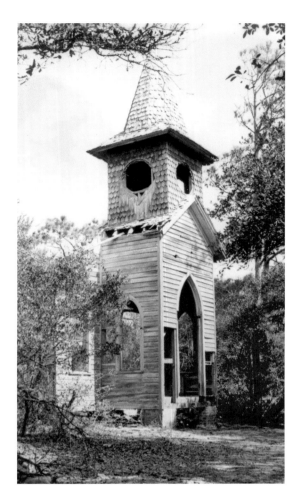

Above left: This is what remained of the Wash Woods church by the early 1950s, located in what is today False Cape State Park. Wash Woods was an unincorporated town in the former Princess Anne County that has been abandoned since the 1930s, except for the lifesaving station that remained operational under the coast guard until the 1950s. According to local legend, the community was started by survivors of a sixteenth or seventeenth century shipwreck. This story is bolstered by the fact False Cape had a long history as a ship graveyard. The village's church and other structures were purportedly built of cypress wood that washed ashore from the shipwreck. At the turn of the twentieth century the area was still inhabited by a community that had expanded to include a grocery store, two churches, and a school. Three hundred people once lived there, most of them working fishermen, farmers, hunting guides and lifesaving boat crew. *Virginia State Parks*[77]

Above right: Two decades into the twentieth century the sea had begun to claim the narrow sliver of sand adjacent to the Wash Woods community to the extent that the people living there started to leave by the 1930s. The site later became home to several hunt clubs. All that remains of the original Wash Woods church steeple is this section, pictured on June 18, 2011, nearly three decades after vandals demolished what remained of the church and the steeple structure. *Virginia State Parks*[78]

There is still a small cemetery adjacent to the ruins of the Wash Woods church (shown here, June 18, 2011). *Virginia State Parks*[79]

Opposite above: In 1728, the colonial governors of Virginia and North Carolina agreed to survey the boundary between the two colonies again. That effort started at the Atlantic Ocean, and surveyors went westward 237 miles until reaching the edge of the European settlement beyond the Dan River. The most prominent member of that effort was William Byrd II, who documented in a highly-opinioned history of the survey what had been a great adventure for him. The surveyors and commissioners started in February, 1728 at the Atlantic Ocean, at what is now the southeastern corner of Virginia's False Cape State Park. In a repeat of the 1710 survey, the Virginians made a hard-to-substantiate claim at the very beginning. As Byrd reported later in *The History of the Dividing Line Betwixt Virginia and North Carolina*: [...] *the first question was, where the dividing line was to begin. This begat a warm debate; the Virginia commissioners contending, with a great deal of reason, to begin at the end of the spit of sand; which was undoubtedly the north shore of Coratuck inlet. But those of Carolina insisted strenuously, that the point of high land ought rather to be the place of beginning, because that was fixed and certain, whereas the spit of sand was ever shifting, and did actually run out farther now than formerly. The contest lasted some hours, with great vehemence, neither party receding from their opinion that night.* The marker at the southern end of False Cape State Park commemorating the 1728 North Carolina–Virginia state boundary survey, photographed on September 30, 2013, was installed in 1887 at the behest of Virginia governor Fitzhugh Lee (1835–1905) and North Carolina governor Alfred Moore Scales (1827–1892). *Virginia State Parks*[80]

Opposite below: The old Kempsville jail had been turned into a residence when this picture was taken in 1950. The structure was located near the intersection of Overland Road and Home Center Lane. *Sargeant Memorial Collection, Norfolk Public Library*

A.D. 1728.

N.C. & Va.
BOUNDARY.
Re 1887. Run
W.D. Pruden N.C.
O.R. Howard. Va.
Commrs.
H.T. Greenleaf.
Engineer.

A.M. Scales
Gov. N. Ca.

Fitz Hugh Lee.
Gov. Va.

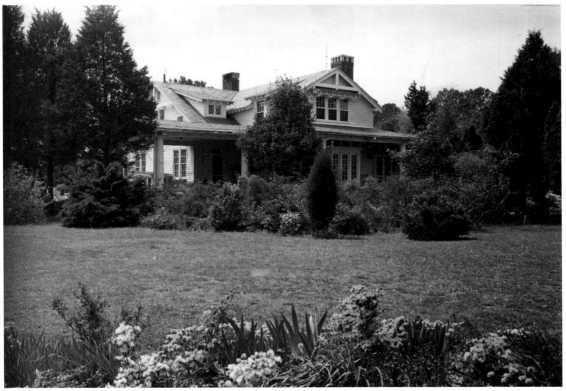

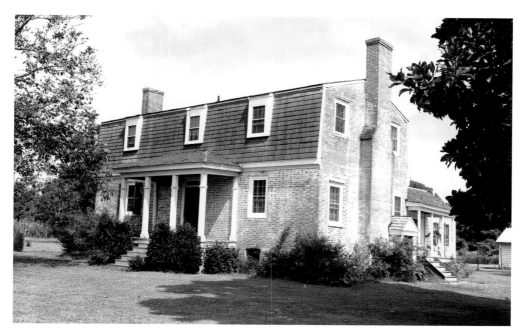

Above: John Pallet acquired six hundred acres of land on Wolf's Snare Creek, first called Oliver Van Hick's Creek, from Adam Keeling II in 1714, and from here he established a trading post from Pallet's Landing. At that time, Wolf's Snare Creek was navigable water that extended past the Eastern Shore Chapel and onto part of what is today Naval Air Station Oceana. The elder John Pallet left the plantation to his son, John, in 1719; he called it Wolfsnare Plantation. The second John, in 1777, divided the six hundred acres between his two sons, Matthew and John III; John III got the western side and Matthew the part with the house on it. John II's will indicated that his widow, their mother, would have use of the house for the rest of her life. Like the Keeling house, Wolfsnare Plantation, shown here as it looked on September 18, 1950, was built later than the 1714 to 1719 period initially believed. John Pallet II built the house in or about 1750. The home, located on Plantation Road near London Bridge, still stands and has been restored; it is privately owned. *Sargeant Memorial Collection, Norfolk Public Library*

Opposite above: This is one of the last photographs taken of the third Eastern Shore Chapel of Lynnhaven Parish at its original location just before it was dismantled and moved. Taken on January 23, 1952, the picture shows the chapel and cemetery still intact on property just acquired by the United States Navy to accommodate growth at Naval Air Station Oceana. A new Eastern Shore Chapel conforming as much as possible to the blueprints of the old structure was rebuilt at the chapel's present site on Virginia Beach's Laskin Road. The baptismal font, pews, stained-glass windows, doorframes, and the stairway to the choir loft were repurposed from the church building shown here, along with some of the eighteenth-century brick walkways. The cemetery was also moved to the Laskin Road location. *Sargeant Memorial Collection, Norfolk Public Library*

Opposite below: In 1918, Portsmouth, Virginia native and cotton industry executive William Collins Hill (1868–1934) purchased Sea Breeze Farm, which became his family's second home. William Hill shared the residence with his sisters, who continued to live there after his death. Elizabeth Gregory Hill (1871–1957) founded the Princess Anne Garden Club on Sea Breeze Farm in 1932 and was the horticulture editor for the *New York Herald Tribune.* Evelyn Collins Hill (1877–1965) was elected to membership in the Royal Horticultural Society of London and received many awards, including gold and silver medals at every international flower show sponsored by the New York Horticultural Society between 1936 and 1960. According to the Hill history,[81] both Elizabeth and Evelyn, as well as sister Blanche Baker Hill (1879–1949) received secretarial training and worked for the Seaboard and Roanoke Railroad and Western Union, Elizabeth as a chief clerk. This picture of Sea Breeze Farm in the Little Neck section of what was then Princess Anne County was taken on April 18, 1950, when the farm was used largely by sisters Elizabeth and Evelyn Hill,[82] the family's horticulturists. Of interest, in 1637 the farm site once served as the old glebe of Lynnhaven Parish, the location of the first colonial court. *Sargeant Memorial Collection, Norfolk Public Library*

The young children who attended the Hillcrest Kiddie Ranch, shown here on July 19, 1951, raised the flag and took it down as part of the daily activities offered by the summer camp, located in the Kempsville section of the former Princess Anne County. Observe that children's hands are respectfully over their hearts as the flag goes up. The ranch was established and operated by James Amos and Jamie Lee Peake Cantwell. The western-themed summer camp typically catered to thirty-three children for a week. The young boy playing the trumpet in the photograph (below) is James Amos "Jimmy" Cantwell Jr. (1942–1999). *Sargeant Memorial Collection, Norfolk Public Library*

Tennessee native James Amos Cantwell (1914–1989) was a graduate of the Cincinnati Conservatory and a music teacher at Princess Anne High School; his wife, Jamie Peake Cantwell (1919–2007), was a native of Churchland (now part of Portsmouth), Virginia, where they were married. The couple shared a love of horses. Shown in this July 19, 1951 photograph of the newly built snack bar at the Hillcrest Kiddie Ranch are (left to right) Janica Snowden, Jamie Palmer "Pam" Cantwell (later Baker), and Sharon Dean Polk. The Cantwells also later ran the Hillcrest School of Horsemanship and the Hillcrest Stables on the Great Bridge Road (still in Princess Anne County just then), Jimmy and Pam Cantwell, who started out helping their parents run the summer camp, ran their own lesson program, teaching three hundred once-a-week students and about fifty boarders. Pam Cantwell Baker, who spent her life in the horse industry, went on to establish a farm in the heart of Virginia horse country near Warrenton, Virginia, reprising the name Hillcrest Farms at her Bealeton horse operation. *Sargeant Memorial Collection, Norfolk Public Library*

There was a solar eclipse on September 1, 1951, that drew hundreds to the Virginia Beach Boardwalk to watch. *Sargeant Memorial Collection, Norfolk Public Library*

This postcard shows the Duck-In seafood restaurant on Route 60 [Shore Drive] at the mouth of the Lynnhaven River at the foot of the Lesner Bridge. The Duck-In, which opened in 1952, was old Virginia Beach; it closed in mid-August 2005 and was razed that December. *Amy Waters Yarsinske*

The intersection of South Military Highway [Route 13, four-lane divided road] and Indian River Road looking south on July 10, 1954, was still largely rural when this picture was taken. At that time, this stretch of road was in Princess Anne County [now Virginia Beach]. The white buildings on the southeast corner of the intersection belonged to Lindsey Lumber Company. Indian River Road headed east was under construction. *Sargeant Memorial Collection, Norfolk Public Library*

A Princess Anne County campaign led by Joseph Willcox "Bill" Dunn (1898–1989), head of the ticket and owner, publisher and editor of the weekly newspaper *Princess Anne Free Press*, assembled on stage at a public meeting held at Virginia Beach High School, located on Cypress Avenue between Twenty-Fourth and Twenty-Fifth Streets, on April 28, 1955. These candidates were part of the so-called "Dunn Machine." Pictured in this photograph is Littleton Banks Walker Jr. (second from left) (1912–1994) playing a humorous recording for the audience. *Sargeant Memorial Collection, Norfolk Public Library*

The Dunn Machine meeting drew hundreds to Virginia Beach High School on April 28, 1955. Dunn established his weekly newspaper to fight the wide-open gambling permitted in Virginia Beach and Princess Anne County during the 1950s. Slot machines were in every hotel and there were a number of casinos. Since he opposed the gambling, Dunn went against the so-called Kellam Machine—the dozen Kellam brothers[83] who controlled the political life of Virginia Beach and who did not oppose open gambling. Dunn's newspaper was opposed in print by the *Virginia Beach Sun-News*, owned by Richard Boykin Kellam (1909–1996). Dunn's outspoken nature led to death threats and he was beaten in the same year this picture was taken. According to the January 1, 1990 *Washington Post*, a few days after that attack, a marine corps boxer told Dunn that he had been given $500 by the chief of police to give him the beating.[84] *Sargeant Memorial Collection, Norfolk Public Library*

Federal, state and local law enforcement descended on the Surfcomber Restaurant on August 16, 1955, seizing gaming equipment and evidence of other gambling and illegal liquor sales. *Sargeant Memorial Collection, Norfolk Public Library*

A political meeting held by the Kellam organization at Virginia Beach High School, located on Cypress Avenue between Twenty-Fourth and Twenty-Fifth Streets, was photographed on May 12, 1955. The head of the organization was Sidney Severn Kellam. *Sargeant Memorial Collection, Norfolk Public Library*

The Kellam organization political meeting was standing room only on May 12, 1955, overflowing the auditorium of the old Virginia Beach High School. *Sargeant Memorial Collection, Norfolk Public Library*

Lewis Roberts Binford (1931–2011), a Norfolk, Virginia native and an undergraduate student[85] in anthropology at the University of North Carolina, Chapel Hill, was touring an archaeological site at Stumpy Lake in what was then Princess Anne County when this picture was taken on June 30, 1955, by James Earle "Jim" Mayes, a *Virginian-Pilot* photographer. Binford examined the area after workmen reported finding what turned out to be three thousand-year-old Native American tools and other artifacts on the site. When he died at age seventy-nine in Kirksville, Missouri, Binford was considered one of the most influential American archaeologist of the last half-century and is credited with fundamentally changing the field with the introduction of processual archaeology (or the "New Archaeology") in the 1960s. He was well known for his influential work in archaeological theory, ethnoarchaeology and the Paleolithic period. Of note, he was an early advocate of a more scientific approach to investigating ancient cultures. Binford went on to earn his master's and doctoral degrees from the University of Michigan after graduating from Chapel Hill. *Sargeant Memorial Collection, Norfolk Public Library*

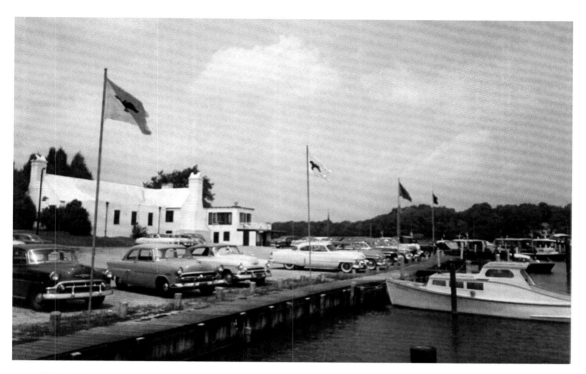

Richard Crane, owner of Westover plantation in Charles City County and a former diplomat, had already begun development of Birdneck Point when he was approached by the Cavalier Hotel's general manager and future owner, Sidney Banks, to build a club for its patrons that featured a first-rate golf course and trapshooting. He agreed and donated the land to the hotel for that purpose. The Cavalier Country Club was completed in 1930 and soon after Professional Golf Association legend Sam Snead won the Virginia Open on the club's course. On March 22, 1947, the club's management announced that the facilities would be called the Cavalier Yacht and Country Club. Later that same year an extension was planned to the fifty-five-foot pier in anticipation of extensive dredging of the Lynnhaven Inlet which would open up Broad and Linkhorn Bays to larger boats. By the summer of 1952 the club was considered to be one of the mid-Atlantic's major yacht clubs, its marina accommodating some 75 yachts and cruisers on their dual 200-foot-long piers. Today, it is known as the Cavalier Golf and Yacht Club. *Amy Waters Yarsinske*

Opposite above: The cars shown here, photographed in 1955, were parked at the Old Ocean Casino [Seaside Park]. *Sargeant Memorial Collection, Norfolk Public Library*

Opposite below: This May 23, 1953 photograph of automobiles traveling on Virginia Beach Boulevard and Laskin Road shows a banner strung over the intersection advertising the first Naval Air Station Oceana open house air show event. *Sargeant Memorial Collection, Norfolk Public Library*

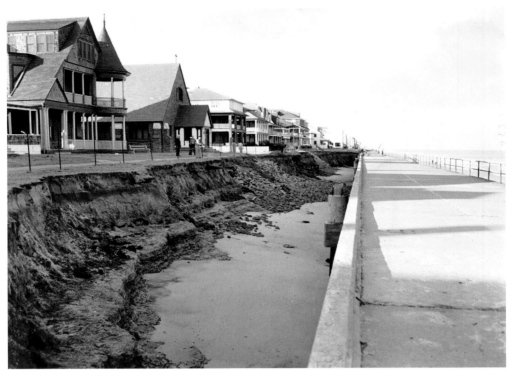

Taken between 1954 and 1955, this picture shows severe beach erosion coming from under the boardwalk. *Sargeant Memorial Collection, Norfolk Public Library*

Joseph Roscoe Johnson (1911–1964) (left) and Robert Edward Whitehead Jr. (1916–1997), the son of the physician who acquired Pleasant Hall near the turn of the twentieth century and who later inherited the property from his father, stand in front of the old courthouse (sheathed in scaffolding) in 1957. Today, with the old courthouse now long gone, the house stands as practically the last early vestige of the old Kempsville, the one-time seat of power in the county. Set amidst its tall old trees, the house bore witness to the conversion of the surrounding broad, flat fields of old Princess Anne County into the vast suburban housing tracts of the modern city of Virginia Beach. *Robertson Photos Collection, Virginia Beach Public Library*

Author and Pulitzer Prize winning playwright Paul Eliot Green's outdoor production "The Confederacy" had a short-lived run of just two years from 1958 to 1959 at the Robert E. Lee Amphitheatre, located on over twenty acres at the intersection of Laskin and Birdneck Roads. Green (1894–1981) also wrote and produced "The Lost Colony," what he called a "symphonic drama" at Roanoke Island, North Carolina, that began its run in 1937. The brochure for "The Confederacy" is shown here. *Edgar T. Brown Collection, Virginia Beach Public Library*

The Robert E. Lee Amphitheatre, setting for Paul Green's symphonic drama "The Confederacy," is shown on this period postcard. *Edgar T. Brown Collection, Virginia Beach Public Library*

Lotus Festival queen Anne Beverly Kennett, daughter of Richard and Caroline Jordan Kennett, posed among the lotuses at the American Lotus Garden in Tabernacle Creek at Sandbridge, in what was then Princess Anne County, during the July 15–22, 1959 festival. *Amy Waters Yarsinske*

Lotus Festival queen Anne Beverly Kennett posted with her attendants at the Robert E. Lee Amphitheatre prior to her coronation on July 15, 1959. Pictured (left to right) are Mary Cody Hughes, Alyce Lucille Savage, Kennett, and Franklynn Roberta "Frankie" Williamson. *Amy Waters Yarsinske*

Lotus Festival organizers posed with Queen Anne Beverly Kennett at the Cavalier Beach Club on July 22, 1959. Pictured here (left to right) are Shirley Wood Keene, chairman of the fifth annual Lotus Festival; Mary Whiteside Freeman, president of the Cape Henry Woman's Club; Kennett, and Thelma Williams Brennan, chairman of publicity. *Amy Waters Yarsinske*

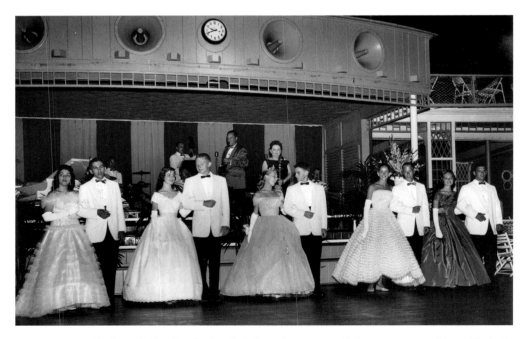

The Lotus Festival ball was held at Cavalier Beach Club on the evening of July 22, 1959. *Amy Waters Yarsinske*

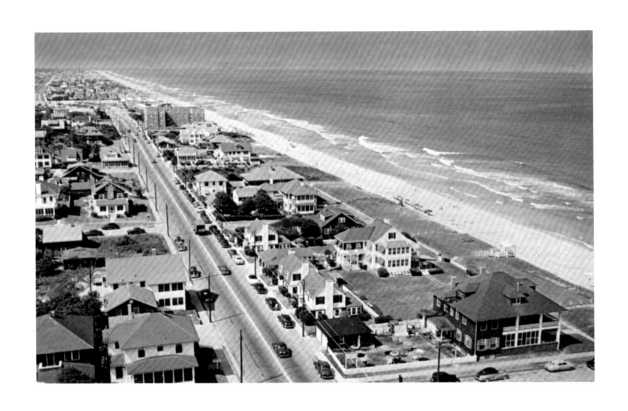

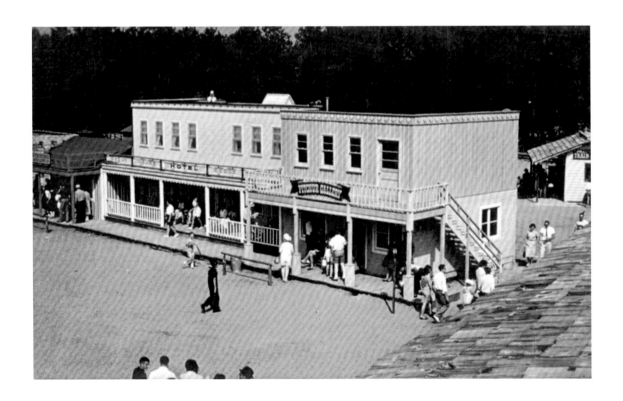

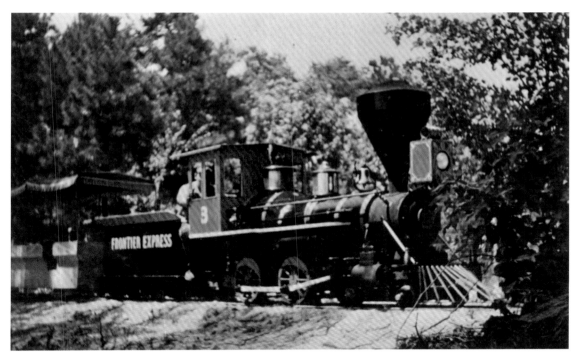

Frontier City featured a stockade town, a paddlewheel steamer, a Longhorn saloon, a stage coach depot, a steam locomotive, and even an Indian village, complete with teepees and snake dancers. By 1965, property within walking distance of the Oceanfront was at a premium, so the owners decided to sell it to make way for an apartment complex. "The land is just too valuable to leave as an amusement park," Charles Daniel Norton, a building contractor who was set just then to negotiate the sale and manage the apartment complex, told the *Ledger-Star* for its May 3, 1965, editions.[86] A week later, apparently in a move to clear the title, the property was sold at a public auction on the courthouse steps for $100,000. There was only one bidder, according to subsequent reporting. The paddlewheel steamer had already sunk, the train and most of its tracks had been sold to another attraction in Ohio, and the Frontier City itself had, fittingly, become a ghost town. *Edgar T. Brown Collection, Virginia Beach Public Library*

Opposite above: The area shown on this postcard, postmarked on July 17, 1961, shows the four blocks between Thirty-Sixth and Fortieth Streets on Atlantic Avenue, which just then was a blend of private Oceanfront residences and commercial cottages that rented to tourists who preferred the quaint accommodations offered in these establishments over larger hotels and motels on the strip. Down the center of the picture, starting with the extreme end (top) was the Cavalier Beach Club and the Sir Walter Hotel (formerly known as the Gay Manor Hotel). The former LeMoine Cottage at Thirty-Sixth Street and Oceanfront, which became the Country Day School for Girls in 1957, is toward the center of the postcard. The Bagley Cottage is shown lower right. None of the buildings in this picture are still standing today. *Amy Waters Yarsinske*

Opposite below: Frontier City opened in 1961 on the outskirts of what was then the smaller city of Virginia Beach in Princess Anne County. The attraction was built on twenty-six acres at the corner of Laskin and Birdneck Roads, the same site where another historic drama—"The Confederacy"—had a short-lived, two-year run dramatizing the life of Robert E. Lee. *Edgar T. Brown Collection, Virginia Beach Public Library*

Taken between March 8–10, 1962, this and other photographs shown here chronicle the aftermath of storm damage done by the Ash Wednesday storm that struck Virginia Beach hard. Photographer Ambrose Harvey Lindsey Armistead was looking west on Eighty-First Street with a dump truck in the road. The houses (left to right) are 203, 117 and 115 Eighty-First Street. *Sargeant Memorial Collection, Norfolk Public Library*

Opposite above: This postcard shows the Frontier City Press, livery stable building and the sign post directing visitors to different parts of the park. Not all of Frontier City was lost to new development, at least not right away. For those old enough to remember, the Indian village portion did reappear briefly in a separate venue opened on an eight-acre piece of property in the woods just across Virginia Beach Boulevard from Pembroke Mall. The new outdoor attraction, the Skicoak Living Museum of the American Indian, even used the Frontier City teepees, until the operators abandoned Plains Indian culture to concentrate on the coastal Indian villages indigenous to this area.[87] Skicoak was open for tours from 1965 to 1971, when the Waldorf family, who operated it, moved its artifacts to Roanoke Island, North Carolina, and opened a recreated Indian village that operated there until 1978. *Edgar T. Brown Collection, Virginia Beach Public Library*

Opposite below: The Cavalier Beach Club, which first opened on Memorial Day 1929, featured a hardwood dance floor on the platform (left) that immediately became the focal point of entertainment featuring the country's greatest big bands and, notably, the club's elegant Sunday afternoon tea dances. Among the biggest names to take the bandstand facing the Atlantic Ocean were Tommy Dorsey, Jimmy Dorsey, Glenn Miller, Harry James, Benny Goodman, Xavier Cugat, Cab Calloway, Lawrence Welk, Bing Crosby, Guy Lombardo, Judy Garland, Johnny Long, and the incomparable Frank Sinatra. The club claimed the sand in front of it. Today, there is nothing left that might indicate there was ever a Cavalier Beach Club on this part of the Oceanfront. This 1960-era Kodachrome postcard of the Cavalier Beach [and Cabana] Club shows the beach in front of the dance platform, the cabanas in the background. *Amy Waters Yarsinske*

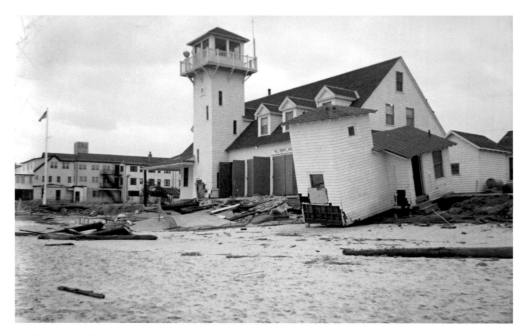

Looking west at (left to right) Albemarle Hall Hotel at 2321 Atlantic Avenue, and the United States Lifesaving Station Number 2 (also called the Seatack Lifesaving Station) on Atlantic Avenue at Twenty-Fourth Street, Ambrose Armistead documented extensive damage to structures from the North End and down the Oceanfront beach. The small building (right foreground) had been part of the United States radio compass station. *Sargeant Memorial Collection, Norfolk Public Library*

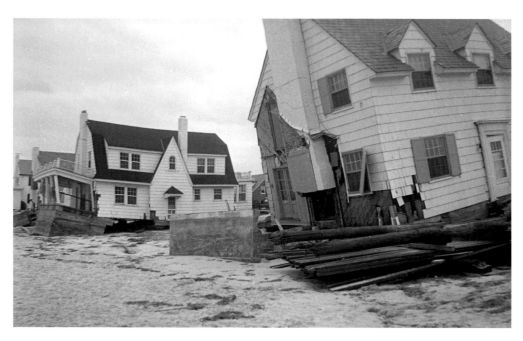

The Ash Wednesday storm damaged many homes beyond repair. Ambrose Armistead photographed these houses (left to right) at 4206 and 4210 Oceanfront Avenue between Forty-Second Street (formerly Cavalier Drive) and Forty-Third Street (formerly Pocahontas Drive). The home at 4210 Oceanfront Avenue was the Ethel K. Royster residence. Both houses were demolished and replaced with new homes. *Sargeant Memorial Collection, Norfolk Public Library*

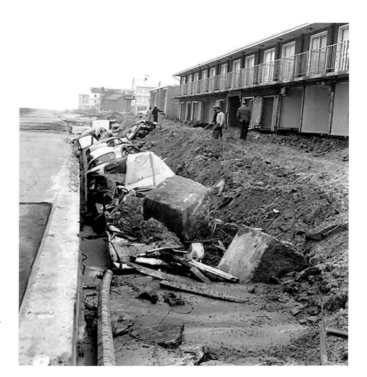

The Ash Wednesday storm of March 6–8, 1962, caused such widespread damage along the Oceanfront that severe erosion along the area of Twenty-Ninth Street looking south on the boardwalk was being backfilled by automobiles ruined in the flooding. Daniel Kiley took to the photograph. *Charles S. Kiley Collection, Virginia Beach Public Library*

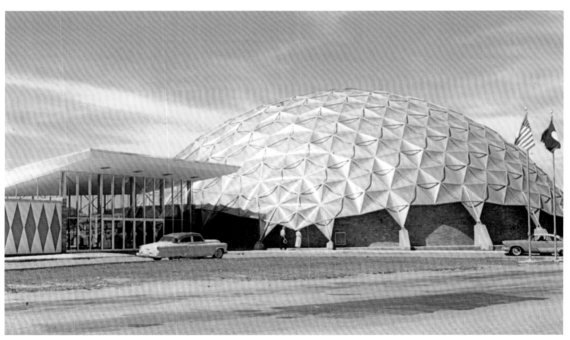

The Alan B. Shepard Civic Center, pictured here as it appeared in the summer of 1963 and later popularly called "The Dome," was Virginia Beach's premier public convention facility before construction of the Virginia Beach Pavilion, which opened in 1980. When it made its debut in 1958 on Pacific Avenue between Nineteenth and Twentieth Streets, it was called the Virginia Beach Civic Center, but in March 1963, city officials renamed it in honor of astronaut and former Virginia Beach resident Alan B. Shepard, who took part in a Mercury program space flight on May 5, 1961. The Buckminster Fuller-designed geodesic building was the first of its kind built in the United States. The Dome was demolished in 1994. *Amy Waters Yarsinske*

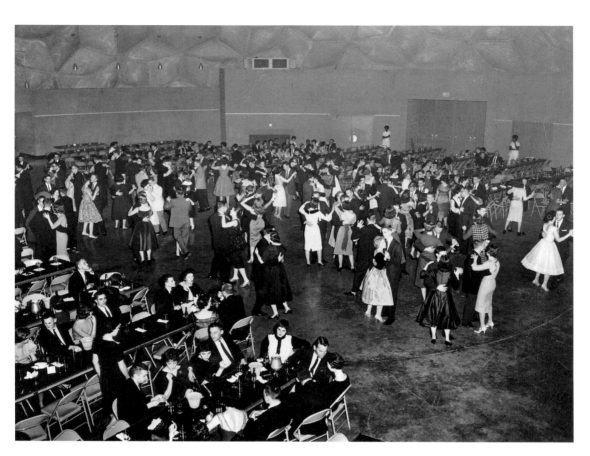

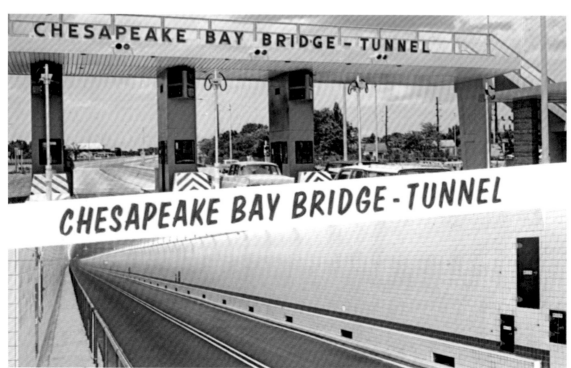

Wallis Earle "Wally" Damon (1926–2009) was a longtime Virginia Beach resident and local artist who hand painted billboards, storefronts and other signage. This is a photograph of some of the first fire department vehicles he lettered in the 1960s for the Chesapeake Beach Volunteer Fire Department. The lineup of the Chesapeake Beach station's vehicles, from ambulances to rescue boat also date to the same period. Damon painted the gold leaf on all of the vehicles and the billboard in the background. *Wallis E. Damon Collection, Virginia Beach Public Library*

Opposite above: Buddy Morris and his orchestra played for a dance held on February 20, 1960, at the Alan B. Shepard Civic Center (later called "The Dome") for students at the Norfolk Division of the College of William and Mary (later Old Dominion University). *Special Collections and University Archives, Old Dominion University Perry Library*

Opposite below: The Chesapeake Bay Bridge-Tunnel (CBBT)—officially the Lucius J. Kellam Jr. Bridge-Tunnel— opened on April 15, 1964. The twenty-three-mile fixed link crossing at the mouth of the Chesapeake Bay connects Virginia Beach with Northampton County on the Delmarva Peninsula. The bridge-tunnel originally combined twelve miles of trestle, two one-mile-long tunnels, four artificial islands, four high-level bridges, approximately two miles of causeway, and five-and-a-half miles of approach roads, crossing the Chesapeake Bay and preserving traffic on the Thimble Shoals and Chesapeake shipping channels. The Virginia Beach tolling facility is shown in this postcard that dates to the time frame of the bridge-tunnel's opening. The CBBT replaced vehicle ferry services that operated from south Hampton Roads and the Virginia Peninsula from the 1930s. Financed by toll revenue bonds, it remains one of only ten bridge-tunnel systems in the world, three of which are located in Hampton Roads, Virginia. *Amy Waters Yarsinske*

Above: The Boardwalk Art Show (shown here, 1964) on the Virginia Beach Oceanfront is the city's oldest event and longest running outdoor art show on the East Coast. The Virginia Beach Art Association (later the Virginia Beach Arts Center and now the Virginia Museum of Contemporary Art [MOCA]) sponsored the first open-air art show on the resort's boardwalk in July 1956. "Best in Show" that first year was Leonette Adler, who went on to participate in the first five shows. Of that first show, Adler recalled that she hung her artwork on the Boardwalk railings covered by umbrellas for shade. Back in the day, artists displayed their works on chicken wire attached to railings, because the Boardwalk was much smaller than it is today. The following year, some of the hotels opened their porches to the artists. Adler made sure she was first in line, so she could secure a shady spot on the porch of the Albemarle Hotel.[88] *Amy Waters Yarsinske*

One hundred-and-sixty-five-acre Mount Trashmore, a former landfill, was in the process of being made into a city park to include two manmade mountains and two manmade lakes when this picture was taken between 1969 and when the park opened in 1974. Mount Trashmore is an example of landfill reuse with mountains fashioned from compressed solid waste and clean soil to make a park. The main mountain is sixty feet in height and eight-hundred-feet long. The smaller mountain was later named Encore Hill. Lake Windsor, located along South Boulevard, is brackish water fed by Thalia Creek. Lake Trashmore, located on Edwin Drive, is freshwater and contains various species of fish. The park also now includes two playgrounds, a skate park and vert ramp, and multi-use walking paths. *Special Collections and University Archives, Old Dominion University Perry Library*

Opposite below: The original Peppermint Beach Club, the iconic mainstay of Fifteenth Street and Atlantic Avenue, was opened in the 1960s by Chester Louis Rodio, owner of many successful Virginia Beach businesses, including the Golden Garter, the Moonraker, Laskin Road Seafood and the Upper Deck Restaurant. But it was the Peppermint Beach Club, shown on a period postcard, that gained fame as the "Home of Beach Music." The club regularly booked popular regional rock-and-roll headliners like Bill Deal and the Rhondels, Sebastian and the House Rockers and Little Willie and the Impressions, as well as national acts like Fats Domino, Roy Orbison and Joey D and the Starlighters. When the club was torn down on March 6, 1995, it was the last of the resort's shingle-style buildings, an architectural style that had once been so common at the Oceanfront from the 1880s and is now all but gone. *Amy Waters Yarsinske*

As Virginia Beach surfers caught the morning beach break on September 20, 2003, a Norfolk-based United States Navy warship returned home after riding out Hurricane Isabel at sea. Hurricane Isabel, which cost the Navy nearly $130 million in damage in the Mid-Atlantic region, made landfall as a category two storm near Cape Hatteras, North Carolina, approximately 100 miles south of Norfolk. Chief Photographer's Mate Johnny Bivera took the photograph. *United States Navy*

Opposite above: The Fort Story shoreline, to include the 1918 United States Weather Bureau building (center), has been rung with riprap to stem erosion and the flooding that has inevitably followed. This is an aerial view of Fort Story taken on January 1, 1983. Fifteen years later, in 1998, three significant and successive storms breached the dunes at Cape Henry. While those dunes were replenished, erosion persisted. Four years later, in 2002, the United States Army had eighteen stone breakwaters constructed on a mile of beach from the south to the old weather bureau building. *National Archives*

Opposite below: The twenty-third mayor of Virginia Beach—Meyera Oberndorf (1941–2015)—is shown in her mayoral city hall office. Oberndorf was the city's longest serving mayor and first woman to hold the position in the over three-hundred-year history of the city (and its predecessor Princess Anne County). She served as mayor from July 1, 1988, to January 1, 2009. In the two years prior to her election, she served as the city's vice mayor. As a member of the city council, she served the city from July 1, 1976, to June 30, 1988, and before that was a member of the public library board for a decade. After her death, Oberndorf was named one of the prestigious Virginia Women in History, an annual program sponsored by the Library of Virginia that honors eight Virginia women, living and dead, for their contributions to their community, region, state, and the nation. *Special Collections and University Archives, Old Dominion University Perry Library*

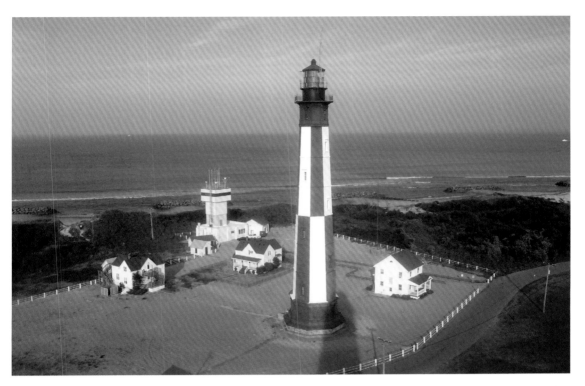

The 1881 Cape Henry Lighthouse was photographed by retired National Oceanic and Atmospheric Administration (NOAA) captain Albert Emil Theberge from the top of the old Cape Henry Lighthouse in October 2004. A number of the breakwaters built north and south of the lighthouse are visible on the shoreline. *NOAA*

Opposite above: The Bell House—also called Cedar Grove—was built in or about 1820 by Joshua James Jr. [89] After James' death, his second wife, the former Mariah Frances Henley (1826–1902),[90] remarried to Alexander Wright Bell (1832–1907), from whom the house takes its name, on January 25, 1863. Alfred Thomas Taylor (1904–1967) acquired the property in 1942 and purchased additional land, bringing the total acreage around the historic house to over one thousand acres. Taylor married Doris Land Malbon (1916–1992) on October 30, 1943. The Taylors made significant changes to the house, adding a den across the back and an additional room over it to accommodate a maid's quarters. Until the Taylors bought it, the only bathroom was an outhouse, which they quickly changed. Taylor also built a small tenant house to the rear of the main house for the caretakers of the Taylors' thoroughbred horses and the farm, in general. The residence was acquired by the navy in 1952 and has largely been used off and on over the years as a residence for the air station's commanding officers. Today, the house is now used a private residence for active duty navy captains and their families. The photograph shown here was taken by Mass Communication Specialist Second Class Antonio P. Turretto Ramos. *United States Navy*

Opposite below: A Sikorsky UH-3H Sea King helicopter assigned to the search and rescue (SAR) unit at Naval Air Station Oceana flies over the Virginia Beach Oceanfront on August 27, 2004. The SAR squadron, which provides rescue services to both military and civilian communities, was disestablished that October 1. Photographer's Mate First Class Anthony M. Koch took the picture. *United States Navy*

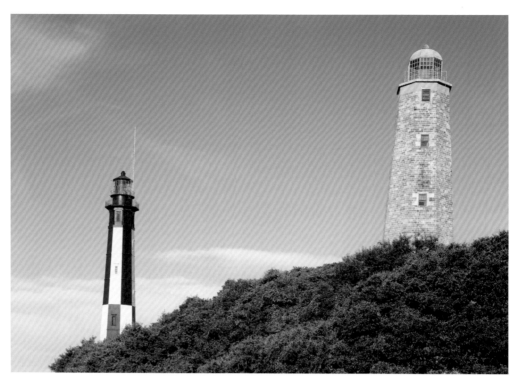

The Cape Henry lighthouses (shown here) were photographed by Carol M. Highsmith on March 3, 2005. *Library of Congress*

Although Lakes Lawson and Smith fall within the Virginia Beach city limits, they are part of a system of ten manmade reservoirs owned and managed by the city of Norfolk department of utilities. Other reservoirs within the so called intown reservoir system include Lakes Whitehurst, Wright and Taylor, and the Little Creek Reservoir and Stumpy Lake. These lakes have been a part of the Norfolk system for over a century and help supply water to Norfolk, Virginia Beach and some Chesapeake residents. Recreational use of the lakes has been allowed since the lakes were created. This view of Lake Smith, taken in August 2005, is from Captain Smith's boathouse, which was located just off Northampton Boulevard on the lake. *Patti Fay Schmitt Collection, Virginia Beach Public Library*

More than 1,200 service members, civic leaders, and civilians using cards made the United States flag during the "9/11 Hampton Roads Remembers" ceremony held at Mount Trashmore Park on September 11, 2006. Mass Communications Specialist Seaman Christopher Hall took the picture. *United States Navy*

Seashore State Park's name was changed in 1997 to First Landing State Park to recognize Cape Henry as the site of the first stopping off point for the English settlers who would go on to establish the first permanent English settlement at Jamestown. Several additions of land and adjustments of the border with Joint Expeditionary Base East [Fort Story] bring First Landing State Park to 2,889 total acres. Additionally, the 3,598-acre Seashore Natural Area, a portion of which overlaps First Landing State Park, was listed as a National Natural Landmark in 1965. The designation recognized the significance of the park's forested dunes and semitropical vegetation. Part of the bald cypress swamp at First Landing State Park was photographed by Angela Pan on January 9, 2008. *Virginia State Parks*[91]

The Cavalier Hotel, shown in this May 28, 2010 photograph, played host to seven American presidents, including John Calvin Coolidge, Herbert Clark Hoover, Harry S. Truman, Dwight David Eisenhower, John Fitzgerald Kennedy, Lyndon Baines Johnson, and Richard Milhous Nixon, from the time it opened in the spring of 1927. The property at Forty-Second Street and Pacific Avenue no longer resembles this picture. After the property was sold in 2013, Cavalier Associates LLC purchased the old hotel on the hill, the land around it and the New Cavalier Hotel on the Oceanfront for redevelopment. While the hotel was restored to include new restaurants, a spa and a distillery, eighty-one homes now swallow up the grounds that once positioned The Cavalier as the undisputed "queen of the Beach." *Serge Melki*[93]

Opposite page: Regent University is a private Christian research university founded by Marion Gordon "Pat" Robertson, an American media mogul, executive chairman and former Southern Baptist minister, in 1977 as Christian Broadcast Network (CBN) University; the name was changed in 1990 to Regent University. The name change was intended to reference a regent, a person who exercises power in a monarchial country during the absence or incapacity of the sovereign, and according to the university's catalog "a regent is one who represents Christ, our Sovereign, in whatever sphere of life he or she may be called to serve Him." The university's current motto is "Christian Leadership to Change the World." The first class, consisting of seventy-eight students enrolled in what is now the school of communication and the arts, started in the fall of 1978, at which time the school leased space in the city of Chesapeake, Virginia. In the years to follow, the university took up residence at the current seventy-acre campus near Interstate 64 and Indian River Road in Virginia Beach. Regent University was first accredited by the Southern Association of Colleges and Schools in 1984. The buildings on the campus are historicist neo-Georgian architecture. The university was named in more recent years among the thirty most beautiful college campuses in the South. Robertson Hall (top), the largest office and classroom building on the campus, is home to the law school, Robertson School of Government and undergraduate studies. In the second photograph (bottom) is the library. Thousands of students now attend the university to earn their associate, bachelor's, master's and doctoral degrees. Both photographs were taken on September 9, 2009. *Debate Lord*[92]

Carol M. Highsmith took this contemporary photograph of this young Virginia Beach enthusiast at one of the community's many public art displays on August 2, 2011. *Library of Congress*

Opposite above: By a deed dated March 30, 1791, for a consideration of five shillings, Anne Nimmo conveyed to the Society of Members of the Methodist Episcopal Church one acre of land in the fork of the roads leading from Sandbridge to Eastern Shore. Work immediately began on the "Nimmo Meeting House." The building was of simple design, without steeple or balcony. A single entrance was at the west end, and the building was of white clapboard construction, with plastered walls. The pews were of Colonial design, high-backed, of stained pine and poplar, edged with walnut. The floor was of random-width pine and carpeted. A fireplace of bricks, which were made on the property, was built in the center of each side of the building. The original structure still stands as the sanctuary, although it has undergone many changes over the years. It is the oldest surviving Methodist church in continuous use in Virginia. In 1872, the church was badly in need of repairs. Four years later, in 1876, church trustees reported that "the inside walls have received four coats of paint, the outside walls three, the seats revarnished, a new pulpit, new carpets, new cushions, etc., the improvements are handsome." A recessed chancel was added to the east end, a steeple and vestibule added to the west end, and the church ceiling was raised between 1893 and 1894. Another renovation was begun in 1927, when a hardwood floor was laid over the old pine floor, theater-type seating installed, and the baptismal font donated by Evelyn Nimmo. In 1956, in order to provide facilities for the Sunday school, wings to either side of the church were built, connected to the sanctuary by arched breezeways. In 1962, the current colonial box pews were added, the original pine flooring was uncovered and refinished, the building was replastered and the balcony restored. During renovations in 1989 to replace the support beams under the sanctuary, the breezeways were enclosed and offices behind the sanctuary were added. The social hall was completed in 1991. This September 5, 2010 photograph shows the church with all significant additions and modifications. The cemetery is in the foreground. *Rlevse*[94]

This September 5, 2010 photograph, taken from Henley's Farm Market across the intersection of Princess Anne and Indian River Roads, shows the only stoplight in Pungo and the shuttered Munden's—formerly Capps and Land—general store. *Rlevse*[95]

Above: Aviators assigned to the Sunliners of Strike Fighter Squadron Eighty-One (VFA-81) walk to greet friends and family members after arriving on the tarmac during a homecoming at Naval Air Station Oceana on June 15, 2011, photographed by Mass Communication Specialist Indra Bosko. The Sunliners, part of Carrier Air Wing Seventeen (CVW-17), returned home after a deployment aboard the *Nimitz*-class aircraft carrier USS *Carl Vinson* (CVN-70) to the United States Fifth and Seventh Fleet areas of responsibility. *United States Navy*

Lake Tecumseh (shown here) was photographed on June 26, 2012, one-and-a-half years after habitat restoration activities were completed. At Lake Tecumseh [also known as Brinson Inlet Lake (per a Virginia Beach city council resolution dated June 16, 1986) and historically as Brinson's Pond] and at Back Bay there are also geophysical indications of harbor inlets. Coastal storms may have changed all of these landmarks just as they continue to change our modern coastline. These waterways throughout the old county afforded protection from the sea, provided a means of transportation and communication, and tied the fertile land together. *United States Fish and Wildlife Service, Virginia Field Office*

Opposite below: Cape Henry was photographed from First Landing State Park looking toward Fort Story and the old weather station (left) on July 26, 2012. *Hanc Tomasz*[96]

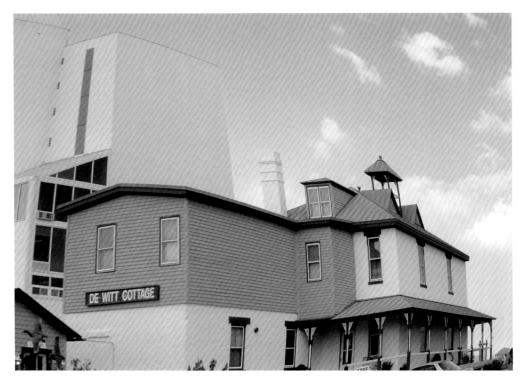

Above: The last remaining nineteenth-century cottage on the Oceanfront is the home that Bernard Peabody Holland built for his wife, the former Emily R. Gregory, in 1895 (shown here, September 30, 2012) at Eleventh Street and Atlantic Avenue. Holland sold the house in 1909 to Cornelius de Witt, and it has been known as the de Witt Cottage or Wittenzand, Dutch for "white sand" ever since. De Witt enlarged the cottage to twenty-two rooms in 1917; it remained in the family until 1988. With its fourteen-inch-thick walls, large room count, basement and attic, the cottage is a good example of an early beach house. Listed on the Virginia Landmarks Register and National Register of Historic Places, the cottage has been home to the Atlantic Wildfowl Heritage Museum, founded by the Back Bay Wildfowl Guild, since 1995. *Sue Corcoran*[97]

Pembroke Manor (shown here, September 30, 2012) is a two-story brick Georgian home laid in the Flemish bond located near the intersections of present-day Virginia Beach and Independence Boulevards. The land that Pembroke Manor was built upon was given to Captain Adam Thoroughgood in a land grant in 1635. The land was subsequently divided among heirs and sold over the generations. Elizabeth Thoroughgood, descendant of the original owner, married Jonathan Saunders who built Pembroke Manor in 1764; he died the following year on January 21, 1765, willing the house to his son, Captain John Saunders, who was the ward of Rose Hall owner Jacob Ellegood. In the fall of 1775, under the direction of royal governor John Murray, Lord Dunmore, Ellegood raised the Queen's Own Loyal Virginia Regiment to bolster British forces in the area and was given the rank of colonel. Other forces just then included the so-called Ethiopian Regiment and regular British units. Ellegood recruited his ward to join the Queen's Own. Captain Saunders was also a loyalist who was so open about his support for the cause of the crown that in 1770 he was called before the Princess Anne Committee of Safety and declared a British subject; this declaration also evicted him from Pembroke Manor and the colonies. After their defeat at the Battle of Great Bridge in December 1775, the members of the Queen's Own remained on board British ships in the Chesapeake Bay and Hampton Roads until the summer of 1776 whereby they moved northward and were assimilated into the Queen's Rangers. Saunders would go on to minor successes throughout the rest of the Revolutionary War and after settling in Nova Scotia, New Brunswick, Canada, he never saw Pembroke Manor again. The home was put up for auction in 1781 by Thomas Jefferson, then governor of Virginia, and purchased by the Kellam family. The graves of the elder Jonathan Saunders and his family are located in the family plot on the east side of the house, presently used as a vegetable garden, even though it is fenced off. The house is on the Virginia Landmarks Register and the National Register of Historic Places. *Sue Corcoran*[99]

Opposite below: Located across the inlet from the Adam Thoroughgood House, the Hermitage (shown here), also known as Devereaux House, was built in three stages. Elements of the one-and-a-half-story, four-bay, Colonial-era frame dwelling are believed to date from as early as 1699, when John Thoroughgood built a house on his portion of Adam Thoroughgood's so-called "grand patent." The second addition to the house was constructed by the Moseley family in about 1820, doubling the size of the dwelling and adding federal-style crown molding and recessed panel wainscoting throughout the house, as well as a central passage. Finally, in 1940, the final part was added, including indoor plumbing and a kitchen. There are three outbuildings, as well as a large subterranean brick cistern, now part of the basement to the house on the property. The property remained a working farm until the middle of the twentieth century, when it became the basis for the county's first modern development—the Thoroughgood neighborhood. The Hermitage is one of the few examples of Colonial architecture extant in Virginia Beach. The picture was taken on September 30 2012. *Sue Corcoran*[98]

Work continued around the clock at the Oceanfront in Virginia Beach from Fifteenth to Seventieth Streets on the first beach renourishment since the Virginia Beach Hurricane Protection Beach Renourishment Project was completed in 2001. The $143 million storm protection project in 2001 included spanning the original boardwalk, adding pump stations, seawall improvements and sand replenishment. This picture was taken by Pamela Spaugy, of the United States Army Corps of Engineers, Norfolk District, on February 1, 2013. Oceanfront damage prevention was estimated just then at $443 million, according to the Army Corps of Engineers' Jennifer Armstrong, project manager for Operation Big Beach. *United States Army*

Opposite above: Bret Fisher took this October 13, 2012 picture of the Old Coast Guard Station (now a museum) at Atlantic Avenue and Twenty-Fourth Street from the boardwalk. *Bret Fisher*[100]

Opposite below: The old Cape Henry lighthouse is lit up with Christmas lights during the annual illumination ceremony on Joint Expeditionary Base East [Fort Story] on November 30, 2012. The tradition started in 1992. Frank Pikul took the photograph. *United States Navy*

The old Cape Henry lighthouse is shown in this montage photographed on June 26, 2014. *Virginia State Parks*[103]

Opposite above: The antebellum Tabernacle United Methodist Church, one of the oldest congregations of Methodism in the United States, is shown in this September 26, 2013 photograph. Located in the Sandbridge section, the first iteration of the Methodist Episcopal church was organized in 1784, and the tabernacle started as a small congregation only five years later in 1789. According to church history, two ministers served the church, located in a chapel that was also on the present site of the building shown here. When the present church building was erected in 1830, Tabernacle became an organized part of the Princess Anne Charge, which also included Nimmo, Charity, Bethel, Providence, Knotts Island, Salem, and Beech Grove congregations. In 1908 the slave balcony was removed, stained glass windows and wood floors were added, a bell tower was erected, and the present pews were added to replace the original three rows of pews. Lights were added in the early 1920s to replace the kerosene lamps that hung from the ceiling; however, most of the main support and wooden pegs still hold the beams together. *Lago Mar*[101]

Opposite below: This picture of First Landing State Park looking towards the entrance to the Chesapeake Bay was taken by David Broad on May 25, 2014. *David Broad*[102]

The native American lotus, a wildflower that bloomed profusely in the small Pungo creek (shown here) during the early to mid-twentieth century, died during the late 1960s, then began to return a few years ago. The waters are once again covered with the massive pods, and the yellow flowers, which open in late June. Located across the street from the pond on Sandbridge Road is Tabernacle United Methodist Church, where members continue to celebrate the flowers. Officially called the *Nelumbo Lutea*, the American lotus is the city flower of Virginia Beach, and the members of Tabernacle United Methodist Church, which is located across the street from the pond and Lotus Garden Park, have held their Lotus Festival each year since the 1950s. The tubers, leaves and seeds served as an important food source for Native Americans, according to Vickie Shufer, a Blackwater resident and native plant expert, when asked about them for a July 11, 2009 *Virginian-Pilot* article about the plant's comeback. The American lotus in this photograph, taken June 28, 2014, are in the pond across from the church in the park (shown here, same date). The park and pond are within the boundary of the unincorporated Sigma community. *Lago Mar*[104]

This is the Virginia Beach boardwalk at night, photographed by Brian Berkowitz on August 19, 2014. *Brian Berkowitz*[105]

Part of False Cape State Park is shown in this September 17, 2014 photograph. *Virginia State Parks*[106]

The Brock Environmental Center (shown here, October 17, 2014) was erected on the last large, undeveloped waterfront property on the Lynnhaven River as part of an initiative to save and permanently protect the vista in perpetuity. The effort to save it from developers was spearheaded by conservation groups, the city of Virginia Beach, the Trust for Public Land, and the Chesapeake Bay Foundation. The land was collectively secured by the Chesapeake Bay Foundation, city of Virginia Beach, and Trust for Public Land in July 2012. The area in which the center was built is Pleasure House Point, a quiet peninsula of beach, marsh, and maritime forest near the Lynnhaven Inlet. The 118-acre property, located just west of the Lesner Bridge and south of the Chesapeake Bay at the confluence of Pleasure House Creek and Crab Creek, has a commanding view of the river that runs around it. *JWallace72*[107]

False Cape was so named because from the ocean it could be easily mistaken for Cape Henry, which lies about twenty miles to the north at the mouth of the Chesapeake Bay. This false impression lured ships and boats looking for Cape Henry into the shallow waters, where they could easily run aground. From the turn of the century until the 1960s, False Cape was a haven for a number of prestigious hunt clubs, which took advantage of the area's abundant waterfowl. The park's Wash Woods Environmental Education Center is a converted hunt clubhouse. A 1966 study of Virginia's outdoor recreation resources recommended that a substantial ocean beachfront be made available for public use on the Atlantic Ocean south of Virginia Beach. The development of the park began with the purchase of approximately 4,300 acres of land. The marker shown here promotes False Cape State Park as the southernmost Virginia State Park. The picture was taken on June 28, 2015. *Virginia State Parks*[108]

The King Neptune statue on the boardwalk at Thirty-First Street and Atlantic Avenue is a thirty-four-foot cast bronze statue that stands at the gateway to Neptune Park and the threshold to the sea. The statue was dedicated by the city of Virginia Beach on September 30, 2005, during the Neptune Festival Boardwalk Weekend. Artists from around the world were considered before Richmond, Virginia sculptor Paul DiPasquale was commissioned to create it. *Ramakrishna Gundra*[109]

Chief petty officers (CPO) recite the Sailor's Creed at the 2017 Chief Petty Officer birthday luncheon held at the Founders Inn Hotel and Spa, part of the Regent University campus. The luncheon marked the closing of the one hundred and twenty-fourth birthday week of the CPO rank. Mass Communication Specialist Third Class Casey J. Hopkins took the photograph on March 31, 2017. *United States Navy*

The symbol of the old Cape Henry lighthouse represents the city in Miyazaki, Japan, Virginia Beach's sister city. The picture of Virginia Beach Square in Miyazaki was taken on March 19, 2017, by a Japanese photographer. そらみみ[110]

Red Wing Park, a ninety-seven-acre park located off of General Booth Boulevard, is well known for its beautiful gardens and annual cherry blossom festival. The property was first acquired by Princess Anne County in 1879 and was formerly known as the old city poor farm. Later, in 1966, it was developed into a park by the city of Virginia Beach and is now home to several feature gardens, to include the peace memorial in the Miyazaki Japanese Garden (shown here), photographed on May 28, 2017. *Pumpkin Sky*[111]

Explosive ordnance disposal (EOD) technicians assigned to Explosive Ordnance Disposal Group Two (EODGRU-2) fast rope from an MH-60S Sea Hawk helicopter assigned to the Nightdippers of Helicopter Sea Combat Squadron Five (HSC-5) during helicopter rope suspension technique training at Fort Story. EODGRU-2 is headquartered at Joint Expeditionary Base Little Creek-Fort Story and oversees Mobile Diving and Salvage Unit 2 (MDSU-2) and all East Coast-based Navy EOD mobile units. Navy mass communication specialist second class Charles Oki took the picture on April 12, 2017. *United States Navy*

The Virginia Beach Oceanfront, photographed by Mark Lagola, is shown teeming with beachgoers on Memorial Day, May 31, 2009. *Mark Lagola*[112]

The United States Coast Guard Cutter *Eagle* (center) is shown at the Lynnhaven anchorage off the coast of Virginia Beach on June 8, 2012. The *Eagle* participated in the parade of sail as part of Operation Sail 2012. The picture was taken by coast guard petty officer third class David Marin. *United States Coast Guard*

ENDNOTES

1 Simeon E. Crittenden was general manager of the Princess Anne Hotel just five years. He died there on June 22, 1893, of what was called "brain congestion" in the June 23, 1893 *New York Sun*.

2 Sewell, Kay Doughtie, "Her oldest resident recalls 71 years at Virginia Beach," *Virginian-Pilot*, March 25, 1956.

3 Holland, Cornelia. Interview by Meg Campbell. Transcript. Tidewater Oral History Society, Virginia Beach, Virginia, September 21, 1987.

4 Of interest, Holland also trained Alpheus Walton Drinkwater (1875–1962), the United States Weather Bureau telegraph operator at Manteo, North Carolina, who for many years—off and on—claimed to have sent the message of the Wright Brothers first flight on December 17, 1903.

5 Wesley Franklin White (1826–1905) was a Portsmouth, Virginia ship's carpenter.

6 Jacob and Elmer Laskin were born near Moscow, Russia, and Louis was born in Chicago, Illinois.

7 Holland, Cornelia (interview), ibid.

8 Ibid.

9 Sewell, ibid.

10 Ibid.

11 By Virginia State Parks (False Cape Lifesaving Watchman) [CC BY 2.0 (http://creative-commons.org/licenses/by/2.0)], via Wikimedia Commons

12 James Otto Capps, Mary Widgeon Capps' husband, was the owner of the London Bridge tourist cabins on Route 58, four miles from the Oceanfront, and the White Oak Tourist Court at Seventeenth Street.

13 Pungo, located in the south-central section of the city of Virginia Beach, was first established as the termination of the Bennett Steam Boat Line, and later the site of a railroad line that ran from Norfolk to Munden Point. The Munden Point train was called the "Sportsmen Special" because it delivered the hunters and fishermen from the resort to their clubs. By the early twentieth century, Pungo had become a prosperous agricultural center. The village had one hundred residents in 1924 along with two large mercantile establishments, two garages, a fish-packing plant, a Ford service agency and an extensive network of consolidated schools and churches, many of which are shown herein. Pungo, according the Traceries report prepared in the spring of 1993

for the city of Virginia Beach, survives as an important crossroads community that offers stores, restaurants and other commercial concerns.

14 Holland Swamp Road (later Holland Road) was not named for Bernard P. Holland, the first mayor of Virginia Beach. There were Hollands in the Virginia colony who first arrived between 1616 and 1622 according to the Jamestown records of the London Company, now at the Library of Congress. More Hollands arrived in Virginia between 1635 and 1666 and as they began to populate the counties to the west, to include Isle of Wight, Nansemond and Southampton, the migration continued to points further east into the Lynnhaven River reaches and into what is today southern Virginia Beach and the watershed of the Currituck Sound. The land area subsequently bearing the name Holland Swamp was highly likely named for the enterprising landowner who got to the rich timber and fertile farmland of this part of Princess Anne County first. In John Hutchings' will probated in March 1789, "... proceeds of the sale of land in Princess Anne County known as Holland..." was recorded. Notably, the Seaboard District, comprising the northeast angle of the county, was the best source of timber in lower Virginia for over two hundred years. The timber consisted of oak, pine, gum, cedar, cypress, elm, holly and persimmon. Eight sawmills were engaged in making timber, mainly pine, oak, cypress, gum and ash at the turn of the twentieth century. Additionally, many cypress shingles also came from this part of the county.

15 Agriculture was a mainstay of the Princess Anne County economy throughout much of the twentieth century and the farms here supplied produce throughout much of the Eastern Seaboard. The farms in the area were typically either dairy farms or truck farms. The term truck farming was used to describe the large-scale production and distribution of crops by road or rail. The word "truck" originally referred to the bartering of goods, and then came to mean the process of carrying goods to market, and eventually came to mean the vehicle used to haul the goods.

16 Traceries. Survey of the City of Virginia Beach–Phase II. Prepared for the Department of Historic Resources and the City of Virginia Beach Department of Planning, May 29, 1993.

17 Ibid.

18 Grace White Sherwood was the last person known to have been convicted of witchcraft in Virginia. A farmer, healer and midwife, she was accused by her neighbors of transforming herself into a cat, damaging crops and causing the death of livestock. She was charged with witchcraft several times. At her 1706 trial, she was accused of bewitching neighbor Elizabeth Hill, causing her to miscarry. The court ordered her guilt or innocence proven by ducking her in water. If she sank, she was innocent; if not, she was guilty. Sherwood floated to the surface and may have spent up to eight years in prison before being released. She was married to James Sherwood, a planter, in 1680, and the couple had three sons named John, James and Richard. On July 10, 2006, three hundred years after her conviction, Virginia governor Timothy Kaine restored her good name, recognizing her case was a miscarriage of justice.

19 Dr. Enoch Dozier Ferebee died in his native North Carolina, having left Broad Bay Manor after his second marriage to Courtney Hickson McPherson (1798–1857). He left Broad Bay Manor to his son George Emory Ferebee (1834–1896), married to Sarah Ann Cason (1838–1908), who in turn passed the property to son Enoch Dozier Ferebee (1875–1921). It was the second Enoch Dozier Ferebee who sold the property to Dey.

20 The first ferry service was started by Adam Thoroughgood.

21 Rlevse [CC BY-SA 3.0 (http://creativecommons.org/licenses/by-sa/3.0)], via Wikimedia Commons

22 Surry Parker (1866–1942) was a designer and builder of steam logging machinery and founder of Pinetown, North Carolina. The collection of negatives in his collection include images from his family and business enterprises in northeastern North Carolina and southeastern Virginia, to include the photographs used herein.

23 *Virginian-Pilot* and *Norfolk Landmark*. "Whirlwind campaign for new beach hotel, May 30, 1915.

24 *Virginian-Pilot*. "Week of festivities to mark opening of Cavalier Hotel, April 3, 1927; "Cavalier Hotel at beach makes its formal bow to public today, April 4, 1927; "Handsome new Cavalier Hotel makes formal bow to public, April 5, 1927.

25 Blackford, Frank, "Born to the '20s, but reaching for the '70s," *Virginian-Pilot*, June 27, 1971.

26 Ibid.

27 Thalia extends from Thalia Creek to Lynn Shores and from the eastern branch of the Lynnhaven River south to what is today Interstate 264.

28 Berent, Irwin M. *Norfolk, Virginia—A Jewish History of the Twentieth Century*. Norfolk, Virginia: JewishHistoryUSA.com, 2001.

29 The weather bureau did not come into existence until July 1, 1891, following what history informs was a tradition of government-sponsored weather observation and forecasting done by United States Army surgeons in 1820, followed by the signal service in 1870. A total of forty-eight buildings were acquired or built between 1897 and 1915 by the new weather bureau, of which the second Cape Henry station was an early build. Built on what was called a lighthouse reservation just then, it was completed in 1901 and the first weather observations were made on October 25 of that year. The last observation was taken from the original bureau station on October 31, 1918, after which the bureau stopped reporting weather from that structure. There were only two observers who lived in the 1901 period weather station at Cape Henry: Corydon P. Cronk (1901–1903) and John Franklin Newsom (1903–1918). The building was not torn down until 1957.

30 After the demise of the Crystal Club, the house and four surrounding acres were purchased in March 1939 by Wachovia Bank and Trust on behalf of the estate of Samuel F. Patterson who had died in 1926. Like the organizers of Crystal Incorporated, he had also been from Roanoke Rapids, North Carolina. Patterson had been a prominent figure in textile manufacturing and had been elected president of the American Cotton Manufacturing Association shortly before his death. Very little is known about the Patterson's ownership. When the property was sold in June 1942, Patterson's widow, Nancy Patterson, and daughter, Mary Blythe Patterson, signed the deed. William and Almira Wilder, who owned numerous motion picture theaters in southeastern Virginia, were the purchasers. It is believed that William Wilder made extensive improvements to the grounds, building the retaining wall, garden wall, dog house, and the stone piers that mark each end of the circular driveway. The Wilders also gave the house the name Greystone Manor by which it is largely known today. The Wilders also lent their name to the street on which the house is located today. The Wilder family lived at Greystone until 1967, when it was purchased by Andrea Hodgson and his wife Anne. In December 1967, the Hodgsons subdivided the property, retaining three acres for development, and selling Greystone and one acre to Charles and Margaret Emanuelson. Charles Emanuelson was an industrialist and his wife a clinical psychologist.

31 By Sue Corcoran (Own work) [CC BY-SA 3.0 (http://creativecommons.org/licenses/by-sa/3.0)], via Wikimedia Commons

32 By Sue Corcoran (Own work) [CC BY-SA 3.0 (http://creativecommons.org/licenses/by-sa/3.0)], via Wikimedia Commons

33 By Sue Corcoran (Own work) [CC BY-SA 3.0 (http://creativecommons.org/licenses/by-sa/3.0)], via Wikimedia Commons

34 While some sources have previously stated that Claude Price was an admiral, this was not the case. Price's death certificate and military registers of officers in the United States Navy indicate he was, indeed, a commander.

35 William Bernard Rudolph was a wholesale and retail dealer of groceries and liquors in downtown Norfolk.

36 By Nicholas Heyob (Own work) [CC BY-SA 3.0 (http://creativecommons.org/licenses/by-sa/3.0)], via Wikimedia Commons

37 The present Creeds Elementary School was built in 1939 and served as a high school for Princess Anne County until 1954 when it was converted to an elementary school. The Creeds school zone is today bounded on the west by the Chesapeake city line, on the north by Indian River Road, on the east by Back Bay, and on the south by the North Carolina line. The school largely serves a rural farming community.

38 Holland, Cornelia (interview), ibid.

39 Calvert Tyler Lester, the granddaughter of Charles Franklin and Mabel Chamberlaine Burroughs, explained later that after Burroughs' death in 1960, he left the Bayville Farm to her uncle, Charles F. Burroughs Jr. Church Point was developed in 1992 into residential homes and commercial property.

40 Rlevse [CC BY-SA 3.0 (http://creativecommons.org/licenses/by-sa/3.0)], via Wikimedia Commons

41 Bowers, Irene, "After years of neglect, historic house gets attention," *Virginian-Pilot*, April 10, 2010. http://pilotonline.com/news/after-years-of-neglect-historic-house-gets-attention/article_508fbf40-ccc9-56ac-b482-843773da16a3.html

42 By Sue Corcoran (Own work) [CC BY-SA 3.0 (http://creativecommons.org/licenses/by-sa/3.0)], via Wikimedia Commons

43 By Virginia State Parks staff (False Cape Uploaded by Albert Herring) [CC BY 2.0 (http://creativecommons.org/licenses/by/2.0)], via Wikimedia Commons

44 By Virginia State Parks staff [CC BY 2.0 (http://creativecommons.org/licenses/by/2.0)], via Wikimedia Commons

45 By Virginia State Parks staff [CC BY 2.0 (http://creativecommons.org/licenses/by/2.0)], via Wikimedia Commons

46 By Virginia State Parks (IMG_1954) [CC BY 2.0 (http://creativecommons.org/licenses/by/2.0)], via Wikimedia Commons

47 By Sue Corcoran (Own work) [CC BY-SA 3.0 (http://creativecommons.org/licenses/by-sa/3.0)], via Wikimedia Commons

48 James Marshall Shoemaker retired as a rear admiral.

49 Jesse Arthur Fairley retired as a commander on November 1, 1955. At that time, he had flown 101 different military aircraft and was a test pilot for many of them.

50 Dorsey, Jack and Louis Hansen, "First F/A-18s roar into Oceana: Beach gives big welcome to planes on 'historic day'," *Virginian-Pilot*, December 5, 1998.

51 Bellinger, Patrick Neison Lynch, "The Gooney Bird," published by the Naval Historical Center, Washington, D.C., 1960.

52 Irvin Lowell Dew returned to Oceana as a captain and commanding officer from November 26, 1962, to June 30, 1964, after which he retired from the navy.

53 Fort Story was named for General John Patten Story, who had been a prominent general officer and coast artilleryman before the turn of the twentieth century.

54 A Brief History of Fort Story: http://www.northamericanforts.com/East/Virginia/Fort_Story/history.htm

55 As the result of the Base Realignment and Closure (BRAC) Commission recommendation made in 2005, Fort Story operations were transferred to the United States Navy. On October 1, 2009, Fort Story and Naval Amphibious Base Little Creek merged, and Fort Story officially became part of Joint Expeditionary Base Little Creek-Fort Story.

56 Former Naval Amphibious Base Little Creek's History: https://www.cnic.navy.mil/regions/cnrma/installations/jeb_little_creek_fort_story/about/history/naval_amphibious_base_little_creeks_history.html

57 Beginning in January 2007, the former Naval Amphibious Base Little Creek and Fort Story personnel began actively developing a process and procedures to effectively implement joint basing between the two organizations. First and foremost, in the planning process was the consideration for the impact to personnel at both installations. The implementation team was forward leaning to make the plan work, yet ensuring that all concerns were taken into account that directly impact all affected personnel. The installations effectively became one command on October 1, 2009.

58 Dam Neck is today an annex of Naval Air Station Oceana and home to Fleet Training Support Center Hampton Roads and a number of other tenant commands to include the United States Special Warfare Development Group (DEVGRU), Tactical Training Group Atlantic, and Combat Direction System Activity (CDSA) Dam Neck. The base is also the home of the Navy and Marine Corps Intelligence Training Center.

59 Richmond, Virginia's iconic Jefferson Hotel was sold by the executors of the Colonel Charles Herbert Consolvo (1871–1947) estate to the Cavalier Hotel Corporation. Consolvo, of Norfolk, Virginia, also owned that city's Monticello Hotel.

60 Burlage was a certified public accountant and practiced law in downtown Norfolk for sixteen years. During this time, he also owned and operated eight Burger Chef fast food chain restaurants in Hampton Roads. Of note, in 1985 he opened the Barclay Towers Hotel and Condominium on Ninth Street and the Oceanfront. He was also instrumental in building the first municipal parking garage on Atlantic Avenue as well as many other hotel projects at the Oceanfront from The Cavalier, the Holiday Inn later built at Thirty-Ninth Street, and the Quality Inn. He ended his career as a developer and operator of Oceanfront properties when he finally retired in 2005.

61 Allie Edward Stakes Stephens (1900–1973), a Virginia lawyer and Democrat Party politician who served in both houses of the Virginia General Assembly, was elected the twenty-seventh lieutenant governor of Virginia from 1952 to 1962.

62 Samuel Gardner Waller (1881–1955) subsequently rose to major general of the famous Virginia Twenty-Ninth Division.

63 The 1938/9 building on the coast guard's military reservation at Little Creek was demolished in 1995, replaced by a modern structure. The original boathouse and garage remain on the present complex and are still in use today. The new main building was dedicated on May 28, 1996.

64 At the time Francis Land VI occupied the house, the plantation was just under seven hundred acres. The current house sits on seven acres of that original plantation.

65 Rlevse [CC BY-SA 3.0 (http://creativecommons.org/licenses/by-sa/3.0)], via Wikimedia Commons

66 Dale Durkee Hinman (1891–1949) was a brigadier general in the United States Army at the time of his death.

67 Nancy Nyshe Pearson was born on July 7, 1880, the daughter of George Washington and Victoria Valentine Pearson. While she died in a hospital in Roanoke, Virginia, on December 30, 1947, after a brief illness, her home of record was on Virginia Beach's Fifty-Fourth Street.

68 Oak Grove Baptist Church (1762) is the direct legacy of Pungo Baptist Church. The original Pungo sanctuary burned some forty-five years after it was built and it is believed that all early records were lost in the fire. The church's written history goes back to 1837. The Oak Grove church is also responsible, beyond London Bridge Baptist, for four other parishes in the region: Blackwater Baptist (1774), Saint John's Baptist (1853), Little Piney Grove Baptist (1870), and Knotts Island Baptist (1876).

69 Morris, Bill, "Past laps around beach survivor," *Virginian-Pilot*, June 13, 1980.

70 Ibid.

71 Giametta, Charles, "Virginia Beach celebrates 20th anniversary," *Virginian-Pilot*, January 2, 1983.

72 Yarsinske, Amy Waters. *The Martin Years—Norfolk Will Always Remember Roy.* Gloucester Point, Virginia: Hallmark Publishing, 2001. All references to Martin's recollections of the merger come from this source.

73 House, by then city manager of Portsmouth, Virginia, was killed in a small plane crash in Columbia, Maryland, along with three other top Portsmouth officials and a Portsmouth police officer, Joseph Weth, who was also the pilot.

74 Holland, Cornelia (interview), ibid.

75 Stover, Charles, "A quiet change comes to a city," *Virginian-Pilot*, September 8, 1969.

76 Ibid.

77 By Virginia State Parks staff [CC BY 2.0 (http://creativecommons.org/licenses/by/2.0)], via Wikimedia Commons

78 By Virginia State Parks staff (DSC_0174 Uploaded by Albert Herring) [CC BY 2.0 (http://creativecommons.org/licenses/by/2.0)], via Wikimedia Commons

79 By Virginia State Parks staff (DSC_0172 Uploaded by Albert Herring) [CC BY 2.0 (http://creativecommons.org/licenses/by/2.0)], via Wikimedia Commons

80 By Virginia State Parks (Monument) [CC BY 2.0 (http://creativecommons.org/licenses/by/2.0)], via Wikimedia Commons

81 The Hill House Museum: http://www.thehillhousemuseum.org/the-hill-house-story/

82 Elizabeth and Evelyn Hill also maintained a plot of land near the Lake Smith fishing station that was formerly part of a larger nursery. They called this plot the wildflower garden and filled it with specimen plants. The city of Norfolk, which owns Lake Smith and the other reservoir lakes now in the bounds of the city of Virginia Beach, helped maintain the plot.

83 The Kellam brothers, the sons of Abel Erastus Kellam (1849–1926) and the former Clara Octavia Eaton (1870–1960), were Frederick Jefferson (1891–1964), Alvah Early (1893–1917), Floyd Eaton (1893–1958), Herbert Stanley (1898–1988), James Goffigan (1901–1976), Sidney Severn (1903–1986), Frank Wallace (1905–1994), Edwin Clay (1907–1989), Richard Boykin (1909–1996), Robert Whitehead (1910–1977), Harold Blanton (1912–1990), and William Page (1914–2005). There were also two sisters: Lillian Ruth (1892 - 1951) and Mary Garland (1896–1943).

84 *Washington Post.* "Editor J. Willcox Dunn, anti-gambling crusader, dies at 91, January 1, 1990. https://www.washingtonpost.com/archive/local/1990/01/01/editor-j-willcox-dunn-anti-gambling-crusader-dies-at-91/3869a2d0-0a45-4515-855f-26f01299a578/?utm_term=.09cad9705f7d In 1958, Dunn was awarded the national Elijah Parish Lovejoy Award for Courage in Journalism for his opposition to political corruption and racketeering in Virginia Beach and Princess Anne County. Dunn, a Suffolk, Virginia native, received his law degree from the University of Virginia in 1922. He practiced law in Lynchburg, Virginia, and worked for Union Carbide in New York City before moving to Virginia Beach in 1936, where he entered the real estate business.

85 Binford had joined the army before entering the University of North Carolina, Chapel Hill, which made him an older undergraduate student. The GI Bill was not enough to fund his education completely so he took up doing construction work, starting a modest business to supplement his income.

86 Germanotta, Tony, "Whatever happened to … the old west theme park at the Beach?" *Virginian-Pilot*, July 9, 2007. http://pilotonline.com/news/whatever-happened-to-the-old-west-theme-park-at-beach/article_9ef65052-dc18-53ef-b9bb-ec9c7b8f915a.html

87 Ibid.

88 Belote, Lee, "Boardwalk Art Show original is still painting after all these years," *Virginian-Pilot*, June 14, 2015. http://webcache.googleusercontent.com/search?q=cache:Xt4CmoQ3FsMJ:pilotonline.com/news/local/boardwalk-art-show-original-is-still-painting-after-all-these/article_59cc10b5-8b30-5e3c-b072-d171586f2430.html+&cd=7&hl=en&ct=clnk&gl=us

89 Joshua James Jr. first married Mary Etheridge on November 15, 1818.

90 Mariah Frances Henley first married to Obed Capps on July 20, 1842. She married Joshua James Jr. on November 4, 1847.

91 By Virginia State Parks staff [CC BY 2.0 (http://creativecommons.org/licenses/by/2.0)], via Wikimedia Commons

92 By Debate Lord (Own work) [CC BY-SA 3.0 (http://creativecommons.org/licenses/by-sa/3.0) or GFDL (http://www.gnu.org/copyleft/fdl.html)], via Wikimedia Commons

93 By Serge Melki from Indianapolis, USA (The Cavalier Hotel) [CC BY 2.0 (http://creativecommons.org/licenses/by/2.0)], via Wikimedia Commons

94 Rlevse [CC BY-SA 3.0 (http://creativecommons.org/licenses/by-sa/3.0)], via Wikimedia Commons

95 By Rlevse (Rlevse) [Public domain], via Wikimedia Commons

96 Hanc Tomasz [CC BY-SA 3.0 (http://creativecommons.org/licenses/by-sa/3.0)], via Wikimedia Commons

97 By Sue Corcoran (Own work) [CC BY-SA 3.0 (http://creativecommons.org/licenses/by-sa/3.0)], via Wikimedia Commons

98 By Sue Corcoran (Own work) [CC BY-SA 3.0 (http://creativecommons.org/licenses/by-sa/3.0)], via Wikimedia Commons

99 By Sue Corcoran (Own work) [CC BY-SA 3.0 (http://creativecommons.org/licenses/by-sa/3.0)], via Wikimedia Commons

100 By Bret Fisher (Own work) [CC0 1.0 Universal Public Domain Dedication], via Wikimedia Commons

101 By Lago Mar (Own work) [CC BY-SA 3.0 (http://creativecommons.org/licenses/by-sa/3.0)], via Wikimedia Commons

102 David Broad [CC BY 3.0 (http://creativecommons.org/licenses/by/3.0)], via Wikimedia Commons

103 By Virginia State Parks (Pic Monkey Collage Old Lighthouse) [CC BY 2.0 (http://creativecommons.org/licenses/by/2.0)], via Wikimedia Commons

104 By Lago Mar (Own work) [CC BY-SA 3.0 (http://creativecommons.org/licenses/by-sa/3.0)], via Wikimedia Commons

105 By Brian Berkowitz ({{own}}) [CC BY-SA 4.0 (http://creativecommons.org/licenses/by-sa/4.0)], via Wikimedia Commons

106 By Virginia State Parks (DSC_0060) [CC BY 2.0 (http://creativecommons.org/licenses/by/2.0)], via Wikimedia Commons

107 By Jwallace72 (Own work) [CC BY-SA 4.0 (http://creativecommons.org/licenses/by-sa/4.0)], via Wikimedia Commons

108 By Virginia State Parks (IMG_0367) [CC BY 2.0 (http://creativecommons.org/licenses/by/2.0)], via Wikimedia Commons

109 By Ramakrishna Gundra (Own work) [CC BY-SA 4.0 (http://creativecommons.org/licenses/by-sa/4.0)], via Wikimedia Commons

110 By そらみみ (Own work) [CC BY-SA 4.0 (http://creativecommons.org/licenses/by-sa/4.0)], via Wikimedia Commons

111 By Pumpkin Sky (Pumpkin Sky) [CC BY-SA 4.0 (http://creativecommons.org/licenses/by-sa/4.0)], via Wikimedia Commons

112 By gargola87 from Virginia Beach, VA (The Oceanfront) [CC BY-SA 2.0 (http://creativecommons.org/licenses/by-sa/2.0)], via Wikimedia Commons, color correction by Patrick Neil.

SELECT BIBLIOGRAPHY

Primary Sources

City of Virginia Beach. Historic resources management plan 1994. http://www.vbgov.com/ file_source/dept/planning/Document/HistoricResourcesManagementPlan.pdf.

Commonwealth of Virginia, Department of Agriculture and Immigration. A handbook of Virginia [sixth edition]. Richmond, Virginia: Superintendent of Public Printing, 1915.

Frazier Associates. Reconnaissance architectural survey report, city of Virginia Beach. Staunton, Virginia, 1992.

Grice, Gary K. ed. [public affairs office]. The beginning of the National Weather Service: the signal years (1870–1891) as viewed by early weather pioneers. United States Department of Commerce, National Oceanic and Atmospheric Administration (NOAA), National Weather Service [no date]. http://www.nws.noaa.gov/pa/history/signal.php

James River Institute for Archaeology. A phase I cultural resources survey of 98.664 acres at Marshview Park in the city of Virginia Beach, Virginia [Virginia Department of Historic Resources (VDHR) file number 2009-2001]. Williamsburg, Virginia, May 2011.

MAAR Associates. Phase I cultural resource survey of the proposed build alternatives for the southeastern expressway, city of Virginia Beach. Williamsburg, Virginia, 1989.

Oxford Dendrochronology Laboratory. The tree-ring dating of the Adam Keeling House [interim report]. Virginia Beach, Virginia: December 2006.

Taylor, Sue. City of Virginia Beach inventory of historic buildings and sites. Virginia Beach, Virginia: Office of Research and Strategic Analysis, 1990.

Traceries. Survey of the city of Virginia Beach–Phase II. Prepared for the Department of Historic Resources and the City of Virginia Beach Department of Planning, May 29, 1993.

United Service Organizations (USO) staff conference. Minutes of the USO staff conference. USO Club [Eighteenth Street and Arctic Avenue], Virginia Beach, Virginia, August 30, 1943.

United States Department of Commerce, United States Coast and Geodetic Survey. United States coast pilot: Atlantic coast, section D, Cape Henry to Key West [third edition]. Washington, D.C.: United States Government Printing Office, 1928.

United States Department of the Interior, National Park Service. National Register of Historic Places [NRHP]:

– . Bayville Farm [Church Point Plantation, Bayside Plantation]. NRHP, May 19, 1980 [delisted June 4, 2008].

– . Cavalier Hotel [Cavalier on the Hill]. NRHP, May 19, 2014.
– . Camp Pendleton/State Military Reservation Historic District [State Rifle Range]. NRHP, September 26, 2005.
– . Ferry Plantation House [Old Donation Farm, Ferry Farm]. NRHP, January 20, 2005.
– . Miller-Masury House, Dr. John [Lakeside (1906–1935), Crystal Club (1935–1939), Greystone Manor (1942–present)]. NRHP, May 23, 1997.
– . Pleasant Hall. NRHP, January 25, 1973.
– . Seashore State Park Historic District [First Landing State Park Historic District]. NRHP, November 16, 2005.
– . The Hermitage. NRHP, February 14, 2008.
United States Department of the Treasury, United States Coast Guard. Annual report of the United States Coast Guard for the fiscal year ended June 30, 1921.
Urban Land Institute. Pungo Crossing, Virginia Beach, Virginia—strategies for a rural gateway. Washington, D.C.: June 11–16, 2006 [an advisory services panel report].

Articles, Pamphlets, Papers, Reports and Speeches

Bancroft, Raymond L., "Princess Anne nudged on water," *Virginian-Pilot*, May 30, 1962.
– . "Norfolk requests to join merger: Kellam Hodges opinion," *Virginian-Pilot*, November 9, 1961.
Barrow, Mary Reid, "An historic revival after years of neglect, the Ferry Plantation House will be renovated, preserving 300 years of local history," *Virginia Beach Beacon*, July 26, 1996.
– . "Venerable cottage being spared for a new life as a restaurant," *Virginia Beach Beacon*, April 23, 1995.
Blackford, Frank, "Born in the '20s, but reaching for the '70s," *Virginian-Pilot*, June 27, 1971.
Borjes, Russell, "It was the start of something big," *Virginian-Pilot*, April 16, 1972.
Bowers, Irene, "After years of neglect, historic house gets attention," *Virginian-Pilot*, April 19, 2010. https://pilotonline.com/news/after-years-of-neglect-historic-house-gets-attention/article_508fbf40-ccc9-56ac-b482-843773da16a3.html
Bruce, Kathleen Eveleth, "Virginia Beach: chance to emphasize our historical priority over every other English-speaking settlement," *Virginia Beach Ledger*, October 6, 1925.
– . "Down on Lynnhaven," *Norfolk Ledger-Dispatch*, April 14, 16–19, 25–26, 28 and 30, 1924, and May 2–3, 1924.
Crist, Helen, "Old Fairfield House to be demolished," *Virginia Beach Sun*, February 17, 1972.
Dorsey, Jack, and Dale Eisman, "Oceana comes out a winner," *Virginian-Pilot*, March 1, 1995.
Doty, Stephen R. The history of United States Department of Agriculture Weather Bureau owned buildings 1890 to 1915 [online presentation]. Dated February 2008. https://myweatherartifacts.files.wordpress.com/2015/12/the-history-of-us-weather-bureau-build-ings-february-20081.pdf
Giametta, Charles, "Virginia Beach celebrates twentieth anniversary," *Virginian-Pilot*, January 2, 1983.
Greer, Kimberly. History of the Princess Anne Country Club, Virginia Beach, Virginia: The first eighty-five years (1916–2002) [booklet]. Published by the club, 2002.
Hartig, Dennis, "Past mistakes haunt Ferry Farm proposal," *Virginia Beach Beacon*, April 15–16, 1987.
Holden, Tom, "Oceanfront auction raises money, fond memories; old friends gather to swap tales and pick up bargains at the Peppermint Beach Club," *Virginian-Pilot*, February 10, 1995.

– . "The Oceanfront's next casualty; club may be demolished; the Peppermint, in bad repair at age 88, would join historic buildings meeting the wrecking ball," *Virginian-Pilot*, September 29, 1994.

Jaffe, Margaret Davis, "Princess Anne County rich in colonial remains," *Virginian-Pilot* and *Norfolk Landmark*, February 28, 1926.

Kyle, Louisa Venable, "A countrywoman's scrapbook: Cavalier William Moseley," *Virginian-Pilot*, January 19, 1958.

– . "The strangest honeymoon at Virginia Beach took place aboard a shipwrecked schooner," *Virginian-Pilot*, April 15, 1956.

– . "Descendants of William Moseley provided Princess Anne County with proud heritage," *Virginian-Pilot* and *Portsmouth Star*, January 22, 1956.

La Gorce, John Oliver, "The warfare on our eastern coast," *National Geographic*, Volume 28, Number 3, September 1915.

Ledger-Star. "Preservation plan urged for beach," September 19, 1987.

Lipper, Bob, "Proud era vestiges remain," *Virginian-Pilot*, December 15, 1974.

McAllister, Bill, "Martin urges talks to merge Norfolk and Virginia Beach," *Virginian-Pilot*, June 14, 1967.

Morris, Bill, "Past laps around beach survivor," *Virginian-Pilot*, June 13, 1980.

New York Times. "Princess Anne Hotel burns," June 10, 1907.

Norfolk Ledger-Dispatch. "Cornerstone of new Cavalier Hotel is laid," Virginia Beach edition, May 9, 1926.

Olsen, Kristen. The life cycle of the Adam Keeling House, Virginia Beach, Virginia [thesis]. History of American Architecture and Building. Ithaca, New York: Cornell University, Fall 2006. Published in conjunction with the Princess Anne County/Virginia Beach Historical Society.

Parker, Stacy, "This old house: beach cottage once occupied by lifesaver," *Virginian-Pilot*, November 10, 2009.

Reed, Bill, "Razing comes to the Peppermint: a venerable beach club joins the Dome and two old hotels in the pages of history," *Virginia Beach Beacon*, March 10, 1995.

Sewell, Kay Doughtie, "Her oldest resident recalls seventy-one years at Virginia Beach," *Virginian-Pilot*, March 25, 1956.

Stone, Steve, "Chester Rodio, an original Virginia Beach boy, dies at 86," *Virginian-Pilot*, May 18, 2008.

– . "Former Oceana commanding officer dies at 75," *Virginian-Pilot*, June 13, 1998.

Stover, Charles, "A quiet change comes to a city," *Virginian-Pilot*, September 8, 1969.

Tazewell, Calvert Walke. Family underground: a record of Tazewell and allied family burial plots [report]. Virginia Beach, Virginia: W. S. Dawson, August 1991.

– . Gleanings on Walke family homes [report]. Virginia Beach, Virginia: W. S. Dawson, 1988.

Thisdell, Roberta, "Dome, sweet Dome: Virginia Beach landmark goes out with a blast of nostalgic rock and lots of memories," *Virginian-Pilot*, June 30, 1993.

Tucker, George Holbert, "Tidewater Landfalls: the cemetery flashed on," *Virginian-Pilot*, March 18, 1974.

– . "What happened here," *Virginian-Pilot*, May 1969.

– . [column] *Virginian-Pilot*, March 18, 1956.

– . [column] *Virginian-Pilot*, November 26, 1950.

Virginia Beach Sun. "All that remains of Fairfield," June 22, 1972.

– . "Fairfield will go," March 2, 1972.

– . "Old Fairfield house to be demolished," February 17, 1972.

Virginian-Pilot. "Beach dig's mysteries to be tapped: experts to work despite lack of time and money," April 10, 1989.

– . "Farm land gives way to luxury dwellings," June 18, 1988.

– . "Builder invites archaeological study," March 19, 1987.

– . "Ferry Farm's owner blocks archaeologist," March 18, 1987.

– . "Archaeological dig is planned at farm," March 12, 1987.

– . "Arts center to get historic farmhouse," March 11, 1987.

Virginian-Pilot and *Ledger-Star.* "Progress crowds fabled farmhouse," March 7, 1987.

– . "Poplar Hall grounds could be hiding archaeological gems, local woman says," March 18, 1984.

– . "Fairfield's appreciation substantial," November 7, 1982.

White, Benjamin Dey, "Gleanings in the history of Princess Anne County," *Virginian-Pilot* and *Norfolk Landmark*, August 12–16, 1924.

Websites

Friends of Ferry Plantation House: http://www.ferryplantation.org

Hill House Museum: http://www.thehillhousemuseum.org/

Historic Maps [City of Virginia Beach]: https://www.vbgov.com/government/departments/communications-info-tech/maps/Pages/Historic-Maps.aspx

Virginia Beach Public Schools [information]: http://virginiabeachschools.info/Pages/AllSchools.aspx

Recommended Reading

While some of the books listed here were published long ago, the Old Dominion University Patricia W. and J. Douglas Perry Library, Virginia Wesleyan College Henry Clay Hofheimer II Library, Norfolk's Slover Library, Princess Anne/Virginia Beach Historical Society, Norfolk Historical Society, Norfolk County Historical Society and numerous local public library branches often have available circulating and archival copies.

Creecy, John Harvie, ed. *Virginia Antiquary.* Volume I. Princess Anne County loose papers 1700–1789. Richmond, Virginia: Dietz Press, 1954.

Dunn, Joseph and Barbara Lyle. *Virginia Beach "Wish You Were Here."* Virginia Beach, Virginia: Donning, 1983.

Hawkins-Hendrix, Edna. *Black History–Our Heritage Princess Anne County/Virginia Beach, Virginia.* Virginia Beach, Virginia: Edna Hawkins-Hendrix [self-published], 1998.

Forrest, William S. *Historical and Descriptive Sketches of Norfolk and Vicinity.* Philadelphia, Pennsylvania: Lindsay and Blakiston, 1853.

Jordan, Frederick S. and James Matthais IV. *Virginia Beach: A Pictorial History.* Richmond, Virginia: Thomas F. Hale, 1974.

Kellam, Sadie Scott and Vernon Hope Kellam. *Old Houses in Princess Anne, Virginia.* Portsmouth, Virginia: Printcraft Press, 1931.

Kyle, Louisa Venable. *The History of Eastern Shore Chapel and Lynnhaven Parish 1642–1969.* Norfolk, Virginia: Teagle and Little, 1969.

Lukei, Melinda. *Princess Anne County, Virginia Bible Records.* Volumes I–III. [Digitized] http://www.archive.org/details/princessannecoun13luke

Mansfield, Stephen S. *Princess Anne County and Virginia Beach: A Pictorial History*. Virginia Beach, Virginia: Donning, 1989.

Mason, George Carrington. *Colonial Churches in Tidewater Virginia*. Richmond, Virginia: Whittet and Shepperson, 1945.

Pouliot, Richard A. and Julie J. Pouliot. *Shipwrecks on the Virginia Coast and the Men of the Life-saving Service*. Centreville, Maryland: Tidewater Publishers, 1986.

Taussig, Charles William. *The Book of Radio*. New York: D. Appleton and Company, 1922.

Virginia Beach Public Library. *The Beach: A History of Virginia Beach, Virginia*. Virginia Beach, Virginia: Department of Public Libraries, 1996.

Wichard, Rogers Dey. *The History of Lower Tidewater Virginia* [three volumes]. New York: Lewis Historical Publishing Company, 1959.

Yarsinske, Amy Waters. *Naval Air Station Oceana—Mud Flats to Mission Ready*. London, United Kingdom and Charleston, South Carolina: Fonthill Media LLC, 2017.

– . *Lost Virginia Beach*. Charleston, South Carolina: The History Press, 2011.

– . *The Navy Capital of the World—Hampton Roads*. Charleston, South Carolina: The History Press, 2010.

– . *The Elizabeth River*. Charleston, South Carolina: The History Press, 2007.

– . *Virginia Beach: A History of Virginia's Golden Shore*. Charleston, South Carolina: Arcadia, 2002.

– . *The Martin Years—Norfolk Will Always Remember Roy*. Gloucester Point, Virginia: Hallmark Publishing, 2001.

– . *Virginia Beach: Jewel Resort of the Atlantic*. Charleston, South Carolina: Arcadia, 1998.

– . *Wings of Valor, Wings of Gold*. Stratford, Connecticut: Flying Machines Press, 1998.

Mansfield, Stephen S. *Princess Anne County and Virginia Beach: A Pictorial History*. Virginia Beach, Virginia: Donning, 1989.

Mason, George Carrington. *Colonial Churches in Tidewater Virginia*. Richmond, Virginia: Whittet and Shepperson, 1945.

Pouliot, Richard A. and Julie J. Pouliot. *Shipwrecks on the Virginia Coast and the Men of the Life-saving Service*. Centreville, Maryland: Tidewater Publishers, 1986.

Taussig, Charles William. *The Book of Radio*. New York: D. Appleton and Company, 1922.

Virginia Beach Public Library. *The Beach: A History of Virginia Beach, Virginia*. Virginia Beach, Virginia: Department of Public Libraries, 1996.

Wichard, Rogers Dey. *The History of Lower Tidewater Virginia* [three volumes]. New York: Lewis Historical Publishing Company, 1959.

Yarsinske, Amy Waters. *Naval Air Station Oceana—Mud Flats to Mission Ready*. London, United Kingdom and Charleston, South Carolina: Fonthill Media LLC, 2017.

– . *Lost Virginia Beach*. Charleston, South Carolina: The History Press, 2011.

– . *The Navy Capital of the World—Hampton Roads*. Charleston, South Carolina: The History Press, 2010.

– . *The Elizabeth River*. Charleston, South Carolina: The History Press, 2007.

– . *Virginia Beach: A History of Virginia's Golden Shore*. Charleston, South Carolina: Arcadia, 2002.

– . *The Martin Years—Norfolk Will Always Remember Roy*. Gloucester Point, Virginia: Hallmark Publishing, 2001.

– . *Virginia Beach: Jewel Resort of the Atlantic*. Charleston, South Carolina: Arcadia, 1998.

– . *Wings of Valor, Wings of Gold*. Stratford, Connecticut: Flying Machines Press, 1998.

ABOUT THE AUTHOR

Amy Waters Yarsinske is the author of several best-selling, award-winning nonfiction books, notably *An American in the Basement: The Betrayal of Captain Scott Speicher and the Cover-up of His Death*, which won the Next Generation Indie Book Award for General Non-fiction in 2014. To those who know this prolific author and Renaissance woman, it's no surprise that that she became a writer. Amy's drive to document and investigate history-shaping stories and people has already led to publication of over 75 nonfiction books, most of them spotlighting current affairs, the military, history and the environment. Amy graduated from Randolph-Macon Woman's College in Lynchburg, Virginia, where she earned her Bachelor of Arts in English and Economics, and the University of Virginia School of Architecture, where she earned her Master of Planning and was a DuPont Fellow and Lawn/Range resident. She also holds numerous graduate certificates, including those earned from the CIVIC Leadership Institute and the Joint Forces Staff College, both headquartered in Norfolk, Virginia. Amy serves on the national board of directors of Honor-Release-Return, Inc. and the National Vietnam and Gulf War Veterans Coalition, where she is also the chairman of the Gulf War Illness Committee. She is a member of the American Society of Journalists and Authors (ASJA), Investigative Reporters and Editors (IRE), Authors Guild and the North Carolina Literary and Historical Association (NCLHA), among her many professional and civic memberships and activities.

If you want to know more about Amy and her books, go to
www.amywatersyarsinske.com